RENEWALS 458-4574
DATE DUE

WITHDRAWN
UTSA LIBRARIES

GOD AND GOLD IN LATE ANTIQUITY

From the conversion of the emperor Constantine in the early fourth century, vast sums of money were spent on the building and sumptuous decoration of churches. The resulting works of art contain many of the greatest monuments of late Antique and early medieval society. But how did such expenditure fit with Christ's message of poverty and simplicity?

In attempting to answer that question, this study employs modern theories on the use of metaphor to show how physical beauty could stand for spiritual excellence. As well as explaining the evolving attitudes to sanctity, decorum and display in Roman and medieval society, detailed analysis is made of case-studies of Latin Biblical exegesis and gold-ground mosaics so as to counterpoint the contemporary use of gold as a Christian image in art and text. The study brings together art-historical, theological, anthropological and sociological approaches to explain the astonishing splendour of the church from late Rome to the Middle Ages.

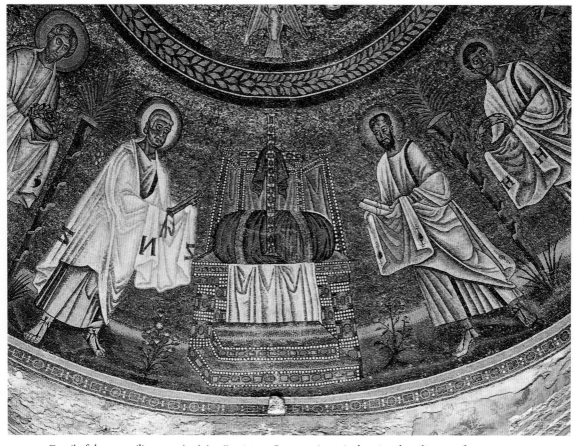

Detail of throne, ceiling mosaic, Arian Baptistery, Ravenna (c. 500), showing the piling up of treasure images to demonstrate the power of the Christian God.

GOD AND GOLD
in late Antiquity

Dominic Janes
Pembroke College, Cambridge

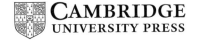

PUBLISHED BY THE PRESS SYNDICATE OF THE UNIVERSITY OF CAMBRIDGE
The Pitt Building, Trumpington Street, Cambridge CB2 IRP

CAMBRIDGE UNIVERSITY PRESS
The Edinburgh Building, Cambridge CB2 2RU, United Kingdom
40 West 20th Street, New York, NY 10011-4211, USA
10 Stamford Road, Oakleigh, Melbourne 3166, Australia

© Dominic Janes 1998

This book is in copyright. Subject to statutory exception and to the provisions of relevant collective licensing agreements, no reproduction of any part may take place without the written permission of Cambridge University Press.

First published 1998

Printed in Great Britain at the University Press, Cambridge

Typeset in Dante $10\frac{1}{2}/13\frac{1}{2}$ [VN]

A catalogue record for this book is available from the British Library

Library of Congress cataloguing in publication data

Janes, Dominic.
God and gold in late antiquity / Dominic Janes.
 p. cm.
Includes bibliographical references.
ISBN 0 521 59403 0
1. Christian art and symbolism – To 500. 2. Christian art and symbolism – Medieval, 500–1500. 3. Gold in art. 4. Gold – Religious aspects – Christianity – History of doctrines – Early church, ca. 30–600. 5. Gold – religious aspects – Christianity – History of doctrines – Middle ages. 600–1500. I. Title.
BR115.A8J36
246'.2-dc21 1998 97-16553 CIP
ISBN 0 521 59403 0 hardback

Contents

Preface	vii
List of illustrations	viii
Note on conventions	ix
List of abbreviations	xi

Chapter 1
INTRODUCTION	1

Chapter 2
ROMAN SPLENDOUR	18
The triumph of the Christians	42

Chapter 3
THE RICHES OF SCRIPTURE	61
Literary symbolism: Latin exegesis	63
Treasures in heaven	84

Chapter 4
THE ART OF PERSUASION	94
Visual symbolism: Christian wall mosaics	105
The taste for brilliance	139

Chapter 5
THE CHRISTIAN DISPLAY OF WEALTH	153
EPILOGUE	165
Bibliography	170
Index	207

Preface

I must take this opportunity to thank a number of individuals and organizations for their help during the period in which this book was researched and written. First and foremost, I owe a substantial debt to Rosamond McKitterick, for her belief in this research, for her unstinting assistance and unfailing support. I must also thank Greg Woolf, who bears considerable and happy responsibility for my original preoccupation with material culture. Valuable advice was offered by many others, amongst whom Catherine Hills, Peter Garnsey and Bryan Ward-Perkins should receive special mention.

I am pleased to acknowledge the substantial assistance towards the costs of my research of the British Academy and of Pembroke College, Cambridge, together with the Cambridge Historical Society and four trust funds of the University of Cambridge: the Prince Consort and Thirlwall, the Kathleen Hughes, the Lightfoot and the H. M. Chadwick Funds. A period of residence in Italy was supported by a Hugh Last Award from the British School at Rome. The publication of this book has been assisted by a grant from the Scouloudi Foundation in association with the Institute of Historical Research (University of London).

I owe a primary debt to two institutions. The excellence of the University Library in Cambridge has been a crucial factor in speeding the completion of my work. Pembroke College, meanwhile, has maintained a roof over my head, both when I was a graduate and, lately, by calling me back from Lancaster University as a research fellow. For such assistance, as well as for the support and pleasant distractions offered by my friends, I can only state the fact of my gratitude.

Illustrations

Plates have been provided with the permission of the following archives:

Conway Library, Courtauld Institute of Art, London [CL]
Deutsches Archaeologisches Institut, Rome [DAI]
SCALA, Istituto Fotografico Editoriale, S.p.A, Florence [SCALA]

Cover and frontispiece. Detail of throne, ceiling mosaic, Arian Baptistery, Ravenna (c. 500) [cover, DAI] [frontispiece, SCALA]

Figure 1. Silver *missorium* of Theodosius (late-fourth-century) [DAI]	29
Figure 2. Detail of Justinian, presbytery wall mosaics, San Vitale, Ravenna (mid-sixth-century) [DAI]	30
Figure 3. Remains of a giant statue of Constantine, Rome (mid-fourth-century) [DAI]	49
Figure 4. Vault mosaic, Santa Constanza, Rome (mid-fourth-century) [DAI]	99
Figure 5. Sarcophagus, Archiepiscopal Museum, Ravenna (sixth-century) [DAI]	102
Figure 6. Niche with mosaic, Pompeii [DAI]	107
Figure 7. Apse mosaics, San Vitale, Ravenna (mid-sixth-century) [DAI]	115
Figure 8. Archangel Michael, wall mosaic, Sant'Apollinare in Classe, Ravenna (mid-sixth-century) [DAI]	120
Figure 9. Detail of Christ, wall mosaics, Sant'Apollinare Nuovo, Ravenna (c. 500) [DAI]	121
Figure 10. Central detail of apse mosaic, Sant'Apollinare in Classe, Ravenna (mid-sixth-century) [DAI]	122
Figure 11. Cross of Agnellus, Cathedral, Ravenna (sixth-century) [CL]	125
Figure 12. Mosaic of Christ the Soldier, Archiepiscopal Chapel, Ravenna (c. 500) [DAI]	131
Figure 13. Apse Mosaic, Sant'Agnese, Rome (early-seventh-century) [SCALA]	169

Note on conventions

Consistency of practice and respect for convention often equate, but all too frequently do not. Therefore, I have decided to refrain from the imposition of a rigid reference scheme. In other words, strict consistency has been sacrificed to comprehensibility. Names of people and places are given in the manner most familiar to the English reader. So, for example, towns appear in their Anglicized form, but churches do not (Santa Maria Maggiore, Rome). Names are subject to even greater caprice in English usage. Thus, well-known figures appear Anglicized (Jerome for Hieronymus), whilst others appear in full or hybrid Latin forms according to common usage (Sidonius Apollinaris/Caesarius of Arles). The AD convention for dates has been applied in titles and in cases of possible confusion with BC, but otherwise has been omitted. However, BC has always been employed. States and regions are capitalized (Roman Empire) but titles of persons not (Roman emperor). Major historical periods are capitalized but not subdivisions within them (late Antiquity, late Antique). On occasion I have used capitalization to single out, for example, the Roman State from any other state, and the Church from a church. Quotations from languages other than English are given in footnotes, with translations in the main text. For the purposes of clarity, capitals have been placed in Latin according to conventions in English.

The referencing system was set out on the principle of providing comprehensive bibliographic and textual references whilst keeping that apparatus as compact as possible; to which aim much use has been made of abbreviations (listed on pages xiii–xiv). Citations appear in the footnotes as follows: primary sources in full on their first appearance, but abbreviated thereafter in the form Alberti, *Pict.* x, z; secondary sources are always abbreviated in the form Adhémar (1934), pp. x–z. The abbreviations list is comprehensive, excluding only examples familiar in mainstream English and the shortened forms of primary source titles (but including the frequently occurring *Apoc.* and *Cant.*) In an attempt to avoid over-cumbersome footnotes, duplicate references have been avoided; therefore, either chapter/section/line numbers are given (usually in the case of primary sources), or page/

column numbers (in the case of secondary sources), but not both. An exception is the case of exegetical texts which are normally subdivided by reference to the Biblical passage under discussion. This should be clear from the text, but in addition the page/column reference to the edition used is given in the footnotes. I have included a separate statement concerning bibliographic conventions (p. 170); however, it may be appropriate to add at this juncture that, in a very small number of instances, full citations are given in footnotes of primary sources that do not appear in the bibliography. These are items which, although of tangential interest, have not been closely examined in the context of this study. In all other cases the bibliography should be regarded as a comprehensive list of the written materials I have employed.

Abbreviations

AAAHP	Acta ad Archaeologiam et Artium Historiam Pertinenta
ACW	Ancient Christian Writers
AH	*Art History*
AHS	*Annales d'histoire sociale*
Apoc.	commentary on the Revelation of John
ASE	*Anglo-Saxon England*
AV	Authorised Version (King James Bible)
BAR, IS	British Archaeological Reports, International Series
BAR, SS	British Archaeological Reports, Supplementary Series
BMGS	*Byzantine and Modern Greek Studies*
BN	Bibliothèque nationale
BS	Bollingen Series
BZ	*Byzantinische Zeitschrift*
CA, FAMA	*Cahiers archéologiques, fin de l'antiquité et moyen age*
Cant.	commentary on the Song of Songs
cat.	catalogue
CCARB	*Corsi di cultura sull'arte ravennate e bizantina*
CCSL	*Corpus Christianorum, Series Latina* (Turnhout)
CEFR	Collection de l'Ecole française de Rome
CIL	*Corpus Inscriptionum Latinarum*
CSEL	*Corpus Scriptorum Ecclesiasticorum Latinorum* (Vienna)
CSSA	Cambridge Studies in Social Anthropology
DOP	*Dumbarton Oaks Papers*
DOS	Dumbarton Oaks Studies
EPROER	Etudes préliminaires aux religions orientales dans l'empire romain
EY	*Eranos Yearbook*
FC	Fathers of the Church
FR	*Felix Ravenna*

	IPA, SP	Istituto Patristico Augustinianum, sussidi patristici
	ISK	Instituttet for Sammenlignende Kulturforskning
	JAC	*Jahrbuch für Antike und Christentum*
	JRA	*Journal of Roman Archaeology*
	JRS	*Journal of Roman Studies*
	LCL	Loeb Classical Library (Cambridge, Mass.)
	MAA, RT	Medieval Academy of America, Reprints for Teaching
	MAH, EFR	*Mélanges d'archéologie et d'histoire, Ecole française de Rome*
	MDAI, RA	*Mitteilungen des Deutschen Archaeologischen Instituts, römische Abteilung*
	MGH	*Monumenta Germaniae Historica* (Berlin, Hanover and Leipzig)
	MGH, AA	*Monumenta Germaniae Historica, Auctores Antiquissimi*
	MGH, S	*Monumenta Germaniae Historica, Scriptores*
	MGH, SRM	*Monumenta Germaniae Historica, Scriptores Rerum Merovingicarum*
	ML	Mediaevalia Lovaniensia
	NPNF	Nicene and Post-Nicene Fathers
	PG	*Patrologia Graeca*, J. P. Migne (ed.) (Paris, 1857–91)
	PL	*Patrologia Latina*, J. P. Migne (ed.) (Paris, 1844–55)
	PP	*Past and Present*
	RAC	*Rivista di archeologia cristiana*
	REA	*Revue des études augustiniennes*
	Rev.	Revelation of John
	RQCAK	*Römische Quartalschrift für Christliche Altertumskunde und Kirchengeschichte*
	SAEMO	*Sancti Ambrosii Episcopi Mediolanensis Opera* (Milan)
	SBF	Studium Biblicum Franciscarum
	SC	*Sources chrétiennes* (Paris)
	SCH	Studies in Church History
	S/ser.	S/series
	SO	*Symbolae Osloensis*
	Song	Song of Songs
	SP	*Studia Patristica*
	SSF, CHL	Societas Scientificarum Fennica, Commentationes Humanorum Litterarum
	S/suppl.	S/supplement
	TCH	Transformation of the Classical Heritage
	TRHS	*Transactions of the Royal Historical Society*
	TTH	Translated Texts for Historians
	VC	*Vigiliae Christianae*
	VCS	*Vigiliae Christianae*, Supplements

CHAPTER I

Introduction

What makes a Christian a Christian? It was said to a famous rhetor that he would not be so counted, although he believed in his heart, since he was not seen in church. His reply was in the form of a question: 'do walls then make Christians?'[1] Augustine, undoubtedly one of the greatest minds of Antiquity, reports this story simply and without irony as a hiatus in the conversion of a pagan to the true faith. Many of the most splendid and opulent works of European art and architecture were executed as acts of Christian piety. The world of the spirit is traditionally placed in direct contrast to the world of the flesh in Christian understanding, but any visible expression of faith on the part of believers in the here and now must needs be material. Before the high Anglican shrine of Our Lady of Walsingham in Norfolk there burn hundreds of small votive candles, on each of which is a label with the name of a church community or a person offering praise or asking help. In the Catholic tradition from the Middle Ages wishes were materially expressed to God and the saints in a variety of ways. Votive objects joined votive candles, each visibly marking an act of attention to the realm of heaven. The boundary between what was properly the realm of the spirit and that of the flesh was never clear, as in the case of the bread of communion. Protests at the intense visual symbolism of much Christian religiosity have led to divergent traditions. In a modern Quaker meeting room, chairs are placed in circles around a table on which there will be no more than a few Bibles and a small bunch of flowers in a vase. But the very act of sitting in silence for a hour in such circumstances is itself a specific material ritual.

The problem can be considered in non-Christian terms as one of how a community regulates its members in relation to its perception of supernatural power, since if God is omniscient, then He knows the thoughts of everyone in any case. It is, however, a fundamental characteristic of humans to exist in societies. Understanding exists through mutual comprehension. Appreciation of divinity, therefore, must be an activity made manifest within the group. However, manifes-

[1] Augustine, *Confessiones*, 8, 2, L. Verheijen (ed.) *CCSL* 27 (Turnhout, 1983), 'ergo parietes faciunt Christianos?'

tations perceivable by the senses constitute material activity even if this is understood in spiritual terms. This is a survey of the magnificent material culture of the churches of late Antiquity, of how it was seen and how it can be interpreted (I should add that I would very much have liked to include comprehensive colour illustrations, but this would have been prohibitively expensive in a specialized monograph with a small print run).[2]

The cultural history of Europe for much of the last two millennia has been dominated by Christianity. That religion bases its view of morality on the example of the life of Jesus Christ, who renounced many of the values of Antiquity. On the evidence of the Gospels, Christ was scornful of worldly wealth. He told his followers that it is 'easier for a camel to pass through the eye of a needle, than it is for a rich man to enter the kingdom of heaven'.[3] He instructed his followers to give away all they had and follow him, yet the churches of the newly Christianized Roman Empire and its successor states were repositories of vast wealth. They were lavishly embellished with valuable 'treasures' such as gold and silver fittings, furniture, vessels and decorations. Such immensely expensive buildings and their associated works of art were one of the most remarkable artistic achievements of the age. That tradition endures today in many Roman Catholic and Orthodox churches despite the strongly hostile attitude of many Christians, especially at the time of the Reformation, to the use of such display.[4] Considerable modern study has been directed towards the theological debates on *personal* wealth found in the writings of the Fathers. However, the inconsistencies inherent in the *corporate* splendour of the Church were not largely fought out through specific tracts. This book represents an attempt to explain the complex cultural situation which allowed the Christians to display their corporate wealth so prominently and proudly.

In Roman society kings, emperors and pagan gods were displayed with gold and silver regalia indicative of their high status. These metals played an important role in the symbolic articulation of social relations. As an element of his promotion of Christianity as the State religion in the early fourth century, the emperor Constantine did honour to his God by showering the Church with gifts in the form of estates, cash, buildings and vast numbers of gold and silver treasures. Having originated in poverty, Christianity took up a dominant place in the social world of the Roman Empire. In that process, use of goods and substances special to the social elite had come to be employed by the Church in pursuit of its own

[2] I have been careful to supply references so that readers can easily find colour illustrations elsewhere.
[3] Mark 10: 25; Matthew 19: 24 and Luke 18: 25.
[4] Duffy (1992) and Coulton (1953). A bibliography on the topic of art and the Reformation is Parshall & Parshall (1986).

self-promotion. Not all Christians approved of this process. Saint Jerome wrote that while the sacred texts were being embellished with gold and silver, 'Christ was left naked and dying at the door'.[5] But most Christians appear to have revelled in the new and huge wealth of the Church. How was it that the Christian God was expressed symbolically by gold, when that substance had traditionally been used to display the power of the secular nobility and pagan gods of Antiquity? Why did Christianity, with its scripturally enshrined mission to redistribute wealth, not only do so little to disturb ancient patterns of aristocratic symbolism, but even adopt them itself? Why should an apparently world-denying religion have devoted such a considerable part of its resources in late Antiquity to the construction of worldly splendour?

This study examines these phenomena by looking at case-studies of Christian imagery in order to try to understand the messages which such display put across at that time. The extensive corpus of gold mosaics from the period, especially from Italy, provides one of the best sources of evidence for luxury church decoration. The acceptance of the jewelled splendour of these churches was bolstered by the Jewish heritage of treasure decoration, as preserved in the sacred words of the Old Testament. Latin Christian interpretation of Biblical texts provides a parallel context in which to understand the nature of late Roman Christian attitudes concerning gold. In contemporary writings, the golden ornaments both of the ancient Jewish temples and of the new churches were described in terms of their 'wonderful glitter and brilliance', symbolic of the 'splendour' of God and the 'brightness' of Christian love. Such texts explain how gold in religious art was contemporaneously interpreted. In order to explain the lack of direct explanations of this phenomenon of 'treasure' use from late Antiquity, I have had recourse to modern social theories, including the notion that many social processes were often so ingrained in contemporary expectations that they were either taken for granted or their full implications were not then explored.

As an atheist of the late twentieth century, I am very much aware of the vast chronological and conceptual difference between my world and that of the period which I have chosen to study. I believe that human emotions and mental processes have not changed in that time. That being so, a work of historical analysis must needs make heavy reliance upon the resources of imagination. The question must be asked, again and again: what conditions would make me think as they appear to have thought and act as they seem to have done? I am also well aware that this study springs from my modern preoccupations. Written sources from the period

[5] Jerome, *Epistulae*, 22, 32 I. Hildberg (ed.) 3 vols., *CSEL* 54–6 (Berlin, 1910–19), 'inficitur membrana colore purpureo, aurum liquescit in litteras, gemmis codices uestiuntur et nudes ante fores earum Christus emoritur'.

do not provide a conveniently direct answer to my question. If they had done then this survey would doubtless have been written long ago. I have had, therefore, to balance two requirements. On the one hand, I want to answer my question as set in my own terms. On the other, I do not want the authentic voice of the period to be obliterated. I have to construct a narrative that includes, as an element in my wider analysis, what people at the time thought they were doing. Nevertheless, I have not abandoned the basic assumption that I am attempting to provide a recreation, however sketchy, of one-time reality, and that I am not simply reproducing ancient rhetoric. An awareness of the 'artificiality' of writing 'history' today does not invalidate the process, but rather acts to define the boundaries of such an endeavour. At the risk of sounding faintly medieval for a moment, I would wish to say that whatever the limitations of myself and of my approach, I have laboured for the sake of truth. But, to put it in a more modern way, I especially aim to persuade.[6]

This research has been influenced by a variety of ideas stemming from the disciplines (especially archaeology, anthropology and art history) which have traditionally devoted much time to the analysis of material and visual culture. This chapter, therefore, sets out to introduce this approach and to survey relevant modern theoretical and comparative approaches to the study of material display. Chapter 2, 'Roman splendour', describes the practice of display by the elite and the related tradition of social criticism as it existed in the earlier Roman Empire, before examining how such practices of secular society had developed by late Antiquity. There follows a discussion of how pagan religiosity was expressed in material forms, prior to an investigation of the immense material endowment of the Church from the time of the conversion of the emperor Constantine in the early fourth century. Chapter 3, 'The riches of Scripture', examines the developing Christian symbolic tradition, the ultimate aim of which was to express the sublime nature of God. Chapter 4, 'The art of persuasion', represents a parallel case-study of the symbolic visual expression of excellence in the large city churches of the western empire (as seen from the evidence of gold-ground mosaics surviving largely from Rome and Ravenna in Italy), together with a discussion of spirituality and aesthetics. Finally, chapter 5, 'The Christian display of wealth', examines the tensions in the deployment of splendour by the church, and how those difficulties and anxieties were largely, but not entirely, overcome.

No single survey can ever hope to exhaust a problem of any complexity. I have had to make tough decisions about what to leave out, as well as what to include. Dating is always a rather arbitrary matter. 'Late Antiquity' is meant to express the period from the developed tetrarchy immediately prior to Constantine's conver-

[6] Clifford (1986), p. 7, 'all constructed truths are made possible by powerful "lies" of exclusion and rhetoric'.

sion, through the growth of the sub-Roman kingdoms of the west, but stopping short at the establishment of the Carolingian Empire. It has been my aim to think in terms of the development of western culture, and, as such, I was interested in the question of prestige display rather than the issue of the worship and repudiation of figural images. There remains, therefore, a very valuable opportunity to follow the question of material prestige in relation to the worship of images during the Byzantine Empire.

Apart from the question of the development of the east, I am well aware that perhaps the most significant absence from this study is a detailed consideration of the nuances of local traditions and individual opinions. It has been my aim to establish the mainstream opinions on the symbolic use and understanding of gold and other 'treasure' in this period. In attempting to construct such a general explanatory framework, I have been indebted to studies from a variety of modern disciplines. Just to restate the obvious, the subject of this work is the product of a late-twentieth-century imagination. No one wrote such a work in late Antiquity. This is the study, therefore, of a topic that was not then recognized as an issue that could be so addressed. The phenomenon of precious metal in churches was, for the most part, taken for granted, which is an interesting fact in itself. There is no question of arguing from silence. Although it is chronologically and geographically scattered, there is such a huge amount of evidence that select case-studies have had to be employed. In piecing together such materials, a modern theoretical framework for analysis is extremely useful. However, the problem with many of the ideas essential to the resulting interpretation is that they are not the products of the society under discussion, but have arisen from modern comparative study of cultures.[7] There is raised, therefore, the important issue of the gap between the historical reconstruction and the nature of the surviving evidence.[8] A modern analysis is not simply an artificial creation, it is also necessarily a simplification for the sake of clarification. Yet this is inherent in the process, and an accessible arrangement of the source materials is very much a strength as well as a weakness. Nevertheless, this introduction has also been provided to stress that whilst recent ideas drawn from a variety of disciplines are important for this study, they are not ultimately the subject of it.

Secular gift to the Church will, in chapter 2, be outlined as a major factor in the development of Christian monuments. These buildings, like aristocratic and imperial dwellings, were lavishly decorated. The imagery used in the late Antique churches was partly derived from Scripture, and partly from the cadres of state and

[7] Bearing this is mind, general statements in the following section have occasionally been provided with corresponding examples from ethnographic study.
[8] This problem is similar to that in writing anthropological analyses of foreign groups and tribes, Asad (1986).

private, secular and religious art. Great use was made of treasures and treasure substances. Treasures, I define as essentially symbolic items made of materials used in association with social excellence (which in Rome meant especially gold, silver and gems, but also included purple silk and ivory, amongst other materials) and functioning as an aspect of conspicuous consumption.[9] Mosaic was one of the foremost elements employed as adornment in churches so as to transmit ideas to the viewer. These messages might pertain to particular Biblical episodes, or to general qualities such as 'abundance'. This art was art for a purpose. Such images as these, that acted to send messages, were symbols. To understand the resulting visual propaganda, the nature of figurative codes and means of presentation will have to be considered.

Symbolism is, of course, a matter of communication. Spoken words are nothing other than symbolic sounds. These sounds do not *mean* anything in themselves. They only mean things to the extent that there is communal ascription of meaning to them. Man has been referred to as *homo symbolicus*.[10] Human societies have varied in the degree to which the individual senses were used for the conveyance of information. From its origins, classical society made extensive use of visual signs. Testimony to that can be found in the evidence for widespread literacy as well as in decorative schemes.[11] In a historical investigation, it is important not simply to read an ancient language, but if possible to do so as it would, or was intended to have been read. Late Antiquity did not blithely employ language and symbols. There was much debate about the meaning of signs, as will be discussed in chapter 3. Debates on the literal or figural interpretation of texts will be applied in the context of the art-historical materials.

It may well be mistaken to try to separate aesthetic from symbolic aspects of artistic production. For example, the temptation is for modern westerners to think that jewellery is merely beautifying and does little else. Yet, in its function of indicating status, 'jewellery merges into regalia', and it can also express a whole range of personal and physical conditions.[12] Ernst Gombrich, in his book, *The Sense of Order*, tackled the importance of decoration in human society. He wished to rescue decoration from the label of 'mere' elaboration. Patterns, he argued, play to the processes of human visual cognition, and may be appreciated aesthetically

[9] 'Conspicuous consumption', as a phrase, has passed into general use, but it was originally defined by Veblen (1899).
[10] Eliade (1976), II, p. 346.
[11] O. Murray (1986), p. 228, 'in a city like Athens well over half the male population could read and write'.
[12] Mack (1988a), pp. 9–22. On 'ethnic' jewellery traditions in general see the catalogue Tait (1976), together with Barry on Africa, Scarce on the Middle East, Untracht on India, Hitchcock on the Far East, Pole on the Pacific, Julie Jones on Precolumbian America, Shelton on Modern Latin-America, M. Wood on North American Indians (all 1988). As Barry (1988), p. 25, remarks, jewellery is almost universally used.

because they pander to the basic processes of mental cognition. Enjoyment of patterns is seen as springing from 'man's pleasure in exercising the sense of order'. This sense is the result of 'the tendency to probe both the real world and its representations with a hypothesis of regularity which is not abandoned unless it is refuted'.[13] By this method of trial and error is the world analysed. Each interruption of regularity delivers a mental stimulant. This stimulation can provide enjoyable mental entertainment when it is managed in the form of artistic production. This does not explain, however, why different societies use and appreciate different patterns. Here we reach the question of implicit and explicit meanings. If someone makes an ink pattern with a pen, that design has been consciously created, yet it is not apparently symbolic in that it appears to be without obvious *intended* meaning. Yet if a pattern is identifying of an individual, group or culture, or if it is applied in a distinctive context, it will have acquired a symbolic dimension.

Stimulation can therefore be seen also to come from an image's power of 'evocation'. So, in a simple example, a flower pattern on wallpaper suggests real flowers, which may suggest a sunny summer day in the country in contrast to the view through the window of a grimy city street. The rural vision suggests holidays and so the evocation continues. The flowers thus provoke positive associations. The problem with analysing the evocative powers of objects is that such activity occurs in the mind of the viewer. It is initiated rather than controlled by the object itself. A pattern is symbolic only in so far as it is found to be symbolic. This means that in addition to looking at the picture, we also have to understand those who viewed it. Moreover, it is also vital to consider the relationship between producer and consumer. Those who made late Roman mosaics had their own purposes in mind. In such an investigation as this, we have to rely on the common ascription, made consciously or unconsciously, of consistent meaning to symbols within a society, without which coherent communication does not occur. That means that we can guess what the creator intended and what the viewer understood since, to follow Miller's discussion, 'no object has an intrinsic meaning; its meaning depends upon the place it is assigned'.[14]

But there is a further complication. Those who view or create do so from the basis of a quantity of mental baggage only a proportion of which self-consciously shapes the intention on the part of the creator, or the impression on the part of the viewer. Therefore, some signalling is deliberate and conscious ('active'), and some

[13] Gombrich (1984), p. 5.
[14] D. Miller (1982), p. 19. Since symbols are defined in social context and social life is variable, so there can be no universal symbols, B. Morris (1987), p. 227. In an interesting comparison with religious beliefs, Freudian analysis suggests otherwise: that certain associations are inevitable because of the shared human unconscious. This can be believed in, but not proved.

is less so ('passive'; i.e. 'artisans doing things in the way that they have learned is the proper way of doing them'.)[15] 'It is through social convention that something comes to stand for something else',[16] but such convention is not always transparent or expressed at the time. This means that contemporary sources cannot provide a conceptual panacea because 'art forms are perceived, although perhaps not explicitly verbalised'.[17] Contemporary texts can only say what they thought was going on by using conventions which themselves were stylized. What *was* taking place can be considered as a triangular relationship between referents, concepts and symbols. Thus, if blood is sacred, blood-colour may symbolize sacredness and a blood-coloured stone may thus evoke blood and be symbolic of holiness. But this does not form a closed system. The stone has now the three attributes: rock, red and sacred. It can itself be expressed by something else. It can be a referent as well as a symbol. Understanding the symbolism of a society may therefore be a question of perceiving in which directions the main flows of associations were moving, as well as determining the points on the network to which conceptual association could flow.

An alternative is therefore necessary to a categorization of 'symbolic' or 'non-symbolic', since it is impossible to create or view something that evokes nothing. Symbolism only exists in a dynamic system that is the sum of the mental behaviour of those participating in that system. The meaning of a symbol depends on its 'relational positioning', that is, on how the participants use it.[18] The symbolism of an age composes a considerable part of the characteristic culture of that age, with all its self-incomprehension and self-delusion thrown in. This inquiry may be said to be a study of the late Antique 'styles', if 'style is a form of non-verbal communication through doing something in a certain way that communicates information about relative identity'.[19] It can be argued that participation in the system implies a dynamic association in which the system largely affects the behaviour of the individual, but the system is nevertheless influenced to some small degree by each participant. So, for instance, one step to being an aristocracy is having an aristocratic style. This style is only established, however, by its presence in the conceptual systems of the rest of those in the wider society. Groups operating within the system can, therefore, be interpreted as attempting to manipulate symbolic understanding – associating gold with goodness, for example – in a semi-conscious attempt to wrest control of the dominant categories of mental classification, as part of the human struggle for survival and aggrandizement.[20]

Such strategies can be used to mark out groups, as suggested, and such attempted separation between units of differing power and status is particularly easy to

[15] Sackett (1990), p. 37. [16] D. Miller (1982), p. 19. [17] Washburn (1983b), p. 6.
[18] Shanks & Tilley (1982), p. 132. [19] Wiessner (1990), p. 107. [20] Bourdieu (1984), p. 483.

identify. The reasons for this are that the resulting styles tend to be highly symbolic, have distinct referents, are actively used and are found in specific contexts, often in association with the utilization of characteristic prestige substances. Style is particularly attractive for such strategies of propaganda, since it can instantly catch the visual attention, provides the opportunity for measured gradations of prestige and can make an extravagant and obvious parade of resources.[21] Success in such a strategy of distinction will depend upon the presence of superior possessions. But since humans must operate with what they *think* is correct, propaganda itself, the strategy itself, is also a possession.

Chapter 2 having examined the social competition for display and disputes over illegitimate splendour in the Roman Empire, chapter 3 will then explore the Christian textual relationship to such symbolic practices. With all this in mind, the interiors of late Antique churches will be considered, in chapter 4, by means of a case-study of mosaic decoration. It will be useful briefly to summarize the implications of the above ideas for the consideration of individual mosaics. Specific details of these should be viewed as individual elements in the wider cognitive system of the time. They were inserted, deliberately or inadvertently, by individuals fired by a Christian ethos, the expression of which was tempered by wider conventions. So, for example, a feature which was intended to be a decorative prop to a central figural motif, might be said to possess a relatively low level of *explicit* symbolism. It was not premeditatedly intended to embody and convey a precise message. Nevertheless, a bower of verdure surrounding a late Antique image of Christ has its own power of evocation, since it was a wider symbol of abundance. It would have been particularly filled with meaning with regard to its specific context. When thinking about Christian practice, we can dismiss the possibility of *mere decoration*, and begin to wonder about the otherness of the society that produced such strange forms. Who, asked Grabar, 'has not been disturbed by the hermetic character of an Indonesian or a Mexican work of art as by a phrase in a language he does not know?'[22] Such complex visual texts were meant to be understood in a certain way. To sum up, images are symbolic, that is, found meaningful, to a greater or lesser extent; with varying degrees of implicitness and explicitness; provoking evocations of greater or lesser variety and coherence; in accordance, in subsequent periods and to varying extents, with the implicit or explicit understandings and intentions of their creators. It is with such considerations in mind that we may approach the art-historical evidence of late Rome.

The above list of provisos and qualifications may help to aid the appreciation of the malleability possessed by the symbolic quality as a result of its location in the

[21] Wiessner (1990), p. 110. [22] Grabar (1968a), p. xliii.

human mind rather than in the image. Since the following discussion is based upon a unitary period, I leave out the question of how images come to be understood in later centuries. However, the issue of the variety of contemporary understandings is one that must be addressed here. An exploration of this subject has been provided by Henry Maguire in his *Earth and Ocean: The Terrestrial World in Early Byzantine Art*.[23] His aim was to explain the pervasive presence of the natural world in, primarily, the mosaic of this period. He signals the fact that the Fathers of the Church provide evidence of widely differing interpretations of the same themes and literary motifs. The primary sphere of variation in this area was in the range from literal to allegorical, that is, in varying degrees towards the employment of specifically contextual symbolic interpretation, from direct evocations (a lamb suggests a lamb) to indirect ones (the lamb suggests Christ). Thus, Theodore of Mopsuestia is known as one of the foremost literal interpreters of Scripture, whilst Origen of Alexandria has been seen as the father of allegorical understanding. Moreover, even individual writers acknowledged that there were varied ways in which Scripture could be understood. Not only that, but it was frequently asserted that ascription of varied meanings (as long as these were seen as non-conflicting) was not only possible, but necessary for true understanding. So, Augustine asserted that the sacred writings on heaven were interpreted literally by some, allegorically by others, but in both ways by himself.[24]

This meant that there was room for an attempt at an expression of complexity since a single image could rightly suggest many things in a poetic fashion. After all, the human mind was scarcely equal to encompassing the immensity of the divine. All that one could do was to see through a glass darkly, and hope, by meditation on the holy word and the holy image, to find a little of the truth that was hidden there.[25] Symbols, to the medieval mind, were repositories of mystery, the meaning of which was as much granted by revelation as by study. Maguire argues that the reason why this has not received the recognition it deserves may lie in the fact that 'modern academics have tended to be unhappy with uncertainty of meaning, preferring to look for solutions that are more clear-cut and precise'.[26] Recent study may also attempt to explain away features which appear peculiar to the modern eye. Certainly, what contemporary people say about the meanings of works of art often appears strange in retrospect. The Memorial Committee that oversaw the erection of the figure of Eros at Piccadilly in London stated that the statue was

[23] Maguire (1987b).
[24] Augustine, *De Genesi ad Litteram*, 8, 1, *PL* 34, cols. 245–485, 'non ignoro de Paradiso multos multa dixesse... Una eorum qui tantum modo corporaliter Paradisum intellegi volunt: alia eorum qui spiritualiter tantum: tertia eorum qui ultroque modo Paradisum accipiunt; alias corporaliter, alias autem spiritualiter... tertiam mihi fateor placere sententiam.'
[25] Gombrich (1972), p. 13. [26] Maguire (1987b), p. 10.

'purely symbolical and illustrative of Christian charity'(!); a statement that can only be understood in terms of Victorian appreciation of Greek art, but fear of its sexual values.[27] The notion of 'decorum' is a most important one.[28] Themes were treated in art in various ways over time, partly because what was thought 'fitting' changed. In nineteenth-century England it was decorous to have a classically inspired statue, but not for the *eros* it represented to be erotic. But it *was* frequently fitting in late Antiquity to indicate divinity using visual symbols which made use of the most expensive materials and most elaborate craftsmanship.

Symbolism should be seen in relation to power.[29] Symbols which 'evoke sentiments and emotions, and impel men [sic] to action' often occur in sites and circumstances of public activities which are the domain in which individual social power can act on others.[30] What matters in social construction is the perceived nature of reality, which can be presented in ritual, or as text, hence the power of myth.[31] Propaganda may be considered as self-conscious myth for a purpose. The medium of ritual and myth is symbolism, since symbols are the abstractions that allow the communication of ideas. Symbols do not have fixed meanings, since they only possess meaning in the viewing mind. To understand that meaning at a particular point, it is important to examine their context, to take a functionalist approach, and ask what they are doing and what their place is in the relations of power.[32]

Power relations can be understood as the field of tension between individuals and groups that are partly ally and partly enemy. Power is the ability to have others serve your interests.[33] Conflict can be seen as deeper than a conscious battle of wills. Higher dimensions of understanding power have been proposed that also take into account latent conflict.[34] Symbolic space can be considered as the visible field for 'mediating' the tensions created by power disparities,[35] which can be used by either accounting for or tactfully obscuring the true order.[36] As means of communication, ritual symbols act so as to prevent open conflict, hence Lévi-Strauss' view of symbolic gift exchanges as 'peacefully resolved wars'.[37] Tensions can therefore be placed in a controlled context through ritual, which can be considered as 'three-dimensional' symbolism: as pictures that change with time. The ritual context is therefore a visible zone in which to express the social roles of the actors, visualized on the terms of those with power.[38] Rituals and symbols are

[27] Gombrich (1972), p. 1. [28] Ibid., p. 7.
[29] Cohen (1974), on symbolism and power, with Lukes (1979) and (1986a), on power.
[30] Cohen (1974), p. ix. [31] McIver (1947), pp. 4–5. [32] Cohen (1974), p. 25.
[33] Dahl (1986). [34] Lukes (1979), especially on 'three dimensional power', p. 23.
[35] Cohen (1974), p. 26. [36] B. Morris (1979), p. 134.
[37] Lévi-Strauss (1949), p. 86, 'les échanges sont des guerres pacifiquement résolues'.
[38] Munn (1973), p. 615. One of the best discussions of ritual is that of G. Lewis (1980).

deployed to evoke a vision of reality, hence the hatred with which 'enemy' symbols can be treated.[39] The ritual stage is a place for making a view of the world clear, though that view may be a fiction. Face-saving is of particular importance in the ritual presentation of power, since it allows juniors to accept the domination of others. Hence the necessary 'misrecognition' in gift exchange and the general obscurity of rituals which appear to be a very complex way of giving a simple message, a phenomenon that will be mentioned, in chapter 2, in the context of the early emperors and the aristocracy.[40] Symbolically expressed patronage can only urge its acceptance by others. It may be observed that if fact and reality are widely separated, it becomes very difficult to sustain such presentations; 'for art to be effective as wish-fulfilment it must attain a certain degree of plausibility', hence the revealing Senatorial attitude to Julio-Claudian divinity.[41]

The waning physical power of Rome can never be so disguised to us as it may have been for contemporaries by the rituals that were initiated to display and legitimate its supremacy. From such examples, ritual, symbolism and power can therefore be seen to be associated, since the one aids the exercise of the other. Treasure items, crowns, thrones, crosses and so forth were extensively deployed in late Roman ritual, as in the dress of emperors, or the silver vessels of the Mass. Treasures, as has been stressed, were given value by general consent since 'goods are neutral [but] their uses are social'.[42] Ian Hodder stressed the fact that symbols are by definition 'employed' in the title of one of his books, *Symbols in Action*. Symbols, he tells us, 'are actively involved in social strategies. Because of this active involvement, the symbols may be used to mask, exaggerate, or contradict certain types of information flow and social relationships.'[43] The use of jewelled symbolism by both the Church and the State might therefore be seen in the context of institutions competing for visible prestige in the visual language of the age.

Social structure has been called an 'artefact' of the symbolic knowledge produced by ritual.[44] Rituals are complex, formalized and repeatable sets of behaviour with one of their central goals being the regulation of the social or ideological order. They have been understood as strategies employed to serve against the drift of meanings and ideas. Because of the power of visual display, 'more effective rituals use material things, and the more costly the trappings, the stronger we can assume the intention to fix the meanings to be'; or at least the stronger the imperative to attempt such a 'fixing'.[45] To be effective symbols must

[39] Kubler (1971), pp. 213ff with reference to the post-Columbian destruction of native American art motifs.
[40] Leach (1976), p. 41. [41] Fischer (1971), p. 158. [42] Douglas & Isherwood (1979), p. 12.
[43] Hodder (1982b), p. 228. [44] I. Morris (1992), p. 9.
[45] Douglas & Isherwood (1979), p. 65. For an example of the link between ritual, material culture and hierarchies as examined from the material record, see the study of prehistoric Wessex, Braithwaite (1984).

be striking to the viewer.⁴⁶ If gold had the power of attracting interest, it is not surprising to find that objects intended to catch attention were adorned with the metal.

We should always ask, what is it that particular objects or materials add to the accomplishment of a ritual?⁴⁷ The elaborate jewelled ceremonial of the late Roman court can be seen as an attempt to *maintain* belief in the imperial power, but that is to ascribe a meaning that was not then articulated.⁴⁸ Lewis is sceptical of ritual interpreted as a medium of communication that outsiders may simply come along and decipher. He notes that what is clear in ritual is how to do it, not what it means.⁴⁹ But that is the point. Ritual and symbol are not reality, they are visions of reality, showing partly the past, and partly the present and partly desires for the future.⁵⁰ The great churches were elite buildings, created at very considerable expense with the main ostensible purpose of housing sacred rituals of worship.⁵¹

Elite markers have a function, which is to show social distinction.⁵² They are controlled by the elite to secure or maintain their dominance. If such markers become too plentiful, 'they may still serve ritual and aesthetic functions, but something else will replace them as the ultimate signifier of value'.⁵³ The formation of an elite subculture is essentially the objectification of social stratification in material terms. This often proceeds through the identification of prestige goods which are subject to sumptuary rules. These prestige goods are more than indicators of wealth; they are the 'material symbols of group membership'.⁵⁴ Prominent display may be seen as an attempt by the elite at mass communication.⁵⁵ Elite culture will try to ensure participation of others in the system of domination; individual support being given for fear of oppression or out of fear of

⁴⁶ Hunn (1979), on the importance on anomalies, things that strike the attention, in systems of symbolism.
⁴⁷ Gorman (1990), p. 34.
⁴⁸ Late Roman court splendour is discussed in chapter 2. For a comparison, see Hodder (1982b), a study of a number of African societies, which identified how material goods can act as links or walls between groups and within those groups. Hodder examined the expansion of the Lozi kingdom in the nineteenth century, in what is now Zambia. As the polity grew more complex it became more important for the ruler to stress his pre-eminence. As the aristocracy as a whole grew richer, the ruler had to use more wealth to express his special status, Hodder (1982b), p. 121. See also the comments of Dalton (1981).
⁴⁹ G. Lewis (1980), p. 19. ⁵⁰ Ibid., p. 33.
⁵¹ The study of secular ritual and Church liturgy, whilst fascinating, has had to be excluded from the present survey (with its focus on symbols) on grounds of space.
⁵² Gorman (1990), p. 107. Such status symbolism is prevalent in modern life. An article in *The Times* noted that: 'mini-bars, pop-up projection screens, huge conference tables: the executive position is today surrounded by often useless paraphernalia which does little more than simply reflect her, or more often his, standing in the company hierarchy', Millard (1992), p. 15.
⁵³ Herbert (1984), p. 301. ⁵⁴ G. L. Barnes (1986), p. 83.
⁵⁵ Gellner (1988), p. 71, on the cultural divide. See Finley (1975a)'s view of a small parasitic elite living off the meagre surplus that the mass rural population could provide.

exclusion.⁵⁶ Such support will take place from a much more stable basis if the appearance and hence recognition of oppression is reduced. All elites, therefore, need an ideology to sustain themselves and so they work out systems of ethical justification.⁵⁷ An apparently contrary debate on the morality of the use of elite symbols may in fact help to support them by establishing the category of morally legitimate display. If ordinary Christians, for example, were exhorted to dress plainly, it was in pointed contrast to the waiting splendours of heaven (as argued in chapter 5).

Gold and silver prestige goods were often *presented* in ritual contexts, as will be discussed in chapter 2. Such donations established a relationship of a positive return of gift, whereas a theft would invite retaliation.⁵⁸ The former can be regulated, while the latter form of exchange is much more unpredictable. Societies based on the former, in Darwinian terms, may be expected to do better than those based on the latter. Gift society represents one in which there is little to trade, and allocation must be made amongst many. The one with something to allocate is thus in a position of power and the recipient privileged.⁵⁹ Gift giving binds people together. It is 'the endless conversion of economic capital into symbolic capital'.⁶⁰ Misrecognition is essential to the success of an exchange and 'the denial of economy and of economic interest . . . thus finds favourite refuge in the domain of art and culture, the site of pure consumption – of money, of course, but also of time convertible into money'.⁶¹ Goods are now seen as the medium of social exchanges, 'less objects of desire than threads of a veil that disguises the social relations under it. Attention is directed to the flow of exchanges, the goods only marking out the pattern.'⁶² Thus, social stability was supported by the exercise of spending, the focus of which, during late Antiquity, shifted from varied forms of civic monument to centre upon church buildings and offerings of prestige movables ('treasures') in the often stated hope of the intercession of the saints.⁶³ Such a practice can be considered as an attempt to establish a relationship with and so to influence, if not to control, the divine.

The employment of goods took place in a competitive environment. A text from the 1970s made the comment that 'every month, a new book inveighs against over-consumption and its vulgar display'.⁶⁴ Protests at 'undue luxury' will, in

[56] G. L. Barnes (1986), p. 83. On aristocracy in general, Powis (1984), esp. ch. 2, 'Family and fortune', on appropriate and inappropriate modes of wealth creation.
[57] Girouard (1980), p. 189.　[58] Samson (1991), p. 91.
[59] Gellner (1988), p. 180, on the 'pre-productive society' as opposed to the 'market economy'.
[60] Bourdieu (1977), p. 195.　[61] Ibid., p. 197.　[62] Douglas & Isherwood (1979), p. 202.
[63] Linders & Nordquist (1987) includes a number of papers on the theory of votive offerings to gods, see especially those of Bierkert, Englund and Linders.
[64] Douglas & Isherwood (1979), p. 3.

chapter 2, be documented in both the high and late Empires. In the Christian age, attacks on those who were playing the game of conspicuous consumption could rely upon the holy words of the Gospels on the same theme. On the other hand, the game of power display was something at which the Church came to excel. It might be considered that the propagation of the Church on earth was best achieved by 'playing the game'. Such struggles were overlaid by the stated intention of service to the divine realm. Acknowledgement of the worldly nature of these processes would destroy the misrecognition which was essential for their effectiveness. To conclude, it may have been necessary for the Church to pay little attention to what was happening. The Church had to find an accommodation with wealth, or its growth would have been jeopardized. That accommodation (described in chapter 5) was reached in the exaltation of charity and the legitimization of institutional resources and corporate display.

Because the surviving texts do not directly explain the operation of the 'treasure society', the theoretical basis for the current study must provide a conception of how that society could have functioned. Late Antique churches, therefore, will be seen as stages on which symbolic images and acts expressed the real and hoped-for power of this world and of the other. In this context, the meaning of each item should be considered in relation to the whole assemblage of objects and to the whole symbolic and socially functional context.[65] The nature of art and symbol and ritual was such that conscious verbal expression was its companion but not its substitute. The influence of the outside world on the visual forms used in an ecclesiastical context was enormous. This was remarkable, bearing in mind the ancient Jewish hostility to images, which was founded upon the passage of the Old Testament in which it was commanded that 'thou shalt not make unto thee any graven image, nor any likeness of any thing that is in heaven or that is in the earth beneath or that is in the water under the earth'.[66] When the Church took in the Gentiles it embraced their modes of visual presentation as useful propaganda. The same thing occurred when the Roman State was brought within the Christian fold. It was for that reason that the section describing this process, in chapter 2, is preceded by a general discussion of elite and devotional presentation in the Roman world. As Gombrich has written, 'iconology must start with a study of institutions rather than with a study of symbols'.[67]

Having acknowledged the essential ambiguities and difficulties of the visual

[65] Ibid., p. 9.
[66] Exodus, 20: 4. See also Deuteronomy, 4: 9 and 5: 8, with the comments of Barasch (1992), p. 15, that these prohibitions may be contrasted with the presence of mimetic imagery in the fittings of Solomon's temple. There was thus conflicting Scriptural authority.
[67] Gombrich (1972), p. 21.

evidence, it remains to re-state the fact of its plentiful nature. This is the result of the pervading presence of display and metaphor in late Rome. Such figurative practice placed great stress on the participation of the Roman viewer, reader or listener. Concepts are in the mind of the beholder. Our internal perception of the world is hugely influenced by the verbal categories we use to describe it.[68] The meaning of a symbol, reliant on concepts, may be manipulated, and mental classification can be understood as being part of the struggle between groups and individuals, since classification reflects values and assumptions.[69] The clue to a symbolic system is what images connect with others. Metaphor is a technique for promoting particular classifications by associating one thing with another.[70] The Church appears to have played the system by attempting to associate a number of popularly recognized 'good things' with Christianity. Favourable aesthetic reaction in Antiquity appears to have concentrated on items that were big, of excellent craftsmanship, or were made of precious materials.[71] The use of treasure by the Church, as with the employment of art in general, was a 'means to an end'.

For a mass audience, abstract concepts are always hard to remember, unless they take some physical appearance.[72] Whether mental images are necessary to the understanding of figurative language and metaphor is a matter of intense debate.[73] Worshippers listening to a sermon were, however, presented with a parallel visual discourse in the form of the mosaic and other decorative schemes of great churches, even though the dangers of the literal interpretation of Christian abstractions were appreciated.[74] People were expected, under the pressure of decorum, to interpret in the expected ways.[75] At the end of Antiquity, messages were understood to be best transmitted through conspicuous stereotyped production. Art and language were well understood to be potent vehicles for prominent display and so for the propaganda strategy of a social or religious group. In the tradition of the rhetoric of the Second Sophistic, striking imagery was seized upon with relish in

[68] Leach (1976), p. 33. [69] Bourdieu (1984), p. 483.

[70] Sapir (1977). For a particularly influential study of the subject, see Black (1962), pp. 25–47, chapter 3, 'Metaphor'.

[71] For example, perhaps the most talked about art objects in Antiquity were the immense (over 10 m. tall) chryselephantine (ivory and gold) cult statues of Zeus at Olympia and Athena at Athens, Lorimer (1936), p. 19.

[72] Douglas & Isherwood (1979), p. 5.

[73] Honeck & Hoffman (1980), esp. p. 11, with historiography of the subject.

[74] Both learning through images and the partnership of text and images were commonplace in the Middle Ages, Fentress & Wickham (1992), p. 50.

[75] Late Antique society was used to symbolic communication. Note the description of 'conscious manipulation of rhetorical devices as a mark of [classical] education', Moss (1993), p. 49. Early medieval art appears to have focused more on patterns, a fact that may be associated with a lower symbolic 'reading' ability. Morphy (1989), on Aborigine art, provides some interesting parallel discussion of varying levels, in different cultures, of communication by means of visual symbolism.

the hammering home of lessons which, bearing in mind the opportunities for ambiguity, could be subtle as well as dramatic. This art may be termed poetic, in that it delighted in multiple meanings and indirect processes of explanation by association.

Explicit reconstruction of poetic and artistic meaning is necessarily highly subjective. With that proviso, this survey applies specific theoretical assumptions so as to transform the evidence into the explanation which we desire today. It is not sufficient to attempt to let the sources 'speak for themselves', since such rhetorical materials present merely *perceived* or *desired* reality; although that self-presentation is itself often very revealing if taken in the context of its possible societal function. Concepts of 'symbols of power in hierarchical societies', and 'the archaeology of religion' help to furnish an explanation for the apparent contradictions of the evidence.[76] Original texts in isolation, even if their rhetoric is accepted as 'truth', can never furnish a complete answer, if only because 'we can never fully be conscious of our conditions of social existence, achieve certain and absolutely coherent knowledge, know precisely why we are acting and thinking as we do'.[77] This is a survey of general prejudices in late Roman culture and, as such, a purely textual theological study might well tell us more about the theories and hopes of great thinkers than of everyday popular practice. Moreover, such an analysis would not provide a detailed framework for the study of the visual evidence. Nor would it set the nature of Christian practice in the context of the traditions of secular society and of other religions. These are the reasons for my particular approach to the primary source material.

In my argument I hope also to allow the occasional inconvenience of the evidence to speak for itself. Many human actions are simply not coherent or reducible to a set of clear explanations. There is much in ancient Christian behaviour that can be seen as both deeply sincere and apparently inconsistent. With that in mind, this book will end with sentiments that draw attention both to the variety of opinions current at the time, as well as to the apparent contradictions in the behaviour of individuals. The ideas given above can never serve to explain every precise nuance of custom and practice. In this introduction I hope I have described my manner of understanding these aspects of late Antiquity as an inhabitant of the modern world with its own elaborate network of assumptions.

[76] These concepts are summarized in the excellent introduction to the archaeological approach to religion provided by Renfrew & Bahn (1991), pp. 356–63 and Renfrew (1994).
[77] Tilley (1991), p. 182.

CHAPTER 2

Roman splendour

Precious metals were very widely employed as a symbol and evidence of power and wealth in ancient Europe, South America, India, the Near East and China. Gold has come to be seen as a substance of particular esteem, an assumption which has almost 'taken on the aura of a universal verity, buttressed by such [apparently] unassailable factors as scarcity, purity, immutability and intrinsic beauty'.[1] The display of special commodities acted conveniently to mark out successors in social competition. Gold was not always the most prized metal in those human cultures which knew of it. In sub-Saharan Africa the role of elite marker was long played by copper, which was extensively used for jewellery and in ritual.[2] Similar conventions may explain the prominence of iron in the luxury arts of archaic Greece.[3] From the tenth to seventh centuries BC the nobility of that region distinguished itself by exploiting its monopoly of the metal and 'iron moved around in a very restricted sphere of exchange, divorced from everyday activity, but it was that sphere [luxury grave-goods, for example] which had the greatest impact on the creation of our archaeological record'.[4] The absence of bronze from such graves might well indicate not the scarcity but the abundance of that metal. A substance would be of no use as an indicator of elite status if the nobility did not have the ability to control its employment.[5]

Differences in physical attributes can help to explain why certain rare substances were more often employed in this role than others. Gold has a number of

[1] Herbert (1984), p. xix. [2] Ibid.

[3] Luxury is used in this chapter in its English sense, except when it is considered in the context of the Latin *luxuria*, in which case quotation marks have been employed to show this.

[4] I. Morris (1989), p. 515.

[5] Ibid., p. 507. The one-time prominence of iron may help to explain why the Greeks, even into the Hellenistic period, possessed a 'perverted taste' for silver so tarnished that it was virtually black, Vickers (1985), p. 109. However, by the seventh century in Byzantium this was certainly no longer the case. Theodore of Sykeon revealed the profanity of the metal of which a silver chalice and paten were made by praying over the items, after which they turned black. On inquiry, the objects were found to have been made from a prostitute's chamber pot. See Georgius Presbyter, *Vita S. Theodori Syceotae*, 42, in C. Mango (1986), p. 144.

characteristics that make it particularly suitable. Pliny noted its brilliance, although he thought that the chief popularity of this substance had been won not by its colour, since silver appears 'brighter and more like daylight'.[6] He believed that gold's status was the result of its malleability and the fact that it was impervious to rust. And it was, of course, scarce. Nevertheless, Pliny adds that 'we must not forget that gold for which all mankind has so mad a passion, comes scarcely tenth in the list of valuables'.[7] The most costly were pearls, which were in use by the elite, but which were far too fragile to be employed for coinage or extensive decoration, and their potential for use in symbolic display was therefore severely limited.

The Roman associations of elite substances themselves, rather than the (mis)uses to which they might be put, can be judged from evidence such as Aulus Gellius' second-century explanation of a line of Vergil. The poet had written of a tunic that was *squalentem* with gold.[8] This, says Gellius, has been criticized since it is out of place to say *auro squalentem*, because 'the brilliance and splendour of gold is quite opposed to the filth of squalor'.[9] The explanation, according to Gellius, was that *squalare* was applied to anything 'overloaded and excessively crowded'.[10] Criticism of gold through to the Middle Ages was to focus on this same question of the *inappropriate use*, or over-use, of gold, or its employment in an inappropriate context. To deny the elite symbol itself was tantamount to denying the idea of the very existence of elites. People fought over who or what was 'best', but did not deny that some were far 'better' than others.

Possession of elite substances marked power. It is hardly surprising, therefore, that the pagan gods were often marked out by gold in the classical world. The goldenness of heavenly bodies such as the stars was closely related in classical thought to the goldenness of the gods and goddesses. So, for example, in poetic convention, Helios had a gold chariot and bed, Apollo a gold cloak, lyre and bow, Mercury a gold cloak, sandals and wand, Hera gold sandals, Pallas a gold helmet, Calypso a gold belt, Juno a gold *sceptra*, Diana a gold bow, Venus a golden bedchamber, Cupid a golden arrow, Circe a golden rod and veil, Bacchus golden reins and robes and Melponene a golden lyre.[11] Worldly and supernatural elites

[6] Pliny the Elder, *Historia Naturalis*, 33, 19, 9, H. Rackham, W. H. S. Jones & D. E. Eichholz (ed. and trans.) *Natural History*, 10 vols., LCL (London, 1938–62), 'praecipuam gratiam huic materiae fuisse arbitror non colore, qui clarior in argento est magisque diei similis'.
[7] Ibid., 37, 78, 10, 'non praetereundum est auro, circa quod omnes mortales insaniunt, decessum vix esse in pretio locum'.
[8] Vergil, *Aeneid*, 10, 314, in H. R. Fairclough (ed. and trans.) *Works*, 2 vols., LCL (London, 1934).
[9] Gellius, *Noctes Atticae*, 2, 6, 5, J. C. Rolfe (ed. and trans.) *The Attic Nights of Aulus Gellius*, 3 vols., LCL (1946), 'nitoribus splendoribusque auri squaloris inluvies sit contraria'.
[10] Ibid., 2, 6, 24, 'Quidquid igitur nimis inculcatum obsitumque aliqua re erat . . . id "squalere" dicebatur'.
[11] Hermann & Di Azevedo (1969), p. 404. Barker (1993), pp. 169–73, references to poetry at p. 172. Hardie (1986), p. 57 on gold as a symbol of divinity in the *Aeneid*. Further examples in Fowler (1989), p. 158.

were often understood as existing in close relation to one another. Gold ornaments together with the most expensive cloth of Antiquity (silk dyed with purple derived from murex-shells) formed the characteristic dress of both kings and gods.[12] Adherents of cults showed their dedication by donating, in the form of offerings of golden treasures, further markers of power. Palaces, temples and cult statues frequently came to be adorned with splendid displays of gold and other precious substances.[13]

The success of particular individuals and their families in a struggle for social pre-eminence could be explained and justified as being the result of divine sanction. Since gods were often anthropomorphically envisioned it was also open to individuals to appear as gods, or as being associated with them. By flamboyant display that others could not or would not dare to match, predominance was proclaimed that religion served well to explain. If the ruler was seen as the ally of supernatural powers, then others could make sense of their own subservience. In early Rome, such a structure of royal pre-eminence was replaced by the considerably oligarchic system known as the Republic. The Roman Republic inherited much from the old Etruscan kingdom, but the dangers of self-aggrandizement were well appreciated and the employment of personal elite symbolism was carefully regulated.[14]

In dress, a specific item, the white but purple-bordered toga, expressed the notion of equality amongst the nobility. Higher expressions of magnificence were restricted to images of the gods, except on rare occasions such as that of the 'triumph'. For great services to the fatherland, individuals were allowed to appear as gods, in the role once played by kings, for a specially sanctioned ceremony of victory celebration. The elite symbols, a purple cloak and gold ornaments, were taken from the statue of the God and worn by the state's hero, his face painted to look like terracotta, as he was drawn through the streets in a gilded chariot.[15] This had the advantage of rewarding outstanding generals, but in a way that ensured that the resulting status was temporary and entirely in the gift of the aristocratic peer-group. The general was constantly reminded, 'remember, you are but a man'.[16]

Under the late Republic, possibilities for flamboyant self-promotion were rising

[12] Hermann & Di Azevedo (1969), p. 403, with Reinhold (1970) and Spanier (1987).
[13] Discussed in this chapter, under 'The triumph of the Christians'.
[14] A. Alföldi (1970c), pp. xii–xiii, on Rome as *das etruskische Erbe*. A. Alföldi (1970a) and (1970b) explore, respectively, the development of imperial ceremonial and the evolution of imperial dress and ornaments. Together they provide a most impressive exploration of Roman monarchic self-presentation.
[15] Livy, *Ab Urbe Condita*, 10, 7, 10, B. O. Foster (ed. and trans.) *Works*, 14 vols., LCL (1924–60), 'the man who, decked with the robes of Jupiter Optimus Maximus, has been borne through the city in a gilded chariot', 'Qui Iovis optimi maximi ornatu decoratus curru aurato per urbem vectus.'
[16] Tertullian, *De Spectaculis*, 33, 4; in T. R. Glover (ed. and trans.) *Tertullian and Minucius Felix*, LCL (1931), pp. 230–301, '*hominem te memento*'.

by the day, as the wealth of the new provinces spilled into Roman hands. Perpetual royal triumph re-emerged in the form of the Empire. Over time, the institution of the imperial monarchy was bolstered and surrounded by all manner of symbolism and self-promotion; either direct, in personal dress and monumental settings, or indirectly in so far as coins and imperial images circulated across the Empire. The varied forms of official dress reflected, as did coins, monuments and ceremonies, the myriad aspects of imperial pre-eminence.[17] Treasure was an ideal medium for the emperors since others could simply not compete in the scale of its use. Such self-promotion was extremely useful in communication with the populace, especially with regard to establishing authority over the army (upon which the power of the emperors rested).

However, the divinely inspired Empire was not established without both physical and rhetorical opposition. Tyranny was the negative image of monarchy.[18] Imperial display was a sensitive issue in that it sought to outshine that of the aristocracy. The dangers of such behaviour in the early imperial period were appreciated by Augustus, who made much of his supposed humility and position as 'first among equals'. Florid attacks on first-century emperors such as Nero repeatedly focus on the inappropriate flamboyance of the ruler. Elite materials made claims to prestige which were open to denial, especially through the contrast of social prominence with moral excellence. The senatorial aristocracy could not win against the early emperors in a competition of wealth, but they could challenge them on morality. Attacks on display in the first century were one element in a range of possible moral criticisms of unnatural excess expressed by the accusation of *luxuria*.[19] It was in these circumstances that Nero was execrated by the aristocracy. Nero set new standards in self-promotion, without providing symbolic support for the upper classes. It was he who was first noted, and condemned, for placing severe prohibitions on the use of purple dye, decrees which closely foreshadow those of late Antiquity which forbade the non-imperial use of finer grades of that extremely expensive colourant.[20] Suetonius tells a story in which

[17] McCormick (1986), p. 20.

[18] MacCormack (1981), p. 314 n. 5, discusses works on Roman opposition to divinization.

[19] The use of *luxuria* demonstrates the linkage in such rhetoric of many types of 'excess' which would fall under a variety of Christian categories of sin, including avarice, greed and lust. For the Romans, 'luxury is what goes against the natural order, what is morally shocking and depraving in its effect', Wallace-Hadrill (1994), p. 145. For a panoramic account of Roman excess, see Friedländer (1964), II, pp. 266–383, '*Der Luxus*'. For an interesting modern analysis of first-century Roman moral rhetoric, with extensive bibliography, Edwards (1993). Seneca, for example, wrote that 'it is the plan of luxury to revel in what is perverse', *Ad Lucilium Epistulae Morales*, 122, 5, R. M. Gummere (ed. and trans.) 3 vols., LCL (1925), 'hoc est luxuriae propositum, gaudere perversis'.

[20] Suetonius, *De Vita Caesarum*, 6, 32, 3, J. Rolfe (ed. and trans.) *Lives of the Caesars*, 2 vols., LCL (1951), 'Et cum interdixisset usum amethystini ac Tyrii coloris'.

Nero pointed out to his agents a matron, who was attending a recital of his, because she was dressed in the forbidden colour.[21] They dragged her out and stripped her on the spot.

The emergence of golden royal symbolism was retarded by cultural opposition as well as by specific political acts such as the assassinations of Caesar, Caligula, Nero and Domitian. The early emperors had insufficient sanction effortlessly to pose as gods in a city with a strong Republican ideology. Being seen as tyrants they lacked the protection of convincing sanctity. Hopkins has asked whether imperial divinity was ever believed in. He argues that the answer is complex, with greater and lesser degrees of respect on the part of individual aristocrats, philosophers and the populace at large.[22] What is clear is that the first-century-AD *damnatio memoriae* was the occasion for the gleeful exposure as a fraud of the trumpeted divinity of the ex-emperor.

Criticism of treasure and ostentation often appeared in the context of social instability, when the exclusivity of the traditional elite was threatened by new structures of power and by those parvenus who were adept at benefiting from the change. It is hardly surprising to find the period of republican collapse as a time of particular tension in this respect. Pliny blamed the conquest of Asia for the wholesale decline in standards, an idea repeated by Livy, who talks of the phenomenon as like a plague, with foreign excess being carried back from the east by the armies on their return to Rome.[23] However, Pliny himself tells us that the first gilded roof 'shocked' Romans in 142 BC, although since then gold ceilings and walls had appeared even in private homes.[24] The picture given by Pliny is of a decadent age in which even women's bathrooms had silver (reflecting?) floors.[25] This author provides repeated examples of the *topos* of vulgar display in the period when the riches of the new empire were pouring in and the newly enriched wished to claim their place in high society. And which family had risen further than the imperial house?

The conservative response was the construction of a 'traditional decorum' which put stress on moderation as a matter of good taste; hence, Ovid's hints to a rich young lady in his *Arts of Love*: 'burden not your ears with precious stones . . . and come not forth weighed down with gold sewn upon your garments. The wealth with which you seek so often repels.'[26] Romans were often jewelled, but

[21] Ibid. [22] Hopkins (1978), p. 213.
[23] Pliny, *Hist. Nat.*, 33, 148 and Livy, *Ab urbe cond.*, 9, 6, 7, 'Luxuriae enim peregrinae origo ab exercitu Asiatico invecta in urbem est.'
[24] Pliny, *Hist. Nat.*, 33, 18. [25] Ibid., 33, 54.
[26] Ovid, *Ars Amatoria*, 3, 129–31; in J. H. Mozley (ed. and trans.) *Works* II (of 6 vols.), LCL, 2nd edn (Cambridge, Mass., 1979), pp. 11–175, 'Vos quoque nec caris aures onerata lapillis . . . nec prodite graves insuto vestibus auro. Per quas non petitis, saepe fugatis, opes.'

they often worried about the correct contexts for display. Suetonius' picture of Nero is largely composed of the very many ways in which that emperor violated the natural order, in his clothing, his adulation of the theatre, his devotion to gladiators. His gifts went to the wrong people, his person was dressed in the wrong way and he indulged in the wrong activities. The sacred symbols of gold and purple were profaned by being made into such trifles as nets with which the tyrant had an urge to fish.[27] We are further informed that 'there was nothing, however, in which he was more ruinously prodigal than in building'.[28] It is very clear from archaeological evidence that the aristocracy in general made very extensive use of precious metal fitments, marble columns and so forth in their own private dwellings. The emperor, in so far as his palaces were his houses, was doing no different, albeit on a dangerously spectacular scale.

Compared with the appreciation of legitimate splendour, the appearance of socially disturbing excess suggests competition for status requiring continuous innovation in the realm of elite presentation.[29] This rapid innovation and competition is what appears characteristic of the earlier empire. Pliny's hatred of excess can be interpreted as deriving from anxiety at the fact of 'upstartism'. New art techniques arriving in Rome could be used by *parvenus* to suggest they had status. There was thus a defensive reaction against these new claims for prestige that were not based upon ancestry. All this debate helped to shape the more complex associations of gold. Since it could be argued, for example, that the use of gold was a divine prerogative, or that such material excess was essentially a characteristic of the new eastern provinces, or of the fripperies of women, a golden emperor might appear excellent, powerful, divine, un-Roman, materialistic or effeminate.[30]

Over time, the superior power of the emperor and those in his favour ceased to be in any sense a novel innovation but simply a fact of life. Nevertheless, the attractions of the image of imperial modesty were slow to vanish completely. Pliny's *Panegyric* to Trajan sheds an important light on the period a century after the foundation of the Empire. At that point, flattery on the theme of the imperial non-usage of treasures was still effective. Not claiming a gold or ivory seat, a nimbus and prayers, Trajan, with his bronze statues, is contrasted with Domitian whose golden images the mob had torn down with fury and delight.[31] By the

[27] Suetonius, *Vit. Caes.*, 6; the golden and purple net at 6, 30, 3.

[28] Ibid., 6, 31, 1, 'Non in alia re tamen damnosior quam in aedificando.'

[29] Wallace-Hadrill (1994), p. 146. Faris (1983), p. 98, summarizes the process whereby maintenance of 'highly stratified systems required continual competition and validation. Elaboration [of design] is in this respect a concomitant of the requirements of the stratification system.'

[30] Barker (1993), pp. 173–7.

[31] Pliny the Younger, *Panegyricus*, 52, B. Radice (ed. and trans.) *Letters and Panegyricus* II (of 2 vols.), LCL (London, 1969), pp. 317–548.

period of the later Empire, however, the concept of imperial domination was broadcast with ever greater vehemence, as part of the massive attempt on the part of the late Antique government to hold the Empire together.

It must be stressed that there was no sudden invasion of 'eastern excess' under the late Empire.[32] The use of treasures had long been a general aristocratic fashion. The first-century senatorial disparagement of ostentation can be seen as a cultural device left over from the Republic, when it had served to maintain the political status quo by opening up to attack anyone who appeared to be materially setting himself above his fellows. Such criticism may have been provoked by the tacit acknowledgement that there was something in the use of prominent display that pandered to the masses. The employment of treasure acted as a legitimating medium for the aristocracy in that gold was *popularly* associated with success, happiness, divine power, or civilization.[33] The gilded splendour of Nero may well have earned him mass esteem. The tales of the martyred emperor who would return are even more evocative of popular opinion than the mention of the fresh flowers left at his grave.[34] These positive elements were subsequently smothered with associations of evil and 'decadence', but it is clear that Nero did enjoy considerable contemporary sympathy. The modesty of good emperors such as Augustus (*primus inter pares* rather than *dominus*) had a material dimension, in that they were careful not to parade constantly and visually their superiority. Nevertheless, the slow but steady rise of the imperial jewelled style in the course of the Empire strongly implies that its overall impact was helpful in bolstering power in the long term.

Why was this style employed? The battlegrounds were the minds of potential adherents.[35] The jealous rivals amongst the senatorial nobility of the Principate initially countenanced the imperial version of reality with reluctance. By contrast, the lower classes were eager to account for their subservience in relation to visible boundaries and religious manifestations. Subjects who rarely if ever saw the emperor 'came to terms' with his grandeur and power by associating him with the divine and the gods which they would likewise rarely see.[36] Since they could not change the social order, they may well have wished to glorify the status quo and their place within it.[37] The symbolic order served to render decorous the true order.[38] In these circumstances, 'despite senatorial reluctance . . . there was a considerable and Empire-wide urge to make the emperor divine'.[39] Various intermediaries, heroes, or forces such as victory and fortune, joined the human and the

[32] Swift (1951), p. 140.
[33] Boëthius (1960), p. 105 n. 18. Moral criticism of such employment by aristocrats can then be seen as relating to squabbles over who was popularly advertising his or her excellence.
[34] Subsequent constructions of Nero are summarized in Davidson (1994), reviewing Elsner & Masters (1994).
[35] See the important ideas of Veyne (1976), pp. 675–701. [36] Hopkins (1978), p. 197. [37] Ibid., p. 198.
[38] B. Morris (1979), p. 134. [39] MacCormack (1981), p. 103.

divine. It was in such a context of spiritual permeability that it was easier to envision imperial divinity.[40] The caution of Augustus, prompted by Caesar's assassination, was tempered by the willingness to initiate cults on the part of the Greek cities which were used to worshipping divine kings.[41] It was in such circumstances that imperial display gradually came to be more acceptable to the upper classes. To be worthy of power, to symbolize the majesty of Rome, divine rulers came to be expected to look the part. Display attempted to give an appearance of success, but could not ensure it. If Caligula could be sneered at for wearing the ostentatious dress 'not even of an ordinary mortal', it was because his fall confirmed that he was not a divine victor, but a fraudulent failure.[42]

The State and its palaces were referred to as sacred in late Antiquity. This begs the question of whether there was a specifically divine element in the golden style which was shared by palaces, grand temples and major churches. It has been a matter of intense debate whether the early imperial palaces were simply political arenas, or whether there was already present a strong element of the sacral and the cosmological. The revolving 'main banqueting rotunda' of the Neronian palace, the Domus Aurea, described by Suetonius, has been the subject of particular speculation.[43] It has been viewed as a 'fantastic structure in which the lord of the *oecume* feasted his guests in the centre of the cosmos', although more recently the divine interpretation of the palace has been played down.[44] Despite the presence of Asiatic influence as a *topos* of abuse in aristocratic thought, the *cosmological* aspects of self-promotion of rule may be derived from the east. Philostratus, in his second-century life of Apollonius of Tyana, described a blue mosaic dome in Babylon in the heights of which were 'the images of the Gods in whom they believe, and they appear Golden as if from the ether'.[45] The high Roman emperors also made use of celestial imagery in their palaces. Severus had

[40] Hopkins (1978), p. 200.
[41] Ibid., p. 203. On the imperial cult, Price (1984) and (1987). See also this chapter, under 'The triumph of the Christians' (pp. 42–60).
[42] Suetonius, *Vita Caes.*, 4, 52, 'Vestitu calciatuque et cetero habitu neque patrio neque civili, ac ne virili ac denique humano semper usus est', 'In his clothing, his shoes, and the rest of his attire he did not follow the usage of his country and his fellow citizens; not always even that of his sex; or in fact of an ordinary mortal.' This passage is offered in damnation. It is followed by a long list of *faux pas*: he went around in the dress of Jupiter when fate had shown he was not a God, he was a man but he wore female attire, and he wore the dress of a *triumphator*, even before a campaign!
[43] Suetonius, *Vit. Caes.*, 6, 31, 2, 'preaecipua cenationum rotunda'.
[44] Lehmann (1945), p. 22. The revolving dining-room of the Golden Palace has been compared to the Persian emperor Chosro II's throne-room, which was seen by the Byzantines after the victories of Heraclius in 624. The great throne of Chosro, which was smothered with jewels and celestial imagery, was found under a revolving dome. This had the stars and planets on the ceiling, and rain and the sound of thunder could be produced within at the imperial whim: Herzfeld (1920); L'Orange (1953), p. 135 and Boëthius (1946), pp. 445–6.
[45] Quoted from Lehmann (1945), p. 24.

paintings or mosaics of the stars made in the halls in which he was wont to give judgement.[46]

By the time of the tetrarchs, an exalted style of imperial rule had been set up. It was in these circumstances that the arch of Galerius showed Diocletian and Maximian during their own lifetimes, enthroned above personifications of earth and sky, in the place of divinity. Under the tetrarchy, 'the emperor was all he could be during his life; death could add nothing'.[47] The history of the rise of the public jewelled style of the later empire has to be pieced together from the tantalizingly fragmentary and difficult evidence afforded by the third century. One glimpse is provided by the salary grants in the fourth-century *Scriptores Historiae Augustae*, one of which included two silver-gilt shoulder clasps and one gold, together with a belt, other jewellery, luxury garments, allowances of food, equipment and a retinue of servants. These were given to the future emperor Claudius Gothicus, who was then a legionary commander.[48] The problematic nature of the source is obvious and well-known. This grant, which is attributed to Valerian, has, however, received specific study by Van Sickle.[49] He saw the phrasing of the body of the letter as standing out from its fourth-century literary context, leading to his conclusion that it represents a genuine document. He dates the *salarium* as late as the tetrarchy, merely on the grounds that such splendid official equipment is not usually seen as a feature of the earlier period. It is best to conclude that the exalted style was the product of gradual evolution. A study of early-fourth-century panegyric shows how far this situation had developed. Imperial imagery was then powered by 'truths that cannot be stated in terms other than those of revelation'.[50]

In Rome, conscious manipulation for political ends (propaganda) interacted with the very real presence of belief. Power was a divine attribute, and both power and divinity were beyond the realm of ordinary people. The position of the emperors should be considered in the light of the quasi-religious sense in which Antiquity made sense of any great ruler who received acceptance by society. These themes can be illustrated by reference to one of the most famous manipulations of personal authority and royal symbolism, the funeral of Alexander the Great. Every attempt was made by his successors to draw attention the status of the great man. The hearse alone took two years to build. It was in the form of an Ionic temple on

[46] Ibid., p. 8 and Boëthius (1946), p. 457. [47] MacCormack (1981), p. 107 and pl. 10, arch of Galerius.
[48] *Scriptores Historiae Augustae, Vita Claudii*, 14, D. Magie (ed. and trans.), 3 vols., LCL (1921–32). See also Painter (1988), p. 108.
[49] Van Sickle (1954).
[50] Discussed with references by MacCormack (1981), p. 108. The study of imperial panegyric is an important one in itself, but there has not been space to treat it in depth in this book. The interested reader is therefore directed to the *XII Panegyrici Latini*, R. A. B. Mynors (ed.) (Oxford, 1964), together with L'Huillier (1992) which provides an introduction, interesting discussion and useful bibliography.

wheels, with a roof composed of gold scales, in which Alexander's mummy was enclosed in a gold sarcophagus. Golden nets prevented the profane gaze from falling upon it. Alexander's gold-embroidered purple cloak was draped over the sarcophagus. The whole thing took sixty-four mules to drag it on an enormously long processional route.[51] Posthumous portraits of Alexander emphasized both his sublime features and royal attributes such as the diadem.[52] Wealth and power and divinity and splendour were intertwined in classical society and whatever changes Constantine brought about, he did not alter that.

Jewelled display was an act of communication,[53] and the late Antique importance of such public statements can be seen from the fact that the State carefully regulated them. This took place because the government of the later Roman Empire was reinforced by treasure insignia that matched the status hierarchy of the *sacra res publica*. In official costumes there was ever more extensive use of high-quality purple dye, of silk and of gold-knit decoration. The emperor himself might wear a military costume, but with the addition of splendid items such as a jewelled helmet. He might be dressed in a toga, but it would be one made of purple-dyed silk sewn with gold and gems and known as the imperial *trabea*. Or he might wear an embroidered, brooch-fastened display cloak, known as the chlamys, over a tunic.[54] He wore also the diadem as a badge of superhuman status.[55] This was a totalitarian regime and as with the official art of the great twentieth-century dictatorships, the leader slowly lost his personal characteristics and was transformed into what Golomstock called 'a figure of allegory'.[56] As Ramsay MacMullen has said, late Antiquity was an age in which 'importance thus expressed itself in a man's outward appearance... An emperor should look like an emperor and should be identifiable by his shoes or by the hem of his mantle.'[57]

The late Roman ruler was dressed pretty much as the earlier classical world would picture a king. The difference, if anything, was in a greater utilization of precious substances. A good example is provided by the diadem. Its Hellenistic form was simply a narrow band of cloth worn round the head, which is a far cry from the late Roman gold and jewelled crown such as appears on coins in the time of Constantine. It is thought by Alföldi that this was first worn in the third century.[58] The use of treasure substances may have been stimulated by competi-

[51] Stewart (1993), pp. 216–24, with a reconstruction drawing at p. 217. [52] R. L. Smith (1988), p. 35.
[53] Brush (1993), pp. 8–29, 'theoretical perspectives'.
[54] Galavaris (1958), p. 101, summarizes what is said at successively greater length by Delbrueck (1932b), with the *Dienstkostüm* described at p. 5, and A. Alföldi (1970b), *passim*.
[55] Pollitt (1986), p. 32. [56] Golomstock (1990), p. xxiv. Images of emperors, Elsner (1995), pp. 159–89.
[57] MacMullen (1990), pp. 97–8.
[58] A. Alföldi (1970b), pp. 145–51, on the late Roman diadem. He suggests the jewelling is the result of 'barbarian' influences, p. 149.

tion with the monarchs of Persia. The word 'diadem', both in Hellenistic Greece and late Rome, had the limited usage of 'royal headband'.[59] In both societies, purple could be worn by those deputized with royal authority, such as ministers, courtiers and some priests, but only the members of the imperial house might presume to wear the diadem.[60] From the second quarter of the fourth century, the brooch and diadem were standard items of the emperors' dress on those frequent representations featuring a cloak. These items were propaganda. They were meant to be noticed and note *was* taken of them. As testimony to that we have the description of the robing and robes of the new emperor Justin (in 565) which was written by Corippus. He described the gold and purple chlamys, upon which 'a golden brooch fastened the joins with its curving bite, and from the ends of chains hung jewels which the fortunate victory in the Gothic war produced'.[61] Here the *fibula* (brooch) was employed as the vehicle for displaying particular gem-stones, and therefore acted as a specific triumphal ornament as well as being a badge of general pre-eminence.

Dress of subordinates was brilliant but regulated so as to be always of a clearly lesser magnificence than that of the monarch. To take the specific example of the shoulder clasps, those worn both by members of the imperial house and by aristocrats were of two distinct types. The emperor's brooch, as Corippus described, was large and jewelled. But those of imperial subordinates were smaller and typically of plain gold.[62] The prerogatives of the imperial house were of great importance and were protected by official decrees. The emperor Leo declared that the brooches of officials worn on the chlamys were to be free of any sort of gems. They were to be 'precious only for their gold and for their craftsmanship'.[63] For similar reasons, there were stringent controls on purple silks, whilst gold woven into silk, wool or linen was forbidden to private persons in decrees such as those dating from 369 and 382.[64]

One of the most striking representations of the state-engineered jewelled hierarchy occurs on the *missorium* of Theodosius, which was probably issued by the emperor on the occasion of his *decennalia* in 388 (figure 1, p. 29). He, who like his colleagues wears the elaborate clasp of the ruler, 'calmly hands down the *codicilli*

[59] R. R. R. Smith (1988), p. 34. [60] Steigerwald (1990) and Bridgeman (1987).
[61] Corippus, *In Laudem Iustini Augusti Minoris*, Averil Cameron (ed. and trans.) (London, 1976), 2, lines 122–4, 'aurea iuncturas morsu praestrinxit obunco fibula, et a summis gemmae nituere catenis, gemmae, quas Getici felix victoria belli praebuit'; commentary at p. 159, to be read with that of Stache (1976), pp. 267–8.
[62] Janes (1996b) discusses these two brooch types.
[63] *Codex Iustinianus*, 11, 11, 1, T. Mommsen and P. Krueger (eds.), *Corpus Iuris Civilis* II (of 3 vols.) (Dublin, 1954), 'de curcumis vero omnem prorsus qualiumcumque gemmarum habitum praecipimus submoveri. Fibulis quoque in chlamydibus his utantur, quae solo auro et arte pretiosae sunt'.
[64] Ibid., 11, 9, 1, 'Auratas ac sericas paragaudas auro intextas viriles privatis usibus contexere conficereque prohibimus' and 11, 9, 2, 'Nemo vir auratas habeat aut in tumicis aut in lineis paragaudas.'

ROMAN SPLENDOUR

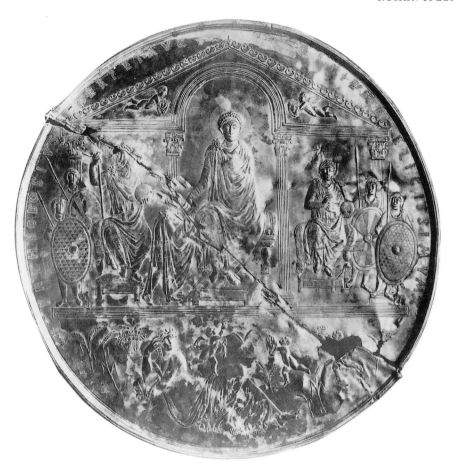

Figure 1. The silver *missorium* of Theodosius (late-fourth-century), one of the most striking representations of the state-engineered jewelled hierarchy.

[letters of office] to, one might almost say, his suppliant', who sports a small, plain 'cross-bow' brooch.[65] The official relationship between emperor and subordinate yet still noble servant, as shown on the *missorium*, is further displayed in the Justinian mosaic panel of San Vitale, Ravenna (figure 2, p. 30). The emperor is depicted dressed in a purple cloak with a gold and patterned patch. The central feature of his *fibula* is shown as a large red stone surrounded by white gems (probably pearls). From this dangle three *pendula* consisting of gems on the end of long chains. At Justinian's side stand the great dignitaries and lay patrons of

[65] MacCormack (1981), on the *missorium*, pp. 214–21 and pl. 55, and quotation, p. 216. A better illustration is Delbrueck (1929), pl. 62.

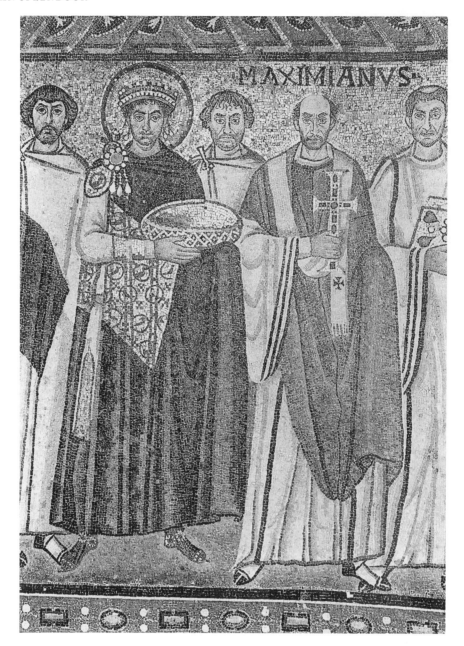

Figure 2. Detail of Justinian, presbytery wall mosaics, San Vitale, Ravenna (mid-sixth-century), with the emperor dressed in purple, gold and gems.

San Vitale. Their cloaks are white with a purple patch and their brooches are plain gold cross-bows.[66]

Such examples show men with the symbols of their own jewelled states, but the prestige of women was also singled out through displays of golden jewellery.[67] The resulting effect can also be seen in San Vitale, where Theodora is shown wearing a vast necklace sewn throughout with pearls, together with sundry hair ornaments and various other jewellery over robes in purple and gold. Her attendants are similarly dressed save without the imperial purple and with far less jewellery.[68] That the representation of this finery was based upon real life is apparent from the survival of a necklace exactly paralleling those worn by several members of Theodora's retinue. It is dated to the late fifth and early sixth centuries and is of gold and decorated with pearls, emeralds and sapphires.[69] Parallels to the ear-rings and bracelets are also known.[70]

Having slowly assumed a jewelled personal appearance, it is hardly surprising that the rulers of Rome chose to live in buildings of an equivalent magnificence. The splendid gold and jewelled decorations of the Byzantine palaces come to us from the words of Corippus, and later from those of *De Ceremoniis*, the fond testimony of emperor Constantine Porphyrogenitus.[71] Such flamboyance would seem, from the testimony of the writers of the earlier Empire, to be 'un-Roman'. Yet parallels from the earliest years of the Roman greatness can be found.[72] The word 'palace' itself derives from the Palatine Hill, where Augustus lived.[73] The transference of meaning is already visible in the poetry of the early Principate.[74] The Augustan rhetoric of modesty aimed to play down what was in all probability a rather grand sort of home.[75] The true style of first-century-AD elite decoration is hard to recover, but there are tantalizing fragments, such as the 400 jewels – on exhibition in Rome in 1986 – which had probably once adorned the walls or ceiling of a room in the first-century *Horti Lamiani*, which had come into the possession of Caligula.[76] The palaces of the Hellenistic world *were* a source of inspiration, but it is

[66] For general discussions see Von Simson (1987) and MacCormack (1981), pp. 259–66. Bovini (1956), pl. 30, is a colour illustration of the Justinian mosaic.
[67] On early Byzantine court jewellery see Hill (1983), K. Brown (1979), Ross (1979) and Weitzmann (1979a), pp. 302–29. [68] Bovini (1956), pls. 35–7.
[69] Greifenhagen (1974), pp. 60–1, with colour illustration; discussion in K. B. Brown (1979), esp. fig 2.
[70] Constantinople was the location of workshops producing fine jewellery that has been found from across the empire, Ross (1979), p. 299: 'by the sixth and seventh centuries, Constantinople was apparently . . . the place of origin for much of the finest jewellery throughout the Mediterranean world'.
[71] Discussed by A. Toynbee (1973).
[72] In fact, to take one example, contrary to Greek and oriental tradition, it was the Romans who employed coloured marbles for columns, see Swift (1951), p. 140.
[73] Recent works on this are discussed by Patterson (1992), pp. 204–7, 'the Emperor at home: the *Palatium*'.
[74] Millar (1977), p. 20. [75] Patterson (1992), p. 205.
[76] M. Roberts (1989), p. 73 n. 26 and Larocca (1986).

clear that not merely the emperors, but also many great senators, were able to surpass those models, as with the case of the *insania* of Scaurus under the late Republic which 'outdid the worst excesses of Nero and Caligula'.[77] This flamboyant style had already been 'made Roman' under the late Republic. It was a visible reflection of the imbalance in the society of the city which had been caused by the injection of vast sums of capital into the hands of prominent Romans.[78]

The fall of Nero's flamboyant government led to the destruction of his *Domus Aurea* in which 'everything was overlaid with gold and adorned with gems and mother of pearl'.[79] Nevertheless, this was very far from spelling the end of lavish palace architecture.[80] Later Roman and Byzantine palaces have been the subject of considerable literature, most of which has focused either upon elaboration of ground plans, or upon extrapolation from literary evidence, such as the above-mentioned *Book of Ceremonies*.[81] Other studies have examined individual elements of palaces such as the Vestibule of the Great Palace at Constantinople, basilican (rectangular) throne-rooms and triclinia (grand rooms with niches).[82] In Byzantium, there were several palaces, some in the centre of town and others outside it.[83] But there, as at Rome, archaeological survival has not been extensive.

One of the best preserved sites is that of Diocletian's palace at Split. This was a formidable structure, very much in the form of a military encampment, with fortified walls and a rigid grid plan.[84] It had, of course, very little in common with temporary encampments in that it had been the brilliantly decorated place of retirement for the greatest Roman emperor since long before then-living memory. The area is now incorporated into the modern town of Split. Archaeological exploration has, of necessity, thus been sporadic, relying mostly upon opportunities to dig up vacant house plots and basements. Nevertheless, it has been found that extensive decorative use had once been made of marble as well as of stone and glass mosaic cubes (tesserae). Excavations in the south-east corner, in an area referred to by the excavators as sector 1, revealed a concentration of glass tesserae,

[77] Pliny, *Hist. Nat.*, 36, 113. Boëthius (1946), pp. 442–3. Patterson (1992), pp. 200–4, discusses recent literature on aristocratic housing in Rome.
[78] Boëthius (1960), pp. 97–8 and 101.
[79] Suetonius, *Vit. Caes.*, 6, 31, 2, 'cuncta auro lita, distincta gemmis unionumque conchis erant'. For a brief introduction to the surviving remains, J. B. Ward-Perkins (1981), p. 59.
[80] See for example, on the *Domus Augustana* of Domitian, J. B. Ward-Perkins (1981), p. 79 and pl. 36.
[81] Swoboda (1969), on the *Domus Aurea* and *Domus Augustana* and J. B. Ward-Perkins (1981), pp. 59–61 and 79, are architecturally focused. Millar (1977), pp. 18–24; Duval (1979) and Dirimtekin (1965), are literary source based, whilst Ebersolt (1910) and A. Toynbee (1973), pp. 185–200, focus on *De Ceremoniis*.
[82] On the *Chalke*, C. Mango (1959); basilicas, Boëthius (1951) and triclinia, Lavin (1962).
[83] Runciman (1980).
[84] Marasovic, McNally & Wilkes (1972), Marasovic & Marasovic (1994) and McNally (1994). Weitzmann (1979a), cat. no 104, at p. 116, is a reconstruction drawing of the palace.

which 'makes an original mosaic wall or ceiling there highly likely'.[85] These cubes, fallen into the earth above mosaic floorings, were 'often' of the gold-leaf type.[86] It is important to add that although it is not known quite what function this zone of the palace orginally played, it was probably not the location of the main state rooms.[87] The palace appears, therefore, even from such fragmentary evidence as this, to have been immensely grandiose.[88]

The imperial residence at Trier, however, may have once been even more impressive.[89] Little survives today, save for a huge building, 67 m. long by 30 m. high, which was probably once a throne room and audience hall.[90] Excavation has shown that it was originally set in an ornamental courtyard with columns and was merely a single part of a far larger building complex.[91] On various grounds, including a coin of 305 found embedded in the walls, this building is firmly attributed to the first decade of the fourth century. The spectacular frescoes of figures with haloes found in a room below the cathedral do not, alas, find parallels in the basilica, which is now in a bleak, stripped condition.[92] There remains, however, black and white marble *opus sectile* flooring, as well as holes which once held supporting pins for marble veneer up to the lowest level of windows. Above this zone there was once elaborate mosaic, traces of which, in the form of blue and green scroll patterns on gold, have been found from one of the window niches in the apse.[93] Fragmentary evidence of the same modes of decoration have been found at the Cathedral, in the form of pieces of marble and glass mosaic-cubes. From this evidence the existence of extensive gold mosaic has been inferred, although the remains cannot provide a date for this.[94]

It is from such fragmentary examples that the precursors of the jewelled mosaics and other decorative elements of late Antique churches can best be sought. As has been made clear, luxury decoration was not restricted to the royal house. The distinction between emperor and nobles was achieved more in matters of degree, than of style. However, the imperial evidence is essential for parallels with church foundations, not simply because of the vital role of imperial patronage from the time of Constantine, but also because the evidence is much better than for the aristocracy. Nevertheless, it is important to remember that, across society, the *paterfamilias* was *dominus* in his own household. The implications of this are played out in the archaeological source-material. The enigmatic evidence of the so-called

[85] Marasovic, McNally & Wilkes (1972), p. 44.
[86] Ibid., p. 26 (gold mosaic techniques are discussed in chapter 4 of this book, pp. 111–12).
[87] Ibid., p. 16.
[88] McNally (1996) is a recent summary of the magnificent marble ornament of the palace.
[89] Vickers (1973), p. 114. [90] Wightman (1970), pp. 109–10 and Krautheimer (1967), p. 117.
[91] Crema (1959), p. 579. [92] Lavin (1967), esp. pls. 5 and 6, and Wightman (1970), pp. 109–10.
[93] Wightman (1970), p. 104. [94] Rheinisches Landesmuseum, Trier (1984), cat. no. 62, pp. 163–4.

palace of Theodoric at Ravenna illustrates that it is far from easy to recognize a derelict palace from late Antiquity and to distinguish it from other town houses or villas.[95] The most well-known controversy on just this issue concerns a site in Sicily. The debate stems from an article in which L'Orange dramatically proposed that the huge villa at Piazza Armerina in Sicily was the 'retreat' for Maximian on his planned abdication with Diocletian in 305.[96] Vast floor mosaics of the labours of Hercules have been a major factor leading to the identification of this building, as were the presence of a large apsed basilica and a triclinium.[97] Maximian was associated with Hercules as Diocletian was with Jupiter and the hunt floorings show figures in characteristic tetrarchic dress. The villa was huge and possessed a substantial basilica, 30 m. by 14 m. This had a semi-circular niche (apse) at the far end, which was flanked by purple-red granite columns[98] and decorated in glittering vault mosaic, a few traces of which have survived.[99] Below the apse there was a special area marked out in *opus sectile* that may well have been the place for a throne.[100] Buildings such as this provide important parallels to the apsed basilican churches of the fourth century and afterwards.

It has now been concluded that the imperial attribution is unproven and that there is nothing to suggest that this building could not have been owned by any rich senator.[101] The presence of audience halls points to nothing other than the fact that a great land-owner was emperor on his estates.[102] The popularity of hunt themes illustrates this at Piazza Armerina, in that the men are shown in the official dress of authority of the tetrarchic age. Despite the strenuousness of hunting they wear the external manifestation of power. Physical exertion was not allowed to disturb this clothing which, as Augustine said, 'reveals each man's rank'.[103] 'Even when thrown from the saddle a *dominus* [lord] remained a *dominus*, immediately recognizable as such.'[104] In an earlier age, when there was greater faith in the body, it was the manner in which the essentially unclothed person bore himself that was important.[105] The baths had not fallen out of use in late Rome, but the elite body

[95] Deichmann (1969–89), *kommentar* 3, pp. 49ff, on the Ravenna palaces, and Duval (1978).
[96] L'Orange (1952), with (1956) and (1965). [97] L'Orange (1952), pp. 114 and 121, with Lavin (1962), p. 7.
[98] L'Orange (1956), p. 595, with reference to the imperial cult of purple. On this see the discussion in chapter 4 (pp. 139–52), under 'The taste for brilliance'.
[99] L'Orange (1956), pp. 595–6 and R. J. A. Wilson (1983), p. 25.
[100] L'Orange & Kähler (1969), pp. 43–4 and pl. 10b, and Dunbabin (1978), p. 201.
[101] R. J. A. Wilson (1983), p. 98. See also Weitzmann (1979a), cat. no. 105, p. 117, which discusses the various theories, and also Duval (1978).
[102] Ellis (1988), p. 575. [103] Augustine, *De Doctrina Christiana*, 2, 25, J. Martin (ed.) *CCSL* 32 (1962).
[104] Thébert (1985), p. 388, 'Même désarçonné, un "dominus" reste un "dominus", immédiatement reconnaissable.'
[105] P. R. L. Brown (1987), p. 246, in the earlier classical period, 'how a man carried himself, in the nude or otherwise was the true mark of his status'.

was by then most commonly hidden in art behind external symbols. Clothing was crucial in social definition. The 'lord' is shown in the North African mosaic of *Dominus Julius*, seated, virtually enthroned, opposite his wife who is being offered a necklace from her jewel-box by an attendant.[106] There are quite a number of large private basilican halls known, such as that in Rome of Junius Bassus, who was consul in 331.[107] A further example of the common language of self-promotion of emperors and nobles is provided by the villa at Konz, which on external evidence seems to have been an imperial residence at the end of the third century, but does not differ noticeably in plan from others in the region.[108] The triple-apsed triclinium, which in Byzantium appears utilized for imperial reception halls, has been found at over fifteen fifth-century villas from the western Empire alone.[109] It was a mark of wealth and status found in great private dwellings in all periods of the Empire and may have been an influence on the development of centrally planned churches.[110]

Nevertheless, the imperial palace and religious architecture stood out in sheer scale. The great Christian foundations such as San Giovanni in Laterano (the Lateran) in Rome were built in the imperial style under Constantine, setting a precedent that was followed by later rulers. The great Christian monuments of Ravenna and Constantinople are directly associated with the imperial patronage of the Justinianic age, in which palace and church buildings were intimately linked. Long before Nero's *Domus Aurea*, golden interiors had been used in private art, but have only been preserved in imperial art and the propaganda of rule.[111] The effects generated by this style were, in Byzantium, placed at the centre of political culture. Visitors entered the Great Palace in Constantinople through the metal-roofed reception hall, the *Chalke*, which was decorated with mosaics of Belisarius' victories and which had the imperial couple and Senate on the ceiling.[112] From there, the way led on into the gold-clad and gem-strewn early Byzantine palace itself, which was compared by Corippus to heaven.[113] In a sixth-century domed room of pre-eminent gleaming splendour, the *Chrysotriclinion*, ambassadors were entertained amongst the maximum possible display of precious objects drawn from the treasuries of the emperor and of the great churches of the city.[114] The experience,

[106] Weitzmann (1979b), fig. on p. 270, mosaic now in Tunis, Musée National.
[107] Dunbabin (1978), p. 204 n. 37, lists examples. On the Basilica of Junius Bassus, see Crema (1959), pp. 579 and 582, fig. 768.
[108] Duval (1978), p. 58, with references. [109] Lavin (1962), pp. 4–5.
[110] Such as San Ambrogio, Milan; San Vitale, Ravenna, and of course, Hagia Sophia in Constantinople.
[111] Swift (1951), p. 135. [112] C. Mango (1959), p. 32.
[113] Corippus, *Laud. Iust.*, 3, 179–80, 'the imperial palace with its officials resembles Olympus', 'imitatur Olympum officiis Augusta domus'.
[114] Dirimtekin (1965); Bertelli (1989), p. 110 and Ebersolt (1910), p. 77.

like that of church services, pandered to the varied senses. Incense hung heavy in the air and organs were played.[115] This embarrassment of riches for the visitor's benefit was fostered by a carefully orchestrated ritual in which the retinue passed between billowing golden cloths and through streets decked with gold, silver, silks and lamps, the populace being encouraged to display its own treasures.[116] The descriptions of Liutprand of Cremona in the tenth century indicate the remarkable impact that the place made upon him.[117]

Employment of prestige materials by the emperors and other members of the elite, suggests domination of the means of production, especially the work-force. Unfortunately, this is not an easy topic to investigate from the archaeological record.[118] It is very significant that the whole world of production was sordid in Roman eyes. Names of few artists have survived. There was little fascination for the process of creation since luxury artefacts acted as attributes of their owners, not of their creators, who were of low social status and so more easily controllable by patrons.[119] Craftsmen in late Rome were arranged into specialized guilds that were almost like castes.[120] Groups of precious-metal workers were employed by the State under the direction of bureaucrats of the Comites Sacrorum Largitionem.[121] Imperial control of resources was used by the Persians as by the Romans to create a

[115] A. Alföldi (1970a), p. 114 and Cormack (1992), pp. 223–7.

[116] Mathews (1971), p. 164, McCormick (1986), p. 206 and Ross (1979), p. 301. Toynbee & Painter (1986), show that silver plate, for example, was used by individuals as 'pictures for display' (p. 15). Such private resources in the city of Constantinople could be orchestrated by government agents.

[117] Liutprand, *Antapodosis*, 6, 5, G. H. Peertz (ed.) *MGH, S* 3 (1839). Cormack (1992), comments on the political efficacy of palaces, p. 222.

[118] Debate has raged, for example, over whether prehistoric metalworking was mainly carried on by itinerant craftsmen, or habitually took place in patronized workshops, see Rowlands (1972), Champion (1985) and Welbourn (1985). On the 'elusive craftsman' in Anglo-Saxon England, Arnold (1988), pp. 94ff. A study of the production of bronze mirrors which have been discovered as grave goods in mounds dating from early medieval Japan found that 'one of the reasons for the localisation of production was to establish local control over the supply of mirrors and their distribution, rather than rely on the exchange network for their supply, and be unable to control either their design or their distribution', G. L. Barnes (1986), p. 91.

[119] I suspect that with the breakdown of the market economy, in so far as it had existed in the Roman period, treasure display became even more significant in both ritual and economic terms. It is therefore interesting that the status of craftsmen may also have been rising. In those Byzantine saints' lives which described cities, craftsmen get far more mention than merchants, Seiber (1974), p. 105. And, in the early medieval west, craftsmen in precious metals were at the social apex of 'blue-collar' workers; for example, metalworkers in early Irish law had the highest 'honour-price' of all craftsmen, along with wrights. For comparison, a leather-worker's honour-price was one-fourteenth of that level, F. Kelly (1988), pp. 61–3. A Frankish gold-worker and moneyer, Eligius, even became a member of the Merovingian royal household, a bishop and a saint whose masterpieces were treasured for centuries by the Frankish Church, see *Vita Eligii Episcopi Noviomagensis*, B. Krusch (ed.) *MGH, SRM* 4 (1902), pp. 634–742. This source is a Carolingian reworking of a Merovingian text, on which see Hen (1994), p. 262, Vierk (1974) and Lafourie (1977).

[120] Thomas (1934) and on silverware, Baratte (1975). A study of peasant metalworkers of modern India found that for them their craft was not so much a job as a way of life, Mukherjee (1978), p. ix.

[121] C. E. King (1980), pp. 143–4. See also Delmaire (1989a and b).

visual network of power symbolism by attaining sanction over many elite crafted forms. It was quite possible to think of court insignia as a sphere of material culture in itself. Hanfmann, writing of the cities of western Asia Minor, attests that the Persian rulers there lived in material 'enclaves', in which only arms given by the king, precious metalwork, luxury glass vessels and rich textiles, 'in short, only arts immediately pertaining to the personal adornments of satrapal courts were distinctively Persian'.[122]

Such a system operated in the sphere of silk production in late Rome, where the emperor was able, with the aid of extensive legislation that reached its pitch under Theodosius II, to control the production and use of expensive cloth.[123] Sporadic injunctions under the early Empire culminated in the early fifth century with the claiming of complete imperial monopoly of the use and production of high-grade purple silks. The retention of garments wholly composed of any sort of purple was made a treasonable offence. 'All persons', declared Theodosius, 'of whatever sex, rank, skill, profession or family, shall abstain from the possessions of that kind of material which is dedicated only to the emperor and his household.'[124] The severe laws of 424 were later relaxed, although, from the sixth to the tenth centuries, 'imperial policy regarding the sale of silk in general and murex-dyed silk in particular remained protective in the extreme'.[125] Cloth dyed from Mediterranean molluscs was, in any case by virtue of its very expense, already restricted to the wealthiest classes. Twelve hundred murex-shells would yield only 1.6 grams of purple dye.[126] It is hardly surprising to find that in Diocletian's *Price-Edict* of 301 one pound of the best purple wool was worth the same as one pound of gold, that is 50,000 *denarii*. A pound of plain wool was 175 *denarii* and the daily wage of a teacher of Latin literature was 200 *denarii*.[127] The 'necessary' exclusiveness of certain visual materials in an aristocratic society is illustrated by the fact that in medieval western Europe, when murex purple was unobtainable, *coccum* scarlet, derived from an insect that lives on oak leaves, replaced it as the textile of enormous cost, worn by princes and cardinals.[128]

Legislation on display was part of the great attempt by the Roman State to display its predominance. The employment of treasure was another element. Ritual context, that is, the active use and transfer of elite symbols, was a matter of great importance.[129] If the churches of late Antiquity and the early Middle Ages were like treasure houses it was because the gift of treasures was an enormously important act in that age. Constantine not only halted the persecutions but was the

[122] G. F. Hanfmann (1975), p. 15. [123] Muthesius (1991), for the structure of the Byzantine silk industry.
[124] *Codex Theodosianus*, 10, 21, 3, T. Mommsen and P. M. Meyer (eds.) 2 vols. (Berlin, 1905).
[125] Bridgeman (1987), p. 161. [126] Munro (1983), pp. 14–15.
[127] Diocletian's *Price-Edict* is discussed with references in Munro (1989), p. 15. [128] Munro (1983).
[129] It is interesting to think, for example, of possible comparisons between State ceremonies and church liturgy.

founder of the vast wealth of the medieval Church. According to Libanius, gold, silver and land were the typical possessions of a rich man.[130] The emperor was by far the richest man in the Empire. Constantine's donations and those of his successors comprised huge grants of money, land, buildings and treasures. Their actions need to be understood in terms both of religious faith and of the manipulation of the expectations of what might be termed a 'treasure society', that is, one for which communication by means of the display and transfer of elite goods was of great importance in defining the self and forming relationships. These links might be forged between a leader and his subordinates, between friends, or between an individual and the divine realm, through the mechanism of 'transactions that are used in the ritual construction of social worlds'.[131]

The 'treasure society' was very ancient. Hierarchies maintained by conspicuous consumption and distribution of elite goods can be identified in the early European Bronze Age.[132] But the Roman Empire brought much enhanced levels of treasure exchange, together with some degree of development towards a market economy. The Romans promoted a huge circulation of gold and silver, much of it in coin.[133] Nevertheless, it must be emphasized that Roman gold coinage was itself 'special-purpose money' associated with the State and military organization, being of far too great a value for ordinary everyday transactions.[134] Indeed, from the end of the fourth century the copper coinage progressively collapsed across most of Europe.[135] What validated the gold coinage was therefore not the State, but the gold.[136] Gold coins along with jewellery items and dishes were given out by the State as gifts to servants and soldiers according to rank. High-ranking officials, the Comites Sacrae Largitiones, were in charge of issuing both pay and jewelled insignia.[137] In late Antiquity, along with building schemes, urban distributions, games and so forth, symbolic treasure gifts were made by the emperor to varied orders in society, with a relational element of the size and nature of gift to the rank of the recipient. These were all part of the euergetistical function of giving to the public that officials had long exercised in the classical world.[138] Decorations, donatives and so forth ensured a long-term buying of favour with troops that tied them to the State.[139] Crisis for the Empire came when units found that they could get more cash and treasure by going independent than they could through official handouts.

[130] Liebeschuetz (1972), p. 75. [131] Cheal (1988), p. 16. On gifts and commodities, see Gregory (1982).
[132] Shennan (1982), p. 160. [133] Aitchison (1960), p. 152.
[134] See the very interesting discussion of Gaimster (1992).
[135] For the evolution of the Roman coinage system in the west, Spufford (1988) and in the east, Hendy (1985).
[136] Bloch (1933).
[137] The specialist on imperial largesse is Delmaire, see (1977), pp. 313–14; (1988); (1989b), pp. 471–94, on 'largesses imperiales, argenterie et orfèvrerie' and (1989a), with *Codex Theodosianus*, 6, 30, 7 and *Codex Iustinianus*, 12, 23, 7.
[138] Veyne (1976) on euergetism in the classical world.
[139] Berger (1981), Maxfield (1981), Steiner (1906) and C. E. King (1980), p. 159.

Personal gifts were a widespread element in communication within high society. This world can be seen operating through the examples provided by the letters of Sidonius Apollinaris, such as that occasion when Euodius asked the bishop of Clermont to write a poem to be inscribed on a silver vessel to be sent to the Visigothic queen.[140] Gift was carried out not only in the context of life, but also in that of death. Post-Roman grave-goods bear witness to offerings to the dead, but presents were also received from the dead, through wills.[141] Roman law made extensive provision for the bequest of such 'tokens of esteem'. A whole chapter of the *Digest* of Justinian is devoted to legacies of gold, silver, jewellery, toilet articles and perfumes, clothing and statues.[142] Treasure items themselves took the form of jewellery and other items of costume, tableware and vessels and general furnishings. Gold and jewels were applied to items as diverse as books, swords, chairs, walls, bridles, carriages and cloaks. Silver tableware was one of the most characteristic treasure forms of the period.[143] Silver plates were visual statements. They were in many cases 'pictures for display'.[144] Specimens with pagan imagery were long appreciated in the Christian Empire and were not infrequently donated to churches.[145]

This wealth, particularly the movable wealth, was of great importance in bringing barbarians into the Empire both as mercenaries and enemies. There was a steady diffusion of Roman objects beyond the frontiers, creating an association of prestige with Roman-style movables.[146] The age of the migrations and onwards can be seen as an age of plunder and tribute. In this period the sources 'are most generous with details and obviously most interested' when the objects of plunder were luxury goods.[147] Through the deposition of grave-goods, jewellery and other treasures provide one of the most important categories of finds from the early medieval period.[148] A clue to the way this society worked may be found among the

[140] Sidonius Apollinaris, *Epistolae et Carmina*, 4, 8, in W. B. Anderson (ed. and trans.) *Poems and Letters*, 2 vols., LCL (1936 and 1963). [141] Janes (forthcoming).
[142] *Digesta*, 34, 2; T. Mommsen & P. Krueger (eds.), *Corpus Iuris Civilis* I (of 3 vols.) (Dublin, 1954).
[143] Good starting points for a study of Roman silver plate are Kent & Painter (1977) and Baratte (1988).
[144] Toynbee & Painter (1986), p. 15.
[145] Compare the early modern period when silverware was commonly remade so that it should fit the latest fashion, Bannister (1965), p. 7.
[146] Hedeager (1978) and Fulford (1985). [147] Reuter (1985), p. 78.
[148] On early medieval prestige jewellery, Arrhenius (1985). A brief overview of provincial-Roman and early medieval metalwork and jewellery, K. B. Brown (1981). For a good selection of recent studies from the immense bibliography on early medieval burial practices and treasure finds from graves, see articles in Carver (1992a), with Shephard (1979), Fehring (1991), pp. 58ff, Webster (1992), Bullough (1983), Edward James (1989) and Todd (1992), pp. 80ff. Theoretical discussions are given in Brush (1993) and Pader (1982). For a comparative perspective on the economic aspects of funerary ritual from a Borneo case-study, Metcalf (1981). Late classical Antiquity is not usually understood as employing grave-objects. The picture is, however, far from clear cut. Halsall (1992) summarizes recent opinion that the row-grave civilization of post-Roman northern Gaul should be seen as 'indigenous' rather than 'Germanic'. And Edward James (1977), on south-west Gaul, was unable to conclude whether the characteristic late Roman tradition sarcophagi of this relatively undisturbed region had once contained grave treasures.

Mesakin and Moro tribespeople of Sudan, amongst whom objects were smashed atop the burial mound after a funeral.[149] The number and expense of the items was directly related to the number of dependants that the deceased possessed. Adherents and family needed to affirm that the one they followed was important and valued if they wanted to prevent a breakdown in the continuity of authority and leadership.

The prominence of treasure was considerable in both the society of Rome and of the successor states of the west. This is not to say that social attitudes and practices were identical. To take one example, treasure prestige in classical society, as illustrated long before in the example of Nero's Golden House, was concentrated upon immovables as well as movables. The Roman villa, however, apparently did not survive long into the Middle Ages.[150] Treasure display in built environments centred upon churches, since these represented the major form of Roman masonry building practices to survive the Empire in the west. Personal treasure adornment appears to have then become more important in defining secular rank.[151] Early medieval states can be understood in terms of a retinue surrounding the ruler, providing service in return for gifts (the 'Personenverbandstaat').[152] Market use of specially minted coins was at a low level, or non-existent, and symbolic use of treasure was intense, especially beyond the old imperial frontiers.[153] Huge deposits of treasures and weapons in bogs may appear characteristically barbaric, but their inspiration may have been very similar to that behind gifts of treasures to Roman churches.[154] Many practices indeed had Roman inspiration, such as the use in England and Scandinavia of 'bracteates', thin gold discs with designs derived from coins. These were typically worn as jewellery. They are likely to have circulated as gifts. Based on Roman money, they nevertheless functioned in accordance with a strongly non-monetary society.[155]

Roman and barbarian treasure practices might be said to differ more in style than in content. Royal treasure-hoards were important both in the world of free Germany

[149] Hodder (1982b), p. 163. Compare Tilley (1984), p. 141, on smashed pottery at middle Neolithic tombs in Sudan. Alternative explanations might focus on attitudes to the role of the spirit of the deceased. For example, the Inca believed that the spirits of the dead played a vital role in the living world. Grave-offerings were renewed amid huge ceremony, and the Inca ruler's mummy was fed and attended as if it were still living, Conrad & Demerast (1984), p. 89. For relations with the afterlife in early Greece, Vermeule (1979), p. 177.

[150] Percival (1976), pp. 166–99 and (1992).

[151] On Byzantine influence on Merovingian court styles, Vierk (1978) and (1981). [152] Steuer (1989).

[153] See Werner (1961), esp. fig. 15, which identifies a line separating the coinage of Merovingian Gaul from the area to the north and east where balances were found in early medieval graves.

[154] Heidinga (1990), on the situation in the Netherlands. For the situation in Scandinavia see the papers in Linders & Nordquist (1987), especially those by Bierkert, Burkert, Englund, Hagberg and Linders.

[155] Gaimster (1992).

and of the emperors.¹⁵⁶ Treasures circulated, with a proportion being withdrawn, especially in the form of religious votive offerings.¹⁵⁷ The difference in the early Middle Ages was that the states were not ensuring fresh supplies of metal. The west was producing little gold. Gold flowed out to pay for goods, was looted to the north, and was hoarded in churches and monasteries.¹⁵⁸ There was a shortage of gold in circulation in the west. This was in contrast to the east: in medieval Persian, the word *rumi* (Roman) was associated with certain colours, red (as in imperial dress), white (as in slave girls) and gold (as in coins).¹⁵⁹ Nevertheless, even by the later medieval period, treasure items can be seen to have played a considerable role in the western economy. Herlihy has found that 40 per cent of recorded transactions from eleventh-century Italy included some means of payment other than coined money, the most frequent medium being gold and silver jewellery.¹⁶⁰

Treasures appear to have been, if anything, of increased importance in the Germanic and post-Roman societies. Jewelled display may have attained increasing prominence in state practice through the need for communication with the increasing number of barbarian soldiers and officials.¹⁶¹ It is this context that may help to explain the intensification of the official jewelled style during late Antiquity. Nevertheless, expression of imperial excellence through treasure did not go unchallenged in that period. Moral attack could insist that the splendour was unjustified, as in bishop Synesius' tract to Arcadius, which by virtue of its content is unlikely to have been delivered, since it made fun of the jewelled appearance of the emperor. The bishop argued that the Empire had been flourishing in the period *before* this form of dress was assumed and was now no longer.¹⁶²

Yet, in fact, ideas of what was decorous for a king remained much the same over the course of the Empire. The treasure substances of honour themselves did not change between archaic Rome and Byzantium. At Caesar's funeral, the decree of the Senate which had granted the Dictator all divine and human honours was read out, whilst the crowd milled around a gilded shrine to the dead leader, with its ivory couch covered in purple and gold drapes.¹⁶³ At the very end of his life, Constantine accepted baptism, and after the ceremony reclined on a white couch, 'refusing to clothe himself in the purple any more'.¹⁶⁴ But very soon after, at the emperor's death, his cadaver lay in state in the diadem and purple robe, before being placed in a gold coffin, under a purple cloth.¹⁶⁵ To those who arranged these

¹⁵⁶ Weidemann (1982) I, pp. 18–20. ¹⁵⁷ Hodges (1989), p. 41. ¹⁵⁸ Vilar (1976), p. 82.
¹⁵⁹ Kazhdan (1991), p. 1633. ¹⁶⁰ Herlihy (1957–8), pp. 2–4.
¹⁶¹ Although it may be that what took place was rather a process of mutual influences.
¹⁶² Texts and discussion in Lacombrade (1951a and b) and Marrou (1963). ¹⁶³ Suetonius, *Vita Caes.*, I, 84.
¹⁶⁴ Eusebius, *De Vita Constantini Imperatoris*, 4, 62; PG 20, cols. 909–1230 (Greek and Latin). It was customary for neophytes to wear white garments in the week after their baptism.
¹⁶⁵ Ibid., 4, 66.

ceremonies, such display was what was required in the circumstances of royalty. The complex prejudices of both early and late Roman society could, however, be brought to bear on those who could be alleged to live by inappropriate social rules. In a sixth-century description of the counting of the spoils of war after a battle, the enemy dead were presented as laden down with all manner of 'effeminate' jewellery as was said to be the Persian custom.[166] It is a distant echo, but an echo nonetheless, of Suetonius' fascinated and disdainful treatment of the alleged indiscretions of Nero.

The triumph of the Christians

An account has been given of what might be termed 'secular *mores*'. Such a phrase is potentially misleading in that it was difficult, then as now, to delineate a clear boundary between sacred and profane. Forms of Christian display could either be considered as sanctified elements of religious practice or as pernicious influences emanating from the profane society in which that religion was embodied. Robert Markus has examined the idea of 'desecularization' in late Antiquity, that is, the absorption of an increasing proportion of secular culture within the Church.[167] During the Middle Ages, the Church achieved enhanced social control by establishing ritual jurisdiction over such ceremonies as marriage and death. Theologians suggested that the worldly realm, including its reserves of wealth, should rightly come under the governance of the Church.[168] Critics of such grandiose designs pointed to the suggested 'purity' of the early (poor) Christians. Before considering the evolution of Christian practice during those centuries, it will be useful to set such developments in the context of sacred display in Antiquity. Religious and secular culture was intimately intermingled in the classical period and that combination led to many of the most remarkable western works of art.

Roman buildings, from the most luxurious to the everyday, were intensely decorated by modern standards. Surfaces were painted, moulded, gilded and generally lavishly adorned with patterns, figures and scenes.[169] Over half of the houses in a recent study of Pompeii had at least one such decorated room, and this

[166] For an introduction to the work of Agathias, Averil Cameron (1970). Texts and translations are Agathias, *Historiarum Libri Quinque* 3, 28, 5, R. Keydell (ed.) *Corpus Fontium Historiae Byzantinae* II (Berlin, 1967), p. 121 and *The Histories*, J. D. Frendo (trans.) *Corpus Fontium Historiae Byzantinae* IIa (Berlin, 1975), p. 99.

[167] On this and the question of 'what was essential to Christianity and what was indifferent, merely linked with the particular form of society in which it was embodied', Markus (1990), pp. 1–17, 'Introduction', with quotation at p. 1.

[168] As will be discussed in chapter 5.

[169] Liversidge (1983) is a useful introduction to the abundance of house decoration. The same goes for movable objects. To take one example at random, Roman shields were elaborately emblazoned with patterns and figural scenes, Bishop & Coulson (1993), pls. 3 and 4, for example.

is likely to be an underestimate, because ground floors and commercial premises (which were in general decorated less often than other rooms) made up a majority of the sample.[170] It is a 'reasonable conjecture', therefore, that every fair-sized town may have been able to sustain one or more painters' workshops.[171] Alas, elsewhere, only tiny fragments survive. Wooden panels have rotted away and plaster has similarly failed to survive well, apart from that in catacombs and the exceptional sites of Pompeii and Herculaneum.[172] From these examples, however, can be seen the huge popularity and vitality of Roman painting in houses and other buildings owned and used by various social ranks. Apart from abstract designs, walls were decorated with architectural and rustic fantasies. Thus, rooms were surrounded with imaginary vistas, whilst atrium walls might have expanses of lush greenery painted upon them. Roman society expected intensively brilliant display throughout residential buildings. Particularly fine artists, a grand scale of production, or especially expensive materials would have to have been employed for a work to stand out. So, for example, in Nero's palaces there was frequent enrichment of the paintings with coloured glass, stucco 'cameos' and gilded stucco mouldings.[173] Such flamboyance was also employed by aristocrats. Surviving example are rare, but do exist, such as that of the stuccoed and gilded barrel vault at the Villa of the Caecilii, Tusculum, dating from the Hadrianic era.[174] Such traditions should be seen in the light of the great use of furnishings and objects in precious metal. These practices and styles were also fully exploited in religious contexts.

Pagan temples were given splendid decorations. Statues, reliefs and walls were all painted. Prominent examples of scenes survive from all the great centres: Rome, Carthage, Athens and so forth.[175] The sacred enclosures, through frescoes, friezes, sculpture and statues, performed the act of 'drawing the eye with a very rich display of colour . . . rewarding it with scenes and symbols full of meaning for even a stranger . . . They constituted the best means by which priests and pious alike could impress their beliefs on the public entering the shrines.'[176] Contemporary attention centred on the cult statue which was often encrusted with precious

[170] Wallace-Hadrill (1994), p. 151.
[171] Ling (1991), p. 214. Paintings in other pre-industrial societies were found across a very wide social spectrum. Studies have shown that in the seventeenth century two-thirds of Dutch and French households had paintings, Wallace-Hadrill (1994), p. 147.
[172] Barbet (1985).
[173] Ling (1991), p. 75, with other references to use of glass in paintings at pp. 85, 87 and 98.
[174] Joyce (1981), p. 73.
[175] An excellent selection of references to painted surfaces and scenes from temples across the empire is provided by MacMullen (1981), pp. 156–7 n. 63. See also Gros (1976), pp. 174–5, and on Roman painting in general, Ling (1991), Barbet (1985), with many brilliant coloured plates and Wallace-Hadrill (1994) for popular use of decoration.
[176] MacMullen (1981), p. 31.

substances. Alternatively, plain terracotta, or wood of ancient holiness, was displayed in a splendid glistening setting, in a similar manner to the bones of martyrs in a Christian church. The treasure-context acted to identify as precious what did not look precious (an old statue or old bones). The very decoration schemes of many temples may have foreshadowed those of later churches, as appears to have been the case with the mosaic-embellished Lupercal Chapel discovered in Rome in the seventeenth century.[177]

Many pagan temples became enormously wealthy through gifts and dedications.[178] This was the pious way of using precious metal. Thus, in Rome very many gold and gilded statues were put up, the earliest in 181 BC in the Temple of Pietas.[179] Augustus proclaimed in his *Res Gestae* (a boast to the populace of Rome) that he had removed eighty silver statues of himself from the streets and had, for their donors' sake, sent gifts of gold to the Temple of Apollo.[180] The study of C. Vibius Salutaris' will by Guy Rogers provides a fascinating insight into the workings of such public piety under the Empire. A leading citizen of Ephesus, Salutaris, in 104 left large sums of money for distributions, metal statues and for an organized procession. The main capital sum was deposited as endowment of the Ephesian Artemis. The gold and silver images weighed 124 lb. They were explicitly referred to as sacred.[181] This was a world in which elite substances were not just displayed as symbols, but employed in religious rituals throughout the year.[182] Gilded statues sat in gilded sanctuaries upon gilded thrones. Christian monuments and their associated precious artefacts have been preserved by virtue of their continuing status as sacred. No such thing was true for the material culture of the pagan cults. Much marble statuary has survived, but precious metal could easily be melted down and reworked. Evidence for pagan treasure items is therefore scarce, but it does exist. A mid-third-century fresco in the Synagogue of Dura Europus shows the Ark of the Covenant taken into the Philistine Temple of Dagron.[183] The statue is shown broken, whilst sacred utensils, bowls, pitchers and ladles, like those found from Byzantine village church treasures, lie scattered all over the floor, even though Scripture only refers to the crumbling of the cult statue.[184]

The classical period was an age of many cults. Each promised access to and

[177] Lanciani (1891).
[178] Finley (1975a), p. 121 and Baratte (1992). A good introduction to the classical temple is Scully (1979).
[179] Lahusen (1978), p. 385, with Vermeule (1979).
[180] *Res Gestae Divi Augusti*, 24, P. A. Brunt and J. M. Moore (ed. and trans.) *The Achievements of the Divine Augustus* (London, 1967).
[181] Rogers (1991), with weights cited at p. 28.
[182] In the form of saints' days, the Christian church was to provide the same spectacle for the later urban populace.
[183] I Samuel 5.
[184] Ghirshman (1962), pp. 286–7 and fig. 367. Compare the items in M. M. Mango (1986).

protection or help from the supernatural, in return for various forms of devotion. Worship might involve the expenditure of time or money or both. Certain cults pandered to particular human needs. That of Asclepius, for instance, was especially associated with healing illness. Although individuals might also pray to a variety of gods and goddesses, nevertheless cults were effectively in competition with one another. The more impressive the cultic buildings and insignia, the more likely they were to stand out. Making the wealth of a cult visible also placed on display the potency of the divinity in question. Since gold spelled excellence, it is hardly surprising that religious centres were involved in the competitive display of treasure, which itself was the donated witness to the devotion of the faithful.

But at the same time, such display coexisted with the strongly held idea that the immaterial and supernatural was, by definition, superior to that which was material. Personal expression of this belief was made by many 'philosophers' and 'holy men', who protested their unconcern for the things of this world. A mosaic at Pompeii shows a builder's level. On one side are a wooden crook and food pouch (the attributes of the Cynic philosopher). On the other end are a sceptre, a piece of purple cloth and the white strip that was the Hellenistic diadem (the attributes of royalty). The level was in balance.[185] This was the world into which Christianity grew, and which, in many ways, it did little to disturb. Constantine may have been revolutionary in stripping wealth from pagan cults and endowing Christianity, as we shall see later in this chapter, but the general principle of gifts to temples and churches went more or less unquestioned in the classical world. The Church adopted many of the images as well as the ways of that world. This enabled the new sect to communicate effectively and so to bring about the maximum number of conversions. Many Jewish and pagan religious and secular practices and images were borrowed, though not indiscriminately, and baptized for Christian use.[186] This is the religious background against which Constantine's legacy should be set.

Many of these pagan cults were intimately bound up with the life of the classical city. Gordon has suggested a division between such forms of worship and the 'oriental' ascetic/ordeal religions which offered personal revelation in return for adherence to codes of behaviour beyond that of the performance of particular rituals.[187] This dichotomy is useful to bear in mind, but in fact each cult balanced ritual action with personal belief. Although some were sceptical, the Roman world in general was possessed of a strong religiosity. Pagan 'high ideas' in late Antiquity were vivid meditations on the nature of divinity. This work cannot attempt to provide any sort of history of philosophy. I therefore leave it to an expert in the field to sum up (referring to Plotinus' ideas as arranged by his pupil, Porphyry, *The*

[185] R. R. R. Smith (1988), p. 34. [186] Beckwith (1970), p. 10. [187] Gordon (1990).

Enneads): 'Plotinus' ideas express an intense spiritual vision, which may be appreciated on many levels, moral, religious, intellectual and aesthetic, but which is in essence a unified conception of all things as emanations from a single immaterial power that so transcends everything else that it is beyond description.'[188] Neo-Platonism considered the physical things of this world and sought to define a path to a superior world that could be perceived, if only with the eyes of the mind. The proximity of such ideas to those held by Christians should be obvious. Such thought, though it aimed to transcend the world, did not scorn it. The rhetoric of the search for God involved enormous use of visual imagery, particularly that of light. Beauty was a quality of moral perfection in Neo-Platonism. In Hellenic thought the eye was an organ of pleasure, but such pleasure as was not morally reprehensible, in so far as light came from God.[189] Love of beauty and love of God went together.[190]

Thinkers sought to make sense of the varied divinities of the pagan world as so many indications of a supreme Deity at the very time of the rising popularity of eastern cults (of which Christianity was one) which likewise embraced this concept. Central to such religions was the confrontation of the individual with the one who ruled the heavenly realm and the 'mystery cults' were especially associated with the search for an afterlife.[191] The propaganda of Christianity was remorseless. Only Christ could offer eternal life. The deep fear of death and the incomprehension of much traditional classical thought on what lay beyond the grave were important factors in the success of the Church, especially when combined with the Christian assertion that abandoning the faith or combining it with others would lead to eternal suffering.

Yet Roman society was enormously conservative. Most of religious life was centred around performing rituals validated by Antiquity. This, as well as the obvious factor of the persecutions, helps to explain why Christianity was not a huge sect prior to the fourth century. Indeed, before the second century it has left very few identifiable remains. The traditional view of this was that it was due to hostility to art inherited from the Jews. However, it has been argued that Christian attacks on Greek art were stylized attacks on the dangers of idols. Art itself was not scorned.[192] Rather we find Clement of Alexandria advising that some images are more suitable than others for a Christian to wear.[193] Church buildings in this period were typically adapted from rooms in town houses. In this Christianity resembles another oriental cult, Mithraism.[194] In that cult the main symbolism of the cult

[188] Long (1985), p. 640. For a detailed introduction with even more detailed bibliography, Gerson (1994).
[189] Onians (1979), p. 115. [190] Beierwaltes (1986). [191] Lane Fox (1986), p. 96.
[192] Finney (1994). [193] Finney (1987).
[194] Elsner (1995), pp. 210–21, compares Mithraic with Christian art and architecture.

room was of a cave, but nevertheless the 'cave' ceiling was often painted or inset with star shapes so as to resemble the canopy of heaven.[195] This cult too made extensive use of decoration in sculpture, painting, mosaic and so forth. An apse at the mithraeum at Ostia was decorated, probably in the third century, with a mosaic depicting a standing haloed figure in a style very similar to that later employed in churches.[196] A further splendid example is presented by the mithraeum under Santa Maria Capua Vetere. The vault, as at the Dura mithraeum, was inset with glass stars. Figures were painted on the walls, with the primary focus being a huge image of Mithras in scarlet dress slaying the sacred bull, on the end wall.[197] Other mithraea had all manner of light effects, with glass insets in altars, rotating stone slabs and the like.[198] The cult also involved using a hierarchy of metals related to the planets to symbolize the progression of worshippers from grade to grade in ascending order from one to seven, with silver and the moon in sixth place and gold and the sun as the last and highest symbols (fascinatingly, this symbolism can also be found in the Jewish context).[199]

The later Roman Empire was a world looking for solutions and apt to make calls upon the divine. Prosperity, happiness and health were no more certain for rulers than they were for anyone else. Emperors fussed incessantly over auspices and auguries.[200] Relations with the true wide immensity of the divine realm were of enormous importance, even to men presented by their propaganda as all-powerful. Bearing in mind the equation of divinity and power and thereby the quasi-divine nature of rule, emperors needed to have consideration for the supernatural. In fact, they actively meddled. The fascinating story of the imperial cult goes back to the very early days of the Empire. The cult acted to legitimate the use of divine substances and special symbolism with regard to the emperor. At a local level, Price has shown how the cult made sense for Greek cities of the newly intruded authority of Rome.[201] In addition, during the third century, various emperors were playing, with steadily greater intensity, on their associations with supreme divinity,

[195] MacMullen (1981), p. 125 and White (1990), pp. 47 and 167 n. 88. [196] Cecchelli (1922), pp. 7–8.
[197] On Mithraic art in general, Vermaseren (1963), pp. 43–66 and L. A. Campbell (1968). On Santa Maria Capua Vetere, Vermaseren (1971), esp. pl. 3. The mithraeum under Santa Prisca in Rome has especially fine reliefs, Vermaseren & Van Essen (1965), esp. pls. 2 and 12.
[198] MacMullen (1981), p. 125.
[199] Goodenough (1953–68), VIII, pp. 46–9, 'The Judaism of immaterial reality: the closed Temple: the mysticism of the seven metals', discussing the temple with seven coloured walls shown in the paintings of the Dura Synagogue, which were a fascinating amalgam of cultural and religious references. The cosmology of a hierarchy of metals was apparently employed as a way of expressing the majesty of the Jewish Temple. See also Goodenough (1953–68), X, pp. 47–8.
[200] Hopkins (1978), pp. 231–40.
[201] Price (1984) and (1987) provide a powerful introduction to modern understanding of the cult, together with bibliography.

as when Elegabulus, the high priest of an extraordinary eastern cult, became emperor. During the latter half of the third century, the majesty of sublime Sol (the sun god) played over the imperial palace.[202] The tetrarchs were explicitly associated with Jove and Hercules. It had become quite normal for emperors to have a novel religious 'policy' and in this sense, Constantine can be seen to have acted in accordance with the traditions of his time.

Such 'policies' were employed with characteristic use of imperial magnificence. Maximinus Daia set up a new order of imperially appointed pagan priests, who, with troops at their disposal, had the power to arrest Christians. They wore a sparkling white chlamys (the cloak of the public man of late Antiquity).[203] In a tetrarchic fortress at the ancient Egyptian temple at Luxor in Egypt, there has been found a temple of the imperial cult dating from the first years of the fourth century and from which fragments of plaster paintings survive. Processions of soldiers were shown along the side walls. Opposite the entrance were placed the tetrarchs amongst their dignitaries, all shown in full frontal perspective. In the apse (niche on the far wall) there was painted an eagle holding a wreath. The tetrarchs were depicted with a nimbus (halo) of light about their heads, and were shown well over life size and larger than the other figures. Each figure was dressed in precious robes.[204] This was the form in which the Lord was frequently presented in the churches of late Antiquity, as if as a reminder that the jewelled style had merely been usurped by the emperors, since its true function was to single out the divine.

The conversion to Christianity of emperor Constantine I and his resulting policies are of immense importance for the nature of the Christian monuments of the ensuing age. The persecuted minority sect of the third century was transformed into the official religion of the Empire. It was a remarkable and revolutionary act. Constantine was to be buried as the thirteenth apostle in a New Rome, a great capital raised by the royal will which was to be known as Constantinople (figure 3, p. 49).[205] The emperor was now shown on coins and official images in the standard late Antique diadem and special imperial brooch, so displaying his unique status.[206] The first appearance of the emperor's special brooch occurs on the coins of Constantine at the *same time* as a jewelled diadem appears on or replaces the wreath

[202] Halsberghe (1972), pp. 160ff, especially on Aurelian and Constantine, although this particular association had started long before.
[203] Nicholson (1994), pp. 6–10.
[204] Deckers (1979), fig. 33, what survives; fig. 34, a reconstruction of the composition and Ling (1991), p. 193.
[205] In the Church of the Holy Apostles, from which his remains were later, tactfully, removed.
[206] It may be that the diadem was later, if not then, the repository of a fragment of the True Cross, since Augustine noted that the sign of the cross at the front of the royal diadem was more precious than gems, *Enarrationes in Psalmos*, 73, 6, D. E. Dekkers & J. Fraipont (eds.) 3 vols., *CCSL* 38–40 (1956), 'Iam in frontibus regum pretiosus est signum crucis quam gemma diadematis.'

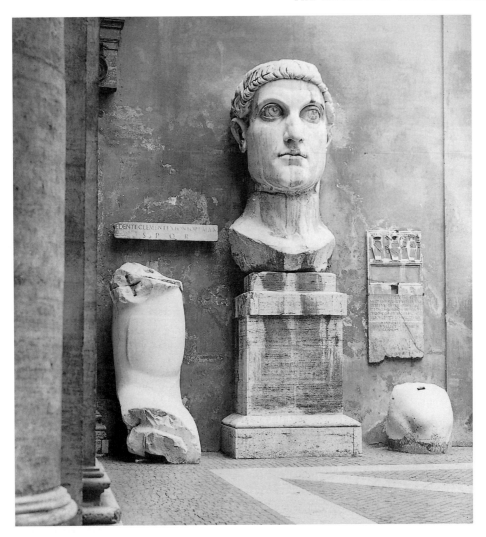

Figure 3. Remains of a giant statue of Constantine, Rome (mid-fourth-century), with eyes raised to heaven.

on the imperial bust. This took place around 325.[207] Bruun has described Constantine's redefinition of the image of the Roman emperor 'both in regard to the imperial dress and to other external manifestations of power'.[208] In fact, these developments cannot be entirely associated with Constantine's appearance as sole emperor. There are examples from the coinage of Licinius of an elaborated

[207] Examples on Constantinian coins and medallions are listed by Wessel (1971), col. 539, and are illustrated in M. R. Alföldi (1963), pl. 17 (nos. 220–3) and pl. 18 (nos. 230–1). [208] Bruun (1976), p. 122.

imperial brooch with *pendula*, suggesting that it sprang ultimately from the tetrarchic passion for identical representation of the co-rulers.[209] But Constantine can be seen as having taken earlier experiments of the imperial houses, in both religious and stylistic fields, further than ever before.

Constantine's innovations, therefore, emerged from the experimentation of emperors through the third century in the use of regalia, ceremony and religious affiliation (especially with Sol Invictus). Being one god amongst many was perhaps less useful and less believable than being the undisputed lieutenant on earth of the one high God. Constantine's concern with ecclesiastical affairs shows how he did not take his role lightly. Religion, after all, *was* a matter of the utmost seriousness. Whether Constantine understood much of the nature of Christianity is a moot point. However, his belief in the need splendidly to endow the new faith can be seen plainly from the testimony of our most important source, the *Life of Constantine* by Eusebius.[210] The accuracy of the bishop of Caesarea's claims are often hard to verify, but one thing emerges very clearly: Constantine's imperial enjoyment of the use of 'calculated flamboyance'.[211]

Constantine, according to his *vita*, was accorded an immortal crown in heaven.[212] The standard of the cross made at his order was a brilliant confection of gold and gems.[213] He ordered magnificently adorned copies of the Scriptures to be made.[214] He arrived at the council of Nicaea, wreathed in gold and precious stones, 'like some heavenly messenger of God'.[215] A splendid banquet he gave after the council was like a vision of heaven.[216] After this he gave presents to the bishops according to their rank.[217] Writing to Macarius, the emperor explicitly stated that the very greatest splendour was to be lavished upon the new church at the Holy Sepulchre, including the use of the finest marbles and the gilding of the roof. It was intended that this building was to outdo all others. Countless offerings of gold, silver and precious gems were provided for it.[218] The sign of the cross, done in precious stones and gold, was installed on a gold panelled ceiling of the palace.[219] Constantine's actions should be seen in the light of the nature of self-ascribed imperial status in the previous decades. By late Antiquity, the vulnerability of rulers to rivals had been amply demonstrated by the turmoil of the previous decades. It is perhaps not surprising that the victors, given time to concentrate on such matters,

[209] Robertson (1982), v, pl. 42 (no. 33) and Delbrueck (1932a), pl. 60 (nos. 2–3).

[210] This was once considered to be of doubtful authenticity, but in 1951 A. H. M. Jones discovered one of the cited letters from the emperor, see Chadwick (1972), pp. iv–vii.

[211] P. R. L. Brown (1971), p. 88.

[212] Eusebius, *De Vita Constantini Imperatoris*, PG 20, cols. 909–1230 (Greek and Latin), 1, 2. Eusebius' presentation of Constantine is discussed by Averil Cameron (1991), pp. 53–6.

[213] Eusebius, *Vita Const.*, 1, 31. [214] Ibid., 3, 1. [215] Ibid., 3, 10. [216] Ibid., 3, 15.

[217] Ibid., 3, 16. [218] Ibid., 3, 30–40. [219] Ibid., 3, 49.

proved assiduous in their presentation of the imperial house, *their* imperial house, as pre-eminent, untouchable and irreplaceable.

The transfer to Christian or, at least, non-pagan imagery was not made all of a sudden.[220] The continuation of the solar nimbus on the coinage is one example, although this has been seen as the result of the 'dead-weight of numismatic tradition'.[221] On the other hand, it can be argued that Constantine for a certain period did 'become' the sun, at least in so far as Diocletian 'became' Jupiter.[222] The concern of Eusebius with the various imperial coin types, such as that showing Constantine with upraised gaze, suggests that the emperor carefully oversaw coin and other image production, or at least that the pictorial content of the coinage was widely noticed.[223] The later Sol coins may have been maintained as a sop to the pagans by an emperor who knew that there was a limit beyond which it would not be safe to take his crusading zeal. But the emperor may not himself have seen a sharp divide between solar worship and that of the Christian God. The supreme Lord in the heavens was a long-standing classical theme. Jupiter was by tradition the supreme god and he was god of the sky. Early Christian representations included Christ shown in the manner of the sun, riding the heavens in a chariot (which especially pertained to the Resurrection and Ascension), hence the radiate halo of the risen Christ in the early-third-century mosaic of the mausoleum of the Julii, in Rome.[224] Liutprand, writing in the tenth century, was able to observe the solar imagery of the rising throne in the Magnaura Palace in Constantinople.[225] Light was a prominent element of Christian worship, but also of late Roman imperial ceremonial. Candles and burning brands were carried in imperial processions.[226] Lowered torches, as lowered flags for us, represented death.[227] Candlesticks appeared side by side with imperial images in prefects' insignia as illustrated in the *Notitia Dignitatum*.[228] The solar monarchy of the tetrarchs was, in a variety of ways, continued in Byzantium.

Such themes as this fit into a wider picture of the slow and selective renewal of symbolism, in which certain elements of classical practice proved more enduring than others. The imperial cult was at an end, but it left a potent ghost. The palace remained a holy place. The emperor, the State and their insignia and ritual expressions were sacred. Eusebius asserts that Constantine modelled his palace on God's church.[229] The gold-clad and gem-strewn sixth-century palace at Constan-

[220] Elsner (1995), pp. 251–70, using the example of silverware, discusses this period in which pagan and Christian imagery were frequently mingled on the same objects.
[221] T. D. Barnes (1981), p. 48. [222] G. F. Hanfmann (1975), p. 90. [223] Eusebius, *Vita Const.*, 4, 15.
[224] L'Orange & Nordhagen (1966), p. 74 and pl. 39, and Bertelli (1989), colour plate at p. 53.
[225] Liutprand, *Antapodosis*, 6, 5. [226] A. Alföldi (1970a), pp. 111–18. [227] Kilerich (1991), p. 123.
[228] *Notitia Dignitatum*, see A. Alföldi (1970a), p. 115, fig. 10.
[229] Eusebius, *Vita Const.*, 4, 17, with G. F. Hanfmann (1975), p. 84.

tinople was compared by Corippus to heaven,[230] whilst both the Lateran Palace and the palace of Charlemagne at Aachen were *sacra palata* and Theodoric's palace was a *domus divina*.[231] After Constantine, as before, imperial palace rituals were sacred rites.[232] The word *aula*, used for 'palace' before *palatium*, was commonly applied to churches. The appearance of heaven was influenced by the appearance of the *palatium*,[233] or at least it was influenced under the same system of symbolism; paradise being on occasion comprehended as a vast imperial palace, whose ministers were the heavenly hosts, and whose armies were the supernal powers. About those who inhabit the 'royal mansions' of God, shine the sun, moon and stars, 'like torch-bearers around the entrance of the imperial palace', wrote Eusebius.[234] High officials, *militares*, were referred to as *praesules*, as were bishops.[235] The similarity between palace basilicas and those built by the State for the Church has been stressed earlier in this chapter. It is hardly surprising to find the same similarity extending to the language of the age, which, as Krautheimer attests, 'establishes the church as the throne room of the emperor of heaven: comparable to the sanctuary where the living God-emperor received the obeisance of his subjects'.[236] The effect of the late Antique Christian monuments, either basilican or domed, palace chambers or churches, was probably much the same as that of many earlier pagan monuments, despite the intrusion of Christian subject matter.[237]

This is a picture of stylistic continuity but, nevertheless, the change in fortunes during this period of the Church and the many pagan cults of the Empire was enormous. Not only did Christianity cease to be persecuted, but its authorities were showered with an avalanche of rich presents. Their attitude is easy to understand. If this be the Lord's will, then God be praised! Those who wished to stay away from the rising splendours of the new urban churches had probably long since abandoned the towns anyway for the purity of the 'desert'. Bearing in mind Constantine's spending commitments and determination it would seem quite possible that he did indeed, as alleged, send out commissioners to strip pagan sanctuaries of their gold, silver and other precious adornments.[238] These, transferred to the Church, would have represented a direct movement of elite symbols from one system to another. This state of affairs would have seemed revolutionary.

[230] Corippus, *Laud. Iust.*, 3, lines 179–80, 'imitatur Olympum officiis Augusta domus', 'the imperial palace with its officials resembles Olympus'.
[231] Lavin (1962), pp. 16–17, with references.
[232] Straub (1967), p. 53, with A. Alföldi (1970a), for what these consisted of. [233] Straub (1967), p. 53.
[234] Eusebius, *Oratio de Laudibus Constantini in eius Tricennalibus Habita*, 1, 2, PG 20, cols. 1315–1440 (Greek and Latin).
[235] Straub (1967), p. 53. [236] Krautheimer (1967), p. 129. [237] Sear (1977), p. 29.
[238] T. D. Barnes (1981), p. 247. Eusebius, *Or. de Laud. Const.*, 8, 1 and *Vita Const.*, 3, 54. *De Rebus Bellicis*, 2, 1, R. Ireland (ed. and trans.) *De Rebus Bellicis* II (of 2 vols.), *The Text*, BAR, IS 63ii (Oxford, 1979), (c. 370), asserts that gold flooded the Empire as a result.

THE TRIUMPH OF THE CHRISTIANS

The Persecutions were more than just a distant memory in the reign of Constantine. Relations between the State and Christians had long been uneasy, especially because of the believers' refusal to sacrifice to the emperor's divinity. Many of the great heroes of the Church were martyred at the hands of Roman officials. Relations between the Church and the newly Christian State were far from unambiguous. At any event, whatever Constantine may or may not have envisaged, a theocracy was not achieved. Nevertheless, whatever the precise nature of Constantine's hopes and beliefs, it was certainly with great generosity that Constantine approached the Church.[239] It was the legacy of Constantine, as described by Eusebius, to place the poverty of Christ in a golden setting. Treasure gift, as has been noted earlier in this chapter, was one of the important ways in which religious devotion was expressed in Antiquity. According to Eusebius, the statues of the pagan gods were brought out amid laughter 'from their dark recesses to the light of day'. The images were then stripped of their valuable materials, which were then melted down (presumably a reference to gold adornments).[240] In contrast, the Christian churches were to be endowed with all the splendours of success and triumph.

The cross, from the moment that Constantine placed that motif on his *labarum* (battle standard), was an official symbol of triumph, both of Christ and of the emperors.[241] It was a vital moment in the uniting of treasure and Christian symbol. Eusebius tells us of this standard, that Constantine, having seen the sign of the cross in the heavens at mid-day (it was a solar miracle), called together the workers in gold and precious stones to construct the *labarum*, which was a gilded spear with a cross-bar. At the top was a wreath of gold and gems with the *chi-rho* in its midst. From the cross-bar was suspended a gem-embroidered cloth. There was a gold half-length portrait of Constantine and his children.[242] It has been suggested that the sign on the *labarum* was a circle at the top of a cross and was, in fact, a solar symbol.[243] It may also have been understood in cosmological terms as pertaining to the four points of the compass.[244] But even if that were true, the fact is still that this was subsequently claimed as both a glorious treasure and a Christian symbol. Further, Eusebius also tells us that Constantine set a *crux gemmata* as the main element on a golden ceiling of the imperial palace.[245] The astounding mystery of a

[239] S. S. Alexander (1971) and (1972) list over twenty churches founded by Constantine. See also Armstrong (1967). A recent Christian polemic casts Constantine as the desecrator of the purity of the Church by his very generosity, Kee (1982).

[240] Eusebius, *Vita Const.* 3, 54.

[241] Grabar (1936), 'la croix triomphale', concentrating on the evidence of fourth-century sarcophagi, pp. 239–43.

[242] Eusebius, *Vita Const.*, 1, 29–31. [243] Drake (1975), pp. 72–4. [244] Lehmann (1945), p. 8–9.

[245] Eusebius, *Vita Const.*, 3, 49.

poor and *modest* Jesus, did not, in the emperor's mind, negate the idea of making rich offerings. Had not the Magi (the Three Wise Men) done just that? Whatever Constantine's understanding of Christianity, in common with many of his age he saw the material celebration of that religion as an imperative in the display of his new devotion. The vast building programmes he initiated should be seen in the context of his many other less dramatic donations such as 'magnificently adorned copies' of the Scriptures,[246] trust funds and extensive doles to the poor. All these find parallel in the tradition of public giving (euergetism) that extends right through the history of Rome, as Veyne has chronicled in his *Le pain et le cirque*.[247]

Since Constantine was a ruler, his donations had to be in the style worthy of a Roman emperor. In that capacity he provided huge endowments to the Christian communities of the greatest cities of the Empire. These donations, as attested by the examples from the *Liber Pontificalis*, included estates as well as special funds and buildings together with luxury adornments. That is not to say that the Church before Constantine had been entirely poor. The issue of the rich Christian was a significant one for the early Church.[248] It is true that the small house-church from Dura Europos is one of the few early buildings that we possess from the period;[249] nevertheless, Christianity in the third century was far from being a totally impoverished sect. Well before then, *aulae ecclesiae* were beginning to emerge, especially via the adaptation of villas.[250] Eusebius referred to these early churches on occasion as *conventicula*, 'meeting houses', but more often as *ecclesia*, or described them as basilicas.[251] The non-imperial endowment of such cathedrals as that of Aquilaea[252] shows that, even without the example of Constantine, splendour would have been lavished upon the late Antique church. We have a list of plate seized from the church at Cirta in North Africa, in 303, which was only a small church in a small town.[253] One of the exemplary stories given by Prudentius in his *Crowns of Martyrdom* centres on the avarice of an official who demanded the precious silver of a church, only to be shown the local virgins, who were presented as its spiritual silver.[254] This example demonstrates that churches in the age before Constantine were thought of by the authorities (at least as depicted in later Christian *vitae*) as stores of treasure.

[246] Ibid., 3, 1. [247] Veyne (1976), reviewed by Garnsey (1991). [248] Discussed in chapter 5.
[249] Weitzmann (1979a), cat. no. 360, pp. 404–5 (*c*. 240) decorated in fresco, reconstructed in Yale University Art Gallery, New Haven, Conn.
[250] White (1990), p. 128. [251] Shepherd (1967), p. 70, with references. [252] Krautheimer (1967), p. 128.
[253] *Gesta apud Zenophilum*, C. Ziwsa (ed.) CSEL 26, pp. 185–97, at p. 187, 'calices duo aurei, item calices sex argentei, urceola argentea, cucumellum argenteum, lucernas argenteas septem, cereofara duo, candelas breves aneas cum lucernis suis septem, item lucernas aeneas undecim cum catenis suis'. These various gold, silver and bronze vessels and lighting equipment are directly paralleled in style, if not in scale, by Constantine's donations of movables that are discussed in this chapter.
[254] Prudentius, *Peristephanon*, 2 (St. Lawrence), in H. J. Thomson (ed. and trans.) *Works* II (of 2 vols.), LCL (1949), pp. 98–345.

The basilican form had been developed in the context of meeting halls and it was as a gathering place for the Christian community that most of these churches were intended. The form itself was used by a variety of groups. The synagogue at Sardis, as rebuilt in the fourth century, was a large basilica with an apse mosaic; its design, albeit on a small scale, was very similar to Old St Peter's.[255] Size for size, with thin walls and a simple structure, the basilican form was relatively inexpensive, thus freeing more funds for decoration.[256] It is, however, interesting to consider that domed churches may have become popular in Byzantium precisely because of the prestige of their greater expense. Constantine's letter to bishop Macarius of Jerusalem spells out that the church to be built at imperial expense at Golgotha should possess marble columns, revetment and, if the bishop desired it, coffered gilded ceilings.[257] Any episcopal thought of refusal of such splendours would have been stilled by the thought that this was all coming about by the will of God. Much earlier, after the 312 victory, Constantine ordered to be built the church that is now San Giovanni in Laterano, but which was then called the Basilica Constantina. It was slightly narrower, but far longer, than the audience hall at Trier. Its apse may well originally have been aniconic. It is described in the *Liber Pontificalis* as being *ex auro trimita*,[258] which may indicate gold foil.[259] The apse of Old St Peter's is also referred to as *ex trimma auri fulgentem*, made of shimmering gold foil. Below, the altar was silver-gilt and set with 400 precious stones. These were just two of an extensive scatter of churches eventually endowed by Constantine and his immediate successors.

Many of the major Constantinian churches, of course, do not survive in their original form and it is certain that many masterpieces of imperially inspired decoration have perished with them. In some instances fragmentary evidence survives as testimony to the fact that no expense was spared in the building of these monuments. One example is provided by the Church of the Nativity at Bethlehem. Although it was a Constantinian foundation, there survives no extensive ekphrasis (description) before the seventh century. However, excavators of the surviving floor mosaics have dated these to the time of the original construction, rather than to the period of the Justinianic rebuilding. The mosaics are partly plain and partly of scroll patterns, but are executed in extraordinarily fine work. The highest-quality mosaics from elsewhere across Palestine tend to possess no more than 150 tesserae per 10 cm². Those of the nave of the Church of the Nativity were of 200 per 10 cm²,

[255] G. F. Hanfmann (1975), p. 88 and G. M. A. Hanfmann (1964), pp. 30–44, with plan, fig. 15.
[256] Krautheimer (1967), p. 129. [257] Eusebius, *Vita Const.*, 3, 31 and Krautheimer (1967), pp. 129 and 139.
[258] *Liber Pontificalis, Pars Prior*, 34 (Sylvester), T. Mommsen (ed.) *MGH, Gestorum Pontificum Romanorum* 1 (Berlin, 1898).
[259] Krautheimer (1967), p. 121.

whilst those of the 'Octagon' (built onto the end of the nave) were of 400 per 10 cm².[260]

The New Rome, Constantinople, was endowed with many churches, of which only fragmentary evidence has survived, since the capital was subjected to the repeated rebuilding that stems from a concentration of resources.[261] Relics were not important in many of these foundations, which gained their glamour from their sheer scale.[262] The Holy Land was plastered with shrines.[263] Extensive study of literary sources has allowed reconstruction of the complex founded by Constantine at Golgotha, which housed, amongst other treasures, a great *crux gemmata* (which was itself pictured in one of the great apse mosaics in Rome).[264] Other churches were built across the Empire by Constantine and his family, at Tyre and Jerusalem, Naples and Capua and many other places.[265]

One of the most famous churches of late Antiquity was the 'Golden Octagon' at Antioch, so called because of its gilded roof. Begun in 327, although not consecrated until 341, this was built next to the imperial palace, and served both as a cathedral for the patriarch and also for the ceremonial attendance of the emperor and the court.[266] In the classical Roman world, domes were used in tombs, baths and audience halls in villas and palaces. They were ill-suited for the assembly of large crowds, which could be accommodated much more efficiently within a rectangular basilican arrangement. This suggests that the centrally planned churches were the result of adoption of domes for their celestial symbolism or aesthetic impact rather than for any practical considerations of the use of space.[267] In late Antiquity the word *caelum* (heaven or sky) was applied to mean 'ceiling'. The effect of the Byzantine dome, with the Pantokrator at its apex, was to bring the All High sufficiently close to earth that He could be seen in symbol, as His presence was believed to be felt in fact.

[260] Harvey & Harvey (1937), dating, p. 16; densities, p. 10; the nave mosaics, pl. 7 and the Octagon mosaics, pl. 6.

[261] On the early churches of Constantinople, see Mathews (1971).

[262] Ibid. p. 177, referring to these and later foundations, notes that in Constantinople the enormous churches of the Saviour, Hagia Sophia and Hagia Eirene were founded without any relic of importance. In the Byzantine church, 'devotion to martyrs was far less important than devotion to the liturgy'. It might be argued that *most* relics served local interests glorifying the locale, rather than imperial ones glorifying the *imperium*, and thus the division is less between east and west than between the mental horizons of local and imperial founders. The True Cross, in this analysis, would be a suitably imperial relic.

[263] Krautheimer (1967), pp. 130ff.

[264] On the literary sources for the site, Wistrand (1952). A modern diagram of the buildings is given by Drake (1975), p. 171, Conant (1956), pl. 10 and Weitzmann (1979a), cat. no. 582, pp. 650–1. See Wilpert (1976), for the apse mosaic of Santa Pudenziana, pls. 20–2.

[265] Downey (1962) and *Liber Pontificalis*, 34 (Sylvester). [266] Krautheimer (1983), p. 86 and (1965), pp. 52–3.

[267] Lehmann (1945), p. 26, or for the cost, as suggested above (p. 55).

The *Liber Pontificalis* for Rome, and the evidence of various pilgrims in the Holy Land, testify to the vast endowments in terms of precious objects provided by the imperial house. The donations listed in the *Liber Pontificalis* are famous for their size.[268] Gifts to San Giovanni in Laterano included a fastigium (a huge canopied screen) with 2,025 lb. of silver revetment. Standing within it were silver statues of Christ, the apostles and angels, weighing 1,760 lb. in total.[269] In the basilica were over one hundred and fifty silver chandeliers and lights weighing in total over 3,700 lb., over one hundred silver vessels weighing about 2,000 lb., over fifty gold vessels weighing over 400 lb., with gold for the apse weighing 500 lb. To provide oil and revenue for the lighting, seven estates were granted, with a revenue of 4,390 *solidi* per annum.

Solidi were generally struck at the rate of seventy-two to the Roman pound.[270] This means that the apse vault cost 36,000 *solidi*. One *solidus* would buy roughly 1,000 lb. of bread or 200 lb. of meat. The price of the apse vault therefore would have bought 36,000,000 lb. of bread or 7,200,000 lb. of meat. At £3 per pound of meat, to give a rough modern approximation, the vault cost the equivalent of £21,600,000. But that does not take into account a cost of living where a poor man could live on 3 *solidi* a year. His wage would be the equivalent of £1,800 in modern food-purchasing power. The modern equivalent poor income might be, say, three times that. The equivalent of the spending, compared with low incomes, would be £60,000,000 for the vault. This was but one component in one of the church foundations, which was but one part of the imperial building programme. At the same time, palaces were being constructed in the same fashion. The standard cost ratio of gold to silver was 1:12, a rate of *c*. 8,000 *denarii* per silver lb (the gold average was 100,000 *denarii* per lb.). At that exchange rate, the cost of the 3,700 lb. of silver lighting fixtures for John Lateran was 22,200 *solidi*. St Melania and her husband were said to have had a combined annual income, at their marriage in 397, of 120,000 *solidi*: in modern purchasing power (low annual wage 3 *solidi* = £5,400 in modern terms), that sum is equivalent to £216,000,000 of income per year; a joint wage, at a 35-hour week, for 45 weeks a year, of £137,143 per hour (in ratio comparison with the cited modern low income of £3.43 per hour). Bearing in mind that as well as the gold and silver items, there was marble, and mosaic, and the very

[268] *Liber Pontificalis* (1989), pp. xix–xxvi, 'the Constantinian church foundations'. The source document has been dated to the middle of the fourth century. However, the present text is early medieval in date and must be understood to represent gifts at various times. It should be considered as a guide to the style of the splendours of the Roman church, but with caution applied to the exact figures, which are given here, nevertheless, as they provide vital evidence of scale. It not likely that the later period would have seen larger gifts than the earlier, if only for economic reasons.

[269] On the fastigium, M. T. Smith (1970) and Grigg (1977), p. 10.

[270] The following figures and exchange rates are taken from Hendy (1985), pp. 202, 449–51 and 465.

cost of the buildings themselves, even one great basilica would have been a strain, although not an impossible one, if spread over a decade or two, for one of the greatest families of the Empire. But emperors, with their disposal of tax revenues, had the available money for huge endowment schemes. This was an arena in which they could easily show their pre-eminence. Such wealth, for the average worshipper, would surely have seemed much closer to heaven than it was to the earth.

The great donations of Constantine were repeated by his successors and other aristocrats in so far as they had the time or the money. Such donations were important for their posthumous reputation (something with which the classical Roman world had been very concerned), as well as being important for the health of the soul. Each church would carefully keep alive the memory of its benefactors. The impact that treasure gift made in the period is telling. Money spent in that way was *very* effective in generating a lasting reputation, though the needs of Christian ideology dictated that accompanying gifts in varied forms such as doles should be given, as had also been the classical Roman custom.

Constantine's churches have suffered frequent rebuilding through the centuries and so it is from the middle of the fourth century that the first major examples of treasure decoration in mosaic are found to have been preserved in late Antique churches.[271] Particularly fascinating, in the aftermath of the reign of Constantine, are the close links between many of the great monuments of gold art and the imperial system. Early churches possessing large expanses of gold leaf can, in instance after instance, be associated with the patronage of rulers. The earliest surviving examples of mosaics with a gold background are those of the cupola at Centcelles, near Tarragona in Spain.[272] On excavation of the latter site, large quantities of gold tesserae were found where they had fallen to the floor. However, enough remained *in situ* to identify that they had been used to form the upper section of the grounds behind throned figures toward the apex of the cupola.[273] Just upstream from Tarragona (the provincial capital), at the modern village of Constantina, this cupola is suggested to have been a mausoleum for a relative of the imperial house, perhaps set in part of an imperial estate or hunting villa.[274] The mosaics are dated on analogies of style to the middle of the fourth century.[275] The best parallel to this domed building is arguably the mausoleum that is now Santa Constanza in Rome. Both originally had Biblical scenes in the vault, below which were rustic motifs such

[271] The question of the original apse decoration of many Constantinian churches is a matter of intense debate, centring on whether later mosaics were modelled on earlier ones, and so forth. On the Lateran, Christie (1970). The thesis has even been advanced that these buildings were aniconic, Grigg (1977).
[272] Schlunk (1959), pp. 344–65; Hauschild & Schlunk (1961), pp. 139ff and Beckwith (1970), p. 13.
[273] Hauschild & Schlunk (1961), pp. 139, 148–9 and 154; pls. 32 and 35.
[274] Schlunk & Hauschild (1978), p. 120. [275] Hauschild & Schlunk (1961), p. 178.

as hunting and harvesting scenes with putti.²⁷⁶ The throned figures in Centcelles are hard to identify, but both Christ and Constans are possibilities.

The first surviving *large* expanse of gold ground in a mosaic comes from the well preserved apse of Sant'Aquilino, a chapel at the side of San Lorenzo, Milan. Christ and the Apostles, clad in white, stare out from a sea of gold tesserae.²⁷⁷ The plain gold background is considered to be original.²⁷⁸ This work is dated to the end of the fourth century, which is spectacular in view of the fact that it was not until the sixth century that extensive gold mosaic became very widespread. San Lorenzo is the only great church from this period in Milan which does not appear to have been founded by Ambrose. He never mentions it as built by himself. His other buildings are considered by Krautheimer to have been constructed in a manner that suggests less extensive resources in comparison with San Lorenzo, which, together with the two chapels built integrally at the same period, was decorated with very great splendour. Later medieval evidence describing the church before the fire of 1071 attests the presence of vault mosaics and extensive use of gold.²⁷⁹ The present dedication dates from the sixth century. Neither it, nor the chapel, were *martyria*.²⁸⁰ It is possible that this complex was originally the palace chapel of the Arian emperors.²⁸¹

The church of St George, Thessalonica, is famous for its cupola mosaics composed of golden architectural forms.²⁸² Once part of the late Antique imperial palace, this rotunda had originally been built as either the throne room or the mausoleum of Galerius. Whichever it was intended to be, it was never used for the latter purpose, since Galerius was buried at Serdica. It was converted into a church in the fourth or early fifth century.²⁸³ It is possible that the mosaics in fact represent imperial art. Iron staples used to fix the plaster for mosaic were installed before the mortar hardened in the walls.²⁸⁴ The upper cupola is, however, of a later date than the lower masonry. The original roof, of the time of Theodosius I, may have collapsed.²⁸⁵ Also with possible royal connections was the 'Golden Church' (*la Daurade*) of Toulouse, the decoration of which was described before the building's demolition in the eighteenth century. The cupola of this church possessed complex figural mosaics set against extensive golden backdrops. Dating is impossible. It may have been the court church of the Visigothic kings.²⁸⁶

²⁷⁶ Ibid., p. 180 and Dunbabin (1978), p. 221.
²⁷⁷ Beckwith (1970), p. 13 and Bertelli (1989), colour pl. at pp. 62–3. ²⁷⁸ Bovini (1970), p. 73.
²⁷⁹ Evidence discussed with references by Krautheimer (1983), pp. 82–8. ²⁸⁰ Ibid., p. 82.
²⁸¹ Kinney (1970–1); J. B. Ward-Perkins (1981), p. 464 and Krautheimer (1983), p. 88.
²⁸² Bertelli (1989), p. 103.
²⁸³ Grégoire (1939); Vickers (1973); Di Azevedo (1979) and Lavin (1962), p. 18.
²⁸⁴ Beckwith (1970), pp. 13–14 and 167 n. 14. ²⁸⁵ Weitzmann (1979a), cat. no. 107, p. 121.
²⁸⁶ Translated text in Davis-Weyer (1986), pp. 59–66.

Many of the great churches of Ravenna were also built in association with royal and imperial patronage. Theodoric had lived in the Great Palace in Byzantium and he made use of imperial-style self-presentation in Ravenna, including a prominent mosaic of himself on horse-back.[287] It is thought that Sant'Apollinare Nuovo may have been the Gothic palace church,[288] whilst San Vitale has been closely associated by Von Simson with Justinian's plans of re-conquest.[289] SS. Sergius and Bacchus in Constantinople was next door to the Palace of Hormisdas, which was incorporated by Justinian into the Great Palace.[290] Similarly, a chamber of the Constantinopolitan palace of Antiochus, guardian of Theodosius II, was converted into the church of St Euphemia after its builder's disgrace in 436. The same thing may have occurred to another domed building nearby which was probably part of Lausus' (another grandee's) palace.[291] These examples indicate that the imperial style was used by nobles, albeit on a lesser scale, but good evidence has not frequently survived.

Many bishops were also nobles and had considerable resources at their disposal. Great bishops could be accused of playing too much the king as they embarked on their own grand building schemes. But the episcopal job was to judge and to give, placing them in the same position as royalty and others who hold great wealth and power in trust. Luxury buildings were one way of giving both to God and to the community of the faithful.[292] Rabulla of Edessa boasted of not having built, since he spent all his money on the poor. But bishops such as he were rare and not necessarily the most popular. As Peter Brown has pointed out, 'the conflict of priorities in the use of the Church's wealth had come to stay'.[293] Such contradictions were the result of communities that had somehow 'found their way around stark choices'.[294] Many of the ways of the 'treasure society' were accommodated with the thought of the Church. It now remains to establish how this process took place.

[287] Agnellus, *Liber Pontificalis Ecclesiae Ravennatis*, 39, O. Holder-Egger (ed.) *MGH, Rerum Langobardicarum et Italicarum Saec. VI–IX* (1878).

[288] Duval (1978), p. 32. On Theodoric's building programme at Ravenna, Johnson (1988).

[289] Von Simson (1987). [290] Dynes (1962), p. 7, with references. [291] Lavin (1962), pp. 19–20.

[292] Others included doles and festivities as discussed above and, in general, by Veyne (1976).

[293] Rabulla discussed by P. R. L. Brown (1992), p. 120. [294] Kaster (1988), p. 79.

CHAPTER 3

The riches of Scripture

According to the Gospel of Matthew, Jesus went out into the desert and, surrounded by his disciples and by a great multitude, delivered what we have come to know as the Sermon on the Mount. This includes some of the most well known of all the passages of Scripture. Central to Jesus' theme was the issue of loyalty to the things of this world: '[Matthew 5: 2] And he opened his mouth and taught them, saying, "blessed are the poor in spirit, for theirs is the kingdom of heaven . . . [6: 19–20] Lay not up for yourselves treasures on earth, where moth and rust doth corrupt, and where thieves break through and steal: but lay up for yourselves treasures in heaven, where neither moth nor rust doth corrupt".'[1]

Jesus died a pauper, urging others to follow his example. But, for antique and medieval commentators, it was also very significant that the first gifts he received, when he was only just born, were of the most precious substances that his visitors could find: gold, frankincense and myrrh. These were viewed as a sign of what gifts were proper to honour God.[2] Nevertheless, the words of Jesus on personal attitudes to the paraphernalia of worldly wealth *were* very explicit. Think about the phrase, 'it is easier for a camel to enter the eye of a needle than for a rich man to enter the kingdom of heaven'.[3] These words may seem unambiguously to indicate to us that wealth and its trappings have no place on the road to Salvation. But elsewhere in Scripture gold and gems were shown as strewn about in sacred settings, such as in descriptions of the Tabernacle, the Temple of Solomon, and in connection with God himself and heaven itself, as in the Vision of Ezekiel and the New Jerusalem of the Apocalypse.[4] The relation of such imagery to Christ the pauper would, at first sight, represent a considerable challenge of interpretation.

[1] This text is from the AV English Bible. Biblical quotations discussed later in this chapter in the context of exegesis are given from the Vulgate, except where this differs from a translation of the Latin version used by the exegete concerned.
[2] Matthew 2: 11. On the Three Wise Men (the Magi) in the Middle Ages, Kehrer (1908).
[3] Mark 10: 25; Matthew 19: 24 and Luke 18: 25.
[4] Exodus 25–7; III (AV I) Kings 6; Ezekiel 1: 26 and Rev. 21. On the Tabernacle in the Old Testament, see Koester (1989).

Exceptional personal wealth and splendour set apart a few members of a society from their fellows. It is in the interests of a religious institution for attention to be directed towards itself, rather than towards particular individuals. However, religions exist within society and, moreover, in order to survive and communicate with and influence that wider culture a sect needs to employ a fair number of shared cultural forms, including those generally used to show social prestige. Indeed, the self-proclaimed supremacy of a religion may lead to its representative body's assertion of supremacy over all worldly affairs. There is, therefore, an inherent tension in the dependency of a faith on its existence in a wider society. This problem is especially acute in the case of Christianity. The mission of Jesus can be considered as a call not only for personal spiritual rebirth, but also for the renewal of the religious institutions of the age. Rabbinic society had reached an accommodation with worldly riches.[5] It was understood that the blessings of personal charity had given wealth a purpose. Jesus, however, proclaimed that the people should no longer cling to the things of this world because the Kingdom of Heaven, that is, the end of the world, was at hand. His followers were commanded to break with their families and get rid of their concern for possessions once and for all.[6]

Heralded as rising from the dead, Jesus was held to have achieved the most extraordinary of victories. His followers wished to spread the message and as they did so they built an institution to act as a focus for the communities of the faithful. Priests taught that persons could save themselves in the Christian style by renouncing their pride and splendour, even as the Church grew institutionally more complex. This is a story of how the Church attempted to set up structures so as to ensure that as many people as possible lived their lives with reference to the example of Christ. Personal humility was placed together with the glorification of God and respect for the institutions of the faithful. The Church engaged with the world, taking upon itself the 'burden' of wealth, and justifying its own glory in relation to its role as lieutenant of God. The growth of the Church was grounded upon the belief that that institution embodied excellence. We have seen how Antiquity delighted in splendour in justified contexts. A vital component in the success of Christianity was the way in which it managed to combine many of the ideas and assumptions of secular culture with the radical message of Christ which was seemingly in contradiction to a considerable proportion of contemporary mores. This victory was fought out in the realm of cultural associations and symbolic understandings, and through it, Jesus came to be seen across Europe not as humiliated, defeated and dead, but as living in regal triumph in heaven.

[5] Hengel (1973), pp. 27–30. [6] Ibid., pp. 31–4.

Literary symbolism: Latin exegesis

Much Christian imagery emerged from a Jewish tradition that expected the coming of the Saviour as King with full regalia and expected him to be honoured in the way fitting for a great ruler. Having accepted the diversity of Scriptural texts as divine revelation, the Christian mind strove to accommodate one with another in the context of the victory of the Church from the time of Constantine. Early Christian writers treated every Biblical passage as the embodiment of profound mysteries. Exegesis drew out of Scripture diversity and immensity. It was seen as an infinite forest, a labyrinth, a gigantic sea, painted afresh at each reading in bright colours and displaying its riches.[7] The importance of exegesis to the Antique and medieval Church was immense: 'the whole life of the community was conditioned by the interpretation of Scripture . . . the whole development of Catholic doctrine is based on the interpretation of a certain number of passages in Scripture in the light of particular needs'.[8] Exegesis acted to convert a bunch of highly diverse texts into one coherent, mutually self-supporting system because 'by means of an allegorical explanation every word of the sacred text becomes rich with instruction'.[9] The employment of metaphorical logic also avoided the initially apparent meanings of some Old Testament passages which were, literally speaking, scandalous.[10]

The civilization of medieval Europe shared with its predecessors a great concern for startling colours and precious materials. One set of attitudes is displayed in the ancient set of texts that make up the Old Testament. This is characterized by a close association of divinity and treasure-substances such as gold and precious stones. In contrast, the early Church which gave birth to the New Testament arose in circumstances of poverty and, hence, the Gospels are barren of physical riches. These two sets of texts were subsequently interpreted by theologians of late Antiquity and the early Middle Ages. The aim was to reconcile those things apparently unlikely or contradictory in Scripture. The tool used to do this was allegorical interpretation. Individual phrases were believed to have a meaning beyond that which was immediately apparent. Various senses of understanding were posited; literal, figurative and allegorical (metaphor behind the literal meaning) and typological (inter-Scriptural reference of one passage to another). This allowed the Bible to be logically understood as coherent in its

[7] Lubac (1959), I, pp. 119ff.
[8] Simonetti (1980), p. 9, 'Possiamo perciò dire che tutta la vita della comunità era condizionata dall'interpretazione della Sacra Scrittura . . . tutta l'elaborazione della dottrina cattolica si fonda su un certo numero di passi scritturistici, interpretati alla luce di determinate esigenze.'
[9] Paredi (1960), p. 369, 'Ogni parola del testo sacro con la spiegazione allegorica diviene ricca di sensi istruttivi.'
[10] Lubac (1959), II, p. 457.

entirety. In his Revelation, John the Divine saw 'a new heaven and a new earth'.[11] The Whore of Babylon, clad in gold and jewels, was defeated and her city replaced by another constructed of the self-same treasure but on a far more lavish scale. The symbolism was found problematic, then as now. Biblical exegesis attempted to account for these details in terms of figurative explanation and the resulting texts breathe the symbolic conceptions and prejudices of late Antiquity and the early Middle Ages.

The message of Christianity was disseminated in both written and visual form.[12] Gold church decorations provided a setting for the liturgy that society found decorous. Symbolic use of gold was promoted by the presence of treasure in much of the Bible. It is of course true that the Church was far from wishing to recreate ancient Jewish sacrificial worship. Nevertheless, the deliberate modelling of liturgical practice upon details found in Old Testament texts has been traced by Johan Chydenius, amongst others.[13] Such novel practices as the anointing of kings, which took place from the seventh century onward, have long been recognized as having emerged in this context.[14] Ancient symbolic use of treasure was carefully interpreted so as to accommodate it with Christian morality. Exegesis, that genre 'essential to medieval culture',[15] enables us to watch thinkers of the period wrestling with the very problem of the idea of treasure in relation to Christianity and moral truth.

The relationship between the Biblical text and the mental and physical world of the exegetes was a complex one. The Bible was considered as the 'map of divine reality'.[16] Exegetical work was the task of attempting to understand these truths that, in their consummate complexity, far transcended the literal meanings of the words of the text. Exegesis was perhaps the single largest category of medieval Christian literature. Its practice involved interpreting ancient texts according to currently prevailing attitudes which were themselves strongly influenced by what was found in those very same Biblical books. The relationship between object, text and general religious practice might be described as 'a progress from experience to [mental] images, and from images to prayer'.[17] A mystical or figural association formed in this process would naturally remain within the individual at the end of his worship, inviting the cyclical process of association previously suggested.

The practice of this system of moral symbolism can be illustrated by a passage

[11] Rev. 21: 1.
[12] Averil Cameron (1991) is an enormously stimulating discussion of the development of 'Christian discourse' in the context of the Empire.
[13] Chydenius (1965).
[14] Nelson (1977), pp. 50–71. The first certain occasion occurs with Wamba of the Visigoths, in 672.
[15] Matter (1990), p. 4.
[16] Ibid., p. 7. [17] Soskice (1985), p. 161.

from Gregory the Great's *Pastoral Care*. In discussing a particular subject the Pope will naturally hasten to call upon the evidence of Scripture. He will then tell us what he thinks the quotation indicates. To do this, he may or may not rely on previous authorities. So, he quotes, 'there the hedgehog had its hole'.[18] Of this, he informs us that the words refer to the 'duplicity of the insincere mind'.[19] He refers to the physical quality of the hedgehog of rolling into a ball as like something having need of concealment under the gaze of inquiry. Now, unlike gold, hedgehogs are but infrequently mentioned in Scripture. Had they been, they would have been caught in the presently investigated process of description and attribution that took place as the understanding of Holy Writ was shaped by late Antique experience and in turn shaped it. Gold as a symbol could not exist independently of gold the physical substance. It may have been 'a world of rhetorical conventions',[20] but the conventions of a world are a considerable component of its culture. Richard Southern pointed to the contribution of Beryl Smalley in bringing the importance of this exegetical material to the attention of the modern historian. He wrote of the period prior to the publication of her book, *The Study of the Bible in the Middle Ages*, that 'it was generally understood, of course, that the Bible became important as a moving force in politics in the sixteenth and seventeenth centuries; but it could be left out of the account, so it seemed, of the preceding thousand years'.[21] It is now clear that the peculiarities of the genre of exegesis were reflections of a mental world very different from that which underpins modern textual criticism. Things that seem problematic to us would not necessarily have seemed so then.

Exegesis had an enormously long tradition in ancient Israel, stretching back centuries before the birth of Christ. Text and commentary became entwined in mutually supporting respect so that the one was, on occasion, even absorbed into the canon of the other.[22] The central task of Jewish exegesis was to show that Scripture governed all aspects of life. This tradition was brought to the attention of the classical world primarily through the writings of Philo of Alexandria.[23] In his allegorical works, Philo, 'like the Greeks, was trying to show how traditional legend and rite have their true meanings only when they are made a typological

[18] Isaiah 34: 15 (AV 34: 14), 'Ibi habuit foveam ericius.' The hedgehog was one of the animals which it was said would infest ruined Assyria.
[19] Gregory the Great, *Regula Pastoralis*, 3, 11; PL 77, cols. 13–128, 'malitiose mentis duplicitas'.
[20] Zimdars-Swartz (1986), p. 333, 'the workings of the medieval symbolic mentality' and other such ideas are discussed.
[21] Southern (1985), p. 1.
[22] Ancient Jewish literary traditions are examined in detail by Fishbane (1985).
[23] See Goodenough (1962); Chadwick (1964), pp. 137–57 and Savon (1977) for good introductions. Radice & Runia (1988) is a bibliography. There was a tradition before Philo, alas now recorded only from fragments of writers such as Aristobulus (*c.* 100 BC Alexandria), on which see Mansfield (1988), p. 71.

revelation of the true path from man to God'. Platonic allegory made the heroes and divinities of the sacred texts of Homer and Hesiod into 'links between God and man', and there was a tradition of pagan exegesis going back to the sixth century BC.[24]

Christian interpretation through allegory made prophets, priests, treasures and jewels equally into expressions of the divine splendour. The showmanship element of exegesis, a certain delight in the display of recondite knowledge (in which Bede, for example, was to excel) may be seen as pioneered in such a work as Philo's, *On the Creation of the World*, which 'should be read as a *tour de force* in which Philo wishes to amaze the Gentile reader with the great amount of Hellenistic cosmology and metaphysics that can be read out of, really into, the first three chapters of Genesis'.[25] Nevertheless, it has been remarked that there is much repetition in Philo, due to the limited number of allegorical themes, something very much true of later Christian exegesis.[26] This gives reading the work an almost meditative feel, as the same phrases and words recur over and over again. This fact reminds us that exegesis was itself a sacred act of worship, which, as in the execution of the liturgy, gave meaning through the ritualized manipulation of symbols.

Origen used Philo and added the typological approach of Justin and Irenaeus, looking for prefigurement of the New Testament in the Old Testament.[27] Both Philo's and Origen's influence were long lasting in the exegetical tradition of late Antiquity.[28] By the late Roman period, all manner of modes of interpretation could be distinguished; literal, spiritual, typological, allegorical, etymological, arithmetical and so forth. The reason for the obscurity of Scripture had been explained by Augustine, in terms of God's wish that the search for truth, though difficult, would be one of pleasure.[29] Like the beautiful curtains in a palace, literal meaning suitably shrouded the inner wonders. Literal and allegorical interpretations, though they might be given a hierarchy, existed in parallel. Thus, in the writings of Gregory the Great, *ignis* (fire) may refer to the Holy Spirit or to human anger.[30] And oxen may be the madness of lust, the hard-working preacher or the humility of the Israelities.[31] However, since my present aim is the understanding of symbolic associations, the philosophical and theoretical aspects of allegorical construction will be left out in favour of the consideration of *which*

[24] Goodenough (1962), p. 140; Caird (1980), p. 167 and Dawson (1992), with the dating from Lamberton (1986), p. 32.

[25] Goodenough (1962), p. 35. [26] Runia (1987), p. 131. [27] Chadwick (1964), p. 183.

[28] On Philo, Radice & Runia (1988); Chadwick (1964) and Goodenough (1962). On Origen, Peterson (1985–90); Trigg (1985); Chadwick (1966) and E. A. Clark (1986c).

[29] Discussed with references by Marrou (1958), pp. 484–94 and 646–51.

[30] Gregory the Great, *Homilae in Hiezechihelem Prophetam*, 2, 1, 3, M. Adriaen (ed.) CCSL 142 (1971).

[31] Gregory the Great, *Moralia in Job*, 35, 36, 39, M. Adriaen (ed.) 3 vols, CCSL 143-a-b (1979–85).

allegories were drawn (Lubac's monumental work is the best introduction to the typology of symbolism and figurative language in this genre).[32] A number of prominent medieval writers, attaching immense significance to the subject, produced a theoretical elaboration quite in contrast to the almost interchangeable usage of 'figure', 'symbol', 'trope' and 'allegory' in modern English.[33] For study of the treasure mentality, the basic associative interpretation is what is of paramount significance.[34]

I have chosen commentaries on the Song of Songs and the Revelation of John the Divine as the basis for a case-study. These image-filled texts were worked upon by a considerable number of the most influential churchmen during late Antiquity. Moreover, although the two books appear very different to the modern eye, this was not so much the case for the medieval reader. Both the Song and the Apocalypse were seen as depictions of the triumphant Church and soul. They were 'increasingly read together, as two accounts of the same divine plan'.[35] An anonymous Merovingian poem, edited in the *Monumenta Germaniae Historica*, provides an illustration of this juxtaposition. On the subject of the Song of Songs, the text's imagery conjures up the celestial Jerusalem of Revelation by drawing on passages from both biblical books.[36] The beauty described in the Song of Songs was seen as 'a *preview* of heaven like St John's apocalyptic vision of the bride and the lamb [my italics]'.[37] Nevertheless, in *literal* terms, these two books are startlingly different. The Song of Songs consists of eight chapters of Hebrew love verse exchanged between a man and woman.[38] Though attributed to King Solomon, its date is a matter of controversy. The text is lush in its sensual imagery, but confusing in its construction. The work's popularity during the Middle Ages appears to have derived from those very obstacles that lay in the path of understanding it as Holy Writ. Its correct comprehension was seen as the greatest of challenges, hardly to be attempted by those, as Origen said, 'not yet rid of the vexations of flesh and

[32] Lubac (1959). See also Chydenius (1960), for detail on the philosophical importance and influence of Augustine. One of the more important technical divisions is between the *allegory* of Song of Songs as the love between Christ and the Church and the *tropology* of the same love between Christ and the soul. A bibliography of works on medieval exegesis is Sieben (1983).

[33] Something which can be verified by checking the Oxford English Dictionary (Simpson & Weiner (1989)) as, for example, 'trope' = figurative use of a word; 'to figure' = be symbol of, represent typically; 'type' = a person, thing, event, serving as illustration, symbol.

[34] Contemporary attitudes toward classification provide yet another distinct and considerable topic, which, likewise, must be omitted for the present.

[35] Matter (1990), for quotation, p. 89. See also, p. 111, 'it is no historical accident that so many medieval exegetes commented on both the Apocalypse and the Song of Songs'.

[36] Anonymous, *Versus in Canticis Canticorum de Deo Sanctaeque Ecclesiae*, K. Strecker (ed.) *MGH, Poetae Latinae* 4, 2 (Berlin, 1923), pp. 620–9.

[37] Astell (1990), p. 33. [38] Carr (1984) provides a typical modern interpretation.

blood'.[39] Yet, for austere men, such as Cassian, the Song of Songs was a holy of holies. In attaining comprehension of its recondite truth, he wrote, 'the soul soaring above all things visible, is joined to the Word of God by the contemplation of heavenly things'.[40]

The Revelation of John the Divine is the only one of the many visions of the Last Things to be adopted by the western Church as canonical.[41] It is a product of the youthful Roman Empire, probably dating from the later years of the first century. Its literalist overtones of the rule of Christ on earth and anti-imperial stance were, over time, to be concealed under allegorical interpretation.[42] It is long, complex and demanding. Its influence on the Middle Ages fluctuated. The eastern church never fully accepted it, whilst in the west its prophecies of the end of the world were to stoke bouts of millenarianism.[43] Naturally, both of these texts were typically read in the west in one or other of the various Latin translations.[44] Richard Bauckham wrote of the 'unusual profusion of visual imagery in *Revelation* and its capacity to create a symbolic world which its readers can enter and thereby have their perception of the world transformed'. This book was only unusual in comparison with the rest of the *New* Testament. Sharing much imagery with the more ancient Biblical texts, this book was accepted as part of a large corpus of texts, every word of which was seen as the embodiment of divine truth.[45] The enormity of the exegetical canon and its repetitiveness require the use of case-studies for my current analysis. However, western commentary on the Song and Revelation has been supplemented, where appropriate, by Latin exegesis of other parts of the Bible which contain significant mentions of treasure, such as Exodus 24–30 (the Tabernacle), III (AV I) Kings 5–7 (Solomon's Temple) and Ezekiel 1 (a vision of God). These shorter passages, in themselves, lack a

[39] Origen, *In Cantica Canticorum*, W. A. Baehrens (ed.) *Origenes Werke* 8, Die Griechischen Christlichen Schrifsteller der ersten drei Jahrhunderte 33 (Leipzig, 1923), pp. 61–198, *prologus*, p. 62, lines 19–22, 'Ob hoc ergo moneo et consilium do omni, qui nondum carnis et sanguinis molestiis caret neque ab affectu naturae materialis abscedit, ut a lectione libelli, huius eorumque, quae in eum dicuntur, penitus temperet.' Origen, *Song of Songs, Commentary and Homilies*, R. P. Lawson (trans.) (London, 1957), provides an English translation of Rufinus' Latin, collated with the surviving Greek fragments.

[40] Cassian, *Conlationes*, E. Pichery (ed. and trans.) *Jean Cassien, Conférences I–VII*, SC 42 (Paris, 1955), 3, 6, 'mens uisibilia cuncta transcendens uerbo iam dei caelestium rerum contemplatione coniungitur'.

[41] L. Morris (1987) provides a typical modern view. Rowland (1982) on the Jewish background.

[42] McGinn (1979), p. 32.

[43] R. Landes (1988); Chocheyras (1988) and Bietenhard (1953), p. 30, after late Antiquity, 'only cranks and heretics put forward an eschatological interpretation'.

[44] Matter (1990), pp. xxxiv–xxxv, provides an overview of some of the problems involved in the study of the Latin Biblical texts themselves. There was a variety of texts in circulation. Matter, pp. xvi–xxxii, provides a useful composite text of the *Cantica Canticorum*, with an English translation, based on the *Biblia Sacra Iuxta Vulgatam Versionem*, R. Weber (ed.), rev. 3rd edn (Stuttgart, 1983). Naturally, many writers, such as Ambrose, used various 'Old Latin' versions which are 'as elusive as they are common' (p. xxxiv).

[45] Bauckham (1993).

strong corpus of exegetical material from this period and were, for that reason, not chosen as central to this study. In addition, I have also taken note of references to Greek commentaries influential in Latin translation. Because the aim is to investigate the prevalence of attitudes through late Antiquity, a line has had to be drawn chronologically and for that reason sources from the Carolingian period have not been used.

There survive late Antique Latin Song of Songs commentaries by Hippolytus of Rome (third century),[46] Origen (third century, Alexandria) as translated by Rufinus (fifth century),[47] Gregory of Elvira (late fourth century, Spain),[48] Aponius (fifth century, Italy),[49] Justus of Urgel (sixth century, Spain),[50] Pope Gregory the Great (late sixth century)[51] and by Bede (eighth century).[52] In addition there exists a twelfth-century collection of Ambrose of Milan's (fourth century) observations on the subject.[53] Pre-Carolingian Latin commentaries on the book of Revelation are by Victorinus of Pettau (late third century, Pannonia), Victorinus as *heavily edited* by Jerome (late fourth century),[54] Tyconius (fourth century, Africa),[55] Caesarius of Arles (early sixth century, Gaul),[56] Apringius of Beja (sixth century, Portugal),[57] Primasius of Hadrumentum (sixth century, Africa),[58] Cassiodorus (sixth century, Italy),[59] Pseudo-Isidore (seventh century, probably Italy)[60] and Bede.[61] In addition, there are references to these books in other works of the major later Latin Fathers (and of Greek writers influential in Latin translation),

[46] Hippolytus Romanus, *De Cantico*, G. Garitte (ed. and trans.) *Traites d'Hippolyte, version Georgienne, Corpus Scriptorum Christianorum Orientalium* 263–4, Scriptores Iberici 15–16, includes a Latin translation.
[47] Origen, *Commentarium in Cantica Canticorum* (trans. Rufinus of Aquilea), W. A. Baehrens (ed.) *Origenes Werke* VIII, Die Griechischen Christlichen Schriftsteller der ersten drei Jahrhunderte 33 (Leipzig, 1923), pp. 61–198. On Origen and later Fathers on Song of Songs see *epithalamium*, Clark (1986c).
[48] Gregory of Elvira, *Tractatus de Epithalamio*, J. Fraipont (ed.) *CCSL* 69 (1967), pp. 167–210.
[49] Aponius, *In Cantica Canticorum Expositionem*, B. de Vregille & L. Neyrand (eds.) *CCSL* 19 (1986).
[50] Justus of Urgel, *In Cantico Canticorum Salamonis Explicatio Mystica*, *PL* 67, 961–94.
[51] Gregory the Great, *Expositiones in Cantica Canticorum*, P. Verbraken (ed.) *CCSL* 144 (1963), pp. 1–46.
[52] Bede, *In Cantica Canticorum Allegorica Expositio*, D. Hurst (ed.) *CCSL* 199b (1985), pp. 166–375.
[53] Ambrose, *Commentarius in Canticum Canticorum*, *PL* 15, cols. 1946–2060 (collected by William of St Thierry).
[54] Victorinus of Petau, *Comentarius in Apocalypsin Editio Victorini et Recensio Hieronymi*, J. Haussleiter (ed.) *CSEL* 49 (1916), pp. 10–154.
[55] Tyconius, *Commentarius in Apocalypsin*, F. Lo Bue (ed.), *The Turin Fragments of Tyconius' Commentary on Revelation* (Cambridge, 1963). On this commentary see Matter (1992).
[56] Caesarius of Arles, *Expositio in Apocalypsin*, *PL* 35, cols. 2417–2452. This text is cited there under the works of Augustine.
[57] Apringius of Beja, *Tractatus in Apocalypsin*, P. A. C. Vega (ed.) (Madrid, 1941).
[58] Primasius of Hadrumentum, *In Apocalypsin*, A. W. Adams (ed.) *CCSL* 92 (1985).
[59] Cassiodorus, *Complexiones in Epistolis Apostolorum et Actibus Apostolorum et Apocalypsi*, *PL* 70, cols. 1381–1418.
[60] Pseudo-Isidore, *Commemoratorium in Apocalypsin*, K. Hartung (ed.) *Ein Traktat zur Apokalypse des Ap. Johannes in einer Pergamenthandschrift der K. Bibliothek in Bamberg* (Bamberg, 1904) (this anonymous text is sometimes referred to as being by Pseudo-Jerome).
[61] Bede, *Explanatio Apocalypsis*, *PL* 93, cols. 129–206.

especially, Ambrose,[62] Jerome,[63] Augustine[64] and Gregory the Great.[65] Ambrose wrote a considerable amount of exegesis, but his references to the Song and Revelation are scattered, though there is a particular concentration in his commentary on Psalm 118.[66] Augustine left no verse-by-verse commentaries on these books, but his intellectual influence was enormous. His exposition, *De Doctrina Christiana*, has been seen as containing one of the prime expressions of theoretical symbolism.[67]

The texts all employ the same symbolic language, which ensures that there are important common threads uniting their interpretations. Most of the above writers comprise what Beryl Smalley referred to as the 'Alexandrian' school of highly allegorical exegesis.[68] This school had a far greater influence than its rival, that of the 'Antiochenes', which favoured a much less thorough use of allegory. Embracing this latter approach was Victorinus of Pettau, who produced the first Latin commentary on Revelation.[69] Martyred in 304, Victorinus was one of the last Orthodox bishops to uphold a literalist view of a thousand-year Kingdom of Christ on Earth. Victorinus did, however, make occasional use of figurative interpretation of individual details. With the Peace of the Church, Victorinus' understanding of Rome as the apocalyptic Babylon was no longer acceptable.[70] Jerome replaced many of the literalist passages, also injecting that characteristic flamboyance of expression which finds such fulsome outlet in his letters. In his edition of Victorinus, Jerome made considerable

[62] In association with the collection noted above, Ambrose, *De Fide*, *De Virginibus*, and *Commentarius in Psalmo CXVIII* [AV, Psalm 119] are particularly useful. See, respectively, *La Fede*, Otto Faller (ed. and trans.) SAEMO 15 (Milan, 1984); *Verginate e vindovanza*, E. Cazzaniga (ed.) and F. Gori (rev. and trans.) SAEMO 14i/i (Milan, 1989), pp. 100–241 and *Commento al Salmo CXVIII*, L. F. Pizzolato (ed. and trans.) SAEMO 9 and 10, 2 vols. (1987).

[63] Jerome, *Epistulae*, I. Hildberg (ed.) 3 vols, CSEL 54–6 (Berlin, 1910–19), esp. *Epist*. 22, on the Song; *Tractatus siue Homilae in Psalmos*, D. Morin (ed.) CCSL 78 (1953), pp. 1–447; *Tractatus in Marci Evangelium*, ibid., pp. 451–500; *Homilia de Natiuitate Domini*, ibid., pp. 524–9 and *Commentarius in Hiezechielem*, F. Glorie (ed.) CCSL 75 (Turnhout, 1964).

[64] Augustine, *De Civitate Dei*, B. Dombart & A. Kalb (eds.) CCSL 47–8 (1955); *De Trinitate*, W. J. Mountain (ed.) CCSL 50–50a (1968). On Augustine's general usage of Song of Songs, La Bonnardière (1955).

[65] A collection of Gregory the Great's exegetical comments was made by Paterius (early seventh century). Other collections were made including one provided by Bede in his Song of Songs commentary. This was written because Bede had been unable to find a copy of Paterius. In addition to Gregory's Song of Songs commentary, extensive references are to be found in the *Pastoral Care*, the *Commentary on Ezekiel* and the *Morals of Job*. For all this, see Paterius, *De Expositione Veteris ac Novi Testamenti de Diversis Libris S. Gregorii Magni Concinnatus*, PL 79, 903–916, 1, 13, *Testimoniis in Cantica Canticorum*; 3, 7, *Testimoniis in Apocalypsin* and Gregory the Great, *Reg. Past.*, *Hom. in Hiez.*, and *Mor. in Job*. It is, of course, only fair to point out that although Gregory had a great influence upon Bede and the English in general, initially at least he was of less importance on the Continent. For this, see Llewellyn (1974) and Hillgarth (1992).

[66] Psalm 119 in the English translations of the Bible. [67] As for example, in Chydenius (1960).

[68] Smalley (1983), chapter 1. [69] Victorinus of Petau, *Cant.*, discussed by Steinhauser (1987), pp. 29–44.

[70] Which is not to say that the end of the world was remote. Indeed, the ultimate wish and hope of the Church was for that end in the return of Christ.

use of the work of Tyconius, as did virtually all exegetes of Revelation during the early Middle Ages.[71] The significance of Tyconius was that, in the words of the fifth-century writer Gennadius, he understood 'nothing carnally but everything spiritually'.[72] He believed in the imminence of the Second Coming, but nevertheless he understood 'the book of Revelation not so much as a prophecy of the end of the world, than as an image of the history of the Church in the world, in other words, not eschatologically, but as a theology of history'.[73] His *Seven Rules* for scriptural interpretation were quoted by Augustine and Bede, amongst others, and so came to be well known during the Middle Ages.[74]

Following on from the work of these earlier exegetes were other commentaries that show 'a re-working of traditions and the re-application of earlier prophecies to meet later needs'.[75] So, for example, an interpretative text might be required for teaching purposes from which passages inspired by out-dated religious controversies and concerns had be excised. Nevertheless, repetition of useful passages of earlier writers represented laudable humility toward the wisdom of predecessors. Such a relationship exists, for instance, between Bede and the works of Gregory the Great.[76] In summary, between the third and eighth centuries, a series of commentaries was written in various parts of Latin Europe, with the aim of making clear the mysterious truths of the Song of Solomon and the Revelation of John the Divine.[77] After Victorinus, these interpretations focused upon the ideas of allegory and figurative interpretation. As has been noted, a primary characteristic of these texts is a systematic borrowing of ideas from earlier interpretations which were found stimulating. The significance of this is that the evidence of the commentaries represents an essentially conservative academic tradition continued beyond the end of the Empire in the west. The fascination of these texts is that they are attempts to make clear, to people of that later period, a text that was Biblical and therefore (albeit figuratively) completely true. If angelic figures in the Apocalypse were dressed in a particular way, that tells us how John, a member of the early church, saw the Elect. If Bede says that these *must* be the Elect, since this is shown by their dress, that tells us something of Bede's own attitudes. Continuity of interpretation is an extremely prominent characteristic of these texts and I shall now illustrate the similarity of our exegetes' symbolic understandings by describing their interpretation of passages refering to light and lightness, gold and jewels.

[71] See the important study by Steinhauser (1987), with Simonetti (1980), pp. 89–91 and P. F. Landes (1982).
[72] Gennadius, *De Scriptoribus Ecclesiasticis*, PL 58, cols. 1053–1120, at col. 1071, 'Exposuit et Apocalypsin Iohannes ex integro nihil in ea carnale, sed totum intellegens spiritale.'
[73] Bonner (1966), p. 5. [74] Augustine, *Doctr. Christ.*, 3, 30, 42ff and Bede, *Apoc., Prologus*.
[75] Smalley (1983), p. vii. [76] Meyvaert (1964).
[77] For a detailed discussion of the relationships and influence of each of the cited texts, see my PhD dissertation, Janes (1996a), chapter 3.

In the Revelation of John the holy walk in white.[78] This is seen, by our commentators, as symbolic of virtue. The robes are sacerdotal and they are unstained. The colour is pure and indicates other states of purity possessed by the wearers. 'They shall walk with me in white, for they are worthy' (Rev. 3: 4),[79] refers to chastity and purity of mind according to Pseudo-Jerome.[80] Faith is also evoked.[81] The hairs on the head of the Lord are white in chastity and like (white) wool in love, *caritas*.[82] For Bede, 'the antiquity and eternity of majesty are represented by whiteness on the head to which all the pre-eminent ones adhere as hairs'.[83] The elect are thus associated in a proximity of whiteness with the Godhead. The white gem that makes its appearance in Revelation 2: 17 is similarly symbolic for our exegetes. It is given, along with manna, to 'him that overcometh'. Manna is immortality; the white stone adoption by the son of God, and the name that of 'Christian'.[84] Bede speaks of this stone as 'a body which is now made white by baptism'.[85] So, naturally, the figure of the Lord who walks in the midst of the seven candlesticks in Revelation 1, is clad in pure white. Though Christ died, he appears immaculate; having 'flesh that is not corrupted by death', as Victorinus says.[86] The text of I Corinthians 15: 53 is quoted with reference to the community of the faithful, 'for this corruptible must put on incorruption and this mortal must put on immortality'.[87] The image is that of a cleansing of sin, something that fits the phenomenon of baptism but can here be applied to cloth made to be once more a pure white, by adoption to the one who cannot be stained. It is a direct moral equation of whiteness and goodness, for as Jerome asks, 'if we read and take all this literally, what is the value of "whiteness", of "brilliance", of "on high"?' But, understood spiritually, Holy Writ is 'transformed and becomes as white as snow; as no fuller on earth can whiten'.[88]

[78] In what follows it should be noted that for white, *candidus* is often used in place of *albus*. André (1949), p. 33, notes that *albus* = white, but that 'le sens fondamental de candidus est "d'une blancheur éblouissante"', a 'shining whiteness'.

[79] Rev. 3: 4, 'ambulabunt mecum in albis, quia digni sunt'.

[80] Pseudo-Isidore, *Apoc.*, p. 7, line 27, 'ambulaverunt in albis in castitate et mentis puritate'.

[81] Ibid., p. 8, lines 11–12, 'vestimentis albis castitatem et fidem, nuditatem infelicitatis'.

[82] Ibid., p. 7, lines 1–4, 'Capud eius deus pater est. Capilli sancti ac virtutes sanctorum. Quod candidi sunt, castitatem significant; per lanam caritatis intelligitur. Per nivem castitas, qui non habet calorem vitiorum.'

[83] Bede, *Apoc.*, col. 136, lines a16–18, 'Antiquas et immortalitas majestatis in capite candor ostenditur, cui praecipui quique velut capilli adhaerentes.'

[84] Victorinus, *Apoc.*, p. 38, lines 4–5, 'manna absconsam immortalitas est, gemma alba adoptio est in filium dei, nomen nouum christianum est'.

[85] Bede, *Apoc.*, col. 139, lines a9–10, 'corpus nunc baptismo candidatum'.

[86] Victorinus, *Apoc.*, p. 22, lines 1–2, 'carnem quae corrupta non est a morte'.

[87] Ibid., p. 30, lines 8–9, 'oportet hanc fragilitatem inuiolantium et mortale hoc uestiri immortalitatem'.

[88] Jerome, *Tract. in Marci Evangelium*, 9, 1–7; p. 480, lines 123–8, 'Hoc quod legimus, si secundum litteram intelligimus, quid habet in se candidum, quid habet in se splendidum, quid sublime? Si autem spiraliter intelligimus, statim scripturae sanctae, hoc est, uestimentia sermonis mutantur, et candida fiunt uelet nix: qualia fullo non potest in terra facere.'

Associated in symbolic terms with whiteness is the concept of transparency; the image is of a crystal in which nothing is hidden, wherein there are no shameful secrets and in which God's light can shine unimpeded. Revelation 21: 18 even makes heavenly gold into something transparent, in that it compares the street of the heavenly city, which is golden, to clear glass. Primasius found this a matter to be discussed at some length, for the two substances were clearly different. For him, the pertinent Scriptural reference was I Corinthians 4, 5; 'therefore judge nothing before the time, until the Lord come, who both will bring to light the hidden things of darkness, and will make manifest the councils of the hearts'.[89] Revelation 22: 1, in a less exotic image, compares the 'waters of life' to crystal. These are also found in Revelation 4: 6, wherein before the throne of God, there is seen 'a sea of glass like crystal'.[90] Bede explains the spiritual connection by saying that 'as our faith is the true baptism, so this is compared to glass in which nothing appears external other than as exists within'. This is the opposite of hypocrisy. Moreover, 'baptism is also represented by crystal which is formed from water frozen into a precious stone'.[91] This account of the genesis of crystal is paralleled in Pliny, from whom Bede might have drawn his information that it was produced as the result of 'intense freezing' and that 'it is certain it is a form of ice'.[92] It is interesting to observe the exegetical reaction to a passage of Scripture which associated a *negative* quality applied to this symbolically good substance; the 'firmament' of Ezekiel 1: 22, which has 'the colour of the terrible crystal'.[93] In his influential commentary, Gregory the Great noted the strength and translucency of crystal, made as it was of solidified water. He explains that this crystal is *horribilis*, that is *pavendum*, frightening. It is a reference to Judgement, of which act of the fount of goodness we should rightly be in fear.[94] In such ways, pallor was matched with goodness in late Antique and early medieval exegesis. Whiteness pertained to divinity in that it was seen as representing perfection in the absence of (moral) stains. Transparency so related in that it could be understood as the image of humility (God's light flowing unimpeded) and honesty (because nothing is hidden). Both rock-crystal and fine clear glass were highly prized during Antiquity. In this respect, classical attitudes, on the evidence of Apocalypse exegesis, appear to have been carried through without challenge into the early Middle Ages.

[89] Primasius, *Apoc.*, 5, 21; p. 294, lines 241–3. [90] Rev. 4: 6, 'Mare vitreum sicut simile crystallo.'
[91] Bede, *Apoc.*, col. 143, lines d9–13, 'Propter fidem veru baptismi refertur ad vitrum, in quo non aliud videtur exterius quam quod gestat interius. Crystallo quoque, quod de aqua in glaciem et lapidem pretiosum efficitur, baptismi gratia figuratur.'
[92] Pliny, *Hist. Nat.*, 37, 8, 23–4, 'gelu vehementiore concretum', 25–6, 'glaciemque esse certum est'.
[93] Ezekiel 1: 22, 'quasi aspectus crystalli horribilis'.
[94] Gregory the Great, *In Hiez.* 1, *Hom.* 7, 19; p. 95, lines 405–6, 'Crystallum . . . ex aqua congelascit, et robustum fit', p. 95, lines 420–1, 'Sed notandum quod hoc crystallum horribile, id est pauendum, dicitur.' On 'Judgement', 7, 20, pp. 95–6.

Together with whiteness, the Biblical text associates divinity with light. Thus, Revelation 1: 16 says that 'His countenance was as the sun shineth.'[95] In this, John the Divine exploited a metaphor that was a popular theme of many pagan philosophers. It was under the influence of such traditions that Gregory of Nyssa wrote that 'God is light, the highest light, from which any other light though it seem exceedingly bright, is but a slight effluence and radiance extending downwards.'[96] So for Victorinus 'the glory of the sun was less than that of the Lord'.[97] He is 'the eternal light',[98] 'the immaculate light',[99] the one 'whose brightness no man has been able to conceive'.[100] As Jerome comments, God is to found 'at noon, in perfect knowledge, in good works, in bright light'. It is for this reason that the Devil 'disguises himself as an angel of light, and pretends that he has the light'.[101] The realm of the evil one was of course, properly, night. Gregory the Great spoke of the morally blind man 'who is ignorant of the light of heavenly contemplation; who, oppressed by the darkness of the present life' cannot see the path of righteousness.[102] But as in the case of the shining majesty of an emperor, both bounty and punishment could be administered. Such light is not so much of a gentle goodness as of an awe-inspiring power and brilliance. Revelation 1: 14 says that 'his eyes were as a flame of fire',[103] to which Jerome, with a touch of Salvianic blood and thunder, responds that 'God's precepts are those which minister light to believers, but burning to unbelievers.'[104]

Gold was more heavenliness than luxury, representing a development from the earlier attitudes I described in chapter 2 (pp. 19–25).[105] The golden light of the sun is associated with the light that shines from gold the metal. 'Spiritual gold' is moral riches gained through suffering. This idea is applied in association with recollection of the sufferings of the martyrs. Victorinus can therefore write concerning the words: 'I persuade thee to buy of me gold tried in the fire' (Revelation 3: 18)[106] that,

[95] Rev. 1: 16, 'et facies ejus sicut lucet in virtute sua'.
[96] Gregory of Nyssa, *Orations*, 32, 15, cited from Egan (1989), p. 474.
[97] Victorinus, *Apoc.*, p. 20, lines 7–8, 'solis autem gloria minor est quam gloria domini'.
[98] Ibid., p. 150, 'lumen aeternam' (from a eulogy on the light of divinity that was very much toned down by Jerome).
[99] Victorinus-Jerome, *Apoc.*, p. 151, line 2, 'luminum immaculatum'.
[100] Ibid., p. 151, lines 3–4, 'cuius splendorem nullus poterit sensus cogitare'.
[101] Jerome, *Tract. sive Hom. in Psalm.*, 90, p. 130, lines 108–11, 'In meridie, in scientia perfecta, in bonis operibus, in claro lumine. Quoniam ergo habemus nos meridium, propterea etiam diabolo transformatur in angelum lucis, et ipse simulat habere se lucem, habere se meridiem.'
[102] Gregory the Great, *Reg. Past.*, 2, 11, 'qui supernae contemplationis lumen ignorati qui praesentis vitae tenebris pressus'.
[103] Rev. 1: 14, 'oculi ejus tamquam flamma ignis'.
[104] Victorinus-Jerome, *Apoc.*, p. 21, lines 11–12, 'praecepta dei sunt, quae credentibus lumen ministrant, incredulis incendium', a passage added to Victorinus by Jerome.
[105] Hermann & Di Azevedo (1969), p. 434.
[106] Rev. 3: 18, 'Suadeo tibi emere a me aurum ignitum probatum.'

in whatever way you can, you should likewise be tested for the Lord's name.[107] A similar passage, 'the words of the Lord are pure words, as silver tried in a furnace', provides a similar association for *that* metal.[108] It was a very popular metaphor, one we find already in use by the pioneering early third-century exegete, Hippolytus of Rome.[109] Likewise, these passages on gold and silver respectively are used by Gregory the Great in a piece of virtuoso rhetoric to explain Job 3: 15, in which Job says that he should have lain 'with princes who have gold, who fill their houses with silver'.[110] For Gregory, these are the 'princes of the Church'. Their gold is wisdom, for 'as temporal goods are purchased with gold, so are eternal blessings with wisdom'. They, 'by preaching the way of right to others should shine with the silver of sacred discourse, and let him call them true princes, the houses of whose conscience are full of gold and silver'.[111] Tyconius pointed here to the image of those purified by sufferings as gold is refined in a furnace.[112] Apringius, talking of the seven golden candlesticks of Revelation 1, seems to be thinking of blood and red-gold, since he says their description as being golden recalls Christ and the martyrs who were dyed with the red blood of their sacrifices.[113]

Gold as an image of the morally good allows explanation of the characteristic combination of a long (white) dress and a golden girdle that occurs in Revelation 1: 13; a description of one 'like unto the son of man' (and in Rev. 15: 6, the seven angels emerge from the temple similarly clad). The long dress of the first passage was seen as being a priestly robe.[114] This is affirmed in the earliest Apocalypse commentary, that of Victorinus, where it is referred to as *sacerdotali*.[115] The golden belt round the Lord's chest is said to signify the 'enlightened conscience and pure spiritual apprehension given to the churches'.[116] The *zonae* (belts/girdles) of the angels, according to Pseudo-Jerome, indicate perfection.[117] Bede adds that 'to bind the breast with

[107] Victorinus, *Apoc.*, p. 42, line 19 and p. 44, line 1, 'si quo modo poteris pro nomine domini aliquid pati'.
[108] Psalms 12: 6 (Vulgate 11: 6).
[109] Hippolytus, *Cant.*, 10, 2; p. 35, lines 9–10, on Song 1: 10–11, 'quia assimilat te hominibus iustis qui sicut aurum sunt probati et purificati' (Latin translation from Georgian).
[110] Job 3: 15, 'cum principibus qui possident aurum, et replent domos suas argento'.
[111] Gregory the Great, *Mor. in Job*, 4, 31, 62; p. 206, lines 43–6, 'aliis recta praedicando, argento sacrae locutionis emitescant, eosque principes repletis conscientiarum domibus auro et argento diuites memorat'.
[112] Tyconius, *Apoc.*, p. 76, lines 3–4, 'Aurum ignitum igni. Id est, ut tu ipse sis aurum pressurarum flammis excoctum et elemosinis ac iusta operatione purgatum.'
[113] Apringius, *Apoc.*, p. 10, lines 19–21, 'quod "aurea" memorat', qui rubicundo sanguine passionis intincti sunt' (on Rev. 1: 12). André (1949), p. 155, discusses instances of gold referred to as 'red' with citations from Martial, Lucan and Juvenal.
[114] Pseudo-Isidore, *Apoc.*, p. 6, lines 24–5, 'Vestitum podere vestis sacerdotalis est.'
[115] Victorinus, *Apoc.*, p. 22, line 1.
[116] Ibid., p. 22, lines 3–4, 'zona aurea accincta pectori: conflata conscientia et purus spiritalis sensus traditus est eclessiis'.
[117] Pseudo-Isidore, *Apoc.*, p. 18, lines 23–4, 'zonas aureas perfectio intellegitur'.

golden girdles, is to restrain all the motions of changeful thoughts by the bands of the love of God alone'.[118] Jerome added to the comment that the figure's 'breasts are the two testaments and the girdle the community of the faithful as gold is tried in the fire'.[119] Golden brass (*aurichalcum*), of which the feet of the lord are made in Revelation 1: 15, indicates fortitude for Pseudo-Jerome.[120] The colour is *like* gold, sharing moral goodness. The feet must, of course, be strong in order to bear the body: they are the apostles and prophets.[121] Victorinus did not say much concerning the metal, but on the evidence of interpolated passages, Tyconius did. A large section was utilized by Caesarius in his first homily. Bronze, through flames, acquires the colour of gold, just as through tribulations and *passiones* the church is refined.[122] Nevertheless, brass is below gold, as the feet are below the body. Victorinus launches into an enthusiastic explanation of Revelation 6: 9–11, stirred no doubt by the reference to an altar. He provides us with a moral hierarchy of these metals, which Jerome is able to express with added pungency, 'for as the golden altar is acknowledged to be heaven, so the brazen altar is understood to be Earth'.[123]

But all that glittered was not gold. Revelation 9: 7 talked of 'locusts' on the heads of which were 'crowns like gold'. Not all that is *like* gold is morally strong *aurichalcum*. Therefore, the Turin Tyconius talks of these crowned creatures as representing the simulated likenesses of the church,[124] which Caesarius expressed with greater clarity as being the representation of heresies.[125] But, in the Bible, gold also occurs in diabolic context. The Whore of Babylon of Revelation 17: 4 was 'decked with gold and precious stones and pearls'. Crucial for understanding the exegetical reaction is the citation in the text of Caesarius which refers the reader to Matthew 23: 28; 'even so ye shall also outwardly appear righteous unto men, but within you are full of hypocrisy and iniquity'.[126] The gems are a misleading covering, a veneer on the surface of darkness. They are not emblematic of evil *in themselves*. The

[118] Bede, *Apoc.*, col. 178, lines c13–15, 'Vel certe zonis aureis pectora stringere est cunctus mutabilium cogitationum motus per solium Dei amoris vincula restringere.'

[119] Victorinus-Jerome, *Apoc.*, p. 23, lines 4–6, 'mammae duo sunt testamenta et zona chorus sanctorum ut aurum per ignem probatum'.

[120] Pseudo-Isidore, *Apoc.*, p. 7, lines 7–8, 'per auricalcum fortitudo intelligitur'.

[121] Ibid., p. 7, lines 6–7, 'pedes apostoli vel predicatores'.

[122] Caesarius, *Apoc.*, col. 2417, bottom line–col. 2418, line 3, 'Ideo aurichalco signavit, quod ex aere et igne multo ac medicamine perducitur ad auri colorem: sicut Ecclesia per tribulationes et passiones purior redditur.'

[123] Victorinus-Jerome, *Apoc.*, p. 75, lines 9–10, 'sicut ara aurea caelum agnoscitur, sic et ara aerea terra intellegitur'.

[124] Tyconius, *Apoc.*, p. 107, lines 5–7, 'Isti autem, qui in se non ueram sed simulatam similitudine eclessiae gestant figuram, non ueras aureas, sed similes auro dicuntur habere coronas.'

[125] Caesarius, *Apoc.*, col. 2429, lines 55–6, 'isti autem similes auro, haereses sunt, quae imitantur Ecclesiam'.

[126] Caesarius, *Apoc.*, col. 2441, lines 64–8.

chalice the Whore holds is *full of* abomination, it is not *itself* turpitude. The gold is not to be blamed for the wrongs that the world does with it. The symbolic association of treasure with goodness was too strong for this to be thought. To function as a deception, the jewels must be a clear signal of excellence. This understanding is notably different from the original attitude of John the Divine, who must have seen these treasure ornaments as appropriate trappings of iniquity. Nevertheless, a division was recognized between spiritual gold and worldly gold. The Whore's chalice could be understood as the 'chalice' ('apple', typologically understood) that Eve took, seeing that the tree was 'pleasant to her eyes'.[127] Those preaching caution of the riches of this world might still recall the words of Jeremiah, 'how the gold has become dim! how is the most fine gold changed!'[128]

Nevertheless, bearing in mind its frequent appearance in sacred context, the primary quality of gold at least as expressed in the late Antique tradition of exegesis was its glorious burning brilliance. The metal's association was thus with the flaming of *caritas* within a body. Silver, in contrast, was associated with whiteness, and thus with clarity. This quality gave it an association with eloquence. The previously quoted passage of Psalm 12, 'silver tried in a furnace', provides the scriptural basis for this interpretation.[129] Alternatively, as Gregory notes, silver appears in its cool yet shining pallor as symbolic of the splendid sanctity of virgin flesh.[130] Nevertheless, silver was inferior to gold. This is illustrated by Gregory the Great's commentary on the first chapters of Ezekiel. The first section of the Biblical text consists of a vision of God and of four creatures. These emerge from the midst of flames, about which there is 'the colour of amber' (AV).[131] The Latin for amber may be *electrum*, which is what is used in the Vulgate. But this word can also be applied to a mixture of gold and silver, which was how Gregory the Great understood the passage.[132] So, in Ezekiel 1: 27, the figure of the Lord is seen as if surrounded and infused with *electrum*, a metal in which the brilliance of gold is tempered and the silver brightened. It is thus a symbol of the mingling of the divine and human natures in Christ.[133]

As the most valuable metal, the basis of the most valuable currency, it is hardly surprising (*pace* Apostolic poverty) that gold should have been symbolic of high

[127] Genesis 3: 6. [128] Lamentations 4: 1.
[129] Psalm 12: 6 (Vulgate 11: 7), 'eloquia Domini, eloquia casta; argentum igne examinatum'.
[130] Gregory of Elvira, *Cant.*, p. 190, lines 281–2, 'Argenteum uero uirginae carnis splendidam sanctitatem ostendit.'
[131] Ezekiel 1: 4.
[132] Gregory the Great, *In Hiez.*, 1, *Hom.* 2, 14; p. 25, lines 3–4, 'Electrum quippe ex auro et argento est.'
[133] Ibid., 1, *Hom.* 8, 25; p. 115, lines 523–6, 'per argentum auri claritas temperatur, et per auri claritatem species clarescit argenti. In Redemptore autem nostro natura, diuinitatis et humanitatis inconfuse unita sibimet atque coniuncta est.'

worth. As Gregory the Great argued, 'what is meant by gold which surpasses all other metals, but surpassing holiness?' It was held up as the symbol of the values of the City of God: 'gold is dimmed when a holy life is corrupted by earthly deeds'.[134] The reading of medieval exegesis yields up veritable panegyric to gold as metaphor. It could be the symbol of eloquence, divine clarity, the splendour of the eternal city, the shining of the age of glory and the beauty of sanctity. For was not in the Song 5: 11, the groom's, that is Christ's head said to be 'of the finest gold'? Supportive reference was available to the heavenly city of Revelation, built of gold like clear glass, and to the belts of gold of the same book, which constrain in orthodoxy and love. The vision was pre-eminently one of 'treasure in heaven', as with Revelation 21: 21 in which we are told of this city that its 'twelve gates were twelve pearls; every several gate was of one pearl, and the street of the city was of pure gold, as it were transparent glass'.[135] Tyconius' commentary on this section was the basis of the last of Caesarius' homilies, wherein we read that it is Christ who is a most precious stone, the light of which infuses this city of ultimate gold founded from golden faith.[136] For the Church is golden, the faith of which shines brilliantly, as do the seven golden candelabra, the golden altar and golden phials.[137] All of these things are symbols, figurative representations of the Church. For Bede, the seven stars that are in the right hand of God in Revelation 1: 16 recall the spiritual church and the passage from Psalm 45: 9, 'on thy right hand did stand the queen in gold'.[138]

Countless examples could be used to illustrate the association of gold and its colour with *best*, rather than merely with *better*. Justus thought that gold and the godhead were rightly compared, for just as there is nothing similar to gold amongst metals, so truly nothing in Creation is such as to be compared with the Creator.[139] The same thing is repeated by Bede.[140] The implications are striking. The effect is to display a Church permeated with a moral light that is intensely metallic. Scripture was seen to be encouraging a spiritual vision of the very forms that treasure took on earth. But because treasure in heaven was better than treasure on earth, this virtually amounts to an appropriation of true 'treasure' as a defining attribute of the other-

[134] Gregory the Great, *Reg. Past.*, 2l, 7, 'Aurum igitur obscuratur, cum terrenis actibus sanctitatis vita polluitur.'
[135] Rev. 21: 21, 'Et duodecim portae, duodecim margaritae sunt, per singulas; et singulae portae erant ex singulis margaritis; et platea civitatis aurum mundum, tamquam vitrum perlucidum.'
[136] Caesarius, *Apoc.*, col. 2450, line 61, 'Lapis pretiosissimus Christus est.'
[137] Ibid., col. 2451 lines 6–9, 'Ecclesia enim aurea est, quia fides ejus velut aurum splendet; sicut septem candelabra, et ara aurea et philae auraeae; hoc totum Ecclesiam figuravit.'
[138] Bede, *Apoc.*, col. 136, lines c11–12.
[139] Justus, *Cant.*, cols. d20–982, a2, 'Et ideo sicut in metallis nihil simile auro, ita nec in creaturis quidquam comparabatur Creatori.'
[140] Bede, *Cant*, 3, 5; p. 284, lines 502–5, 'Quod uidilicet caput aurum est optimum quia sicut auro nil pretiosius aestimatur in metallis ita singularis et sempiterna Dei bonitas iure omnibus quae ipse fecit bonis antecellit.'

world. Origen fastened upon the word *'similitudines'* in his version of the Song 1: 11 ('likenesses').[141] They are going to make for the Bride, that is for the *worldly* church, 'not gold, for they possess none worthy to be given to her, but in the place of gold they promise to make her likenesses of gold'. He says of these that they 'are all of them the likenesses of gold, and not true gold. Let us take it then that true gold denotes things incorporeal, unseen and spiritual; but that the likenesses of gold, in which is not the Truth itself but only the Truth's shadow, denote things bodily and visible'. Such 'likenesses' included the Ark of the Covenant and all the Temple itself; 'but the visible gold itself, just because it was visible, was not the true gold, but the likeness of that true and unseen gold'.[142] The implication of this is that a church filled with treasure items is a pale *likeness* of heaven. Even the most precious Tabernacle was of this lower grade of precious metal, the earthly kind, which is nevertheless properly a symbol of the divine and is therefore properly dedicated to Christian use.

Alongside the Christian praise of gold and brightness there coexisted the ancient tradition of revelling in the full diversity of colours. Peter Dronke illustrates what he called the tradition of 'joyous and loving perception of divine beauty manifesting itself in the physical world'.[143] He quotes from Paul the Silentiary's splendid description of the brilliance of Hagia Sophia and also from Pseudo-Dionysius, 'if a form for heavenly beings is found among precious stones one must think if they are white, that they are images of light, if red, of fire, if yellow, of gold, if green, of youth and the flower of the soul. For each form you will find an image that can lead the mind aloft.'[144] A whole genre of literature, the lapidary, was inspired by the special qualities of these rare substances. Important examples include book 20 of Pliny's *Natural History*, the *De Gemmis* of Epiphanius of Salamis and book 16 of Isidore's *Etymologiae*, '*De Lapidibus et Metallis*'. All through the Middle Ages and after, learned opinion pondered the subject of gems.[145]

[141] Pre-Vulgate Song, 1, 11, 'similitudines auri faciemus tibi cum distinctionibus argenti', 'we will make thee likenesses of gold, distinguished with silver'.

[142] Origen, *Cant.*, 2; p. 159, lines 3–5, 'Indicant ergo quod ipsi faciant sponsae non aurum – neque enim habebant tale aurum quale dignum erat offerri sponsae – sed pro auro "similitudines auri" facere se promittunt', p. 160, lines 11–15, 'ista omnia "similitudines auri" fuerunt, non aurum verum. Quod scilicet aurum verum in illis, quae incorporea sunt et invisibilia ac spiritalia, intelligatur, "similitudo" vero "auri", in quo non est ipsa veritas, sed umbra veritatis, ista corporea et visibilia accipiantur', p. 160, lines 25–7, 'sed et ipsum aurum visibile, pro eo quod visibile erat, non erat aurum verum, sed "similitudino" erat illius veri "auri" invisibilis'.

[143] Dronke (1972), p. 66.

[144] Pseudo-Dionysius, *De Caelestia Hierarchia* 15, 7–8, quoted from Dronke (1972), p. 66.

[145] Kitson (1978) and (1983) on lapidaries in Anglo-Saxon England. An early modern example is the 1672 essay (reprint edn) Boyle (1972), p. 112: 'the Rarity of transparent Gems, their Lustre and their great Value, which their scarceness and mens Folly sets upon them, emboldens some to say, and inclines others to believe, that such rare and noble Productions of Nature must be endowed with proportionable, and consequently with extraordinary qualities'.

Jewels valued in Antiquity spanned the spectrum of colours. There are several passages of Scripture in which such a diversity of gem-stones are listed together. The main instances are the twelve gems on the breast-plate of the high-priest of the Tabernacle (Exodus 28: 17–20), the nine that were the covering of the King of Tyre (Ezekiel 28: 13) and the twelve gems that are foundations of the heavenly City (Rev. 21: 19–20). No clear comparative understanding of these gem lists emerged in late Antiquity. Jerome, in his exegesis of the second of these passages, made a brave stab at the problem.[146] He was puzzled by the differences between the lists, as well he might have been since there is no obvious moral imperative for divergence in the order or type of gems listed.[147] He was forced to fall back on those passages of Scripture which mention stones collectively.[148] The effect of this is to suggest a negation of the contemporary power of individual types of gems as metaphors in their own right.

There was, however, an agreement that the diversity of jewels indicated the 'forms, order or diversity of the virtues', as Bede recounts, echoing Jerome's understanding.[149] As Ambrose said, the breast-plate of Exodus 28 was made of twelve stones closely joined one onto another, because if any should separate them then 'the whole fabric of the faith falls in ruins'.[150] However, discussions of moral qualities suggested by *specific* gems do occur in Gregory the Great and Bede. This suggests that the desire for inner meanings led, over time, to an expansion of conceptual understanding from primary motifs such as light, gold and silver, to secondary ones such as particular gems. A moral differentiation of these would have been aided by variations of worldly appreciation. Gregory gives some hints on this when he says that there are many other precious stones which immeasurably exceed sardonyx and sapphire.[151] And, in the *Pastoral Rule*, he adds that the carbuncle (red) is preferred to

[146] Jerome, *In Hiez.*, 9, 27, 11–19; CCSL 75, pp. 389–95.

[147] Vulgate (English versions are not identical), Exodus 28: 17–20 lists, in the following order, sardion, topaz, emerald, carbuncle, sapphire, jasper, ligure, agate, amethyst, chrysolite, beryl and onyx; Ezekiel 28: 13 lists sardion, topaz, jasper, chrysolite, onyx, beryl, sapphire, carbuncle and emerald; Rev. 21: 19–20 lists jasper, sapphire, chalcedony, emerald, sardonyx, sardion, chrysolite, beryl, topaz, chrysoprase, hyacinth and amethyst.

[148] Jerome, *In Hiez.*, 9, 28, 11–19; p. 393, lines 283–8, for example, refers to Isaiah 54: 11–13 (AV translation differs), of a metaphorical building in carbuncle, sapphire, jasper and crystal, and p. 394, lines 290–4, to Psalm 20: 4 (AV 21: 4, again differs), crowning 'with precious stone', 'coronam de lapide pretioso' and Matthew 20: 6, 'treasures in Heaven', 'thesauros in caelo'.

[149] Bede, *Apoc.* col. 197b, 'Variorum nominibus lapidum vel species virtutum, vel ordo, vel diversitas, indicatur.'

[150] Ambrose, *De Fide*, 2, *Prologus*, 4; p. 130, 'duodecim lapides sibi inuicem coherentes. Nam si eos aliquis separet adque secernat, omnis fidei structura dissoluitur'.

[151] Gregory the Great, *Mor. in Job*, 18, 27, 75; p. 939, lines 3–4, 'multi alii pretiosi sint lapides, qui longe istos aestimatione magnitudinis antecellant'. It should be recalled that Gregory's sapphire is probably lapis lazuli. Our sapphire, it is thought, was their hyacinth. Sardonyx would today count as only a semi-precious stone.

the hyacinth (blue), yet a deep hyacinth is superior to a pallid carbuncle. In this way certain men of low status exceed morally those of high birth.[152]

The foundations of the heavenly city seen by John the Divine were each of a different precious gem; jasper, sapphire, chalcedony, emerald, sardonyx, sardion, chrysolite, beryl, topaz, chrysoprase, jacinth and amethyst. Of the surviving commentaries, that of Bede goes into by far the greatest detail on these twelve varieties of gems described in Revelation 21: 19–20.[153] Primasius, otherwise the fullest gloss, tells us simply that the description signifies the supporting and gracing of the virtues by which the holy are ornamented.[154] It is as though Bede takes such comments as a spur to the provision of a learned exposition of these very gracing qualities. However, Bede and his two best known sources, Pliny and Epiphanius, take widely divergent attitudes to the gems which they are discussing. Pliny's interests lay in explaining the precise qualities of each mineral, where each was to be found, if there were any interesting anecdotes concerning them, and how best they should be worked.[155] For him, they were an exotic part of nature's bounty, at the disposal of rich men who may then proceed to revel in them to excess. Pliny makes an attempt to play down feelings of wonder toward precious stones. He is keen to point out that many possess defects.[156] However, he does not deny gems a degree of exaltation since he says that they may on occasion be 'the highest and most perfect insight into nature'.[157] But, as Isager argues in his book on art in the *Natural History*, 'Pliny maintains that with certain exceptions it is the destiny (*causa*) of gems to be worked so that they may serve man'.[158] This reference to the popularity of engraving in Roman times indicates the subservient position to man of even the most precious gem as being simply another mineral.

Epiphanius, in his *De Gemmis*, provides a much closer parallel to Bede's commentary, since he is commenting on a Scriptural context, in this case the twelve gems of Aaron's breastplate.[159] These were each inscribed with the name of one of the

[152] Gregory the Great, *Reg. Past.*, 3, 28, 'Quis . . . nesciat quod in naturae gemmarum carbunculus praeferatur huyacintho? Sed tamen caerulei coloris hyacinthus praefertur pallenti carbunculo . . . Sic ergo in humane genere et quidam in meliori ordine deteriores sunt, et quidam in deteriori meliores.'

[153] Meier (1977) is an exhaustive treatment of the allegorical and other qualities attributed to gems in the Middle Ages. Most of the source material is from the later medieval period. Of the eighth century, Kitson (1983), p. 77, writes, 'it is clear that no firm tradition had developed as to the symbolic value of particular stones'. This should not be read as meaning that there was no tradition at all, however.

[154] Primasius, *Apoc.*, 5, 21; p. 295, lines 269–70, 'significantur decora ac firmamenta virtutum quibus et unusquisque sanctorum spiritaliter perornatur'.

[155] Pliny the Elder, *Hist. Nat.*, 37.

[156] Ibid., 37, 18. [157] Ibid., 37, 1, 'ad summam absolutamque naturae rerum contemplationem', etc.

[158] Isager (1991), p. 213.

[159] Exodus 28: 17–20, see Epiphanius, *De Gemmis* (Latin version), PG 43, 321–66, and for sections not preserved in this, '*De Gemmis*', the Old Georgian Version with the Armenian and Coptic-Sahidic fragments, R. P. Blake & H. de Vis (ed. and trans.), Studies and Documents 2 (London, 1934).

patriarchs of the tribes of Israel. Thus, these jewels being symbolically blessed, Epiphanius could find it quite fitting that their present counterparts were able to carry out cures much in the way that relics could. Embracing Hellenic quasi-scientific traditions, he illustrates the way in which such Greek medical ideas were disseminated across the west, through Christian media and in Latin translation. Incidentally, it is interesting to observe that several Greek names for gems entered the Latin language as terms for colours during the period of the earlier Empire, including some we have already met, such as *amethystinus, hyacinthus* and *smaragdinus*.[160]

Pliny wrote partly to confute 'magi', magicians, 'for in many of their statements about gems they have gone beyond providing an attractive substitute for medicine into the domain of the supernatural'.[161] It is a description that says much about Bede in comparison to bishop Epiphanius and the Roman past. In early medieval exegesis the entrenchment of symbolic reading ensured that spiritual quality had assumed a higher importance than the physical attributes on which that association had originally been based. By the time we get to Bede, the imperatives of mystical allegory have become so strong that the characteristics of the individual gems could be asserted as being symbols of specific moral virtues. Bede's figurative commentary is very much his own, though it was built up on a long-held set of associations in the works of the Fathers, based ultimately upon Scripture as understood in the classical world. For Bede, the significance of the stones is that they signify the variety of virtues upon which is built the heavenly Jerusalem.[162]

So we are told that jasper is 'the greenness of faith'[163] which chases away ghostly fear. Opaque and green in hue, it is like the sea and so recalls the waters of baptism. Sapphire is 'the light of heavenly hope'.[164] It shines, and is the colour of a clear sky. It is eloquent of heaven and He of eternal light who dwells there. Chal-

[160] André (1949), pp. 232–5, provides references from the early Imperial period.

[161] Pliny, *Hist. Nat.*, 37, 14, 'quando vel plurima illi prodidere de gemmis ab medicine blandissima specie ad prodigia transgressi'.

[162] For what follows it is useful to compare Suger, twelfth-century abbot of St Denis, *Liber de Rebus in Administratione sua Gestis*, Erwin Panofsky (ed.) *Abbot Suger on the Abbey Church of St Denis, and its Art Treasures* (Princeton, 1946), pp. 40–81, at pp. 63, 65, 'Unde, cum ex dilectione decoris domus Dei aliquando multicolor, gemmarum speciositas ab exintrinsecis me curis devocaret, sanctarum etiam diversitatem virtutem, de materialibus ad immaterialia transferando, honesta meditatio insistere persuaderet', 'When, out of delight in the beauty of the house of God, the loveliness of the many-coloured gems has called me from external cares and honourable meditation has led me to reflect on the diversity of the sacred values, transferring from that which is material to that which is immaterial.'

[163] Bede, *Apoc.*, cols. 129–206. In the following list, the first quotation of each section is Bede's summary of his previous exposition. This is followed by comments from that exposition. As here; ibid., col. 202, lines c8–9, 'fidei viriditas', see also col. 197, lines c9–d12.

[164] Ibid., col. 202, line c9, 'spei caelestis altitudo'. See col. 197, line d13–col. 198, line a15.

cedony is 'the flame of internal love',[165] shines with a pale light and recalls holy modesty. The emerald is 'the bold expression of the same faith in the midst of opposition'.[166] It is of greater greenness than any plant. It comes from the inhospitable wilderness and its luminescence represents the steadfastness of the true faith in the face of every trial and privation. Three-banded red, white and black sardonyx is 'the humility of saints amid their virtues'.[167] Scarlet sardion is 'the revered blood-shed of the martyrs'.[168] Chrysolite contained flickers of gold within green: in general, Bede sees it as 'spiritual preaching in the midst of miracles' [169] Beryl is 'the perfect work of preachers'.[170] It gleams only when it is polished and signifies the quality of the intelligent who shine all the more by the light of heavenly grace. Topaz is 'fervent contemplation' by the same.[171] Chrysoprase is 'the work and the reward of the blessed martyrs'.[172] It is green-gold with a purple gleam. It signifies that 'those who well deserve the greenness of the eternal country by the brightness of perfect love, make it manifest also to others by the purple light of their own martyrdom.'[173] Hyacinth is 'the heavenly exaltation of doctors to things on high, and their humble descent to human things for the sake of the weak'.[174] It is azure. It goes dull with the clouding of the sky. It therefore represents the struggle of those mere mortals who wish to approach the angelic life as far as they are able.

Gems, therefore, were known in all their wide diversity of colours. In textual association with divinity, it was 'natural' to see them as an image of the range of the virtues. Gems were found beautiful, often showing clarity and (when cut and polished) shining with brilliance. In this they could outdo bright flowers, whose charms were but fleeting. This text of Bede shows the fascinated attention that one of the greatest scholars of the early Middle Ages could apply to the figuratively moral understanding of splendour and treasures. In doing so, he built upon a venerable tradition which included many of the greatest writers of the earlier Church. I have taken pains to provide a large number of textual references so as to demonstrate the uniformity of symbolic understanding. Allegorical interpretation

[165] Ibid., col. 202, line c10, 'flamma charitatis internae'. See col. 198, lines b1–c6.
[166] Ibid., col. 202, line c11, 'ejuisdem fidei fortis inter adversa confessio'. See col. 198, line c7–col. 199, line b12.
[167] Ibid., col. 202, line c12, 'sanctorum inter virtutes humilitas'. See col. 199, lines b13–d6.
[168] Ibid., col. 202, line c13, 'reverendus martyrum cruor'. See col. 199, lines d7–12.
[169] Ibid., col. 202, lines c14–15, 'vero spiritualis inter miracula praedictio'. See col. 199, line d13–col. 200, line b5.
[170] Ibid., col. 202, line d1, 'praedicantium perfecta operatio'. See col. 200, lines b6–c7.
[171] Ibid., col. 202, line d2, 'eorumdem ardens contemplatio'. See col. 200, line c8–col. 201, line c1.
[172] Ibid., col. 202, lines d3–4, 'martyrum opus pariter praemium'. See col. 201, lines c2–d4.
[173] Ibid., col. 201, lines c5–8, 'Qui significat eos qui viriditatem aeternae patriae, perfectae charitatis fulgore promerentes, eam etiam caeteris purpurea martyrii sui luce patefaciunt.'
[174] Ibid., col. 202, lines d4–6, 'doctorum caelestis ad alta sublevatio, et, propter infirmos, humilis ad humana descendio'. See col. 201, line d5–col. 202, line b3.

from the time of Christian emperors firmly and consistently associated treasure with moral excellence and God with gold.

Treasures in heaven

Symbols were not seen as arbitrary or subjective. They were believed to 'represent objectively and express faithfully various aspects of a universe that was perceived as widely and deeply meaningful'.[175] Although the later texts appear often to go into more elaborate detail, the case-study of Latin exegesis shows an extremely high level of consistency (after the fall from popularity of Victorinus' literal approach) of symbolic understanding of colours and treasure as expressed in texts from a variety of areas and centuries. Light, whiteness and brightness were always seen as strongly positive qualities. Purple and red were likewise comprehended, although in the more specialized contexts of martyrial and royal symbolism. It could be argued that because these texts were understood as referring to divine things, therefore the imagery used *must* have been interpreted as positive. Whilst there is much in that argument, another example provides further significant evidence. The description of the Bride as black in the Song 1: 4 required elaborate explanation, since black *outside the text* was seen as a negative image. Also revealing is the understanding of the splendours of the Whore of Babylon as unjustified, false ornamentation which should have been reserved for the presentation of the true glory of God.

Jewish tradition said that the Song of Songs was about the union of Yahweh (God) and Israel. Revelation emerged from a long tradition of Jewish apocalypse texts on the subject of the return of the King.[176] To generalize for a moment, the allegorizing exegetes believed in the Christian sanctity of the Song and of Revelation and they were convinced that the splendours of both referred to the faithful, the Church and to the Trinity. The society that produced these texts had a similar symbolic understanding of brightness and splendour, as expressions of excellence, to that of the exegetes. The contribution of the latter, through allegorical interpretation, was further to consecrate such imagery by directly associating it with such Christian ideals as chastity, humility and compassion. On the one hand, worldly gold was held as inferior to that which it symbolized, such as spiritual love. On the other hand, symbolic connection was affirmed between the two. In this way, worldly symbolism which appealed to the hopes of society at large was appropriated in the promotion of the Christian message. These symbols were therefore a means to an end, but were nevertheless of enormous importance in the popular success of the religion. As will be seen in chapter 4, the Church likewise did not

[175] Ladner (1979), p. 227. [176] Robert (1945), p. 211.

flinch from exploiting to the full popular visual imagery for the same purposes. This self-promotion presented Christ as triumphant in the powerful symbolic language of the age, employing forms of rhetoric closely related to those used by the State. The Church as the beautiful Bride of Christ, or as the splendid City of the Faithful, was presented as the glorious instrument of the Lord's work. Those who might criticize these visions were in danger of being seen as enemies of the Church and therefore as heretics. Orthodoxy believed that the splendours of the world, having come from God, were not to be preferred but were not to be despised either. Having disencumbered oneself from *personal* burdens, such as great wealth, the rightful use for splendour was left not only as its employment in charity but also in the presentation of the Christian message of spiritual victory and in the decorous worship of the Lord.

The Church, therefore, attempted to consecrate secular society and many of its symbols to God. This enterprise can be seen as a delicate compromise between dedication to heaven and concern for the fate of Christians in this world. The use of popular symbols required constant stress to be placed on their spiritual meaning. The dangers of this situation were, it seems, apparent, at least to one of the greatest of Christian thinkers, Augustine. It is an unrewarding task to search his *City of God* for references to gold and gems. Even commenting on the descent of the heavenly city in book 20, his talk is of brightness and incorruption.[177] The alternative approach may be illustrated by the *Pastoral Rule* of Gregory the Great which used chunks of treasure-strewn Old Testament texts as metaphor. For him, what else is symbolized by the precious Ark of the Covenant but the Holy Church? Its four rings are the four Gospels. Staves are set into these rings that it may be borne by teachers, 'for to carry the Ark with staves is to bring Holy Church through preaching to the untutored minds of unbelievers'. These staves are overlain with gold and then carried by priests, 'that when the sound of their preaching goes forth to others, they may themselves shine in the splendour of their way of life'.[178] The power of such teaching was in its very comprehensibility. A coherent message was extracted from the texts at the direct expense of literal understanding and thus at the cost of giving the treasure found in the texts an explicitly positive *moral* meaning.

The presence in Scripture of treasure made it very difficult to attack the symbolic associations of prestige substances. Jerome was distinctly *unusual* in going beyond a

[177] Augustine, *De Civ. Dei*, 20, 17, discusses Rev. 21: 2, 'And I saw the holy city, New Jerusalem, coming out of Heaven.' The bishop makes no mention of treasure. Poque (1984) discusses Augustine's use of imagery. Puritan poetry provides an interesting example of Christians struggling with the distrust of imagery and the desire to employ it, Daly (1978).

[178] Gregory the Great, *Reg. Past.*, 2, 11, 'Vectibus aream portare, est bonis doctoribus sanctam Ecclesiam ad rudes infidelium mentes praedicando deducere. Qui auro jubentur operiri, ut dum sermone insonant, ipsi etiam vitae splendore fulgescant.'

view of the making of idols described in the Old Testament as merely a human *misuse* of precious metals. For him, silver and gold themselves were most proper to heathens, yet even he would not attack those with a different understanding. The clay crib of Jesus' birth, he relates, had been recently replaced by one of silver: 'I do not find fault with those who made the change for the sake of honour, nor with those that made the gold vessels for the Temple, but I wonder that the Lord, Creator of the Universe, was born not surrounded by gold and silver, but by mud.'[179] His were perhaps the most critical words on the subject for centuries. It is only in the light of much later events that Jerome's words appear so powerful, as when he says that 'parchments are dyed purple, gold is melted into lettering, manuscripts are dressed up in jewels, while Christ lies at the door naked and dying'.[180] The strength of secular values, together with the sharing of these associations by the Old Testament writers, ensured that, in the meantime, the symbolism of jewels and precious metal were widely accepted as an integral part of life in the Christian world.

The foregoing account has concentrated upon treating precious substances one by one, but in the thought of the time, as with the rainbow of gems, they were considered complementary. The almost elemental universality of the treasure world is illustrated by commentary on the Song 3: 9. Thus Ambrose quotes, 'Solomon made himself a couch (*lectum*) of wood from Lebanon. Its pillars were of silver, its bottom of gold and its back strewn with gems'. For Ambrose, these are the four elements of which the body is composed. The gems are the splendour of the brightness of the air, the gold is fire, the silver is water and the wood, earth.[181] This analysis is related to the traditional understanding of the four colours of the robes of the high priest of the Tabernacle.[182] As explained by Ambrose, these colours are the four elements, white (linen) which is earth because flax grows from that element, purple which is water because the dye comes from sea-snails, scarlet which is fire, and hyacinth (the colour of the blue gem) which is air.[183] Gregory in

[179] Jerome, *Hom. de Nat. Dom.*, p. 525, lines 36–40, 'Non condempno eos qui honoris causa fecerunt (neque enim illos condempno qui in templo fecerunt uasa aurea); sed admiror Dominum, qui creator mundi non inter aurum et argentum, sed in luto nascitur.'

[180] Jerome, *Ep.*, 22, 32, 'inficitur membrana colore purpureo, aurum liquescit in litteras, gemmis codices uestiuntur et nudes ante fores earum Christus emoritur'.

[181] Ambrose, *De Virginibus*, 3, 21; p. 226, ' "Fecit", inquit, "sibi lectum Salomon ex lignis Libani; columnae eius erant argenteae, acclinatorium eius aureum, dorsum eius gemmatum stratum." Qui est iste lectus nisi corporis species? Namque in gemmis aer specie fulgoris ostenditur, in auro ignis, aqua in argento, terra per lignum: ex quibus corpus humanum quattuor constat elementi.'

[182] Exodus 28: 4–39.

[183] Ambrose, *De Fide*, 2, *Prologus*, 12; p. 134, 'Hyacinthus autem aeris habet similitudinem, quem spiramus et cuius carpimus flatum: purpura quoque speciam aquarum exprimit, per coccum ignis intellegitur, terra per byssum.'

his *Pastoral Rule* provides a detailed analysis of the brilliant robes of the high priest,[184] one that was copied by Bede. For the Pope, the gold of the vestments was resplendent beyond all else since he (the priest) should 'especially out-shine all in the understanding of wisdom'. Hyacinth, sky-coloured, is present that 'he may not stoop to the base favours of earth, but rise up to the love of heavenly things'. Purple occurs that the heart should reject vice 'by the use of kingly power'. 'Twice-dyed scarlet' refers to the flame of love coming from the heart. Whilst 'what else is designated by the (white) linen but chastity shining with the beauty of bodily fineness?'[185] The very elements were here incorporated into the comprehensive vision of Christian triumph. A Church born from poverty awaited eternal splendour in contradiction of its past. It was to be the sixteenth century before the incongruity of this became fatal for the universality of the Catholic communion in western Europe and those who remained within that Church stood true to the ancient notion that 'loving images was loving God and gilding the Church part of the vision of the new Jerusalem'.[186]

Job asked where might he find wisdom. He knew he could not buy it: 'it cannot be had for gold, nor shall silver be weighed for the price thereof. Nor shall it be compared to the dyed colours of India, nor to the most precious sardonyx stone, nor to the sapphire. The gold and the glass cannot equal it. Neither shall vessels of gold, high and over-topping be exchanged instead of it. Nor shall they be mentioned in comparison with it. For wisdom is drawn out of sight. The topaz of Ethiopia shall not equal it, neither shall the purest dyes be brought into comparison.'[187] The Biblical text appears today as saying two things. Firstly, that there are a number of precious substances of high price, and secondly, that none of these are worth enough to buy wisdom. This understanding now seems obvious and inevitable, but it was not that reached by Gregory the Great in his *Morals of Job*. He expends pages on elaborate rhetorical dances, arguing, as he must, from within the web of associations already outlined.[188] The fine gold, he writes, is the angels, who are without taint. Living men can only be at best *impure* gold. But it was the

[184] Exodus 39: 2, 'aurum praetextit et postea hyacinthum ac purpuram cum cocco subiunget et bysso'.

[185] Gregory the Great, *Reg. Past.*, 2, 3; col. 29, lines b3–4, 'ut in eo intellectus sapientiae principaliter emicet', b5–6, 'non ad favores infimos, sed ad amorem coelestium surgat', b12, 'eisque velut ex regia potestate contradicat', col. 30, lines a3–4, 'Et quid per byssum, nisi candem decore munditiae corporalis castitas designatur.'

[186] Aston (1987), p. 207, for quotation.

[187] (Gregory's Vulgate text), Job 28: 15–20, 'Non dabitur aurum obrizum pro ea, nec appendetur argentum in commutatione ejus. Non conferetur tinctis Indiae coloribus, nec lapidi sardonycho pretiosissimo, vel sapphiro. Non adaequabitur ei aurum vel vitrum, nec commutabuntur pro ea vasa auri, excelsa et eminentia non memorabuntur comparatione ejus: trahitur enim sapientia de occultis. Non adaequabitur ei topazium de Aethiopia, nec tincturae mundissimae componetur.'

[188] Gregory the Great, *Mor. in Job.*, 18, 44, 71 to 18, 54, 93, of which what follows is a paraphrase.

Creator Himself, not an angel that was sent to save us. Then 'because the divine revelations are often denoted by silver',[189] this metal is the Fathers and Prophets, none of whom was the Redeemer. The 'dyed colours of India' are the so-called wise of this world.[190] They must be inferior, as such dyes are almost like a veneer. For it is right to disregard this worldly coloration choosing rather to display this wisdom 'by the purity of truth alone', and 'not to stain it with the dyeing of speech'.[191] The sardonyx, being red, is a symbol of men and of Adam. The sapphire, being blue, is the symbol of the angels in heaven. Respectively, they can also be seen as the Fathers of the Old and New Testament, in that only the latter 'laying aside the desires of carnal procreation, followed after the things of heaven alone'.[192] But neither of these are the equal of that wisdom which is God. 'Gold and glass', is the heavenly country whose citizens 'shine with clarity and are transparent by pureness'.[193] Thus, being of gold and glass, they are transformed from the humble clay. The assembled saints have a *likeness* of God, but they are hardly equal to him. The 'vessels of gold' are the prophets and are similarly unworthy in comparison. They are as the sparkle of the sun in a mirror, or to use Gregory's phrase, 'wisdom tends to be referred to as light, as are the servants of wisdom; but that light [wisdom] as light that lights, and they [the servants] as light that has been lit'.[194] The topaz is of many colours and comes from a land of black people. It is thus the man possessing both virtues and sins. 'The purest dyes' are the most humble and holy, who know that they are only virtuous through the action of Grace. Yet these, though still inferior to the Godhead, are better by far than 'the dyes of India'. For those were not said by Job to be pure 'that he might distinguish the dye of true virtues from that staining of the philosophers'.[195]

Based primarily upon Old Testament texts and Revelation, all the highest elements of the Church, save God, are here symbolized by treasure. A paramount reliance on the Gospels might well have led to a strong association of gold and jewels as attributes of *this* world. That tradition was certainly not forgotten, but rather was incorporated with established symbolism. The contrast was constantly drawn

[189] Ibid., 18, 45, 73; p. 937, lines 37–8, 'argento saepe eloquia diuina designatur.'

[190] Ibid., 18, 46, 74; p. 938, lines 4–5ff, 'Tincti autem colores sunt Indiae, huius mundi sapientes'. By 'the wise of *this* world' he means philosophers.

[191] Ibid., 18, 46, 74; p. 439, lines 25–6, 'sola puritate ueritatis ostendere, non autem eloquii tinctione fucare'.

[192] Ibid., 18, 48, 76; p. 940, lines 29–32, 'Per sapphirum uero qui aetheri est coloris, testamenti noui congrue praedicatores accipimus, qui carnalis propaginis desideria postponentes, caelestia sola sectati sunt.'

[193] Ibid., 18, 48, 77; p. 941, line 17, 'claritate fulgent et puritate translucent'.

[194] Ibid., 18, 50, 81; p. 944, lines 4–6, 'Lumen autem sapientia, lumen et serui sapientiae uocari solent. Sed illa lumen illuminans, isti lumen illuminatum.'

[195] Ibid., 18, 54, 87; p. 950, lines 13–17, ' "Non confertur tinctis Indiae coloribus" eosdem colores non intulit mundos. Hoc uero in loco ut tincturam ueracium uirtutum ab illa philosophorum fucatione distingueret, tincturas dicens, addidit mundissimus.'

between worldly treasure and superior moral treasure in heaven. But the result was a failure to leave these substances as the preserve of the secular world. The rhetorical effect was of a hierarchy of treasure. Heavenly gold was true gold, in the rhetoric more like gold than worldly gold. It shone more. It was more beautiful. It was more valuable. But the result of such moral identification in religious rhetoric was to legitimize the parallel emergence of Christianity as a religion of visual splendour on earth in association with its corporate exercise of spiritual guidance and help. Christians were encouraged to hand over their splendour to the Church. In this way, the words of St Matthew ('Jesus said unto him, "If thou wilt be perfect go and sell what thou hast, and give to the poor, and thou shalt have treasure in heaven" ')[196] were able to be encompassed in the same religious tradition as that of the high medieval writer Abbot Suger of St Denis: 'When we see how that admirable cross of St. Eligius, together with the smaller ones and that incomparable ornament vulgarly referred to as the "crest", are placed upon the golden altar, then I say, sighing deeply in my heart; "every precious stone was thy covering, the sardion, topaz, jasper, chrysolite, onyx, beryl, sapphire, carbuncle and emerald".'[197]

Such attitudes as Suger's were doubtless accepted without question by huge numbers of the faithful. Yet the potential incongruity was painfully clear to St Augustine. He warned his congregation at Hippo that images were dangerous to the unwary. God was not enclosed in a body. He was light and but not material light, and so 'you should not honour light such as we see with the eyes, amplifying it through the fantasy of your ideas, so that in your vain thoughts you imagine fields of light and mountains of light and trees of light'.[198] What then are we to make of John Chrysostom's picture of the Second Coming with Christ as Emperor, in gold and purple and diadem and clasp,[199] or of the fourth-century *Vision* of Dorotheus, which describes heaven seen as an imperial palace with courtiers all in official dress?[200] Such Christian discourse 'boldly exploited the very imagery it was ostensibly denying'.[201]

[196] Vulgate, Matthew 19: 21, 'Ait illi Iesus: si vis perfectus esse, vade, vende quae habes, et da pauperibus, et habebis theasaurum in caelo'. The major issue of the Church and benefaction to the poor is discussed in chapter 5 of this book.

[197] Suger, *Liber de Rebus in Admin.*, p. 63, 'dum illam ammirabilem sancti Eligii cum minoribus crucem, dum incomparabile ornamentum, quod vulgo "crista" vocatur, aureae arae superponi contueremur, corde tenus suspirando: "Omnis", inquam, "lapis preciosus operimentum tuum, sardius, topazius, jaspis, cristolitus, onix et berillus, saphirus, carbunculus et smaragdus" (a reference to Ezekiel 29: 13). Eligius was a goldsmith who was made a Gallic bishop in the early seventh century.

[198] Augustine, *Sermo* [Mainz 54], 5; F. Dolbeau (ed.) *REA* 37 (1991), pp. 261–306, at p. 275, 'nec si hanc qualem uidemus oculis augeas, dilatans eam per phtasiam cogitationum tuarum, et facias campos lucis et montes lucis et arbores lucis'.

[199] John Chrysostom, *Homilae in Epistolam ad Romanos*, 14, 10; *PG* 60, col. 537.

[200] *Papyrus Bodmer 29: Vision de Dorothéos*, A. Hurst, O. Reverdin & J. Rudhardt (eds.) (Geneva, 1984). For date see Bremmer (1988).

[201] Averil Cameron (1991), p. 175, taken from the chapter, 'The rhetoric of paradox', pp. 155–88.

Imagery is ambiguous in that it places the burden of interpretation explicitly on the viewer or reader.[202] 'Participating in an author's metaphorical thinking is an imaginative process' and both Christian visual and literary propaganda demanded participation.[203] An image held in memory is a concept, and 'as such, it interacts with other concepts in a conceptual, rather than in a concrete fashion'.[204] That very phenomenon allowed the potential danger of a wrong and uneducated interpretation. However, it was only through images that the message of the ultimate things could be communicated.[205] Texts could be weapons in the hands of the soldiers of Christ.[206] Other rhetorics were available for use. Averil Cameron has discussed the enormous importance of preaching and of the spoken word (along with the visual image) in reaching a wider community than the written word.[207] Verbal images were given out in preaching far more often than warnings about imagery. Preaching and exegesis were bound together in the thought of many. For example, the homilies of Gregory the Great were meditations on Scripture. The preacher's task, with the aid of the Holy Spirit, was to unfold for his listeners the secret meanings of the sacred text.[208] A modern handbook on preaching emphasizes the enormous importance of using symbols because, 'verbal, abstract expression is the province of the few, whereas the visual, sensory and image filled discourse is accessible to virtually everyone . . . Abstract proposition-centred preaching affects few people. Most humans are not . . . constituted to thrive on abstraction.'[209] The effectiveness of imagery depends upon its very familiarity.[210] Augustine used both styles: abstraction in his treatises and imagery, judiciously applied, in his sermons.[211] For example, he did make use of the image of gold purified in a furnace (a Biblical metaphor), especially with regard to those who were purged through Christ of their dross and chaff, to emerge as pure gold sparkling in heaven. Yet the ambiguity of gold, through its

[202] Caird (1980), pp. 85–108, ch. 4, 'Opacity, vagueness and ambiguity'. There is a huge bibliography on Scriptural language and use of metaphor, see Rollinson (1981); Soskice (1985) and Caird (1980). There is also a well-developed field of study of metaphor as a phenomenon in its own right: Honeck & Hoffman (1980) with Reichmann & Coste (1981) provide good introductions to 'science', figurative language and the imagination, the latter text especially with regard to the extent to which mental imagery plays an important role in the way that similes and metaphors work.

[203] Macky (1990), p. 297. [204] Fentress & Wickham (1992), p. 48.

[205] A medieval sermon necessarily taught through a series of visual images, Fentress & Wickham (1992), p. 50.

[206] Averil Cameron (1994) and B. Baldwin (1982).

[207] Averil Cameron (1991), pp. 79–80. On preaching in the later Roman Empire, Oberhelman (1991), pp. 101–20 and Hunter (1989).

[208] Evans (1986), pp. 87–95 on Gregory's exegesis, with the quotation at p. 90. See also in general on Gregory, J. Richards (1980) and Straw (1988). Another example is that of Ambrose, see Paredi (1960), p. 368.

[209] Wilson-Kastner (1989), p. 13. [210] Ibid., p. 53.

[211] Oberhelman (1991), p. 119 and Mohrmann (1958–65c), p. 369.

worldly use, made Augustine hesitate in its wholesale employment as an image.[212] Others, less astute, might be less wary, bearing in mind the imperative to communicate with the greatest effectiveness.[213]

This is a study of the mentalities of an age, rather than a study of high ideas and philosophy.[214] Gold may have been an elite symbol, but its power lay in the fact that its symbolic meaning was comprehensible to all. Think of the strong modern associations of gold, as demonstrated by these definitions taken from the Oxford English Dictionary: '*golden* . . . of high value, most excellent, important or precious, of inestimable value, of inestimable utility, exceedingly favourable or propitious . . . of time or an epoch, characterized by great prosperity and happiness'.[215] The word does not have negative attributes in mainstream English. Nor did it in classical Latin: '*aurum*, gold, things of gold, the colour or lustre of gold, the gleam or brightness of gold, the Golden Age . . . *aureus*; golden, furnished with gold, of physical or mental excellence or attractions, golden, beautiful, splendid, *aurea venus*, etc'.[216] In fighting to denigrate gold, Christians must needs have fought their own language. It was much easier and more persuasive to say, 'indeed everyone knows that gold is very precious, but I know something better'. This, however, legitimated gold as something of excellence, albeit lesser excellence, which was then related to Christian divinity as it was already related to pagan divinity.

Although Christ the friend and Christ the humble provided important images, the idea of gold was vitally important in sustaining the Christian God in his supremacy. Indeed the two elements, pertaining to his divinity and his humanity, provided a thrilling contrast that challenged the mind to think what really was of high worth; as with the gold set round a relic, which was intended to provoke the viewer into perceiving the remarkable greater glory present in what looked like mere bone. This imagery was meant to make readers and viewers think about what was going on. People were confronted with images that reminded them of the golden rhetoric of empire, and they were invited to think of which king was the ultimate overlord, he who ruled in Constantinople or He who ruled in heaven. Nevertheless, the concept of a heavenly king gave comparative honour to that of an earthly ruler. It has been shown, in chapter 2, how much Church splendour was associated with the patronage of emperors. They wished to associate themselves

[212] Discussed with numerous textual references in Poque (1984), I, pp. 110–14, with notes at II, pp. 170–2.
[213] Averil Cameron (1991), p. 35, 'the concern for audience is surprisingly modern'.
[214] I understand mentalities as defined by the possible range of opinions in a society and the most commonly held or influential views, see G. E. R. Lloyd (1990).
[215] Taken from Simpson & Weiner 20 (1989), pp. 652–5, entry 'gold' and pp. 656–8, entry 'golden'.
[216] Taken from Lewis & Short (1879), p. 207, entry '*aureus*' and p. 208, entry '*aurum*'.

with divinity and associate the Church with their government. For that to work, the two institutions needed to adopt the same styles, otherwise a bare religious style of the church would seem an explicit criticism of the golden style of the Empire. In tandem, each could do honour to the other.

The taste for treasure has led Roberts to talk of the 'jewelled style' of late Antique poetry, such as that found in Prudentius' use of the imagery of the gold and jewelled heavenly Jerusalem in his allegory, *Psychomachia*.[217] The influence on the Middle Ages was immense. Just to take one example, in the writings of the Anglo-Saxon writer Aldhelm, such imagery truly appears to run riot as the author attempts to describe the glories of virginity in the most spectacular way possible. A virgin in her mother's lap is a jewel in a wreath, gold or a purple gem in gravel, or a pearl in an oyster.[218] The prose version of this text compares marriage and virginity, praising the latter but not denigrating the former, saying that silver is good, but gold better; marble good but ruby better; woollen yarn good but purple silk better; implements are useful, but it is the diadem and insignia they make that are precious.[219] The significance of all this for the artistic tradition has been clearly recognized by Averil Cameron: 'it was a small step from pervasive metaphor in Christian language to the symbolic repertoire of early Christian art – the Good Shepherd, the Vine and so on. For Christian language, like Christian art, was trying to express mysteries that were essentially inexpressible except through symbol.'[220]

Auerbach gave a famous impressionistic picture of late Antiquity as a world in which it appears that the sensory, the perceivable, runs riot.[221] The contemporary power of images overrode their dangers. This was so in the literary field, as it was in the visual. We have entered the world in which the Church was 'triumphantly, unashamedly rich'.[222] The holy of holies, the very words of Scripture, were set out in treasured books that were bound in jewelled covers. The sixth-century Codex Petropolitanus from Asia Minor was written in 'monumental' silver uncial on purple vellum, with the *sacra nomina* written in gold (other similar examples from late Antiquity are the Vienna Genesis, and the Rossano

[217] Prudentius, *Psychomachia*, lines 826–87, at lines 853–4; in H. J. Thomson (ed. and trans.) *Works* I [of 2 vols.] (1949), pp. 274–343, the walls are made of jewels and 'the light from on high pours out living breathing colours from their clear depths', 'animasque colorum viventes liquido lux evomit alta profundo'.

[218] Aldhelm, verse *De Virginitate*, lines 150–75; R. Ehwald (ed.), *Opera*, MGH, AA 15 (1919). See also Orchard (1994).

[219] Aldhelm, prose *De Virginitate*, 9; R. Ehwald (ed.) *Opera*, MGH, AA 15 (1919). Along with such imagery, Aldhelm juxtaposes imagery of brilliantly coloured flowers. This was a popular comparison, the importance of which is discussed in the next two chapters.

[220] Averil Cameron (1991), p. 59.

[221] Auerbach (1946), pp. 56–80, writing on the world of Ammianus Marcellinus.

[222] Nelson (1987), p. 25, writing of the Carolingian period, but true for many earlier instances.

and Synope Gospels).²²³ At the time of the Reformation, the Passion was shown with all the trappings of horror. In late Rome and the early Middle Ages, the cross was typically displayed without its gory burden, but rather glistening with gold and gems, as demonstrated by the Anglo-Saxon poem, *The Dream of the Rood*, which equates the image of a gold and jewelled cross swathed in purple with that of the first-century reality.²²⁴ This is not to say that the irony was not appreciated, but rather it was revelled in as an element of catholic and orthodox decorum.

This chapter began with words of Jesus from his Sermon on the Mount. To me, at least, they appear to jar with the previous description of the practices of the late Antique church. However, that institution was seeking to fulfil the message of Jesus as then understood. Jesus said, 'lay not up for yourselves treasures on earth, where moth and rust doth corrupt, and where thieves break through and steal: but lay up for yourselves treasures in heaven, where neither moth nor rust doth corrupt'.²²⁵ The Church said exactly the same thing *to individuals*. The splendour of the Church was seen as justified because that institution was the agent of God who had legitimized matter by His incarnation. Those who, through the course of the Middle Ages, asserted that personal pride lurked under a veneer of institutional display, were either allowed to set up their own reform movements or orders (which themselves often went on to accumulate great corporate wealth) or were condemned as heretics.²²⁶ The issue of the Church and personal poverty will be addressed in more detail in chapter 5. In the meantime, it can be noted that if Jesus left abundant testimony on rules for personal behaviour, he furnished no such blueprint for the creation of the Church itself, other than in the general example of the Apostles who held their treasures in common.²²⁷ Late Antique Christian writers were, by and large, perfectly sincere men and women and they lived in a world far closer to that of Jesus than is our own. Who are we to say that their interpretation of Scripture was inferior to ours?

²²³ McKendrick (1994). Weitzmann (1977), pp. 16–17, illustrations, Vienna Genesis [Vienna, Nationalbibliothek cod. theol. gr. 31], pls. 23–8, Rossano Gospel [Rossano, *Codex Purpureus*], pls. 29–33 and Sinope Gospel [Paris, BN, suppl. gr. 1286], pl. xiv. For further western examples see McGurk (1994), which discusses the Old Latin Psalter, Paris, BN, lat. 11947; the Old Latin Brescia Gospels, Bibliotheca Queriniana and the Gothic Codex Argenteus, Uppsala, Kungliga Universitets Biblioteket. Ganz (1987), pp. 30–1, describes the Carolingian pleasure in such manuscripts as expressed by the poet Godescalc's words, 'golden letters on purple pages promise the heavenly kingdoms'.

²²⁴ *The Dream of the Rood*, discussed with references in J. Smith (1975). ²²⁵ Matthew 6: 19–20.

²²⁶ B. Hamilton (1986), ch. 3, provides a brief introduction to this topic.

²²⁷ Acts 2: 44 and 4: 32–5, discussed by Gonzalez (1990), pp. 79–86.

CHAPTER 4

The art of persuasion

Churches were intended as the closest there could be to a recreation of heaven, both in the sanctity of those gathered there and in the very experience of being in the place. Art in these buildings was intended to impress and instruct the viewer and to do honour directly to God and indirectly to the donors. An appealing vision of the Christian paradise was of enormous importance in the spread of the religion, because the promise of that place was the greatest thing that Christianity could offer. Classical metaphors of excellence focused upon great quantity and high quality. Luxuriant nature could portray abundance. Light could represent the concept of sublime purity. Gold could represent both ideals. All these elements were made use of in the construction of the Christian view of paradise. Scriptural employment legitimated all these modes of the presentation of excellence and precedents for each could easily be found in the repertoire of classical visual art. Many other themes of that art, such as those of an explicitly sexual nature, were not acceptable in the Christian contexts of late Antiquity. Gold was rescued from such oblivion by the 'spiritually' golden nature of the Christian paradise.

In the Israelite tradition, belief in sky and underworld gods was replaced by worship of the one God, Yahweh, who lived in heaven. A crucial date was 586 BC, when the Babylonian army crushed the Judaean monarchy. This led to the desire for the literal resurrection of the dead and return of the earthly kingdom, whilst longing also waxed for a life of bliss with Yahweh in his spiritual realm.[1] But, for Jesus, heaven was a place not of material reward but of experiencing the divine.[2] His poor background set the tone for his unconcern for worldly things. Paul and others believed that Christianity was a complete religion in its own right. Not all early Christians, however, so totally equated their religiosity with their Christianity. The Scriptural Apocalypse was inspired by John the Divine's horror at the imperial cult and at the participation of Christians in it.[3] The Apocalypse describes the dignity and

[1] Precise beliefs varied from sect to sect. The Sadducees, for example, even believed that the soul withered at death and that there was no resurrection.
[2] McDannell & Lang (1988), p. 30. [3] See chapter 3.

splendour of the heavenly worship. This took place not in something like the Jewish Temple, which was a house of God, but in something like an immense synagogue. The place is described as a gigantic hall built of the most precious materials of which John could conceive, gold and gems, and, since our seer was preoccupied with those materials, he only briefly mentioned what actually happened in this miraculous structure, which was never-ending liturgy.[4] The powerfully pictorial form of this vision of the triumph of God was to be re-emphasized in the times of persecution to come. The struggle for survival in a hostile environment encouraged the view of heaven as the compensation for earthly troubles. Martyrs were held up as the heroes of the Church. It is hardly surprising that they were described entering heaven using the symbolism of triumph.[5]

Such imagery received sanction from the jewelled metaphors of the Old Testament which stemmed from the long tradition of Jewish sacred monarchy. The Israelites were a people who were waiting for the coming of a king, a great king, a king in the mould of their ancient kings, with riches, magnificence and all the trappings, who could be imagined in his heavenly palace, its walls built out of precious stones.[6] Solomon had once brought gold back from India and dwelt amid golden splendour.[7] Beautiful robes and golden ornaments were characteristic of the ancient Tabernacle and Temples.[8] Judaism was also a religion of the law. That law forbade the use of images.[9] The splendour of the Lord could not therefore be depicted visually, unless through the medium of literary images. In ancient Jewish tradition precious stones were the symbols of the undepictable God and of divinity: 'Jerusalem will be built with sapphire and emeralds, her walls with precious stones and the towers and battlements with pure gold. The streets of Jerusalem will be paved with beryl and ruby and the stones of Ophir.'[10] Such imagery resurfaces spectacularly in the New Testament in the Apocalypse of John the Divine, as discussed in the last chapter.[11] The use of such symbols avoided the danger of picturing Yahweh in anthropomorphic terms. Treasure was the medium employed by secular elites, kings and pagan cults, yet this *could* be condemned as false

[4] McDannell & Lang (1988), pp. 41–3.
[5] Discussed in the course of this chapter. See especially the discussion of crowns below (pp. 126–8).
[6] Goodenough (1953–68), 10, p. 71.
[7] III (AV I) Kings 10: 23 and II Chronicles, 9: 22. Further on Solomon's wealth, III (AV I) Kings 10: 14 and II Chronicles 9: 13. (In English versions the Vulgate I and II Kings have become I and II Samuel.)
[8] Exodus 25–9 and III (AV I) Kings 6.
[9] Exodus 20: 4, 'Non facies tibi sculptile neque omnem similitudinem quae est in caelo desuper et quae in terra deorsum nec eorum quae sunt in aquis sub terra.'
[10] Tobit 13: 16–17. See also Isaiah 51: 11; Ezekiel 28: 3; Exodus 28: 17–20, and the theophanies, Exodus 24, Ezekiel 1 and Rev. 4 and for God described as a king, Isaiah 28 and 62.
[11] Jart (1970), on the precious stones of the heavenly Jerusalem in John's Apocalypse. In Hindu epic there was also a divine city, Dwáráka, which abounded with precious stones, see Gonda (1991), p. 152 n. 7.

divinity, blasphemy and trickery.[12] It was understood that God, at the end of time, would reclaim what was rightfully His.[13]

Many early Christians felt themselves to be very different from the Jews from amongst whom they were in the process of emerging, but they had to express themselves in the languages of the ancient world, which were necessarily closely bound up with ancient culture.[14] Written and verbal polemic was very important in the early days of the Church. Ancient imagery was used for the purposes of the new faith. This was, however, much slower to take place in the realm of art. Kitzinger wrote of the Christian faith's 'categorical rejection of images, and, indeed, of all art, which it proclaimed during the first two centuries of its existence'.[15] This view has recently been challenged by Murray with careful textual re-readings.[16] What *is* clear is that although the story of Christian art effectively begins in the early third century, it seems that the acceptance of visual images was an enormously useful accommodation to classical culture, and seemingly crucial in the promotion of religious belief in late Antiquity.

Despite some scepticism, there was widespread popular belief in an afterlife amongst pagans in Antiquity.[17] Philosophers had no difficulty in understanding heaven in abstract terms as a place of perfect 'beauty' (virtue). Such philosophical comprehension was less easy for the masses. Jesus may have appreciated the sublime immateriality of the divine, but ordinary people had to be persuaded of the joy of such experience. The premier pagan expression of heavenly bliss was that of the Elysian Fields, of Arcadia and of the Golden Age. This was a rural paradise, summoned with the nostalgia for a distant era without troubles. It was spiritually 'golden', yet it was without the worldly gold that caused so much trouble to procure in the present.[18] Antiquity was entranced by the ideal of serenity and powerful late Roman visions of life in heaven were of a sleep, a banquet, a palace

[12] Frerichs (1969), p. 120.

[13] Jewish opinion saw a variety of more literal or more figurative interpretations of this imagery, Frerichs (1969), p. 119.

[14] Mohrmann (1958–65b), p. 173. [15] Kitzinger (1954a), p. 85.

[16] C. Murray (1977) and (1981). See also Finney (1994).

[17] Gardiner (1993) provides an extensive bibliography on the subject of heaven.

[18] *De Rebus Bellicis*, 2, R. Ireland (ed. and trans.) *De Rebus Bellicis* II [of 2 vols.], The Text, BAR, IS 63ii (Oxford, 1979), 'certe aurea nuncupamus quae aurum penitus non habebant' and p. 26, 'Certainly we speak of those [ages] as "golden" which had absolutely no gold at all.' For an introduction to the 'Golden Age' see J. Z. Smith (1987). The early imperial period presented in rhetoric as a Golden Age was (as was seen in chapter 2, pp. 19–25) notoriously golden in a literal manner, see Barker (1993) and Wallace-Hadrill (1982), but the best introduction is Zanker (1987), pp. 171ff, on the *aurea aetas*. Fascinatingly, Golden Ages in other cultures were *imagined* as golden. In Hinduism, all accoutrements were supposed to have been gold to begin with, Carpenter (1987) and Gonda (1991). Also, in the Scandinavian prose Edda (early twelfth century) we read that to begin with 'they had all their furniture and utensils of gold, and that age is known as the Golden Age', Snorri Sturlesson, *Edda, Gylfaginning* 14; A. Foulkes (trans.) (London, 1987), p. 16.

and a garden.[19] Divine assistance was also invoked in the bettering of life on this earth. Such desires ensured that images involving prosperity were commonplace in the late Antique house, important amongst them pictures of animals and plants and streams as emblems of fertility.[20] These popular desires united with the imagery of Scripture to produce such characteristic experiences of Roman Christianity as the visions of paradise described in *Vitae* as seen prior to martyrdom; as for example when Marianus, in mid-third-century North Africa, saw a cup by a fountain from which he drank, whilst Marculus saw a silver cup, a golden crown and a palm.[21]

Treasure substances had their place in such dreams, but in the classical period were not used in flagrant defiance of naturalism. Plants were not shown as literally golden. The power of naturalism favoured the use of gold to represent that substance as found in reality. Decoration consisted, in addition to abstract designs and motifs taken from the natural world, of figurative and narrative scenes. These compositions themselves were often of a stylized form. Nevertheless, through Antiquity, the beauty and excellence of an artistic production continued to be consciously related to degrees of naturalism. Such presentation, of course, always coexisted with decorative motifs. Plaited plant stems and flowers were thus often employed in an attempt to imitate real garlands. Purely decorative treasure motifs do appear in late Antiquity, but as the result of naturalistic imitation of the cabochon settings of gems on gold.[22]

Much of Roman art was concerned with telling stories, and the same was true of Christian art.[23] There remained, however, the problem of controlling what was evoked. The desire for the transmission of clear yet subtle messages acted as a force for abstraction, or rather for formalization, that is, for the limitation of options for a naturalistic presentation. Symbols acted to emphasize universal qualities through the compression of narrative and time. Familiar typological formulations were readily comprehensible to an audience and could receive enhanced content through association.[24] The development toward symbolic expression was the result of a strong attempt at precise communication and led to a deliberate, active, explicit art.[25] Despite this, Mango has noted that even if *we* think of the resulting depiction as decreasingly naturalistic, this was not the opinion of the times; 'the Byzantines themselves, judging by their extant statements, regarded it as being *highly* naturalistic and as being directly in the tradition of

[19] Amat (1985), pp. 392–401. P. R. L. Brown (1982).
[20] Maguire, Maguire & Duncan-Flowers (1989), pp. 9–16, 'designs invoking prosperity', at pp. 9–13, on plants and animals.
[21] This genre and these examples are discussed in Meslin (1972), with Marculus at p. 141 and Marianus at p. 144.
[22] See later in this chapter (pp. 128–9). [23] Brilliant (1984). [24] Ibid., pp. 163–4.
[25] Elsner (1995), p. 287, 'in the end Christianity did not need a mimetic art . . . in a society that perceived everything in the material world to be a symbol of something that transcended nature'.

Phidias'.[26] We should ask how it was considered proper to represent people and narrative subjects. If an artist portrayed a saint, he wanted to portray his *saintliness*, an ambition which was not in easy accordance with the naturalistic portrayal of the figure as it appears in the everyday.[27] *Vitae* may tell of the virtuous shabbiness in life of many holy men and women, but their 'true' appearance was that of their beautiful soul, in which form they would be made manifest in the shimmering decorum characteristic of heaven. In late Antiquity, it was not proper to show shoddy things simply for the sake of a delight in naturalism. One may compare this attitude with an *emblema* of a Hellenistic mosaic (c. 200 BC) from the palace at Pergamum. This has the artist's name shown upon a label, which appears to be peeling up at one corner.[28] This indicates a playful awareness and enjoyment of naturalism of a very different sort to that employed in late Roman sacred contexts.

The classical enjoyment of all aspects of the abundance of the Earth was very slow to decline, as shown in Maguire's study of the terrestrial world in Byzantine art.[29] Thus one of the commoner forms of decoration from the period is the vine *rinceau*. Grape-vine stems were used to form the borders of regularly sized spaces into which depictions of animals, everyday objects or, less commonly, humans or buildings were inserted. Such elements of animal and plant life also made their way into the great monuments of Christian art. Beauty and excellence could therefore be seen in *this* world. The Church may have emphasized the view that the present was but a shadow of paradise, but nevertheless a shadow has a relation to that which creates it. In such circumstances, it was almost irresistible to see the heavenly paradise as like this world, save with the wrinkles ironed out. Thus, in heaven there are trees that not only are always green but are always in fruit and dress that is always bright and unstained. The eastern iconoclastic period illustrates that it was plant and animal luxuriance on the one hand and treasure, gold and jewels on the other which were thought most suitable for Church decoration in the absence of the human figure. A good example is provided by the south choir of the ruined iconoclast church at Thessalonica.[30] This features multiple jewelled crosses painted on plaster together with vegetal elements. These provided evocations of excellence and abundance respectively.

A similar aesthetic can be seen in the far earlier (early-fourth-century) vault mosaics of Santa Constanza in Rome. This building was originally a mausoleum, with the tomb standing where the altar now is. On either side of this focus but not elsewhere the vault features, amongst the vegetation, various metal vessels touched up with gold tesserae (figure 4, p. 99).[31] Whilst vine-harvesting continued

[26] C. Mango (1963), p. 65. [27] Tatarkiewicz (1970), p. 37. [28] Onians (1979), p. 107, fig. 110.
[29] Maguire (1987b). [30] Lafontaine-Dosogne (1987), fig. 1.
[31] Wilpert (1976), pl. 4, discussed by Gage (1993), p. 41. The placing of these pots suggests that they had a spiritual association.

THE ART OF PERSUASION

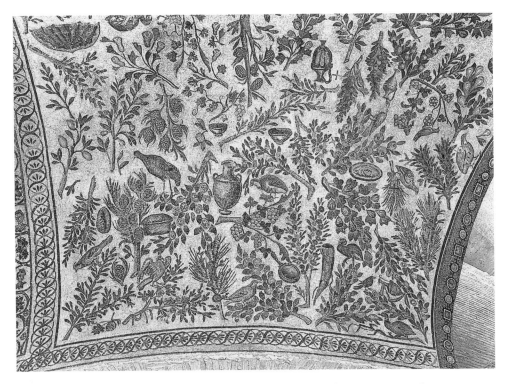

Figure 4. Vault mosaic, Santa Constanza, Rome (mid-fourth-century), featuring amongst the vegetation, various metal vessels touched up with gold tesserae.

as a motif, that of two birds flanking a vase from which a vine springs became far more commonplace in late Roman mosaic.[32] Such vessels are placed in association with birds with particular frequency in funerary such as sarcophagi, as with the six-shell-niche (on each long side) example presently in the Archiepiscopal Museum in Ravenna (figure 5, p. 102).[33] This features columns atop which there are 'shell' shapes. These are ancient Roman symbols of heaven. Beneath the columns are crosses (the premier Christian symbol of triumph over death), date palms, two sheep eating dates from a palm and two peacocks drinking from a fountain spraying up from a vase. These are both versions of the spirit ingesting life.[34] An excellent late Roman example of art playing on themes found decorous in the

[32] Maguire (1987b), with Michaelides (1988), a jewelled vase between birds on a mosaic floor from Kourion, Cyprus, fig. 5 and Bagatti (1971), on birds in funeral mosaics, pp. 340–3.

[33] Duval (1977). Bovini (1954), pp. 61–3, fig. 52, originally in Sant'Apollinare in Classe.

[34] Bagatti (1971), on birds in funeral mosaics, pp. 340–3. Donceel-Voûte (1988), on vases in mosiac pavements: 'Point focal de la composition, elles sont clairment le réceptacle de breuvages vivifants, attirant les deux animaux comme une source de l'eau vive, selon un schéma que l'art connait depuis une haute antiquité', p. 482, confimed by Effenberger & Severin (1992), p. 178.

context of a church is that of the vault of San Giovanni in Laterano, which shows birds flanking vases on gold ground between swags of fruiting verdure amongst which peacocks stand.[35]

The presence of Biblical inspiration was vital in the Christian employment of motifs. Jewelled representations were sustained in late Antiquity by the testimony of texts such as the Apocalypse of John. Vegetal imagery was supported by the Old Testament descriptions of the Garden of Eden, a subject investigated by Daniélou in his article 'Terre et paradis chez les Pères de l'Église'.[36] The connection between water, greenness and goodness is perhaps more obvious in warmer climates than that of England, and the Fathers of the Church revelled in the literal and/or figurative fertility and abundance of paradise. Their heaven often appears as the pagan bountiful Earth writ large, and as such could be evoked by the use of the same motifs. By miraculous inversion, the wood of the Crucifixion, the tree of death, was for a Christian *lignum vitae*. But, by a further transformation, the cross was typically shown as made of gold. Christian triumph was increasingly expressed by the use of elite substances, a process which saw plant motifs shrink back at the expense of gold in the mosaic art of the early Middle Ages.[37]

Early Christians, torn between the words of Jesus on the vanity of worldly riches and the material values of the wider culture of the Empire, turned for inspiration to the Biblically presented past and future. In the Old Testament it was commanded that 'thou shalt not make unto thee any graven image nor any likeness of any thing that is in heaven or that is in the earth beneath or that is in the water under the earth'.[38] The lack of figural art of the early Christian period is very much a legacy of older attitudes. However, as the religion spread, it embraced increasing numbers of Gentiles who were used to living in the midst of a culture that made enormous use of figural and ornamental decoration. Fascinatingly, representative art appears even to have invaded the synagogues in late Antiquity. In the first and second centuries there is was almost no representational art. In the third century there are

[35] Lehmann (1945), pp. 15–16 and fig. 46. Such motifs of treasured vessels and the waters of life were not restricted to the Christians, but were an element in wide cultural understandings. The synagogue at Sardis possessed a splendid apse mosaic (dated by style to *c*. 400) which showed a twining plant growing out of a huge golden vessel, G. F. Hanfmann (1975), p. 88 and G. M. A. Hanfmann (1964), pp. 30–44, with plan, fig. 15 and mosaic, fig. 17.

[36] Daniélou (1953).

[37] But metallic tesserae were too delicate for extensive use on floorings. In that context there can be seen a strong continuity of aristocratic taste. It was with such carpets of vines, and scenes of birds, animals and fish, that the Roman aristocracy had been accustomed to decorate its villas, Grabar (1968a), pp. 51ff. Certainly, the classical mode was still very much alive in Constantinople, as the floor mosaics of the Great Palace attest. Originally held to be masterpieces of late Rome, they have since been identified as belonging to the Triclinium of Justinian II and so as dating from the later seventh century; Nordhagen (1963), at pp. 66–9, summarizes his conclusions on dating.

[38] Exodus 20: 4.

not many examples, but many more than before and of varied types. In the fourth to seventh centuries there was a great frequency of motifs and images, if of a relatively restricted number of forms.

A list of images from the fifth-century synagogue from Capernaum includes stars, acanthus leaves, Hercules' knot, eagles, wreaths, flowers, swags, shells, garlands, Torah shrine, *genii*, grapevines, wheeled carriage, swastikas, olive branches, pomegranates, menorah (seven-branched candlestick), lions, Capricorn, palms, griffins and an incense shovel.[39] During this period the synagogue of Sardis was rebuilt from a rectangular room into something just like a basilican church, with atrium, columns and apse.[40] This was not always the case: the synagogue of Dura Europos remained on the domestic scale. Yet this synagogue developed extensive paintings which stylistically resembled those in pagan sanctuaries across the city.[41] At Sardis, inscriptions attest to the gift of paintings, mosaics, pavements, marble revetments, fountains, basins, lamps and altars, given by both Jews and sympathizers. These 'Roman' practices had invaded the synagogues of Palestine as they had invaded the churches of the Christians.[42]

However much difference polemics sought to assert existed between the different faiths, or even between different varieties of the same belief, the fact remains that all were using much the same verbal and visual rhetoric by the early fourth century. It becomes very difficult, for example, to say whether certain artistic motifs are 'Jewish' or 'Christian', or indeed 'pagan'. The crown, for instance, was employed as a premier symbol of Christian martyrdom. It was also used by the emperors as an attribute of victorious rule and it can also be understood as a Jewish symbol, associated with the feast of the Tabernacles.[43] To take another example, late Antique churches were smothered with images of birds, which were also hugely important in Jewish imagery. Goodenough's index entry for birds as a symbol in Judaism has over forty headings.[44] Birds, in both Christianity and Judaism, were images of love and the soul. The same phenomenon appears in relation to verdure in general,[45] and to vines in particular (a very prominent pagan and Christian motif). The motif of a vine growing from a wine cup was employed by and gave the same meaning of life to pagans, Jews and Christians.[46] The same was true of light and divinity as a metaphor. In Goodenough's study there are over thirty index headings. Over twenty references are cited to 'God as light' alone.[47] Treasure and gold, meaning 'excellence', were employed by Jews in specific reference to the divine in the midst of all manner of

[39] Neusner (1991), pp. 152–3. [40] White (1990), p. 73, fig. 14.
[41] Stähl (1988), pp. 69–99; White (1990), p. 75, fig. 15 and p. 77, with Goodenough IX (1953–68), pp. 15 and 28.
[42] White (1990), pp. 84–5. [43] Daniélou (1964), pp. 1–24, on palms and crowns at pp. 15 and 19.
[44] Goodenough (1953–68), XIII, pp. 64–5 and VIII, pp. 22–70.
[45] Daniélou (1964), pp. 25–42, on 'the vine and the tree of life'.
[46] Goodenough (1953–68), VI, pp. 131 and 65 n. 9. [47] Ibid., xiii, p. 108. See also this book, p. 74.

Figure 5. Sarcophagus, Archiepiscopal Museum, Ravenna (sixth-century), intended to be read allegorically as the ingestion of eternal life.

natural motifs of abundance. In terms of material culture, adherents of the different faiths had far more in common than would set them apart.⁴⁸ Much the same can be said of their employment of literary metaphor. Christianity made great use of symbols from the world of Antiquity on the basis that they were part of God's creation and available for His praise.

Imagery was, however, not simply deployed at random. Birds in earlier Roman wall-paintings have been seen as relating to a delight in illusion as shown in the presence of apparently living things, especially as positioned on architectural backgrounds the perspective of which was itself designed to provide the appearance of space.⁴⁹ Such an aesthetic did not disappear, but there *were* alternatives to the decorative schemes chosen and clearly some images were thought more appropriate than others on *symbolic* grounds. An early illustration of Christian attitudes is provided by book 3 of the late-second or early-third-century writer Clement of Alexandria's *Paedagogus*. This work discusses in detail those emblems which a Christian should and should not wear on finger-rings. Subjects forbidden were portraits of heathen Gods, swords, bows, drinking cups, lovers and whores; an unsurprising list. Motifs to be favoured were doves, fish, ships, lyres and anchors.⁵⁰ The infusion of generic images with Christian meanings was an important factor as the Church emerged from its initial hostility to images in accordance with Jewish tradition. Those images which accorded with the new religion were adopted, those which did not, were not. So it is that harvesting and Bacchic elements were slowly removed from vine decoration. Similarly, there was a concentration on particular animals, such as birds in general and doves in particular. Choricius noted that at St Sergius of Gaza the mosaicist had 'rightly rejected the creatures of the poets, the nightingale and the cicada, so that not even the memory of these fabled birds might intrude into the majesty of this sacred place; in their stead he has artistically executed a swarm of other birds'.⁵¹ An example of *suitable* animals is provided by the marble *ambo* (pulpit) of Agnellus (archbishop of Ravenna, 556–569). This shows rows of animals carved in stone, in succession, lambs, peacocks, deer, pigeons, ducks and fish; all are what might be termed 'peaceful' emblems.⁵²

To give a counter example, a contrast can be seen here with the warrior symbol of the eagle. This attribute of Jupiter, inherited together with the ancient triumph, had been utilized by the emperors in the form of an eagle-sceptre as a symbol of victory.⁵³ Sword pommels in late Antiquity were made, on occasion, in

⁴⁸ With reference to the last chapter, note also Markus (1990), p. 12, 'there was just not a different culture to distinguish Christians from their pagan peers'.
⁴⁹ Renaud (1993). ⁵⁰ Discussed with references by Finney (1987).
⁵¹ Choricius, *In Praise of Marcian*, 1, 33, quoted from C. Mango (1986), p. 62. ⁵² Volbach (1961), pl. 183.
⁵³ A. Alföldi (1970b), pp. 156 and 230ff.

the shape of the head of an eagle, examples of which can be seen clasped by the porphyry tetrarchs at San Marco, Venice.[54] This predatory bird was still favoured in the late Antique *palatium*, as can be seen from the fact that the four supports of the gilded canopy of the imperial throne were in the shape of eagles, as shown in a miniature of a ninth-century manuscript of the sermons of Gregory Nazianzen which depicts the writer meeting Theodosius the Great.[55] Furthermore, the bird was used as a motif in the architectural decoration of palaces, as is demonstrated by the fifth-century marble capital adorned with eagles which was found at an imperial landing stage at Constantinople.[56] Images which could not be spiritually reinterpreted, as was the eagle to St John, were excluded from the repertoire of Christian triumph.[57]

Late Roman culture, as has been seen, made distinctive use of elite substances. These were employed by Christians in association with a careful consideration of symbolic appropriateness, bearing in mind that the gold of the ancient temples of Israel suggested that these substances were not sinful in themselves. They were a beautiful part of God's beautiful creation, and whilst it was a duty not to misuse them, it was also a duty to use them well. It has been seen in chapter 2 how the secular world showed eminence by treasure display. The decorum of the age demanded that the powerful should be honoured in many ways, including by material means. Society's favourable response to Christianity brought such items and materials to the Church, thus enmeshing that religion in the value systems of Roman society. Holy men might not dress themselves in splendour, but at their death the faithful rushed to pay in the visual currency of respect. The precedent had been set by emperors for the behaviour of lesser nobles in providing donations of buildings, land and objects, so setting in train the immensely powerful financial position of the Church in the Middle Ages. What is so fascinating is that the secular forms of elite display, as used within the church, were apparently at odds with the world-denying, poverty-lauding bases of the Christian life.

Nevertheless, the immense symbolic power to communicate possessed by worldly treasures was such that they were made reference to and made use of by many in the Church. Ecclesiastics wished to promote Christian ideas. It was the secular world, including the imperial system, that offered the most influential systems of visual propaganda, bearing in mind that early Christianity had initially inherited the Jewish hostility to image-making. The rapprochement with classical culture led to a hybrid situation in which Christian ideas were promoted using non-Christian-inspired imagery, which extended to the exploitation of treasure and

[54] Ibid., p. 185 and P. R. L. Brown (1971), p. 22 and pl. 12.
[55] Paris, BN, MS. gr. 510, folio 239; see Omont (1929), p. 24 and pl. 41 and Lehmann (1945), p. 19 and fig. 57.
[56] Mamboury & Wiegand (1934), p. 11 and pl. 27.
[57] Lehmann (1945), p. 17.

concepts of treasure as propaganda.⁵⁸ The symbolic understanding of Scripture constructed paradise as like the best things of this world but better. The superiority of the otherworld was emphasized. Nevertheless, it was heresy to condemn all things of this world, because signs toward the comprehension and celebration of heaven had been placed by God in the present age for the cause of our salvation.⁵⁹ Treasure adornment could be seen as the use of divinely inspired allegory to the end of explaining the greatness of God. This situation was promoted by the influence of Scripture, much of which related to archaic Jewish custom. This could be invoked to promote a mystical understanding of treasure as moral allegory, separate from vulgar wealth; the crucial distinction being one of how the items of value were employed. Adornment of churches was accepted as morally good, as one form of Christian gift; just as another was giving doles to the poor.

Christianity looked to a *heavenly* Jerusalem as described in the Apocalypse, built of gold, pearls and precious gems.⁶⁰ For many of the faithful, the future they would hear tell of was of spiritual riches, but their hopes could only be conjured up in the worldly language of wealth and abundance with which they were familiar. Heaven would provide 'sweet draughts' and 'rich banquets', 'beautiful music', 'ease' and 'splendour'.⁶¹ Earthly self-denial was a prelude to future enjoyment for those who were less than enthused by the philosophic satisfaction of uniting as one glint in the source of supreme light. The very awe with which many ascetics were treated is a testament to the intensity of the desire that they had not so much to overcome, as to postpone. The popular metaphors of excellence were concentrated in churches across the Empire. It was, of course, orthodoxy to claim that the splendours of the churches were incidental; so in Christian terms they were, but their very presence was apparently necessary. Crucial was the example set by the emperors, but crucial also was the role played by Christian bishops, already prior to the imperial conversion, but with renewed gusto afterwards, in endowing their churches in material terms. Their example has left us with a string of monuments of late Roman and early medieval art which were the direct result of a belief that an important component of the role of the Christian patron was to channel money to the material glorification of God.

Visual symbolism: Christian wall mosaics

The extensive corpus of surviving late Antique church mosaics which make use of gold provide an excellent oppportunity for a detailed study of Christian visual

⁵⁸ As will be described in chapter 5, this compromise was allowed by a strong distinction between corporate wealth and personal poverty.
⁵⁹ Manichaeism taught that this world was filth, see P. R. L. Brown (1969). ⁶⁰ Kühnel (1987), p. 59.
⁶¹ Amat (1985), pp. 392–401.

rhetoric and symbolism. Mosaic developed as one of the arts of classical and Hellenistic Greece. The basic technique of construction involved setting small cubes (tesserae) of stone or coloured glass in plaster. Patrons either employed and supervised workers in the same way that interior designers and craftsmen are employed today, or else they possessed their own dependent employees.[62] The materials used were determined by patrons, bearing in mind the availability of supplies, craftsmen and funding. Mosaic was employed in the Roman world to the extent that examples have been found in every part of the Empire. Since Romans relished figural and naturalistic depiction, and yet also found great enjoyment in abstract patterns, designs varied from plain floorings to lapidary tapestries and complex figural schemes. Unfortunately, much of the mosaic art of the earlier Roman period has not survived. Floor mosaics were indeed widespread and have often been well preserved. However, the collapse of buildings, which acted to protect floorings by smothering them, has caused the destruction of virtually all the extensive schemes of wall mosaics installed under the earlier Empire.

Nevertheless, even from the surviving fragments it can be seen that the imperial fashion was for comprehensive decoration of floors, interior walls and ceilings with paint or mosaic, as was noted by Pliny.[63] This technique of decoration was applied even to external walls and roofs of tombs.[64] There are some tantalizing survivals. The most extensive examples are to be found at Pompeii and Herculaneum, where wall mosaic was particularly used for fountains (figure 6, p. 107).[65] At the latter, the apsed wall of an inner courtyard of one house was found to have been colourfully adorned with mosaics depicting hunting, vines and garlands.[66] Elsewhere, the one-time existence of wall mosaics has frequently been inferred by the presence on a site of *tesserae* made of glass. This material had the advantage over stone of much greater brilliance and of coming in a wider range of bright colours. However, glass was too fragile for widespread use in floorings which had to be able to take the pressure of feet. Using such indications, a recent study has listed 287 pre-fourth-century Roman wall and vault mosaic schemes, of which 165 come from Italy.[67] From this evidence it can be seen that such buildings as the baths of Caracalla and Diocletian in Rome would originally have possessed vast expanses of colourful wall mosaics.[68]

There are thus two contrasting bodies of evidence. Firstly, there are the widespread floor mosaics from throughout the Roman period, which are often uncomplicated creations, although they could sometimes be highly elaborate. Floor mosaics, having to be much more hard-wearing than those of walls, were

[62] Ling (1991), pp. 212–20. [63] Sear (1977). Pliny, *Hist. Nat.*, 36, 64. [64] Alföldi-Rosenbaum (1970).
[65] Good plates in Joly (1962) and Bertelli (1989), pp. 26–7.
[66] L'Orange & Nordhagen (1966), pp. 43–4 and pl. 7. [67] Sear (1977). [68] Ibid., p. 29.

VISUAL SYMBOLISM: CHRISTIAN WALL MOSAICS

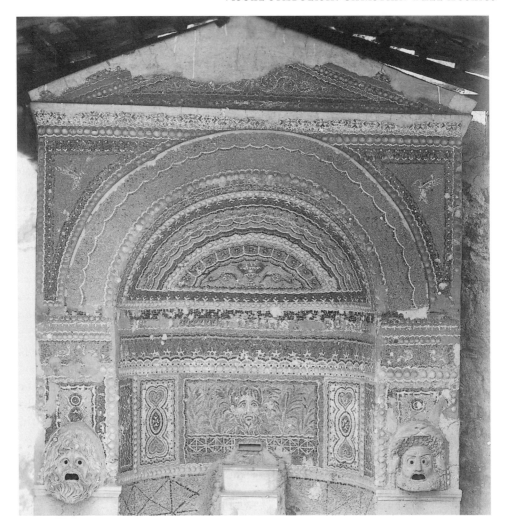

Figure 6. Niche with mosaic, Pompeii, which, together with other examples from the same town, represents one of the best survivals of wall mosaics from the earlier Roman period.

typically coarser. A fair cross-section of floor mosaics has been preserved, including that majority which were composed of rough geometric patterns. In fact, the most complex schemes would have been placed on walls, since it is this position that has the greatest prominence to the eye. A floor, since it is only seen at an oblique angle by those who walk on it, is not a good place to display large-scale iconographic schemes. Rather it is better suited to detailed patterns which yield interest at close range. In decorative terms, the Roman floor mosaic was the equivalent of a

modern carpet, although on occasion very fine figurative scenes were employed, as in the case of the celebrated pavement of the Great Palace in Constantinople.[69] However, not infrequently spared destruction in the Middle Ages, it is the Christian architecture of the late Empire (primarily churches but also baptisteries and tombs) which houses by far the best preserved wall mosaic schemes to have survived from Antiquity. These works of art owe their survival to the fact that they, as well as the buildings that housed them, were seen as beautiful and sacred through the intervening centuries. That is not to deny that a very great deal has been lost. Nevertheless, the level of survival is immeasurably higher than in the case of pagan or secular wall decorations, of which, as has been seen, there remain but fragments.[70] From the fourth century onwards, remarkable schemes are found preserved in the churches of Rome, Ravenna and Thessalonica.[71] It is only in the case of such monuments that the issue of the decoration of complete buildings with mosaic can be addressed with any confidence.

A 'typical' church was a rectangular meeting hall (basilica) divided by two lines of columns up its length (the nave) and with a curved recess at the opposite end to the entrance which was roofed by a half dome (apse).[72] An alternative was the square-plan church in which the whole building was topped by a dome.[73] Floors were composed of patterned mosaic or of plain or patterned slabs, typically marble (*opus sectile*). Columns were marble and were topped with carved and often painted marble capitals. Marble revetment ran up the lower walls. The upper walls of the nave and the apse vault (and sometimes other interior and even exterior walls) were adorned with mosaic, stucco or fresco, whilst the roof was typically of painted and gilded timber. On the upper walls, complex decorative motifs, often derived from nature, were interspersed with prominent human figures, many of which were shown staring straight back at the viewer in a way that today appears almost hypnotic. The underlying aesthetic can be generalized as featuring a delight in a profusion of form, colour and light. The overall effect of these splendid works would have been similar in style to those of many Roman temples and grand houses. The decorative schemes of these churches, moreover, also had direct pagan antecedents, as illustrated by a third-century apse mosaic from the *mithraeum*

[69] Nordhagen (1963). [70] On pagan art and on palaces, see chapter 2 (pp. 30–4 and 42–4).

[71] Wilpert (1976) provides especially thorough coverage of Italian church wall mosaics together with splendid colour illustrations and for that reason I have frequently preferred that work in the citation of illustrations. Other important general surveys are, on Rome, Oakeshott (1967) and on Ravenna, Deichmann (1969–89), with Sant'Apollinare Nuovo in *Kommentar* 1, pp. 125–90, Arian Baptistery, pp. 251–5, Archiepiscopal Chapel, pp. 198–204, Catholic Baptistery, pp. 15–47, San Vitale in *Kommentar* 2, pp. 47–232 and Sant'Apollinare in Classe, pp. 233–82.

[72] Such as Santa Maria Maggiore, Rome and Sant'Apollinare Nuovo, Ravenna.

[73] Such as San Lorenzo, Milan; San Vitale, Ravenna and Hagia Sophia, Constantinople.

at Ostia; by an early modern sketch of the now-destroyed Lupercal Chapel of Romulus and Remus in Rome, and by the painted plaster fragments of the tetrarchic temple of the imperial cult at Luxor.[74]

Sear, in his study on wall mosaics, pointed out the aesthetic importance of mosaics: 'they had all the qualities of painted decoration with the added advantage of possessing a brilliant light-reflecting surface, which was apparently much appreciated in dark and damp places such as grottoes, baths, tombs and Mithraea'.[75] The materials of which mosaics were constructed were clearly chosen with reference to their colour. Nevertheless, by late Antiquity, the use of specific costly materials was an important consideration in the appreciation of the result. By contrast, the earliest mosaics (from up to the third century BC) were made out of pebbles and are seen as 'the result of the need for a hard-wearing and inexpensive floor-covering'.[76] For this reason the earliest floor mosaics are found in private houses rather than in palaces, which were paved with slabs of expensive stone. The multi-coloured mosaics of the later period, however, with their elaborate iconographic schemes, were luxury items. There was an element of revelling in the employment of expensive materials as an aspect of conspicuous expenditure. A similar phenomenon may be seen in the increasing use of *opus sectile*. This technique of patterning in expensive marbles and other stones managed to combine costliness of material and the need for extensive craftsmanship. Nevertheless, the work needed to set millions of tesserae would have been even greater. Late Antique mosaic, therefore, required all three elements associated with prestige in crafted objects; considerable expense, labour and skill.

Together with carefully prepared glass of various colours, church mosaics were constructed from special stones such as marble. A staple of floor mosaics, this hard-wearing material provides the brilliant white background of the vault mosaics of Santa Constanza in Rome (figure 4, p. 99).[77] In later mosaic art, marble is used in specific circumstances with regard to its gentle colours and matt surface, as in the white architectural screens in the Baptistery of the Orthodox, Ravenna, and in the rocks shown on San Vitale's lateral walls.[78] Likewise, the softly reflecting qualities of marble led to its use for garments, as in the veils of the procession of virgins in Sant'Apollinare Nuovo, Ravenna.[79] It is also used for the robes of St Peter in the Arian Baptistery of the same city.[80] The other Apostles are shown using glass tesserae. It has been postulated that 'the artist wished to suggest a special type of

[74] Discussed in chapter 2 (pp. 44, 47 and 48). See also L'Orange & Nordhagen (1966), p. 45 and pl. 7, Wilpert (1976), p. 9 (with illustration) and Ling (1991), p. 193.
[75] Sear (1977), p. 31. [76] Nordhagen (1966), p. 33. An example is shown by Bertelli (1989), p. 17.
[77] Weitzmann (1979a), cat. no. 108, p. 121. [78] Bertelli (1989), pp. 68–9 and Von Simson (1987), pl. 13.
[79] Bovini (1956), pl. 20. [80] Bertelli (1989), pp. 76–7.

pallium, possibly made out of lamb's wool, which was worn by persons of great distinction'.[81] The careful choice of this material in preference to white *smalto* (tesserae of glass) indicates the great care given to the selection of materials in relation to both the final visual and symbolic result.

Another example makes the same point. Contemporary court fashion placed great stress on the use of pearls. Imperial headgear, especially the diadem, was traditionally sewn with them in the early Byzantine age. Pearls were one of a trinity of gems the use of which was restricted by the emperor Leo, in order to protect the defined prerogatives of the royal family.[82] Not surprisingly, they are a prominent feature of the Theodora mosaic panel in San Vitale.[83] Here pearls are represented by disks of mother of pearl. There is further evidence of such verisimilitude. Precious stones themselves may well have been embedded in the mosaics. The centre of Justinian's *fibula* (shoulder-brooch) in the imperial image in San Vitale, Ravenna (figure 2, p. 30) is made today of a huge piece of red glass, but Nordhagen thought that this was a restoration and that 'it is reasonable to assume that there was originally a massive semi-precious stone here'.[84]

Mosaics were made from a variety of substances, as has already been indicated. At some point during the imperial period metallic tesserae were invented. These came to be employed under the late Empire in ever larger numbers. Their popularity appears to have been inspired by the same impetus that led to the extensive use of gilding on wood, stucco and marble.[85] Metallic tesserae were manufactured by placing a thin film of silver or gold upon a sheet of glass, over which a second layer of glass was poured. The colour and thickness of the glass could be altered to vary the brilliance of the effect. Similarly, the tesserae could be set in the plaster at an angle so as to increase the light-catching power of the metal. It was this very brilliance that was of huge importance in the rapidly rising popularity of glass mosaic. The fashion for shine may be inferred from the fact that paintings were usually highly polished. Paint could be used to execute the same iconographic schemes, but could still not be made so sparkling as glass mosaic.[86] By the end of the fourth century artistic leadership had definitely passed from wall painting to wall mosaic.[87]

[81] Nordhagen (1966), p. 59.
[82] *Corpus Iuris Civilis*, 11, 11, 1, 'Nulli prorsus liceat in frenis et equestribus sellis vel in balteis suis margaritas et smaragdos et hyacinthos aptare posthac vel insere . . . Nulli praeterea privatorum liceat (exceptis scilicet ornamentis matronalibus et tam muliebrium quam virilium anulorum habitu) aliquid ex auro et gemmis quod ad cultum et ornamentum imperatorium pertinet facere.' For further detail on this imperial legislation see chapter 2 of this book (p. 28).
[83] Bertelli (1989), pp. 78–81. [84] Nordhagen (1966), p. 59.
[85] McNally (1996), p. 22 and Reutersward (1960), pp. 227–42.
[86] Hubert, Porcher & Volbach (1967), pls. 131–2. [87] Ling (1991), p. 197.

Although large-scale employment dates from the fourth century, metallic tesserae have been found in small quantities in mosaics from as early as the second century.[88] The earliest explicitly Christian vault mosaics are those of mid-third-century mausoleum of the Julii at the Vatican which show Christ 'Helios' with a golden halo. Nearby are Jonah, Jesus as the Fisherman, and the Good Shepherd. Much of the background is of yellow glass tesserae, which would have helped to light up the cavern in the torch-light.[89] It has been suggested that gold use in the sepulchral context was prefigured by the insertion into damp plaster of the gilt-glass bottoms of the deceased's drinking glasses.[90] By the fourth and fifth centuries gold tesserae were being employed on a considerable scale in place of yellow. An example of this occurs in the scene of Joshua fighting the five Amorite kings (Joshua 10: 9–16), in Santa Maria Maggiore. Gold is there applied, as highlights, to the figure of Joshua, to the helmets of the soldiers at his back and to the leather collars and shields of the fallen.[91] Prior to late Antiquity, however, precious metal was most frequently used to represent objects that were made of such substances in the outside world. Jewellery provides a good example of this, as in the early-third-century Orbe mosaic of the days of the week, in which the necklaces of the Nereids are made from gold tesserae.[92]

However, during late Antiquity, a new phenomenon appeared that was to remain a prominent aspect of a very large proportion of medieval western and eastern mosaic art. This was the use of gilt tesserae to provide the illusion of a solid gold background. The earliest surviving examples of large-scale gold grounds are the fragmentary mid-fourth-century cupola mosaics of Centcelles, near Tarragona in Spain[93] and the monumental apse mosaic of the late fourth century from Sant'Aquilino, Milan.[94] The former scheme is in a very poor condition. Masses of gold tesserae were found, having fallen to the floor. However, enough remained *in situ* to identify that they had been used for jewellery and for a golden portrait of Nebuchadnezzar, as well as forming the upper section of the ground behind throned figures towards the apex of the cupola.[95] Other dome vaults preserve

[88] Parlasca (1959), p. 74 n. 3, and pl. 93.
[89] Toynbee & Ward-Perkins (1956), pp. 72–4, L'Orange & Nordhagen (1966), p. 74 and pl. 39 and Bertelli (1989), colour plate at p. 53.
[90] It was common for such vessels to bear the name and portrait of their owners, since they were commonly made for family occasions such as weddings and birthdays. Therefore such items well served to identify places of entombment, Beckwith (1970) and Swift (1951), pp. 136–7.
[91] Brenk (1972), p. 22 and fig. 8. Also on Jewish examples found from Rome, see Goodenough (1953–68), XII, p. 37. [92] Brenk (1972), p. 18.
[93] Schlunk (1959), pp. 344–65, Hauschild & Schlunk (1961), pp. 139ff and Beckwith (1970), p. 13.
[94] Beckwith (1970), p. 13 and Bovini (1970).
[95] Hauschild & Schlunk (1961), pp. 139, 148–9 and 154; pls. 32 and 35. The throne scene is reconstructed in Schlunk & Hauschild (1978), pl. 4 (opposite p. 37).

important evidence, but many of the greatest survivals are found in rectangular Christian basilicas. The visual focus of these buildings was the apse, which was typically embellished with mosaic.[96] In welcome contrast to Centcelles, one of the late-fourth-century apse mosaics of Sant'Aquilino (a chapel at the side of San Lorenzo, Milan) is well preserved. The plain gold background is considered to be original.[97] Christ and the Apostles, clad in white, stare out from a sea of gold tesserae.[98]

Many great works of church wall mosaic did continue to be constructed without the use of gold ground, such as the apses of Santa Pudenziana and SS. Cosma e Damiano in Rome.[99] Nevertheless, even these included prominent use of gold tesserae in the depiction of treasure items such as crowns, thrones, jewellery, robes and crosses. In the time of the early Middle Ages such gold ground can be found displacing many of the elaborate decorative motifs favoured by Roman taste, a trend that was to lead to the full golden style that can be seen in medieval Italian and Byzantine churches.[100] The sixth-century apse of Sant'Apollinare in Classe featured a significant lowering of the horizon and concomitant increase in the extent of the gold background (figure 10, p. 122). This phenomenon reached its apogee in the seventh-century apse of Sant'Agnese in Rome, in which the saint, dressed like a Byzantine empress, stands against a brilliant sheet of gold. The luxuriant verdure of earlier apses is reduced to a thin strip at her feet (figure 13, p. 169).[101]

In many later examples of Christian wall mosaic, not only were the background tesserae metallic, but they were often set in special patterns and at steep angles so as to maximize the brilliance of the effect. There was, therefore, an extensive repertoire of effects available so as to ensure that the metallic tesserae could be made to appear more brilliant or more muted as the occasion required.[102] So, at Santa Maria Maggiore and at Sant'Apollinare Nuovo some cubes were reversed to show a greater thickness of glass, whilst elsewhere colour was sometimes added.[103] All of this indicates that the manipulation of light-effects was of considerable importance. Examples of this developed style can be found in virtually all the major mosaic schemes from the period. The geographical spread of these monuments

[96] M. E. Frazer (1979a), p. 556. In what follows, 'apse mosaic' generally refers to the mosaic in the vault of an apse as opposed to compositions lower down the walls.

[97] Bovini (1970), p. 73.

[98] Bertelli (1989), colour pl. at pp. 62–3. The gold tesserae were randomly mixed with those of other colours, producing a rather more muted effect than was the case in many later compositions. This may have been a stylistic choice or an economy measure.

[99] Wilpert (1976), pls. 20–2 and 101. [100] Bertelli (1989), pp. 120–224 and Borsook (1990).

[101] Another example of this is the sixth-century apse mosaic of the Church of the Virgin at St Catherine's monastery, Mt Sinai, on which heavenly figures billow against gold above a narrow strip of green laid out in token representation of the earth, Bertelli (1989), colour pl. at pp. 120–1 and Elsner (1994b).

[102] Roncuzzi (1993). [103] Gage (1993), p. 43.

was undoubtedly far more extensive than the accidents of preservation would suggest. There is, for instance, a tantalizing glimpse of such a monument in Gaul provided by the eighteenth-century description of the Golden Church (*la Daurade*) of Toulouse written shortly before its demolition in the eighteenth century. The cupola of this church possessed complex figural mosaics set against extensive golden backdrops.[104]

When assessing this phenomenon of the widespread employment of gold, it is important not to consider the fabric of these images in isolation. They were very much part of the buildings which they decorated, not only in that they were set directly on to the walls, but also indirectly, in that they were but one element in the intricate and sumptuous decoration of these buildings. The complex interrelation between precious image and precious substance in this period can be illustrated by reference to Nordhagen's article, 'Icons designed for the display of sumptuous votive gifts'.[105] This concentrates upon the evidence of the frescoes of Santa Maria Antiqua in Rome. Many of these images have been dated to the period before Pope John VII (705–707). The painting of Solomone, mother of the Maccabees, featured an onset brooch. Although the item itself has disappeared, the silver nails which once affixed it have been found still embedded in the plaster. Imitation of literal treasure, as in this instance, was accompanied in these images by evocation of figurative treasure through the same method of the application of precious substances. An image of St Demetrius was found to have holes drilled into the plaster at the corners of the mouth. It is hypothesized that the nails here once held lips formed of metal (probably gold).[106] Meanwhile, at the top of the saint's halo was a very large hole, which may well have been the fixing for a votive lamp which then ensured that the painted halo was itself externally illuminated. This delight in what we would term 'illusionism' has led Nordhagen to examine the image of the Virgin with crossed hands, which is in the same church. He discovered that there was a hole in the sixth-century image which, he wrote, was one of 'several factors which lead in my view, to the conclusion that a costly votive gift was displayed just below the left hand of the Virgin'.[107]

The role of the donation of wealth by secular society is a vital theme in the study of luxury church decoration. The example provided by Constantine was of great importance. It was his decision, having converted to Christianity, to patronize the Church using the full panoply of imperial wealth and wealth-based propaganda. The metaphor of substances special to the elite, as markers of excellence, was placed at the centre of the State's embrace of Christianity. One of the classic vignettes of the ensuing Christian 'treasure society' may be found on either side of

[104] Text in Davis-Weyer (1986), pp. 59–66. [105] Nordhagen (1987).
[106] On later Byzantine precious metal revetments on icons, Grabar (1975). [107] Nordhagen (1987), p. 459.

the high altar of San Vitale, Ravenna. In two panels, the sixth-century imperial couple, Justinian and Theodora, are shown in their full court splendour as intermediaries between heaven and earth.[108] Set above rich marble inlays of *opus sectile* work in green, yellow, white and much purple, these mosaics are set at the feet of the imperially inspired 'Christ in majesty' scene of the apse (figure 7, p. 115). The royal couple are shown walking towards the altar, bearing treasure gifts: Theodora a chalice and Justinian what may well be a paten.[109] The emperor is shown wearing a brooch-fastened display cloak, known as the chlamys, over a tunic (figure 2, p. 30). The distinction of the ruler in this costume (referred to by German scholars as the *Dienstkostüm*) was achieved by the use of especially expensive dress materials.[110] The emperor wore the diadem as a badge of pre-eminence, as had been the rule under the cultic representations of the Hellenistic sovereigns.[111] The imperial brooch that fastened his chlamys was larger and showier than those of his officers and it was covered in gems.

The status counterparts for women of the men's brooches included broad necklaces of gold and gems. Theodora is shown wearing a vast example made largely of pearls. She also sports the diadem, coupled with other complex jewelled hair ornaments, ear-rings and gold bracelets. Her robes are of purple and gold. Her attendants are similarly dressed, save for the royal purple and with less jewellery.[112] The background of these panels is gold, like the background of the apse-vault. They are framed with a motif inspired by cabochon gem-settings on gold. Furthermore, each panel is defined at each side by the representation of a jewelled pillar. In real life, large pillars were usually of plain marble (as in San Vitale), although mosaic-decorated pillars exist from Pompeii, and may well have been in use in late Antique palace architecture.[113] Small marble columns with patterns of recesses for glass inlays have been found at the late Antique churches of Polyeuktos, Ioannes and Euphemia in Constantinople.[114] Such examples show that these treasure motifs were directly based upon real life.

As has been stressed, mosaics were but part of total programmes of church

[108] There is a huge bibliography on these panels, of which some of the most important discussions are Nordström (1953), pp. 98–102, Deichmann, part 2, *Kommentar* 2 (1976), pp. 178–87, Stricevic (1962), Grabar (1968d), Barber (1990) and Elsner (1995), pp. 177–88. Colour illustrations, Bertelli (1989), pp. 78–81. These panels are in a subordinate position and bishop Maximian is shown in the position of honour in front of Justinian in the depicted procession to the altar.

[109] Grabar (1968d), p. 461.

[110] Galavaris (1958), p. 101, summarizes what is said at successively greater length by Delbrueck (1932b) with the *Dienstkostüm* described at p. 5, and by A. Alföldi (1970b).

[111] Pollitt (1986), p. 32. See also chapter 2 of this book (pp. 27–8). [112] Bovini (1956), pls. 35–7.

[113] Sear (1977), pl. 30–1 and Cecchelli (1922), p. 3.

[114] Matthews (1971), pp. 56 and 62–3 and pls. 41, 44, 49 and 50 and Harrison (1989), pls. 82–3 and 94. Examples are in the Istanbul Archaeological Museum, cat. nos. 3908 and 5078.

VISUAL SYMBOLISM: CHRISTIAN WALL MOSAICS

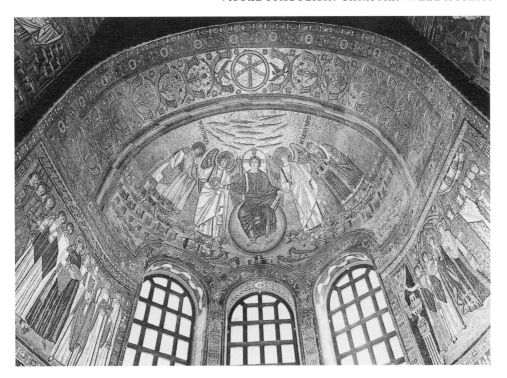

Figure 7. Apse mosaics, San Vitale, Ravenna (mid-sixth-century), showing Christ in majesty, whilst below on each side are depicted the imperial couple, Justinian and Theodora, in their full court splendour as intermediaries between heaven and earth.

furniture and decoration which made extensive use of treasure substances throughout. Precious materials were employed in church furniture and equipment. Silver revetments for the altar, *ciborium* (altar-canopy), chancel-screen, *ambo*, doors and elsewhere, required particularly large quantities of metal.[115] Wall decoration schemes were, therefore, but one element in the ostentatious use of precious substances in late Antique churches, paralleling the application of gold, silver ink and purple dye to codices and the attachment of gold and silver plates to icons. Light flashed from fittings, from vessels and from reliquaries glistering with gems, as well as from the mosaics and from various other items fixed to the walls. Nevertheless, by virtue of its iconographic prominence, precious-metal mosaic enjoyed an especially important position in these comprehensive compositions. In particular, the apse mosaics were the visual, if not the religious, counterparts of the main cult statue in a pagan temple. It is therefore important to examine the iconographic significance of

[115] M. M. Mango (1986), p. 3 and (1992).

these mosaics, as is the purpose of the current section, before examining the general position played by the symbolism of gold in this period.

Unfortunately, symbols in art are notoriously easy to identify and very difficult to interpret correctly. It is for that reason that the discussion of this evidence has been preceded by an examination of Christian literary symbolism in late Antique culture. Such an approach is all-important if late Antique and early medieval Church mosaic is to be understood as evidence for the period which produced it. Many questions spring to mind. To what extent were these works of art the product of aesthetic attitudes? To what degree were they expressions of specific contemporary ideas and understandings? In what ways might they have been *functional* in so far as they were intended to have, or did fulfil, a propagandistic role? As has been noted, these Christian mosaics made extensive use of treasure materials in their construction and included many representations of treasure items. The particular significance of this evidence is that it provides abundant examples of context. Specific people are shown with specific jewellery. Particular use was made of gold tesserae for particular parts of the complete iconographic schemes. This is of remarkable assistance in establishing the position of treasure as a metaphor for excellence in Christian society.

Bearing in mind the discussion of symbolism as an issue in its own right,[116] it is now open to consider the multiplicity of positions played by treasure in late Antique mosaic. This can be done under a variety of headings. Firstly, there is the portrayal of treasure items from the 'real world', that is, those which did exist outside the mosaics. In this category would be the depiction of a silver vessel on an altar, for instance. Secondly, there is the issue of the use of precious substances to portray either abstract designs or items which were not so constructed in the real world. An example of that would be the use of gold tesserae for stars. Bearing in mind such principles of division as this, treasures and treasure use in mosaic can be divided into a number of categories (which, it should be emphasized, are not discrete).

1. Direct depiction of a specific real treasure item, such as the silver *ciborium* of Demetrius shown in the mosaics of the church of St Demetrius, Thessalonica.[117]
2. Direct depiction of non-specific real treasure items, such as the imperial court jewellery in the San Vitale panels of Justinian and Theodora (figures 2 and 7, pp. 30, 115).[118]
3. Treasured depiction of an item that might or might not be so constructed outside the mosaic, such as the cross shown in the apse of Santa Pudenziana, Rome, which is jewelled as real votive crosses often were.[119]

[116] In chapter 3. [117] Cormack (1985a), no. 32 and (1985b), p. 70 and pl. 27.
[118] Bertelli (1989), pp. 78–81. [119] Ibid., pp. 58–9.

4 Depiction of a real non-treasure item, but using treasure substances, such as the stars on the ceiling of the Mausoleum of Galla Placidia.[120]
5 Abstract use of treasure, that is as a decorative motif, as with the strips of gold set with gems which were used as borders as in the apse of Sant'Agnese in Rome and elsewhere (figure 13, p. 169).[121]
6 Use of treasure substance as a colour, as in the case of the gold used in place of yellow used as highlighting in the panel of Joshua fighting the five Amorite kings (Joshua 10: 9–16), Santa Maria Maggiore, Rome.[122]

As indicated above, these are not exclusive categories. They merely display the variety of situations of treasure use and depiction in mosaics. In the following discussion, it has not been my intention mechanically to list all occurrences of treasure items. Rather the form of such usage will allow exploration of the interaction between a treasure item and its image in the late Roman period. It should be emphasized that mosaics are here taken as a well-evidenced example of wider usage on a variety of media, such as wood carving and tapestries.[123] The visual language of these mosaics was that of their own time. There was no canon of earlier Christian monuments on which to draw. Parallels for grand devotional buildings, apart from pagan temples, were the great dwellings of the contemporary elite, hence the importance of palaces as discussed in chapter 2. Figures from the sacred Biblical past were pictured in a way that would make visual sense to an age already grown very distant from the time of the life of Christ. Flamboyant late Antique costumes and details were employed in Christian compositions illustrating times long past (the Old Testament) and also times to come (the Last Judgement). Ragged holy men communicated effectively when seen in life: when speaking, when praying, when berating. As still depicted shapes they were difficult to distinguish from vagabonds. The advantage of elite dress was that it was designed to communicate a sense of superiority without the need for words. This mode of representation was necessary for clear visual explanation of the distance and supremacy enjoyed by the glorious martyrs, by others of the elect and by the angels on high.

As such, contemporary gold adornments appeared upon the figures of ascetic saints long dead, whilst the flashing of gold in the resulting images simply mirrored the brilliant treasure equipment of the church itself. The reason why religious scenes were not immune from these secular systems of presentation is simple. People's visual symbolic language was rooted largely outside the Church. Therefore, secular metaphors had to be used in Christian propaganda, or else such

[120] Ibid., pp. 66–7. [121] Ibid., pp. 88–9. [122] Brenk (1972), p. 22 and fig. 8.
[123] Such as Weitzmann (1979a), cat. no. 477, pp. 532–3, a sixth-century wool tapestry icon from Egypt, showing Mary, on a jewelled throne flanked by angels, below God the Father in a *mandorla*.

arguments would not have been comprehensible to the masses. This led, at times, to magnificent ironies, the most prominent of which is provided by the adulation of poverty and abstinence using the language of abundance, brilliance and wealth. As such, it is fascinating to observe how the secular ornaments of the ruling powers were transferred to religious figures. Clad in purple, and adorned with gems set in precious metal, saints appeared against brilliant grounds of gold tesserae. Thus, in the chapel of San Venanzio attached to the Lateran Baptistery, we find martyrs depicted in the seventh century as court dignitaries complete with the chlamys and cross-bow brooch.[124] The same thing may be observed at Thessalonica, where St Demetrius appears dressed in this manner in the mid-seventh-century dedication mosaic of his church, as he does elsewhere in the church. These Greek images, as Cormack comments, were created both to commemorate events and as icons for worship. The small gold insigne of the saint's brooch overlaps with the huge gold badge of his halo.[125] Different groups competed in the use of such symbolism. In that world, saints were shown with jewels and emperors with the nimbus, that artistic formalization of emanating other-worldly *virtus*.[126]

Treasure baubles were not, however, applied indiscriminately. There was a careful application of appropriateness. Thus, although worldly items were bestowed anachronistically, they were applied usually in accordance with what was known of the life of the saint. Thus, the martyr Demetrius is suggested in one tradition to have been an official of high rank, which supports depiction of him in State uniform.[127] Likewise, in Thessalonica the same practice can be observed in the rotunda mosaics of the church of St George, where Onesipheros, a soldier-saint, is shown with cross-bow brooch and chlamys.[128] They are nevertheless shown dressed in the splendours of this world, not as John the Divine would have expected them to appear in heaven, having 'washed their clothes and made them white in the blood of the lamb'.[129] Still less is there any equivalent of the Renaissance enthusiasm for lamentations about the figure of Christ taken down from the cross. These saints appear in the full panoply of *worldly power*, with its attendant treasure symbolism. Ancient artists, it appears, were not encouraged to cope with the Passion in the realm of public art.[130]

Late Roman people, like their predecessors, sought to show the 'ideal human', and likewise thought that that figure would appear victorious, serene and beautiful

[124] Grabar (1968a), p. 43 and pl. 107. [125] Cormack (1985b), p. 53 and pl. 14.
[126] The nimbus is discussed on pp. 143–5, under 'The taste for brilliance'.
[127] Cormack (1985b), p. 59. [128] L'Orange & Nordhagen (1966), pl. 46.
[129] Rev. 7: 14, 'laverunt stolas suas et dealbaverunt eas in sanguine agni'.
[130] Van Der Meer (1967), p. 120. There is an exception in that 'private art' for the 'spiritually elite viewer', manuscript-illumination. The 'extremely expressive realism' of the Rabbula Gospels includes a full-page miniature of the Crucifixion, pl. 45. See also Hutter (1988), p. 97.

both in body and in spirit, as in the style with which the royal house promoted its members.[131] So again, on the mid-fifth-century triumphal arch mosaics of Santa Maria Maggiore in which a king with full imperial costume is seen welcoming the Christ child, Mary is shown dressed rather like one of Theodora's attendants in San Vitale, Ravenna (the same thing can be seen elsewhere on the triumphal arch of Santa Maria Maggiore).[132] Furthermore, the imperial prototype itself was reproduced directly as the reflection of heaven, hence the appearance of Caesar's distinctive brooch clasping the imperial purple at the shoulder of Christ Militant in a mosaic of the Archbishop's Chapel at Ravenna (figure 12, p. 131).[133] From its symbolism of *virtus* and majesty, this special dress was also applied to figures less directly 'imperial' yet still illustrious, such as the archangels in Sant'Apollinare in Classe (figure 8, p. 120).[134] This phenomenon was by no means restricted to mosaic art. For example, by the same token, king David appears in the sixth-century Sinope Gospel with diadem, chlamys and a classic imperial brooch with three pendants.[135] By contrast, Pilate, an imperial agent seated in judgement flanked by the imperial images, appears in the Rossano Gospels of the same period with the chlamys and a cross-bow brooch, which was the nobles' equivalent of the imperial *fibula*.[136] This intrusion of dress types derived from Roman military practice is especially startling, but it is well to observe that even when Christ appears dressed as a civilian, which is his normal mode, his clothing is most often shown as made of purple, which was by far the most expensive dye-stuff and restricted in use by imperial decree (figure 9, p. 121).

In addition to all of this, as Grabar has demonstrated at length, 'Christian iconography inherited from Imperial iconography, not only formulas but subjects', such as Christ in majesty, Christ enthroned and Christ crowning the saints.[137] This took place because it was the Christian imperial court that was *the* non-pagan source of readily appreciable allegories of power and which had hitherto specialized in the visual presentation of high authority. In all these above examples, real items and figures are seen employed in a partially figurative manner. Here we find the typical ambiguity between symbol and 'reality' that haunts these works. Perhaps we should accept that these images were supposed to be ambiguous and so to provoke generalized feelings of awe and admiration, as well as inducing thoughts about their context. Certain items, the cross is a good example, were

[131] Winfield & Winfield (1982), p. 185, Byzantine figures in art 'do not exemplify any break of tradition between the Classical and Byzantine worlds'.
[132] Cecchelli (1956), pl. 53. [133] Bovini (1956), pl. 14. [134] Ibid., pl. 46.
[135] Paris, BN, suppl. gr. 1286, folio 15. See Grabar (1948), plate 3, fig. 5 and discussed p. 13.
[136] Rossano, Cathedral Treasury, *Codex Purpureus*. Facsimile, *Codex Purpureus Rossanensis* 1 (1985-7), p. 15; discussed by Loerke (1985-7), pp. 145-8.
[137] Grabar (1968b), pp. 42ff and (1936), chapter on 'L'art impérial et l'art Chrétien', pp. 196-243.

THE ART OF PERSUASION

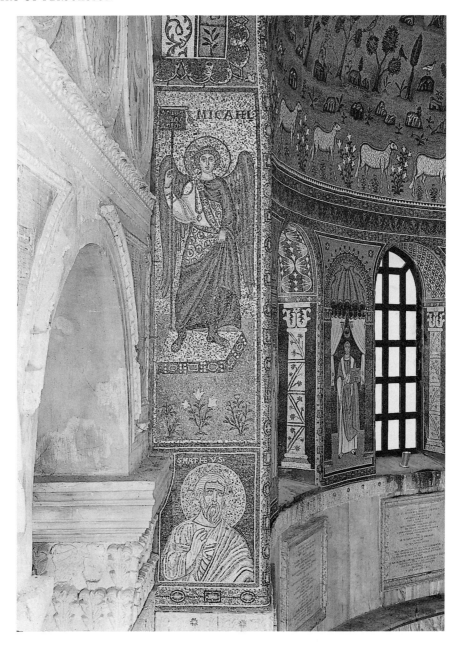

Figure 8. Mosaic of archangel Michael, Sant'Apollinare in Classe, Ravenna (mid-sixth-century), which gives a spiritual being imperial dress.

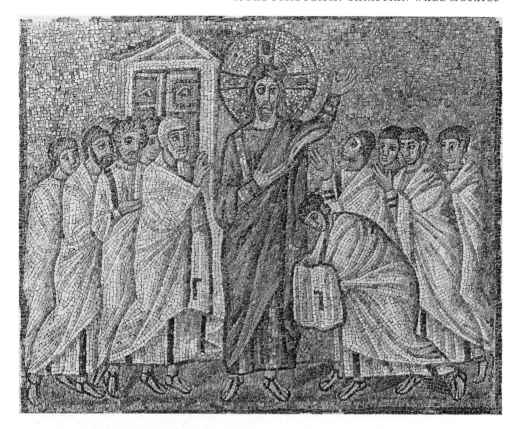

Figure 9. Detail of wall mosaics, Sant'Apollinare Nuovo, Ravenna (*c.* 500), with Christ distinguished by purple clothing and a jewelled halo.

shown as golden in art and were often constructed of that metal in reality. In both cases, treasure materials, primarily gold and gems, were employed as a way of enhancing the power of the object as symbol and of the image as symbol in the context of the 'potency' of precious materials (meaning the strength of their positive associations). Use of a special substance, together with positioning and scale, were all means of indicating the importance of an image.[138]

[138] A parallel may be drawn with the double-headed axe that was the symbol of the chief Minoan goddess. The shape was related to sacrifice, as was the cross. In the palace of Knossos, 'the symbol was displayed as frequently and conspicuously as the cross in Christian buildings. It might be made in bronze of gigantic size, or very often in gold'. Monumental examples were set up to dominate rooms, whilst at the other end of the scale miniature examples have been excavated in scores from tombs and caves, Hawkes (1968), p. 131 and pl. 16, miniature gold axes from the cave of Arkalochori, *c.* 1500 BC. These echo the gold-leaf crosses that have been found in Lombard graves in early medieval Italy, Menis (1990), pp. 180f, on the finds from the aristocratic Lombard burial, tomb 119, Castel Trosino. See also pp. 223 and 226f. These are mostly seventh-century examples.

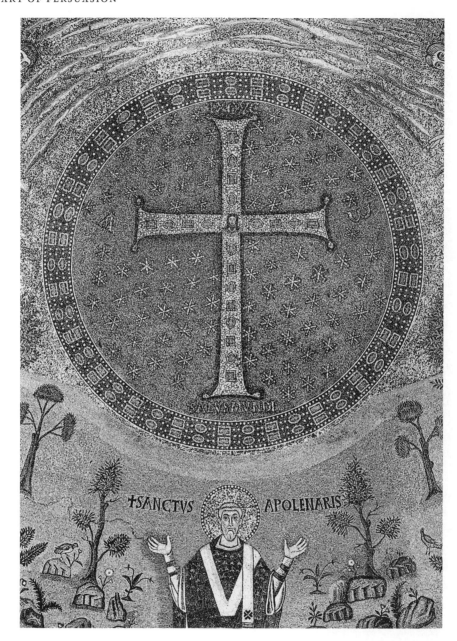

Figure 10. Central detail of apse mosaic, Sant'Apollinare in Classe, Ravenna (mid-sixth-century), with a huge jewelled cross in the heavens set amidst a golden sky.

It is vital to realize that the cross, from the moment that Constantine placed that motif on his *labarum*, was a symbol of triumph both of Christ and of the emperors.[139] Shortly after, a giant *crux gemmata* was erected at Golgotha.[140] From this point, the jewelled cross was clearly an attribute of Christ's power. Especially in the *chi-rho* form, there was, in naturalistic terms, no imperative to show the cross as jewelled, unless one wished to represent a contemporary votive cross in preference to that on which Christ died. But then the very fact that many votive crosses were jewelled tells us something in itself. The addition of such ornaments aided the focusing of attention on this item. The application of gems added prestige. In the context of the cross, this is a particularly poignant reminder of the comparison between the later adulation and the earlier vilification of Christ, a contrast of which the Church was very much aware. Yet, modern irony notwithstanding, take one look at the apse of Sant'Apollinare in Classe, Ravenna and you will appreciate the power of this motif. Above the lushness of paradise, the cross towers gold and gaudy with gems, set in a jewelled border against a glittering backdrop of stars (figure 10, p. 122).[141] We find it easy to appreciate this potency because gold and gems are still for us the preserve of the rich and the powerful. It is therefore hardly surprising to find the cross in a place of prominence in several other major mosaics. A jewelled example towers over the Christ on the throne in the apse of Santa Pudenziana.[142] The backdrop is Jerusalem. This cross is a representation of the *crux gemmata* at Golgotha.[143] The same motif is similarly prominent at San Stefano Rotundo and San Lorenzo.[144] Unjewelled gold crosses are carried by figures in the Mausoleum of Galla Placidia.[145] Christ carries a tall and jewelled cross at the centre of the apse of San Michele, Ravenna.[146] Other examples can be found from Hagia Sophia to the Baptistery of the Orthodox at Ravenna and the basilica of Casarenello; in other words, from the full range of late Antique churches.[147] Representations of jewelled crosses made their way onto treasure items themselves, as may be illustrated by the huge example shown between two angels on a sixth-century silver plate now in the Hermitage.[148] What late Antique votive

[139] Grabar (1936), 'la croix triomphale', concentrating on the evidence of fourth-century sarcophagi, pp. 239–43.
[140] Kühnel (1987), pp. 66–9.
[141] L'Orange & Nordhagen (1966), pls. 76a and 77. This church is thought to have been the inspiration behind the similar decoration of the apse of SS. Nero ed Achilleo in Rome, Wisskirchen (1991), esp. fig. 1.
[142] Wilpert (1976), pls. 21–2 and Beckwith (1970), p. 13.
[143] Kühnel (1987), pp. 66–9. [144] Oakeshott (1967), San Stefano, pl. 91 and San Lorenzo, pl. 77.
[145] Wilpert (1976), pls. 73–4.
[146] The apse mosaic of San Michele is now in Berlin, see Effenberger & Severin (1992), cat. no. 47, pp. 128–31, with Bovini (1969b).
[147] For example, Wilpert (1976), Orthodox Baptistery, pl. 87, Casarenello, pl. 107.
[148] Kent & Painter (1986), cat. no. 67, pl. 26b.

crosses were like can be inferred from the precious survival of such items as the sixth-century processional cross in silver attributed to the gift of archbishop Agnellus of Ravenna (figure 11, p. 125).[149] We are also very lucky to have preserved the cross given by the emperor Justin in the sixth century to the church of Rome.[150]

In the course of discussions of jewelled symbolism, it should never be forgotten that the naturalistic impulse coexisted with the symbolic, at least in determining the form of these motifs and in conditioning what was thought suitable for decoration. So, for example, representation with gems hanging on the side arms of crosses does not appear as demanded by the essential symbolism of the cross, which depended simply upon its shape and the materials of which it was made. However, there do exist a number of representations of crosses with *pendula* (hanging jewels) suspended by chains from the side-arms. A use of such crosses almost as a pattern motif can be seen around the base of the gold-ground apse mosaic of Sant'Aquilino, Milan.[151] A further example is provided by the ceiling of the eastern apse of the Lateran Baptistery, which dates from the time of Sixtus III (mid-fifth century).[152] The top section consists of the lamb of God and four doves with lilies and roses. Hanging down into the acanthus scroll below are six crosses set with red and green gems, with a single *pendulum* on each side-arm and two more at the foot. These can have had no symbolic justification except in so far as they were images of contemporary votive crosses.

Similar items are shown in roundels, flanked by animals, in panels that frame the chancel altar of the church at Qasr-el-Lebia, Cyrenaica.[153] Both these and Justin's cross have two gems on each side-arm. Mosaic pavement depiction of crosses is uncommon because of the imperial prohibition on walking on this sacred symbol,[154] although examples exist, as at the church at Umn-er-Rus in Palestine.[155] A cross with three pendants on each arm is shown in marble *opus sectile* on a wall of Hagia Sophia.[156] Another example is provided by the crosses borne by angels on the walls of the presbyterium in San Vitale.[157] These have letter-shapes hanging from their arms. An alpha and omega are likewise shown so positioned under the arms of a cross on a late Antique sarcophagus in the church of SS. Decenzio e Germano, Pesaro.[158] Exact parallels are hard to find, however an early Byzantine silver cross of uncertain provenance has an alpha and omega on each of its side-arms and an Armenian example has a single omega-shaped pendant surviving out of an original pair.[159]

[149] Mazzotti (1960). [150] Elbern (1964). [151] Bovini (1970), pl. 7. [152] Wilpert (1976), pls. 25–7.
[153] Alföldi-Rosenbaum & Ward-Perkins (1985), pp. 133–5 and pl. 45.
[154] *Codex Iustinianus*, 1, 8, 'Edict of Theodosius II', dating from 427, in C. Mango (1986), p. 36.
[155] Avi-Yonah (1934), cat. no. 326, p. 45. Kitzinger (1970), p. 647, notes that crosses were employed apatropaically on thresholds and other 'vulnerable' parts of buildings.
[156] Underwood (1960), pl. 3. [157] Von Simson (1987), pls. 14–15. [158] Gabrielli (1960), p. 109, fig. 10.

VISUAL SYMBOLISM: CHRISTIAN WALL MOSAICS

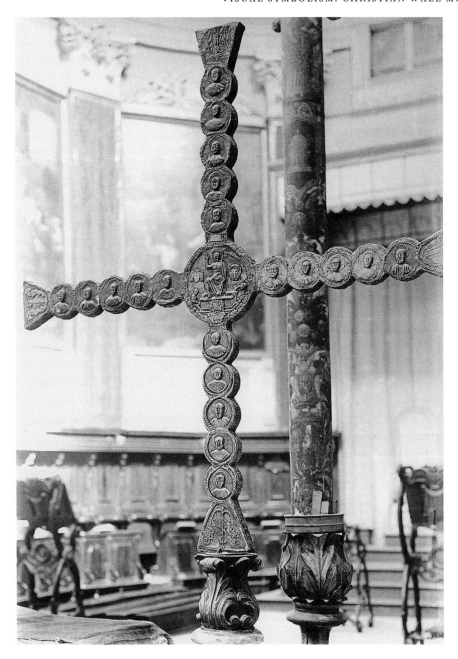

Figure 11. Silver cross, Cathedral, Ravenna (sixth-century), attributed to the gift of archbishop Agnellus.

Such concern for detail on the part of mosaicists draws attention to the fact that gold and gems appear prominently in mosaic precisely because they occurred prominently in the late Antique world. The application of gold and gem-settings to texts carried by mosaic figures signals the prominence of jewelled book covers, such as are familiar from medieval Church treasuries.[160] The codices indicated may be the whole Bible, or, borne by individual Evangelists, may represent separate Gospels. The point is the same: these are texts of the greatest worth. Their value is therefore visually highlighted by the presence of jewelled covers. Representation in this style can be seen in Rome at San Venanzio at the Lateran Bapistery, Sant'Agnese (figure 13, p. 169) and San Marco,[161] at Ravenna in San Vitale (figure 7, p. 115), Sant'Apollinare in Classe (figure 10, p. 122), Sant'Apollinare Nuovo[162] and at the Basilica Euphrasiana, Poreč,[163] amongst many others. Manuscript evidence is not extensive for late Antiquity, but during the early Middle Ages it was quite standard to provide such treasure covers for codices. Thus, it was inscribed in the Lindisfarne Gospels that a certain anchorite, Billfrith, had made a cover for the manuscript, adorned with gold, gems and gilt silver. As Henderson has written of the elaborately decorated Book of Kells, 'the Gospel and its cover are likely to have been equivalents of one another, in status and artistry'.[164] In general, gems were of growing prominence as a promotional motif, as can be seen from the appearance of emperors and empresses of the middle Byzantine period. Emeralds, sapphires, rubies and pearls had by then completely taken over formal state costume and the rulers appear as if encased in jewelled straitjackets, as in the depictions of the empress Zoe and her husband in Hagia Sophia (early eleventh century).[165]

One distinctive item that saw the same process of 'jewelled inflation' was the victory crown (*corona*). Pliny listed several forms, some of leaves, some of metal.[166] In the Roman army, the gold crown was one of a variety of triumphal ornaments which were displayed with pride by their recipients. So, for example, the tombstone of C. Allius Oriens, a legionary centurion buried in the first century AD at Vindonissa in modern Switzerland, displays, as its sole ornamentation, three *coronae aurea*, two *torques* (barbarian-derived neck-rings, worn by Romans of the early Empire in pairs at the shoulder), two *armillae*

[159] Dodd (1987), pls. 1, 2 and 8.
[160] Frazer (1992).
[161] At Rome, Wilpert (1976), San Venanzio, pl. 110 and Oakeshott (1967), San Marco, pl. XXIII.
[162] At Ravenna, Wilpert (1976), pl. 94; Bovini (1956), San Vitale, pl. 28 and Von Simson (1987), Sant'Apollinare in Classe, pl. 22 and Sant'Apollinare Nuovo, pl. 33.
[163] At Poreč, Tavano (1975), Basilica Euphrasiana, fig. 18.
[164] G. Henderson (1987), Lindisfarne Gospels, p. 112 and Book of Kells, p. 179.
[165] Bertelli (1989), pp. 134–5. [166] Pliny, *Hist. Nat.*, 22, 4.

(arm-rings) and a set of *phalerae* (medallions which were worn on a chest-harness).[167] The jewelled crown of Jupiter the sky God, held above the one celebrating a triumph, became the attribute of the emperors, essentially from the time of the decree of the Senate which granted Julius Caesar all divine and human honours.[168] Crowns, like modern medals, were handed out by emperors. Gellius tells us that triumphal crowns are those which are sent to commanders because of the honour of triumph. These crowns 'were anciently made out of laurel, but afterward they began to make them out of gold'.[169] The change appears to have taken place in the second century.[170] The Christian use of such imperially inspired imagery was aided by the tradition of Jewish royal crowns, in which this item was a symbol of the Messianic kingdom.[171] Paulinus of Nola wrote of Christ the King handing out crowns and brilliant robes to the saints.[172] In San Vitale, Christ the world ruler is shown sitting upon a globe and handing out crowns as a symbol of victory (figure 7, p. 115).[173] Christ himself, of course, was the supreme victor, and so properly was also crowned, as were emperors, by God, or by personifications of victory or by angels.[174]

Crowns or wreaths were also commonly presented to the dead as a sign of belief that the deceased had triumphed by reaching the otherworld.[175] In just this way, crowns were used in Christian iconography as an attribute of martyrdom. In Christian mosaic, they are sometimes shown as wreaths with a central gem (the original form of the *corona aurea*), as at Santa Pudenziana and SS. Cosma e Damiano, amongst many other examples.[176] Such crowns also appeared in a number of mosaic pavements.[177] However, especially in the later period, from the late fifth century onward, crowns are typically shown as being completely formed of gold and jewels, no attempt being made to imitate leaves, as with the imperial diadem that was shown worn by the emperors from the time of Constantine as a symbol of eternal triumph.[178] It was at this time that such an item first appeared as a fixture on the imperial coinage.[179] Examples of this form of crown may be seen at, amongst others, San Vitale, Ravenna (figure 7), San Vittore in Sant'Ambrogio, Milan, and at San Lorenzo, San Pietro in Vincoli and

[167] Maxfield (1981), pl. 6a. Types of *coronae* are illustrated at p. 73, fig. 6. Steiner (1906), on the *corona aurea*, pp. 38–40.
[168] A. Alföldi (1970c), p. xiii.
[169] Gellius, *Noct. Att.*, 5, 6, 6–7, 'Haec antiquitus e laure erant, post feiri ex auro coeptae.'
[170] Baus (1940), p. 148. [171] Breckelmans (1965), pp. 7–38.
[172] Paulinus of Nola, *Carmina*, 18; G. de Hartel (ed.) *CSEL* 30 (1894).
[173] Grabar (1936), pp. 202–5 and pl. 32 n.2. [174] MacCormack (1981), p. 176. [175] Mathews (1993), p. 163.
[176] Bertelli (1989), Santa Pudenziana, pp. 58–9 and SS. Cosma e Damiano, p. 74.
[177] Balty (1977), no. 39, pp. 88–9. [178] A. Alföldi (1970b), pp. 38–41, on crowns, pp. 145–51, on diadems.
[179] Examples on Constantinian coins and medallions are listed by Wessel (1971), col. 539, and are illustrated in M. Alföldi (1963), pl. 17 (nos. 220–3) and pl. 18 (nos. 230–1).

Sant'Agnese in Rome (figure 13, p. 169).[180] The two styles are mixed in the procession of saints in the nave of Sant'Apollinare Nuovo.[181] In this case, in which the holy men carry their crowns in procession (which may also be seen with the Apostles on the cupola of the Arian Baptistery at Ravenna)[182] these *coronae* are being borne towards Christ as offerings.[183] The imperial ceremony of *aurum coronarium*, when leading senators brought crowns as tribute from their respective cities, may well have been the prototype for this form of depiction.[184] Just such a scene in Christian form is presented by Prudentius, who describes as bringing crowns the cities from whence came the eighteen martyrs who were the subject of one of his poems; 'you Tarraco, mother of godly children, will offer to Christ a beauteous diadem with three gems [representing three martyrs]'.[185]

Treasure decoration was applied to items in the imagery of these mosaics, as often in reality, so as to highlight the object in question and to provide it with an association of high status, so transforming, for instance, a seat into a throne. A further example of the use of gold and gems as a way of signifying extra prestige on the part of whatever was so adorned is furnished by the representations of the walls of holy cities as jewelled. The heavenly Jerusalem was described by John the Divine as being built of gold and jewels, thus providing Scriptural justification for this artistic trait.[186] This city therefore, and also Bethlehem, is shown built out of treasure substances in the mosaics of Santa Maria Maggiore, Rome, whilst all the other cities are shown with plain walls.[187] The same phenomenon can be seen in Rome at San Venanzio and San Lorenzo.[188] A seventeenth-century drawing by Campiani shows that the same motif was once present at Santa Sabina.[189] Another such illustration suggests that such cities were also present on the original apse mosaic of Old St Peter's,[190] of which fragments survive to testify to the authenticity of the drawing.[191] What was applied to these cities, a combination of imitation gem-settings on gold, was a decorative motif, a pattern which was furthermore frequently used in the form of a jewelled band as a border decoration.[192] This can be found in some floor mosaics,[193] as well as in a majority of the late Antique and early medieval schemes of wall mosaics; examples can be seen in the basilica of Casaranello, San Prisco at Capua and the Baptistery of San

[180] Baus (1940), San Vitale, p. 201. Wilpert (1976), San Vittore, pl. 77a; Oakeshott (1967), San Pietro, pl. 154 and San Lorenzo, pls. 75–7.
[181] Bertelli (1989), p. 85. [182] Ibid., p. 77. [183] Grabar (1936), 'l'offrande au Seigneur', pp. 230–4.
[184] Klauser (1944); MacCormack (1981), pp. 58 and Kinney (1992), pp. 204–5. Regulations concerning *aurum coronarium* can be seen at *Codex Theodosianus*, 12, 13, 1–6.
[185] Prudentius, *Perist.*, 4, 21–2, 'tu tribus gemmis diadema pulchrum offeres Christi, genetrix piorum Tarraco'.
[186] Rev. 21, *passim*. [187] Wilpert (1976), pls. 71–2.
[188] Ibid., San Venanzio, p. 94, fig. 63 and Oakeshott (1967), San Lorenzo, pl. 77.
[189] Wilpert (1976), p. 13. [190] Ibid., fig. 35. [191] Oakeshott (1967), pl. 29.
[192] Gage (1993), pp. 73 and 278 n. 51. [193] Donceel-Voûte (1988), p. 448.

Giovanni, Naples.[194] In Rome the motif was employed at Santa Maria Maggiore, San Venanzio, San Stefano Rotundo, San Lorenzo and Sant'Agnese.[195] At Ravenna it occurs in San Vitale (figure 7, p. 115), the Arian Baptistery[196] and San Michele,[197] amongst others.

Perhaps the pre-eminent case of the piling up of treasure images to construct specific motifs of power can be seen in the example of the symbolically occupied throne. A splendid example occurs in the cupola of the Arian Baptistery, Ravenna (frontispiece). Around the central image of baptism, the Apostles are lined up facing toward the Lord's throne. The chair itself is set with pearls and red, blue and green gems. On the throne is a purple cushion, on which is a cross set with gems and draped with another piece of purple cloth.[198] Another such throne, which has a crown upon it, appears at the apex of the triumphal arch of Santa Maria Maggiore, Rome.[199] Elsewhere in Santa Maria Maggiore, the baby Jesus is shown sitting on a jewelled throne.[200] Other examples can be found at Santa Pudenziana, Rome;[201] San Prisco, Capua and the Orthodox Baptistery, Ravenna.[202] From Paulinus of Nola's description, it appears that the now-destroyed apse at Fundi, likewise had a cross on a throne as its focal point.[203] Similarly from surviving illustrations it appears that the original triumphal arch of SS. Cosma e Damiano also featured a lamb and cross on a throne, set together in a complex of references to the Apocalypse, including golden candles.[204]

The presence of 'imperial' purple on these thrones was of great importance. Purple cloth and above all silk, was, along with gold and gems, one of the most important symbols of prestige in late Rome.[205] It was praised, in much the same language as gold, for its *brilliance*. Its production was protected by imperial writ and its use was likewise restricted, the best forms being retained for the adornment of the imperial house, hence its power in mosaic as an indicator of the supreme ruler.[206] The depicted purple-covered and jewelled thrones appear to have been inspired by cultural prominence of the motif as reflected in the practice of

[194] Wilpert (1976), Basilica, Casaranello, pl. 107; San Prisco, Capua, pl. 83 and Baptistery of San Giovanni, Naples, pl. 15.
[195] Ibid., Santa Maria Maggiore, pls. 54–70ff; San Venanzio, pl. 110 and Oakeshott (1967), San Stefano Rotundo, pl. 91; San Lorenzo, pls. 75–6.
[196] Wilpert (1976), San Vitale, pls. 108–9 and Oakeshott (1967), Archiepiscopal Chapel, pl. 128 and Arian Baptistery, pl. 78.
[197] Effenberger & Severin (1992), cat. no. 47, pp. 128–31, with Bovini (1969b).
[198] Bertelli (1989), p. 76. Such *insignia Christi* were mentioned in a seventh-century inscription from San Chrysogoni in Rome, Grabar (1968c), p. 347.
[199] Wilpert (1976), pl. 69. [200] Ibid., pls. 61–2. [201] Ibid., pls. 20–2.
[202] Ibid., San Prisco, pl. 84; Orthodox Baptistery, pl. 90 and Arian Baptistery, pl. 100.
[203] Discussed by Goldschmidt (1940). [204] Wilpert (1976), p. 15.
[205] Muthesius (1991) gives a huge bibliography on the Byzantine silk industry.
[206] Reinhold (1970) and Gage (1978), pp. 109–10. See also chapter 2 of this book (pp. 21–37).

emperors and the depiction of pagan deities.[207] Cathedrals themselves were throne rooms. Churches were the houses of God and places for meeting, but they were also the audience halls of bishops, whose *cathedrae* were important insignia. That of Paul of Samosata at Antioch, at least, was noted for its splendour.[208] The *Liber Pontificalis* tells us that Christ was shown seated in monumental silver statuary, both as a teacher on a stool and as a ruler on a silver throne in the Lateran Basilica.[209] Emperors would have sat throned when attending services. They certainly did so in the palace.

Was all this imagery *derived* from the State? Caesar had enjoyed a golden place in the curia.[210] This seat became a jewelled throne.[211] According to the sixth-century testimony of Corippus (describing the occasion of the donation of largesse by Justin II in forms such as silver vessels filled with gold coin), 'in the great hall was a seat, built with great complication, proud with gold and jewels, having its own light without the sun. The gems' nature illuminated all nearby, changing the colours of things and putting into the shade the rays of the shining Phoebus'.[212] This throne was covered further in precious draperies.[213] Yet Thomas Mathews has identified and condemned what he refers to as 'the emperor mystique', which has led to the excessive identification of imperial derivation in Christian art.[214] Christ indeed sat on a jewelled throne in the apse of Santa Pudenziana, but the seated disciples were grouped before him as if at the feet of a philosopher. To sit in the imperial presence was forbidden at an audience.[215] Mathews argues that this and the other thrones in Christian art were not typically modelled on the imperial throne as described by Corippus, which was probably a jewelled example of the ancient stool, the *sella curalis*, but were based on the thrones of pagan divinities.[216]

It is indeed easy to agree that such studies as that of Christa Ihm were overly preoccupied with identifying signs of imperial influence at almost every turn.[217] In reality, much of the message of Christianity could not be expressed at all in the language of empire. Other images were needed to show Christ as healer,

[207] See entry 'throne', in Kazhdan (1991), pp. 2082–3. [208] Shepherd (1967), p. 71.
[209] *Liber Pontificalis*, 34 (Sylvester), the *'fastigium'*, with M. Smith (1970). [210] Suetonius, *Vita Caes.*, 1, 76, 1.
[211] Herzfeld (1920); L'Orange (1953), p. 135; Boëthius (1946), pp. 445–6 and Lehmann (1945), p. 24.
[212] Corippus, *In Laud. Iust.*, 4, lines 114–18, 'aedibus in magnis miro constructa paratu extabat sedes, auro gemmisque superba, lumen habens sine sole suum; inlustratque propinquos gemmarum natura locos, rerumque colores mutans et Phoebi radios fulgentis obumbrans'. The passage is discussed at p. 198.
[213] Ibid., 3, lines 194–200.
[214] Mathews (1993), esp. pp. 16–20 on historiography, from Kantorowicz through A. Alföldi, Grabar and L'Orange. This revisionism is, however, far from convincing.
[215] Ibid., p. 101.
[216] Ibid., pp. 103–9, but note Breckenridge (1980–1), p. 260, on the lyre-backed throne found both in mosaics and in the imperial palace.
[217] Ihm (1960).

VISUAL SYMBOLISM: CHRISTIAN WALL MOSAICS

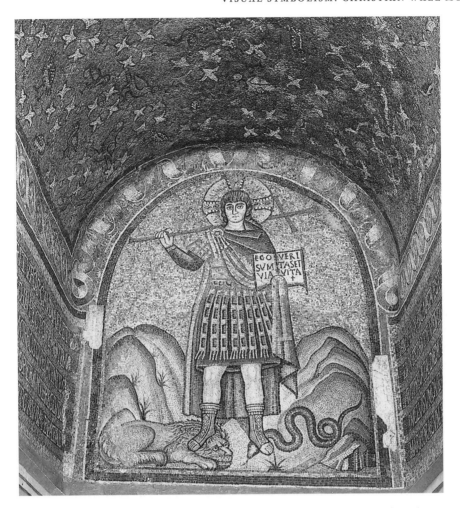

Figure 12. Mosaic of Christ the Soldier, Archiepiscopal Chapel, Ravenna (*c.* 500), echoes the visual rhetoric of empire.

Christ the friend of the humble.[218] Nevertheless, imperial rule did provide visual metaphors for the Biblical Christ the King. Indeed, Jesus was on occasion even shown as a soldier, as in the Archiepiscopal Chapel, Ravenna (figure 12, p. 131).[219] The visual rhetoric of empire produced some of the most prominent contemporary language of power and potency in art. Furthermore, Scriptural authority was available to justify the use by the Church of images similar to those of the State.

[218] Mathews (1993), p. 92. [219] Wilpert (1976), pl. 92.

THE ART OF PERSUASION

The Ezekiel vision of God's throne of the appearance of sapphire is but one example.[220] Indeed, many of the objects that we have been discussing were themselves also Biblical images. All manner of symbols employed in the Apocalypse appear in mosaic; for example, Christ on the globe in the apse of San Vitale holds a scroll with seven seals (figure 7, p. 115), and the facade mosaics of the Eufrasian basilica of Poreç include seven candlesticks.[221] It is perhaps fairest to conclude that the State was exploiting treasure as a popularly understood metaphor of excellence. The Church could do the same, as had pagan cults. In so doing, a clear challenge was sent to the mind of the viewer to decide, at the cost of high stakes, which institution was the possessor of victory, or whether their victories were complementary.

Jesus Christ could, therefore, be shown on a jewelled throne as in the apse of Santa Pudenziana, and as could God the Father in San Michele.[222] Likewise, the saints in the nave procession of bishop Agnellus, which replaced Theodoric's entourage in Sant'Apollinare Nuovo, proceed towards Christ on a gemmed lyre-backed throne.[223] This *was* a direct representation of an item now understood to have been present at the imperial palace from at least the fifth to the ninth centuries.[224] Such treasure images were combined with the depiction of natural profusion and fertility, as in the case of the swirling foliage of both the mosaic vault and of the carved stone capitals in San Vitale.[225] These capitals would most probably have been kept painted, providing the transition from the colourful marble of the pillar below to the glistening frames of mosaic panels above. And I have been keen to stress that the golden art of the period must be held to encompass the movables as well as the fixtures of these buildings. Peter Brown has emphasized the fact that mosaics were part of the total decoration of and the experience provided by late Antique churches which attempted to provide an experience of heaven on earth. The otherworld was a precise place, he writes: 'the solemn liturgy, the blaze of lights, the shimmering mosaics, and the brightly coloured curtains of a late Antique church were there to be appreciated in their entirety . . . Taken together, they provide a glimpse of paradise.' Movements,

[220] Ezekiel 1: 10ff. It is by no means clear that the Vulgate 'sapphire' referred to what it does today. It may well have been lapis lazuli. In any event, it was certainly blue and/or blue-violet in colour. See Herzog (1987), p. 80. A particularly direct interpretation of Ezekiel's vision of God in his throne-chariot appears in the apse paintings at Bawit, Egypt; L'Orange (1953), apse with chariot details stressed, fig. 91, and apse with chariot details played down and throne shown jewelled as in Santa Pudenziana, fig. 92.

[221] This and other examples are discussed in Van Der Meer (1978), pp. 53ff.

[222] Wilpert (1976), Santa Pudenziana, pls. 20–2 and Effenberger & Severin (1992), apse of San Michele, now in Berlin, cat. no. 47, pp. 128–31, with Bovini (1969b).

[223] Cutler (1975), fig. 18. Frugoni (1991), pp. 30–53, discusses the fate of the royal Ostrogothic mosaic schemes, including the procession, which latter subject is examined in detail by Von Simson (1987), pp. 81ff.

[224] Breckenridge (1980–1), p. 260. [225] Volbach (1961), pls. 161–2.

flashes of silver vessels, rustling curtains, he argues, 'were the "triggers" of a late Antique worshipper's sense of majesty'.[226]

Even ascetics could not easily escape this taste for splendour, largely because much of the Bible's text was in no such way immune. The New Testament did not espouse the literal use of treasure found in the Old Testament, but it certainly employed figurative use. By stressing the importance of that allegorical message, Christian apologists merely acknowledged the potency of the metaphor. The propagandistic importance of display being keenly appreciated, there was no alternative but to paint the portrait of allegorical wealth in a way that would be recognized. Symbolic interpretation was seen in the last chapter as the key to late Antique textual reading of Scripture. We saw that literary exegesis aimed to make the Bible make 'sense' in contemporary terms (as Mathews notes, 'the narratives of the Gospel they rewrote with freedom to forge images of memorable impact').[227] Late Antique Christians wanted clear explanations as much as we do. Their imagery reeks of triumph and imperial symbols were plundered, together with much of the remainder of the repertoire of classical art, with all the brazen confidence of a victor. If the images are diverse it was because God in his wisdom had given multiple ways in which to show the truth.

Elsner has argued that the transition over time, from the early to late Empire, is not so much from materiality to spirituality, as in a falling away of irony and the rise of the austere and magnificent seriousness to be seen in the mosaics surviving in Ravenna.[228] In comparison with the private and ironic art of Roman secular amusements, pagan religious art is argued as having been presented with a more direct intention to control interpretation, since it was intended that the initiate see the prearranged secret that was holiness. Such art has need of a certain stylistic rigidity if it is not to be 'misinterpreted'. This dramatic symbolic art may be seen as spreading out over time across Europe from its increasing use both by the initiate religions, especially Christianity, and by the State. The imperial image became transformed from an individual one based on personal appearance and lineage, to one of the general exalted position of the emperor as validated by a linked web of overt and active symbolism.[229] The Christian viewer was expected actively and correctly to interpret the subtle images placed before him in a church. That religion required allegorical interpretation of its art since it wished to represent in images a truth beyond human depiction.

[226] P. R. L. Brown (1980), pp. 24–5. The inclusiveness argument is supported by theoretical discussions, cf. Douglas & Isherwood (1979), p. 9, 'the meaning of each [object] is in relation to the whole'.
[227] Mathews (1993), p. 180. [228] Elsner (1995).
[229] Barber (1990), p. 34, on the San Vitale panels, 'the emperor identified as Justinian can in truth only be read as *an* Emperor, designated as such by the imperial purple, the crown and the halo'. See also Elsner (1995), pp. 159–89.

Christian selectivity can be seen to be active especially in weeding out unsuitable classical motifs, whilst promoting those, including many treasure images, that were found to be useful and compatible with propounding the Christian message. The images under discussion were but one part of an unremitting campaign of verbal and visual propaganda. All manner of images were pressed into the service of the Christian religion with gusto and determination. Bearing in mind that it was recognized that images were merely a means to an end, and that some imagery was unsuitable, art was a resource that was exploited to the full. Church buildings themselves, therefore, were visual rhetoric, each of which attempted to communicate the ultimate wonder of heaven. To that end, and at the cost of accommodations and contradictions, they literally became treasure houses. The use of gold in mosaic was paralleled by the employment of expensive stones in increasingly complex *opus sectile* (that of the Eufrasia basilica at Poreç, for example, used thirty different marbles, glass, ivory, and mother of pearl).[230] The golden style in mosaic rose slowly from the time of Constantine to reach great prominence from the sixth century onward. In late Antiquity, the gilded Church roof was compared to the sky, below which bloomed brightly coloured stones.[231]

Mosaics, thus, were but one element of a parade of riches, which was in turn reflected in the content of the mosaics themselves. Great buildings of late Roman civilization were meant to impress partly with reference to the amount they must have cost. In this respect, mosaics incorporating precious substances were one aspect of the luxurious fitting out of a late Antique basilica, which would have included huge quantities of treasure items such as eucharistical silver. The treasure display of the mosaics reflected that of movables kept within the building, a phenomenon which should be seen as a product of the Church's necessary involvement in lives of the entire social spectrum of a civilization that made extensive use of precious gifts in social communication. Many churches became very rich institutions, and enormously significant in local patronage. The *Liber Pontficalis* describes the work of Constantine and his successors which ensured that in terms of liturgical silver the Lateran alone had 7 silver *altaria* (200 lb. each), 7 gold *patenae* (30 lb. each), 16 silver *patenae* (30 lb. each), 7 gold *scyphi* or *calices* (10 lb. each), 20 silver *scyphi* or *calices* (15 lb. each), 40 *calices minores* or *ministeriales* of gold (1 lb. each), 50 silver *calicies minores* of *minesteriales* (2 lb. each), 2 gold *amae* (50 lb. each), 20 silver *amae* (10 lb. each), 7 silver *cervi fundentes aquaem* (80 lb. each) and for lighting purposes 1 gold *farus* (50 lb.), 40 silver *fari* (20 lb. each), 4 gold *coronae* (15 lb. each), 1 gold *fara canthara* (30 lb.), 1 silver *fara canthara* (50 lb.), 45 silver *farae*

[230] Terry (1986), esp. pl. 1.
[231] Prudentius, *Perist*. 3, 196–200. See also 11, 218. On flowers and gems as paired themes, M. Roberts (1989), p. 76.

cantharae (30 lb. each), 25 *farae cantharae* (20 lb. each), 50 silver *cantharae cereostatae* (20 lb. each) and 7 *candelbra* of *aurichalcum*, an alloy of gold and bronze (300 lb. each).[232]

After 321, churches were allowed to inherit property and from the early Middle Ages much of our best evidence for endowment comes from wills.[233] One such is the donation list of a seventh-century Frankish cleric, Desiderius, who was bishop of Auxerre between 605 and 623. He received a chapter in the ninth-century *Gesta Pontificum Autissiodorensium*, which was modelled on the *Liber Pontificalis*. The relevant section is attributed to the monks Heric, Alagus and Rainogala who were active in the years following 870,[234] however, the nature of the text strongly suggests that it is very largely composed of material which Rouche speaks of as 'évidement extrait du Testament de Didier'.[235] He refers to an extraordinary list which takes up two pages of printed text.[236] This consists of Desiderius' treasure donations to St Stephen's church. A second list describes items that went to St Germanus.[237] It is carefully noted that to Stephen went in total 420 lb., 7 oz. of silver plate. Germanus got rather less, 119 lb. and 5 oz. These totals do not quite add up to the listed weights. These, in modern terms, equal about 137 kg. One of the greatest hoards ever found in Britain, the Mildenhall treasure, is dwarfed by comparison.[238]

Apart from the cross of Justin II, most of the surviving late Antique ecclesiastical treasures come from village churches.[239] These silver vessels are thus but minor examples compared to those once found in the great churches. Items were given by the faithful to fulfil a vow, to obtain salvation or to give thanks for a cure. Once donated, such treasures were inalienable except for emergencies such as famine and the ransoming of prisoners. The most complete texts are those of the *Liber Pontificalis*, but individual inventories also occur.[240] The greatest amount of precious metal occurred in furniture revetments for the altar, *ciborium*, chancel screen, ambo, and doors. It has been calculated that the silver revetments of Hagia Sophia, if 1 mm. thick, would have taken 12,000 lb. of silver, or, if 3 mm. thick,

[232] These are the various vessels and pieces of lighting equipment listed in *Liber Pontificalis*, 34. R. P. Davis (1976), going through each of eighteen foundations, table 6, p. 462, lists eucharistic equipment, table 7, p. 463, baptismal equipment, table 8, p. 464, lighting equipment.

[233] I. N. Wood (1994), pp. 206–7, provides an introduction to Merovingian wills.

[234] *Gesta Pontificum Autissiodorensium, de Desiderio*, in L. M. Duru (ed.) *Bibliothèque historique de l'Yonne* (Auxerre, 1850), pp. 332–40.

[235] Rouche (1979), p. 200, n. 111.

[236] *Gesta Pont. Autissio, de Desiderio*. The text runs from the top of p. 334 to line 7 of p. 336. It is thus too long to give here in full.

[237] Ibid., p. 337, line 18 to the foot of the page.

[238] Kent & Painter (1977), p. 33, although the catalogue entry notes that 'though many [late Roman] families possessed silver plate, a set of this quality would have belonged to a person of outstanding wealth and status', the Mildenhall treasure comes to less than 26kg.

[239] M. M. Mango (1986). [240] Ibid., no. 91, pp. 263–4.

36,000 lb.²⁴¹ Portable objects could be specifically liturgical (chalices, patens, ewers, strainers, fans, processional crosses), ex-votos, lighting equipment, or secular silver donated for its metal value. Other treasures included books, reliquaries, silks and so forth.

Donated silverware typically had the name of the donor, the name of the recipient and the reason for the gift, in the same way as apse mosaics often bore the names of their donors. These inscriptions were witnesses of the sacred act of donation. Donations were regarded as being to saints, not to churches. Offerings were made, *in memoriam*, for the repose of a soul, for the donor's salvation, as atonement for sins, in an act of worship and in thanksgiving (for benefits received or desired). In the case of the Kaper Karaon village treasure, found buried in a hoard, the church of Sergius nearby received most of the items. The inscriptions on the objects have allowed family trees of donors to be drawn up.²⁴² At the top end of the spectrum, donation and endowment of entire churches was possible; at the bottom end, people could club together to subscribe funds for a section of pavement. In the sixth century a silver spoon would cost about the same as a very humble book, and a plain small silver chalice about the same as a panel of floor mosaic. Still, the Hama paten, worth about 12 *solidi*, was given by an archbishop whose salary could have reached well over 2,000 *solidi* a year.²⁴³ Such gifts were symbols. From the donor's point of view the appearance of the object was of as much importance as its raw weight. As with gold mosaic, it was the impression that counted.²⁴⁴ Such gifts could be used as a way of displaying personal eminence and private wealth. Both buildings and objects were endowed with prominent donation inscriptions, as well as with portraits of benefactors.²⁴⁵ In classical Roman society, a notable was expected to provide a 'Nile of gifts'.²⁴⁶ It appears that old civic ideals of personal fame for public giving had resurfaced 'in a peculiarly blatant form'.²⁴⁷ Re-using or selling such items was a socially dangerous act. Ambrose drew fire for melting down silverware, even though he had the added justification that it was given by supporters of his Arian predecessor.²⁴⁸ The destruction of such gifts was not to be undertaken lightly by churchmen, since that would be an implicit rejection of the symbolism behind the gift.

Mosaics also provide a rich source of evidence for donations, since they often

[241] M. M. Mango (1992), pp. 128–9. [242] M. M. Mango (1986), p. 9, fig. 1.1.
[243] Perhaps the archbishop made similar small gifts to very many churches, much as the Roman emperor gave donatives to all his troops.
[244] M. M. Mango (1986), p. 13. [245] See my epilogue (pp. 168–9).
[246] P. R. L. Brown (1992), p. 97. Such gifts could be made to individuals, religious institutions, or cities, see Johnston (1985).
[247] P. R. L. Brown (1992), p. 95.
[248] Melting down of treasures was permissible only in emergencies, such as for the ransoming of prisoners.

featured texts celebrating their donation.[249] Ordinary mosaic *pavements* were not an especially expensive part of churches. A study of texts in Italian floor mosaics which give costs suggests figures such as 18 m² for 6 *solidi*.[250] Evidence from fifth-century Palestine produces similar findings. There, 15 m² of geometric pavement cost around 5 *solidi*, whilst the same money would buy about 8 m² of figural floor mosaics.[251] Such offerings were within the range of many people. Ordinary craftsmen were not paid much in late Antiquity. Nevertheless, grand wall schemes would have needed considerable resources, including access to craftsmen of the highest standard. An excellent way of increasing cost, in a manner efficient to the visible returns, was to make use of expensive materials, such as gold, and to spread them in a thin film across the walls.

For churches to be able to act as patrons of the needy they needed disposable wealth. Even if rich in objects, churches were often lacking in revenue-producing estates in the fourth century. Even in great centres there could be problems. In Palestine, for example, not until the fifth century were *regular* imperial grants made to churches.[252] From the fifth century, the papacy began to insist that foundations should be backed up with sufficient funds for the upkeep of the buildings as well as with a poor dole fund.[253] The desire for lay patronage was very great, especially in the context of competition between centres. Legacies and gifts from pious noble-women such as Melania the Younger were of huge importance.[254] As mentioned above, Melania persuaded her aristocratic husband into the ascetic life after their two sons died. They had a huge fortune at their disposal. Having fled from the Goths, we find them passing through Thagaste in Numidia, where Melania gave to the local church 'revenues as well as offerings of gold and silver treasures, and valuable curtains, so that this church, which formerly had been so poor, now stirred up envy on the part of other bishops of the province'.[255] The display from such benefactions was itself important for attracting worshippers and further potential donors, who might be persuaded to give cash as well as treasures.[256]

Wealth, however, was also stored by churches in their role as banking centres. A law from the middle of the sixth century ordered that weights kept for taxation purposes were to be stored in churches.[257] Temples had fulfilled all these roles in

[249] Caillet (1993) is a study of pavement evidence from northern Italy. Ten examples from the fourth to seventh centuries testify to the gift, not just of mosaics, but of buildings, pp. 399–400.
[250] Ibid., pp. 451–9. [251] Ibid., p. 431. [252] Hunt (1982), p. 142.
[253] Discussed by Pietri (1978), and see also (1981).
[254] P. R. L. Brown (1988), pp. 344–5. On female ascetics in late Antiquity, Elm (1994).
[255] *Vita Melaniae*, 21.
[256] MacMullen (1984), p. 114, 'there is no sign or likelihood that the church after Constantine, more than any other cult, attracted a kind of person who felt himself above material benefits'.
[257] M. M. Mango (1986), pp. 3ff.

the classical period.²⁵⁸ Votive offerings were made to churches, as had been the case with temples, by representatives of all levels of society. The most spectacular gift was the provision of a complete church or monastery and from the time of Constantine the new buildings kept on rising even when other forms of urban building had ceased.²⁵⁹

Many of the workings of classical society, including much of its mosaic production, were disrupted with the onset of the medieval period. Nevertheless, the characteristic participation of the Church within the workings of the 'treasure society' had been assured. In Rome, as elsewhere, there lingered huge built remnants of the Roman past, the remains of which were pillaged in the construction of new buildings.²⁶⁰ Nevertheless, most early medieval patrons could not afford to rival the relics of the high Empire in sheer scale, and so they concentrated on complex decoration.²⁶¹ Certainly there continued to be an 'audience for architecture' in post-Roman Gaul.²⁶² Yet here, as in Anglo-Saxon England, churches appear to have had 'very cluttered interiors', judging just from the sculptural survivals.²⁶³ The main interest of their builders was apparently not in the spacious but in the sumptuous.²⁶⁴ Yet church building itself was the great survival of the euergetistical building practices of Antiquity.²⁶⁵ Hosts of small institutions were springing up in major centres such as Rome, as well as, subsequently, across the early medieval countryside.²⁶⁶ The golden style of mosaic can be seen to have re-emerged in the Carolingian age.²⁶⁷ The visual culture of the Middle Ages inherited from Antiquity an expectation of the splendid decoration of sacred buildings. The opportunities for educating and inspiring even the illiterate by means of art were very apparent to the medieval Church. So it was that the riches of this world were repeatedly depicted and deployed in churches as the only way of expressing here and now, in symbolic form, the abstract wealth of the otherworld. This was perfectly acceptable to aristocratic patrons who were used to expressing their own pre-eminence and excellence by displays of precious metal, in coin, plate and personal ornament. Individual motifs and scenes each told their own story to

[258] Baratte (1992).
[259] B. Ward-Perkins (1984), chapter 4, notes that churches were the significant form of secular building patronage to survive in the west.
[260] Greenhalgh (1989) and Brenk (1987).
[261] Wickham (1989), p. 103, argues that the small scale of early medieval churches was due to lack of competition from the State in building works.
[262] See the important study of I. N. Wood (1986). [263] Cramp (1986), p. 103.
[264] Dodwell (1982), p. 43, plus on Anglo-Saxon taste, pp. 24–43, and craftsmen, pp. 44–83, and jewellery, pp. 188–215; these are excellent studies which put the surviving artefacts together with the literary evidence.
[265] B. Ward-Perkins (1984), chapter 4. [266] Reekmans (1989).
[267] Dodwell (1993), pp. 49–50, on the apse mosaic of the Oratory of Theodulf of Orléans, Germigny-des-Prés, which is dated c. 799–806.

the viewer. Treasure was hugely important in signalling the meaning 'sacred and precious'. Think of how a relic, as a physical object outside its jewelled reliquary, looks just like a horrid lump of old bone.[268] In the glittering gold expanses of the late Roman and medieval churches, symbolic and aesthetic efficacy were combined. Figures of saints and figures of patrons stood prominently against plain gold backdrops and moral justification was ensured by verbal rhetoric on who was doing honour to whom.[269]

The taste for brilliance

In society 'there is fitting behaviour in given circumstances, a fitting style of speech for given occasions and of course fitting subjects for given contexts'.[270] Such social rules apply to public display and so help to shape and define the aesthetics of a particular culture. The secular world of late Antiquity has been seen as possessing complex attitudes to the appropriate or inappropriate display of wealth using symbolic substances such as gold and silver. Decorum lay in flaunting riches in the correct manner, in the use of legitimate and not 'vulgar' display. The great churches of the late Empire provided a display of wealth, symbolic of power, that proclaimed the importance of the Church as an institution in society. Large buildings were necessary to hold extensive congregations. Elite decoration of those churches was expected by contemporary ideas of decorum. Plainness would have suggested that the patron did not think the building's function to be of high prestige. The rise in gold grounds from the late fourth century was part of an attempt to increase the appearance of splendour even further by greater use of precious metals. This section examines the developing golden aesthetic from Antiquity into the early Middle Ages.

In late Antiquity there was a desire for the expression of moral qualities in both figurative and abstract form. The Christian moral understanding of whiteness, brightness, gold and jewels was explored in chapter 3. As we saw there, spiritual goodness was held to be of far greater worth than any precious substance of this world. Yet, an image for the former had to be found if it were to be represented in art. The traditions of church adornment, as described so far in chapter 4, were the product of widely held attitudes, since treasure was used for its symbolic associations, that is, for its communicative ability. Visual symbolism ran in parallel with literary symbolism. The fact that gold and jewels were not displaced in the great churches of much of Europe until the end of the Middle Ages testifies to the power

[268] Geary (1978), pp. 5–9, 'relics as symbol', quotation at p. 5.
[269] As in the apse mosaic of Sant'Agnese (figure 13), on which, see my epilogue (pp. 168–9).
[270] Gombrich (1972), p. 7.

of treasure as a positive motif in the earlier period. This potency was enough to prevent a groundswell of opinion that would argue for the inappropriateness of such secularly employed symbols in a religious context. Bearing in mind Scriptural *exempla*, these treasure substances were used visually for their brilliance and colour, mostly without moral agonizing, yet with a conscious understanding. The visual attraction of gold lay in its reflective quality and brightness. These qualities saw treasure substances caught in cognitive networks that linked them with light, life and goodness, as we saw in the case-study of exegesis. The morally charged environment of Christian rhetoric, of which these mosaics were part, relied upon a stock of relatively simple primary associations. This came about because of the reliance upon parable and easily comprehensible metaphor for the purposes of teaching an understanding of the often complex Christian concept of the moral life.

Classical art was interested in three-dimensional space and volume, direction of light and structure of objects, such as humans or animals. This is not the impression given by much late Antique, early medieval and early Byzantine art. The traditional interpretation was that people were 'trying to do the same thing', but in an age of 'cultural decline' were succeeding less and less well. There was indeed a simplification of details, a suppression of relief and an increase in stylization and standardization of images. It is now unfashionable to say that one culture was better than another and it is now more often asked why particular cultures were doing things in their own particular ways. The unavailability of craftsmen in times of insecurity and upheaval may account for no mosaics having been made in much of Europe. It does not account for why huge, expensive mosaics were made in a different style, especially when earlier examples were available for comparison.

The Church was using art for a new purpose in a new context. Adaptation may therefore be expected. Moreover, the whole aesthetics of Antiquity may have been changing in late Rome. Early imperial descriptions often tended to read meanings or associations into the experience of viewing an object. This process, of placing stress on the role of the viewer, appears to have intensified during the course of the Roman Empire, resulting in 'a heightened visual imagination, enabling one to see things that were not there'.[271] Familiarity with symbolic art, with its use of linked images and ideas, promoted a general expectation of figurative meaning. This meant that less and less detail was necessary on the original object, for a figure, for example, to be appreciated as a good image of a human, 'so real it might be expected to move'.[272] This mentality also allowed churches to embrace both of the main images of Paradise, the urban and the rural. The pastoral was included by the rhetorical convention of understanding precious substances as referring to

[271] Onians (1980), p. 17. [272] On the dream of the 'living' image, Gross (1992).

living things; marble columns became trunks of wonderful trees and the multi-coloured floors became meadows in full bloom.²⁷³ This was a vision of what people *wanted* to see.²⁷⁴ In the imagination of Gregory of Tours, wrote Peter Brown, we enter a Paradisical world as 'bright and shimmering as a mosaic-laden church'.²⁷⁵ In these buildings we are looking at the dreams and hopes of a civilization.

It is impossible to view the art of other cultures other than through our own eyes, be they ever so wide open. When that other culture has not provided us with oral or written evidence the problems become even greater,²⁷⁶ but that is not true of late Roman society. Complex iconographic schemes were then addressed in terms of abstractions, much as lines of Scripture were interpreted as references to Christian moral qualities, such as humility, charity and divinity. Late Roman descriptions of churches often focus not on imagery, but on overall effect, with particular emphasis on the play of light, brilliance and shine. Such ekphrasis (art description) has been condemned both for lacking focus and for presenting such details as it does provide with a relish for classical *topoi* of naturalism, even though these works of art were thoroughly stylized.²⁷⁷ A seminal article by James and Webb has pointed out the singular nature of the ekphrasis of the period.²⁷⁸ Many of these texts have long frustrated historians keen to establish the precise forms of works. This is because the style of the descriptions seems both standardized and strangely imprecise and abstract. This has led to the conclusion that many were mere literary exercises and are of little value as historical evidence. However, it is now argued that the function of such ekphrasis was to recreate the impact of an image on the viewer. The description does not say what the work was like, but what it was like to see the work and what it was important to see in the work. This does not provide good evidence for the precise nature of the item involved, but it is enormously telling for the attitudes of those who were the audience, since ekphrasis 'states explicitly what was implicit in the image'.²⁷⁹

The importance of this lies in the fact that Church art had specific functions, spiritual rather than purely aesthetic. What appear to us to be claims that such art is *realistic* in fact represent the intensity of Christians' spiritual response to it.²⁸⁰ If an artist depicted a saint, he wanted to portray his soul, an ambition which was not in easy accordance with the naturalistic portrayal of the figure as it appears in the

²⁷³ For example, Prudentius, *Perist.*, 3, 196–200.
²⁷⁴ Compare in literary rhetoric, Averil Cameron (1991), ch. 3, 'Stories people want'.
²⁷⁵ P. R. L. Brown (1977), p. 6 and De Nie (1987).
²⁷⁶ Megaw & Megaw (1994), on 'reading' early Celtic art. ²⁷⁷ Maguire (1981).
²⁷⁸ James & Webb (1991). On earlier Roman practice, Laird (1993). ²⁷⁹ James & Webb (1991), p. 11.
²⁸⁰ Ibid., p. 14, '*ekphraseis* were attempts to convey the spiritual truth residing in art'.

everyday.²⁸¹ Much religious ekphrasis did not need to describe in careful detail, rather it instructed. It was 'to the crowd beneath the mosaics' that it was addressed.²⁸² Such commentary aimed to link Christian spiritual truths to the desires of that crowd. The visual message of much sacred classical art centred on a deep religious preoccupation with rest, with the good life, with 'the miracle of a sheltered garden imagined in the broiling summers of a Mediterranean city'. It was only over time, with the onset of late Antiquity and the Middle Ages, that the airy early Christian paradise became a court of heaven which, in its rarefied golden excellence, was conceptually far closer to the instructive abstractions of didactic ekphrasis.²⁸³

The images themselves were, therefore, of secondary importance to the message they imparted. However, images and metaphors were understood as a *necessary* concession to human weakness. This is the argument used by the earliest defenders of icons. So, in the sixth century, Hypatius, bishop of Ephesus, advised John of Atramytium by letter that, glorying in the love of God in the holy writings, 'we take no pleasure at all in sculpture or painting. But we permit simpler people, as they are less perfect, to learn by way of initiation about such things by sight which is more appropriate to their natural development.'²⁸⁴ God is reflected in material objects, 'it is their capacity of reflections that such objects can be called *eikones*'.²⁸⁵ The western medieval position was set out in the *Libri Carolini* of 791, proclaimed at the Synod of Frankfurt in 794. This stressed the aesthetic value of art in itself, but denied that pieces had any magical quality in themselves.²⁸⁶ This essentially restated the views of Gregory the Great, expressed in two letters (sent in 599 and 600) to bishop Serenus of Marseille admonishing him for destroying images. These, said Gregory, were not to be worshipped, but not to be destroyed either for they were useful, since the unlettered could 'read' by looking at pictures.²⁸⁷ The fear of producing idols meant that the cult of icons never grew luxuriously in the west.²⁸⁸ Isidore, custodian of useful facts for the early medieval west, noted that 'picture (*pictura*) sounds like fiction (*fictura*). For this (*pictura*) is a fictitious image and not the truth.'²⁸⁹ This was the view of the west, as we read in the *Libri Carolini*: 'pictures shaped by the art of artists always

²⁸¹ Tatarkiewicz (1970), p. 37.
²⁸² P. R. L. Brown (1982). ²⁸³ Ibid., pp. 202–3.
²⁸⁴ Hypatius of Ephesus, *Letter to John*, P. J. Alexander (ed. and trans.) (1952), p. 179.
²⁸⁵ Kitzinger (1956), p. 139. On icon-worship in the sixth century, Averil Cameron (1979).
²⁸⁶ *Libri Carolini*, H. Bastgen (ed.), *MGH, Concilia* 2 (1924). McKitterick (1983), pp. 164–5.
²⁸⁷ Gregory the Great, *Registrum Epistularum*, 9, 208 and 11, 10, D. Norberg (ed.), 2 vols., *CCSL* 140–140a (1982–3). Discussed by Kessler (1985) and Markus (1978).
²⁸⁸ If icon-worship is understood as the result of popular piety, then perhaps its place in the west was taken up by the special prominence of the cult of relics, but this is a line of inquiry that I shall have to leave for another occasion.
²⁸⁹ Isidore of Seville, *Etymologiae*, 19, 16, W. M. Lindsay (ed.), 2 vols. (Oxford, 1910).

lead into error those who glorify them'.²⁹⁰ That does not mean that they had to be broken 'for we do not reject anything in pictures but the adoration of them, since we allow pictures of the saints in the basilicas, not for adoration, but for the commemoration of events and for the beauty of the walls'.²⁹¹ In the east, the rise of iconoclasm led to a stress on decorative materials at the expense of image. The use of treasure, in other words, took place whatever the local preference with regard to pictures.

The desire for brilliant abstraction extended back into classical Antiquity. In early belief, light and heat were closely associated with life and with its source, divinity. Originally, in the Greek world, 'eye' and 'light', were closely intertwined, only later becoming distinct yet still related ideas.²⁹² The opposite conceptual construction, black = bad = evil = death, was present, perhaps above all because of the danger of night time, when man's main sense organ, the eye, is inoperative. In contrast, light and fire were equated with humanity and growth. Those in love were said to 'burn', to be possessed by a hot spirit.²⁹³ Stoics believed that souls passed at death as fire to the heavens, hence the ancient fascination with the stars.²⁹⁴ The association of light and the mind led to such concepts as that of the nimbus of light around the head.²⁹⁵ The word means 'cloud' and in late Antiquity was employed with reference to a radiance which was possessed especially by the spiritually great. The spirit was seen to reside in the head and greater (hotter) spirits were believed to burn more brightly than lesser ones. The nimbus in art was therefore an indicator of power, including divine power, since the spirit, the *genius* of each person, was his or her super-terrestrial essence.²⁹⁶ Thus had come about the pagan use of the radiate crown. The third-century emperor Gallienus, in an effort to make his head shine, was alleged not only to have worn the radiate crown, but also to have sprinkled gold filings in his hair.²⁹⁷

The nimbus was fully accepted by Christians. The Transfiguration scene on Mt Sinai was one of a number of manifestations of God in the midst of light and fire. It was an ancient element of Jewish tradition, as in the incident of Moses and the

²⁹⁰ *Libri Carolini*, I, 2, 'Imagines artificum industria formatae iuducunt suos adoratores . . . semper in errorem.'

²⁹¹ Ibid., 3, 16, 'Nam dum nos nihil in imaginibus spernamus praeter adorationem, quippe qui in basilicis sanctorum imagines non ad adorandum, sed ad memoriam rerum gestarum et venustatem parietum habere permittimus.'

²⁹² Onians (1979), p. 115. ²⁹³ Onions (1954), pp. 159–60. ²⁹⁴ Ibid., p. 164.

²⁹⁵ See entry, '*nimbus*', in Kazhdan (1991), p. 1487. Collinet-Guérin (1961) provides a general treatment of the subject through and after the classical age. This association of light and the head was very ancient. Amongst the grave-goods from Mycenaean graves were tiaras in the form of gold rays, as in an example from the Upper Grave Circle, Mycenae, that dates from the sixteenth century BC, Hawkes (1968), p. 176 and pl. 22.

²⁹⁶ Onions (1954), pp. 166–7. ²⁹⁷ *Scriptores Historiae Augustae, Gallieni Duo* 16.

Burning Bush.²⁹⁸ Prudentius told how, as Lawrence was stripped by his murderers, so 'his face shone with beauty and a glory was shed about him'.²⁹⁹ As an art motif the nimbus was inherited from classical Antiquity, whence it had distinguished the heads of gods and heroes. From the time of Constantine, it displaced the specifically pagan rayed corona in the symbolism of imperial representation. The nimbus spread slowly through Christian art, first being restricted to Christ and the Lamb. But later it was used for saints, angels, prophets and eventually even living persons, who were distinguished by the use of a square nimbus. A variation on this was the *mandorla*. Such a cloud which enveloped the whole body was most commonly found in Transfiguration scenes, such as that of the monastery of St Catherine on Mt Sinai. This *mandorla* is blue and from it beams of light shine out from Christ's body.³⁰⁰

With the adoption of the gold background there came the challenge of distinguishing the nimbus, which previously had likewise been gold. One possibility was to use blue, but that failed to satisfy the imperative of suggesting the presence of divine light. One possibility was to set the metallic tesserae at different densities, in varied patterns, with different glass-thicknesses and set at steep angles in the plaster so as to maximize the reflected brilliance of the zone within the thin line by which the nimbus was delimited. Another solution was to employ silver, a substance of lesser value, but differently and appropriately coloured. Such use occurs, for example, in Christ's nimbus in the cupola of St George in Thessalonica. There, differentiation of the nimbus in the case of people of lesser rank was achieved by the differential setting of gold tesserae. This enabled a special distinction to be retained for the Godhead. A similar phenomenon can be seen in the fact that Christ, as repeatedly in Sant'Apollinare Nuovo, is often given a jewelled nimbus (figure 9, p. 121). Other examples of this are found at the Archiepiscopal Chapel at Ravenna (figure 12, p. 131)³⁰¹ and San Lorenzo at Rome.³⁰² A similar symbolic representation occurs at the apex of the apse of the Basilica Euphrasiana at Poreč. There, in a roundel, the lamb of God is shown against a starry sky, with a jewelled, cross-shaped nimbus.³⁰³ In other cases, jewelling was not used, but a cross shape was retained, as at the Oratory of John VII and at the Confessione in the old basilica of St Peter's.³⁰⁴ This use of jewelling confirms that gems were employed iconog-

[298] Matthew 17: 2. Exodus 3. Elizabeth James (1990), p. 180, on the Transfiguration as a 'feast of light'.
[299] Prudentius, *Peristephanon*, 2, 361–2, 'illis os decore splenduit fulgorque circumfusus est'.
[300] Brendel (1944) describes how, over time, the employment of the *mandorla* stabilized as a divine aureole (there had been some uses of it as an externally produced cloud of protection in the mosaics of Santa Maria Maggiore).
[301] Wilpert (1976), Sant'Apollinare Nuovo, pls. 98–9 and Archiepiscopal Chapel, pl. 95.
[302] Oakeshott (1967), San Lorenzo, pl. 77. [303] Tavano (1975), fig. 10.
[304] Oakeshott (1967), Oratory of John VII, pl. 109 and *Confessione*, pl. 111.

raphically to act as an extra mark of status, since such jewelling hardly maintained any literal illusion of divine light. So again, the centre of the apse of the Basilica Euphrasiana, Poreč, features the Virgin on a throne, with the Christ child in her lap. Mary is given a plain nimbus, whilst that of the Lord is endowed with a jewelled cross.[305] This dramatic example illustrates that all such decoration can be seen as symbolic since it 'makes more visible, by concentrating attention and vision to those surfaces or areas which it adorns'.[306] The nimbus was the personal emanation of light. It was the personal counterpart of the total effusion of light in late Antique churches. The cloud of light, whether personal or otherwise, acted as a centre of attention.

In common with Neo-Platonists, Christian mystics frequently expressed morality in terms of visible substances. One of the most pictorially vivid expositions of this is furnished by the mysterious Pseudo-Dionysius.[307] For Pseudo-Dionysius the contemplation of visible things was an important step in rising to the contemplation of the immaterial.[308] The progression might be compared to that between reading the literal text of Scripture and then discovering its spiritual meaning. God lay in the darkness beyond light, but one led to the other.[309] Neo-Platonic philosophical thought emphasized the inferiority of matter. This attitude was fired by the notion of a duality between good and evil, a concept most strongly expressed in Manichaeism, in which the material world, including the human body, was evil, and individual souls were sparks trapped in this darkness. Such a denigration of the material was rejected by orthodox Christians. Augustine saw that the world, as it was created by God, must therefore be good and that there were traces of beauty in everything.[310] The ancient view of beauty was not purely materialistic: all beauty was understood to contain a sensuous and a spiritual element. In that culture, that which only 'appeals to the senses is pleasant, but not beautiful'.[311] Light was a premier metaphor for divine goodness, and reflection and emission of light were not clearly distinguished in Roman thought and literature.[312] Neo-Platonism stressed the viewing of matter as the first step towards the contemplation of

[305] Tavano (1975), fig. 17. [306] Braithwaite (1982), p. 81.
[307] See Rorem (1993) and (1984), in general on Pseudo-Dionysius.
[308] Rorem (1993), p. 28 and Kitzinger (1954a), p. 138, 'to Pseudo-Dionysius the entire world of the senses in all is variety, reflects the world of the spirit. Contemplation of the former serves as a means to elevate ourselves toward the latter.'
[309] Note the similarity of such attitudes to those of Abbot Suger, as discussed in chapter 3 (p. 89). This understanding is important for worldly splendour, since the colours of worldly churches were seen to accord with those of the upper realm, Benz (1972), pp. 283–91, on Pseudo-Dionysius, *Heavenly Hierarchy*, at p. 289, 'die Kirchenfarben entsprechen den Farben der Engel-Welt'.
[310] He wrote against the Manichaeans that 'nature is never without some good', Augustine, *Contra Epistolam Manichaei*, 34, *PL* 42, col. 199, 'Natura nunquam sine aliquo bono', discussed by Tatarkiewicz (1970), p. 53.
[311] Ibid., p. 294. [312] Barker (1993), p. 169.

divinity, so allowing physical wealth to be seen as a gateway to its spiritual counterpart. Gold, through its brilliance, appeared almost to escape from the dullness of everyday matter. And gold, being a secular elite symbol, was already a metaphor of excellence.

Christ had said of Himself, 'I am the light of the world; he who follows me will not walk in darkness.'[313] Mosaic inscriptions make repeated reference to light and to the brilliance of these works of art. Donors and craftsmen were fully aware of this aspect of these works. So, the church of SS. Cosma e Damiano, in its dedicatory inscription, was said to be a hall of God that 'shines brilliantly with its adornments, wherein there waxes the precious light of faith'.[314] The same sentiments were expressed at the now ruined, late-fifth-century church of St Andrew at Ravenna: 'either light was born here, or confined here rules freely. Perhaps it is the earlier light, whence comes the beauty of the sky. Perhaps, the modest walls generate the splendour of daylight, now that external rays are excluded.'[315] Such descriptions would have been reinforced at the time by the employment of vast numbers of lamps, over ten different types of which appear in the *Liber Pontificalis*.[316]

With regard to the use of worldly substances, it is necessary to consider the ancient delight and belief in similitudes. Objects were expected to be evocative. We would say that gold and gems reflected light; ancient writers might say that they suggested or embodied light, which was sent by God as a metaphor of faith.[317] The Church Fathers, all too aware of the transience of this world, and the vanity especially of the human form, differed amongst themselves over the position of visual symbolism. At one extreme was the view that nothing in the material realm was of concern. In silence, darkness, abstinence and contemplation in emptiness of the otherworld lay the only proper concerns of this life. From there, graded shades of opinion gave steadily greater importance to the imagery of this world. At least as manifested in great churches, the predominant cultural desire was for (legitimate) splendour. That is why the monuments of the age sparkled with every glowing colour that artifice could gather.

Generalized splendour did not have the controversial associations of iconic depiction. It is with this is mind that we should regard the growing presence of the background in early medieval mosaics. Pattern mosaics naturally possessed a ground colour, but this was by no means inevitable in figural depiction. In such

[313] John 8: 12.
[314] Wilpert (1976), p. 329, 'Aula Domini claris radiat speciosa metallis in qua plus fidei lux pretiosa micat.' Gage (1993) translates *metallis* as 'mosaics', p. 275 n. 71.
[315] This inscription is now badly damaged. It is quoted by Gage (1993), p. 46.
[316] Ibid., ch. 3, provides an excellent discussion of light, lighting and liturgy. R. P. Davis (1976), table 8, p. 464 and lighting discussed, pp. 108–10.
[317] Ladner (1992), pp. 85 and 94.

cases, there was often a strong desire to provide a naturalistic setting. Hence the presence in many of our apse mosaics of areas of grass and rocks, as in that of San Vitale (figure 7, p. 115).[318] However, in that example, the horizon appears abruptly only a little above the hems of the garments of the standing figures. Above that point is a sheet of gold tesserae. To illustrate the stylistic change this represents, we may mention the apse mosaic of Santa Pudenziana in Rome, which dates from 150 years earlier. Here the sky is shown as a naturalistic blending of blues, greys and white in a shimmer of opacity. Whilst the symbols of the Evangelists arise from this firmament, Christ is shown below enthroned. He appears against a heavenly Jerusalem that is not only shown like a city, but was apparently modelled on the monuments of the earthly city of Jerusalem.[319] The alternative option is illustrated by a late-fourth-century apse mosaic of the Capella di Sant'Aquilino, Milan, whereupon Christ and the Apostles are shown against a gold ground.[320] There is no later equivalent of Santa Pudenziana's cloudy depiction of the sky. Rather, later Italian tradition was wont to depict the sky with less direct evocation, by using a ground of deep unearthly blue. This appears in the vault of the Mausoleum of Galla Placidia in Ravenna and the Baptistery of San Giovanni, Naples, amongst others, wherein gold and silver stars glimmer out of the ethereal gloom.[321] This representation of the heavens, itself naturalistic, as of a clear night sky, would have been well appreciated by pagan Antiquity.[322] It also bore a Christian resonance, since many church services took place at night in late Antiquity.

But it was the image of the daylight sky which Christianity found particularly suited to its own purposes among the images of Antiquity. Christ was the true light. His worship by Constantine was prefigured by adulation at the turn of the fourth century of the sun-god. The might of the Trinity was imperfectly expressed by the subtle twinkling of stars in a firmament of darkness. Rather, the heavens were to be seen as a realm from which streamed the brilliant light of goodness down to the earth. Glass mosaics were ideally suited for an aesthetic that valued light so highly, since, unlike fresco, they were highly reflective. More specifically, gold and silver were ideal for such representation. They were substances of great importance on earth. Of high value in the form of bullion, they were the life-blood of the government. Anything associated with that institution was, by late Antiquity, elevated to the realms of sacredness in State propaganda. Precious metals were substances that could be recognized and appreciated by everyone for their

[318] Von Simson (1987), pls. 10–11. [319] Bertelli (1989), pp. 58–9. [320] Ibid., pp. 62–3.
[321] Wilpert (1976), Mausoleum of Galla Placidia, pl. 75 and Baptistery of John, pls. 8 and 18. Perhaps the blue grounds of ninth-century apses from Rome were a result of lack of funds? This is an interesting question, but one beyond the chronological limits of this inquiry.
[322] P. R. L. Brown (1971), pp. 78–80.

importance. And these substances were found to be beautiful. Silver display plates adorned the villas of the nobility, and gold jewellery their wives. Aesthetic impact is a power to impress and the expense of precious metal was a factor in this. The position of these metals was also fostered by their brilliance, a factor of their natural colour and resistance to corrosion. Gold and silver were ideally suited as embodiments of heavenly light, since not only did they have very strong associations of worth, but they were also the right colours. Furthermore, being shone upon, they reflect back that light and appear to shine themselves. Figures in heaven could therefore be most easily differentiated from figures on the earth by setting them against a symbolic background of heavenly light. Such usage found its justification not merely in popular metaphors of goodness, but from the inclusion of such imagery in Scripture itself.

As has been stressed, gold was then and should now be considered as a symbolic substance. One way to explore this is to compare modern and ancient attitudes, neither of which is uncomplicated. So Averincev, who takes this approach, approaches the dichotomy and paradox, commenting that the ancients 'méprisaient le luxe pesant du despotisme oriental. Cela est vrai, mais il n'en est que plus significantif de voir quelle place importante la magie de l'or, rejectée par la mentalité esthétique de l'Europe moderne, occupait dans leur art'.[323] The despotic over-use of precious metals by Hellenistic and later sovereigns does indeed receive a very mixed reception in the non-panegyrical sources. It was a stock item of rhetorical abuse, especially on the part of Roman senators with regard to emperors, as has been described in chapter 2. But the use of precious substances would have been counter-productive if they had not acted mainly to convey positive values in the contexts in which they were employed, be that in the palace or, under the late Empire, in churches. Rhetorical abuse concerning luxury can therefore be seen as referring to the misuse of treasure, rather than to any moral dilemma inherent in placing so much value upon the substances themselves. Fascinatingly, in the aftermath of the hostile attitudes of many New Testament passages to worldly riches, this is generally the very point of view reached by the Fathers of the Church, as will be described in the next chapter. Gold was a substance capable of making good things happen. The alternative was to waste it, but as with wasted water, it in itself did not suddenly become bad. The good ends of use included giving to the Church for the sake of that visual aggrandizement that we might understand as religious propaganda.

Treasure, the medium of worldly worth, had triumphed in the worldly Church. It was within this substance that the bones and blood of the martyrs were cradled,

[323] Averincev (1979), p. 49.

just as were the bodies of the emperors, in purple and gold, as the only fitting adornments to power in *this* world. Naturally, aesthetic appreciation was one aspect of this ascribed status of gold and gems. As described by John the Divine, the wonder of the heavenly gold lay in its transparency and brilliance. Earthly gold may not be as transparent as water, but it could still be understood to hold light, especially if light is considered to be yellow, as was natural in a world that had venerated the sun. Gold in that case would appear as 'matière pénétré par les énergies divines'.[324] Then again, the resistance of gold to rust was a vital factor in its aesthetic appreciation and use as a material for coinage and ornament. Its undying brilliance appealed to the aesthetic for startling colours and dazzling lights. Yet also, in religious understanding, there was something miraculous about the fact that this substance, like gems, did not fade or tarnish. As such, it was the figurative counterpart of goodness, of purity and virginity. It was 'un emblème de l'intégrité morale, et aussi un emblème de l'integrité physique'.[325] This factor had long been thought noteworthy. Pliny stresses that it was not the colour of gold that gave it its allure, for silver was brighter, but the fact that gold did not tarnish: 'those persons who think that it is the colour of starlight in gold that has won it favour are clearly mistaken because in the case of gems and other things with the same tint it does not hold an outstanding place'.[326] This 'down to earth' approach was admitted by Pliny not to be held by everyone. There were those who, in mystical fashion, saw in the gold the semblance of stars, which in Stoic thought were the souls of the 'dead'.[327]

'Secular' aesthetic attitudes were of enormous importance, especially in so far as major churches were productions of aristocratic culture and of its values.[328] Nevertheless, the significance of specifically religious symbolism must never be forgotten. Light was such a powerful metaphor for goodness and excellence that not only gold, but liturgical equipment, silk vestments and hangings, silver vessels and the jewels of enamels, reliquaries and books, 'all were developed in the early Christian centuries *primarily as receptacles and images of light*'.[329] This attitude resulted from the position of hue in contemporary culture. Colours were viewed more with regard to their degree of saturation or brightness than is the case today. They were seen as 'light materialised'.[330] The important study of Berlin and Kay suggested that colour schemes of cultures other than of the modern west tend often to discriminate primarily between degrees of brightness.[331] White, red and black are the first shades to be distinguished and other colour terms develop

[324] Ibid., p. 58. [325] Ibid., p. 65. Also, Elizabeth James (1990), p. 283.
[326] Pliny, *Hist. Nat.*, 33, 19, 'manifesto errore eorum, qui colorem siderum placuisse in auro arbitrantur, cum in gemmis aliusque rebus non sit praecipuus'.
[327] Onions (1954), p. 164.
[328] Gage (1993), at p. 39, discusses a late Antique 'attitude to Christian art which is thoroughly secular'.
[329] Ibid., p. 40 (my italics). [330] Elizabeth James (1990), p. 26. [331] Berlin & Kay (1969).

afterwards. It has since been pointed out that it may be misleading to view this evolutionary schema as rigid, since particular instances of colour word formation should be seen in individual societal context.[332] Nevertheless, division along the lines of the spectrum, from red to violet, is very much a modern innovation. 'Colour is in the mind',[333] since although the human eye is capable of distinguishing thousands of shades, the number of basic colour terms employed in human language is considerably more limited.[334] This repertoire is also by no means necessarily identical in every language and society. A recent study of Byzantine colour sense points out that we, not they, see the rainbow through the eyes of Isaac Newton.[335] Elizabeth James has commented of a rainbow of Michael Psellos, which is conventionally translated as red, green and purple black, that an 'equally valid' approach is to 'abandon the modern anachronistic concern with hue'. This done, Psellos' rainbow translates as 'bright, less bright and dark'.[336]

Moreover, colour classification often takes places in close relation with association to qualities, such as black = night = bad, elements of which survive as the secondary meanings of such colour words in modern English (as mentioned in chapter 3, p. 91).[337] As Bousfield has commented of the colour classification of the Ndembu people of Zambia, which is based on white, red and black: each of these colours is related to qualities, but the resulting symbolic perceptual bundle is the most significant mental artefact. So, for instance, in that society, 'it is not clear that we can separate from each other the symbolic references of e.g. "red" and "blood". It is red-as-the-colour-of-blood that carries the symbolism.' Red for the Ndembu is an equivocal symbol; the blood association leads both to the suggestion of fecundity and birth, and murder and death.[338] The example of 'purple' is instructive for the case of Roman society. *Purpura* dye, extracted from sea-shells, was one of the most expensive and prized colourants in Antiquity.[339] It was one of the few truly colour-fast dyes and its manufacture was subjected to stringent controls under the late Empire. As such, it has been mentioned as a royal symbol in chapters 2 and 3. The deepest shades were evidently the most highly praised, but they were eulogized in terms of their brilliance. Purple was associated with the white (bright) end of the spectrum. It was not distinguished clearly from red 'which had been seen as a surrogate for white or gold'.[340] So what appear to us as comparatively sombre

[332] Bousfield (1979). [333] Gage (1993), p. 14. [334] Sahlins (1976), p. 1.
[335] Elizabeth James (1991), p. 69. [336] Ibid., p. 72.
[337] Gilbert-Rolfe (1981), p. 104, also notes that colour in the art of the Middle Ages and in many non-western cultures is often explicitly used as a metaphor, a practice the awareness of which has become dulled in the modern west.
[338] Bousfield (1979), p. 214, together with B. Morris (1987), p. 244.
[339] Reinhold (1970); Steigerwald (1990) and Bridgeman (1987).
[340] Gage (1978), p. 108. This was similarly true in the Germanic world, see Barley (1974b).

draperies, produced for the ancients the impression of shining.[341] Our difficulty in coping with descriptions of purple silk as both dark and bright illustrates the relative poverty of this aspect of English vocabulary relating to the fact that modern society stresses hue to a great extent. Bearing in mind the Ndembu example, purple, like gold, can be seen to have had its main conceptual presence in the form of a bundle of associations. Gold was a prestige substance then as today. Purple cloth was only prized in Antiquity. Golden, then as now, had a positive transitive meaning. Purple only means 'purple', but *purpureus* also meant 'shining' and 'splendid'.

Substance, colour and moral quality were enmeshed in classical society. This indicates that the late Antique enthusiasm for flowers and bright colours was for the massed effect of coruscating brilliance that dazzled the eye as it did the mind with associations of power, abundance and goodness. Gold was particularly useful in such portrayals, since it would catch the glimmers of the innumerable lamps which were lit so that these churches should be 'generators of light', physically as well as spiritually.[342] Besides which, gold mosaics would magnify the pouring in of daylight, the effect of which could be enhanced by the employment of coloured glass.[343] The spectator 'through his whirling about in all directions and being constantly astir', watched the figures of the saints floating out of the brilliant and mysterious splendour of the walls above his head.[344] This aesthetic was reinforced not merely by effects of the gently swinging lamps, but also by the shimmering and blowing of the abundant textiles with which these churches were also hung.[345] Modern photographs can never do justice to the remarkable effect that must have been made by such visual theatre.

The quality of artificiality in such display was recognized with varying degrees of clarity by Christians. The power of secular metaphors of excellence was such that the Church did not replace them, especially bearing in mind their employment in much of Scripture. Rather, it was only through such metaphor that the Church was able to envisage for the masses, or to 'sell' to them, the Christian triumph. 'Fantasy worlds' are neater constructions than the real world. They can therefore be presented as more perfect, more 'real'.[346] They are set forth in comparison with the everyday world, as similar but better. The tendency is to take the pleasures of this world and accentuate them, especially in the case of new cults, which have to make especially strong claims to be noticed.[347] This requires, even in the context of a denigration of the pleasures of this world, an assurance that there is something better waiting. For that reason, religion appears doomed to be parasitic on social

[341] James & Webb (1991), p. 11. [342] Gage (1993), p. 46. [343] Iturgaiz (1972).
[344] Photius, quoted from C. Mango (1986), p. 185, is discussed by Gage (1978), p. 121.
[345] Mathews (1971), pp. 162–71. [346] Gordon (1980), p. 19. [347] Ibid., pp. 22–3.

reality.[348] However, if that social reality is seen as the product of God, then this ceases to be such a problem, since the ways of this world rightly give clues to the operation of paradise.

To celebrate the twentieth year of his reign, Constantine invited the bishops to celebrations. Reclining on couches about the imperial table, they feasted in circumstances 'splendid beyond description . . . One might have thought that a picture of Christ's kingdom was thus shadowed forth, and a dream rather than reality.'[349] It was a vision of heaven suited by the writer to his emperor, just as the golden churches offered a vision of the sacred as desired by late Roman society. It was for this reason that such glistening display was prized by the Church as a show of decorous reverence in the context of the divine and as a God-given means of communication.

[348] Ibid., p. 21. All this was written with regard to Mithraism, but it is equally applicable to Christianity.
[349] Eusebius, *Vita Const.*, 3, 15.

CHAPTER 5

The Christian display of wealth

Christianity began as a small reform movement. It then spread through the cities of the Empire, acquiring as it did so more and richer converts. Nevertheless, its progress was gradual and was occasionally reversed by periods of persecution. For a long period, therefore, Christian communities remained small and their corporate institutions did not possess great wealth. The huge donations of Constantine were therefore made to an institution that had had plenty of time in which to orientate itself in relation to the mores of the classical world. Many areas of the Christian message, such as the idealization of virginity and renunciation of personal property, were radically at odds with the mainstream of contemporary society.[1] It is hardly surprising, therefore, that the Christians felt the necessity to promote these ideals using the most powerful rhetoric at its disposal, including the wholehearted use of imagery in both textual and visual forms.

Jesus addressed himself to individual people and so did the Church. Its task was to save souls by means of transferring people's attention from this world to the next. Private property was one of many potential impediments to personal salvation. The Old Testament offered a very mixed legacy on wealth and virtue.[2] It is strewn with injunctions protecting private property and, for much of their history, the Israelites were obsessed with the idea of taking possession of the Promised Land and enjoying its overflowing milk and honey.[3] The Hebrew tradition was that God was the arbiter of who was poor and who was rich. Jesus, however, taught that the possession of wealth was a barrier to entry into heaven.[4] He objected to devotion to money itself, threw the money-changers out of the Temple and forbade its use to the Apostles on an individual basis.[5] Judas carried a supply of

[1] Goody (1983) overestimates the premeditation of Church policy towards property. The primary concern was the saving of souls. On the Christian preoccupation with virginity, P. R. L. Brown (1988).
[2] Wilks (1987), p. xv.
[3] Exodus 20: 17; Deuteronomy 3: 7 and 20: 5. See also Davies (1974). Derrett (1984) points out that the 'land of milk and honey' (Exodus 3: 8–17 and 13: 5) vanishes from the Christian tradition even as allegory.
[4] Matthew 5: 3 and 6: 19; Mark 10: 23–6; Luke 6: 20, 12: 21 and 16: 23 and James 2: 5.
[5] Matthew 21: 12 and 22: 21; Mark 11: 15 and 12: 17; Luke 20: 15 and John 2: 14–5.

coin which was common between them all and the first community in Jerusalem was based on communal wealth.[6] Patristic discussion was thus left to pick up the pieces of this mixed Scriptural legacy.[7] Two opinions could be drawn. The first argued that the Apostles set an example of the life that all Christians should follow. The second opinion argued that Jesus had offered a counsel for perfection. Support for this view comes from Matthew's prefix, '*if you would be perfect* sell all you have and follow me'.[8] This view allowed for a much easier accommodation with society as a whole, one which parallels the advocacy of virginity as the perfect path along which only a few are destined to travel. It is no surprise that it was to be the orthodox view.[9] How could one give to the poor, it was argued, if one were poor oneself?[10] Opposition to mainstream opinion was, of course, heresy. Certain sects, such as the Eusthasians of mid-fourth-century Asia Minor, appear to have advocated literal renunciation of wealth, along with denunciation of marriage and advocacy of prayer in private homes. Each position related to literal readings of New Testament texts. The Synod of Gangra in *c.* 345 condemned the sect, stating that 'we do not despise wealth if it is united to justice and liberality'. The acts of this synod were included in the first translation of Greek canons into Latin and enjoyed wide circulation in the west.[11]

One of the principal works which defined the consensus position was the *Quis dives salvetur?* of Clement of Alexandria. He argued that it was possible to have great riches and yet not to love them.[12] The significantly more ascetic Basil of Caesarea demanded of people a strong commitment to charity, yet he declared that possessions were not evil in themselves. This attitude is found again and again. 'The wealth does not commit the crime, the will does', wrote Ambrose.[13] Augustine, likewise, identified that evil was not a substance, but rather it was the corruption or misuse of what was by nature good.[14] Commenting on 'lay up for yourself treasures in heaven', Augustine referred to Christ as the keeper of the great celestial bank to which all earthly riches ought to be committed.[15] All

[6] John 12: 6 and 13: 29. Acts 2: 4–5 and 4: 32–5. [7] McGuckin (1987). [8] Matthew 19: 21.

[9] De Ste Croix (1975), p. 25.

[10] Ibid., pp. 28–31. De Ste Croix found only three non-heretical writers who, in selected passages, provide 'partial exceptions' to this consensus; Origen, who, unlike Clement, did not wish to allegorize away texts that attacked wealth (Chadwick (1966), p. 123: there is much in Origen that is 'illiberal, world-denying and ascetic'), Basil writing from a monastic world of communal wealth and, in some very ambiguous passages, Ambrose.

[11] Discussed by McGuckin (1987), p. 13. Gaudemet (1989), p. 573, 'Si les Pères ne condamnent pas la propriété, ils en dénoncent le mauvais usage, le luxe insolent des riches en face de la misère des pauvres.'

[12] Countryman (1980), p. 69, with references to Clement of Alexandria, *Quis dives salvetur?*

[13] Ambrose, *Expositiones Evangeli Secundum Lucam*, 5, M. Adriaen & G. Coppa (eds.), G. Coppa (trans.) *S. Ambrogio: Esposizione del Vangelo secondo Luca*, 2 vols., SAEMO 11 and 12 (1978).

[14] Gonzalez (1990), p. 214. MacQueen (1972). [15] Matthew 6: 20; Augustine, *Enn. in Psalm.*, 38, 12.

property, in other words, should be in the hands of the Church. In the meantime, Augustine believed that what mattered was what a person wanted wealth for and what they did with it. Abundance was not to be shunned. Had not Abraham's house abounded with gold, silver, servants and cattle? This was a scene of happiness, if of a lesser order than spiritual happiness. The good Christian should use rather than ignore the world, yet should not be entranced by it. Abraham was rich. If God gave, then it should not be scorned. The eye of the needle blocked not riches but the *desire* for riches. This does not mean that wealth is not a danger, since it is hard not to love it. Therefore it is better to be without it.[16] The best thing to do is to give wealth back to its true owner, God, as exemplified by the Church.

Personal renunciation of property was an act of enormous spiritual significance. The example of Melania the Younger was especially important, indicating that the rich could be saints too, by virtue of using their money in certain ways.[17] However, there was then the difficult issue of whether giving should be to the poor or in material form to the Church. If the former, the donor handing out coins was in danger of appearing just like a pagan grandee before dependants. Caution concerning the latter course was spelled out to a correspondent by Jerome: 'others may build churches, dress the walls with marbles, procure massive columns, deck the unconscious columns with gold and precious ornaments, cover church doors with gold and precious ornaments and adorn the altars with gold and gems. I do not blame those who do these things and I do not repudiate them.'[18] Such acts were surely still better than hoarding the money, he continued, but nevertheless you would be better advised to spend your time helping the poor. The moderation of this passage was prompted by the fact that such splendour was employed in the service of Christ. The merely implicit nature of Jerome's criticism is striking when compared with Seneca's denunciation of the splendid buildings of his age: 'we admire walls veneered with a thin layer of marble, although we know what it is hiding . . . Nor is such superficial embellishment spread only over walls and ceilings. All of those whom you see walking tall have nothing but a gilt prosperity. Look and you will know how much evil lies under that thin coating.'[19]

[16] Augustine, *Enn. in Psalm.*, 143, 18.

[17] *Vita Melaniae*, although, of course, she did *live* ascetically as well.

[18] Jerome, *Ep.*, 130, 14, 'Alii aedificent ecclesias, uestiant parietas marmorum crustis, columnarum moles aduehant earumque deaurent capita pretiosum ornatum non sentientia, ebore argentoque ualuas et gemmis aurea uel aurata distinguant altaria – non reprehendo, non abnuo.'

[19] Seneca, *Ad Lucilium Epistulae Morales*, 115, 9, R. M. Gummere (ed. and trans.), 3 vols., LCL (1925), 'Miramur parietes tenui marmore inductos, cum sciamus, quale sit quod absconditur. Nec tantum parietibus aut lacunaribus ornamentum tenue praetenditur; omnium istorum, quos incedere altos vides, bratteata felicitas est. Inspice, et scies, sub ista tenui membrana dignitatis quantum mali iaceat.'

Great was the desire for splendid churches as impressive settings for the sacred liturgy. Donors were keen to provide such splendour, which both did honour to God and to themselves. It is my belief that there were indeed some ascetic Christians who did not approve of the splendid golden churches of the towns. Such people would have looked to the wilderness as the place to save them from the linked horrors of urbanity and sin. But the eloquence that has preserved so many early Christian voices was a product of urban classical culture. Eloquent opposition was heresy. The result, for the most part, was silence. Even Jerome, no shrinking violet himself, occasionally felt compelled to pull his punches.

The title of a recent study is revealing, *The Rich Christian in the Church of the Early Empire: Contradictions and Accommodations*.[20] In the earliest years, the 'righteous poor dominated to such an extent that there could be little discussion of the meaning of Christian wealth'.[21] But the Church of late Antiquity wished to be the Church of everyone in society. It needed the rich to endow it with wealth to provide centres for worship and to succour the poor. The institutional structures of the Church, based around episcopal sees, wished to maintain authority over the communities of the faithful so as to ensure that individuals did not stray into error. The great churches provided a focus for the attention of all ranks in the local community and their social centrality was constantly reaffirmed by miracles resulting from the possession of relics. In such a context it was easy to imagine the perfect Christian community as being like a splendid city with everyone in their due order.

However, in the actions of individuals there was another potential focus of sacred power. Charismatic holy men and women were difficult to accommodate within the ordered episcopal structure. A strong tradition of opinion in late Antiquity held that true salvation was best sought by an individual who turned his or her back on 'the city' and went out into 'the desert'. The potential sanctity of such an act could not be denied. It *was* dangerous, however, in the eyes of orthodox opinion to insist on ascetic perfection not just for oneself, but for everyone. The inconsistencies of the Catholic Church's accommodation of the rich were brilliantly described in an early-fifth-century tract preserved in a corpus of Pelagian material. This piece, known simply as *De Divitiis*, demands, 'let there be an end to false allegory, now that we are furnished with the truth and now that it is not the approval of the reader that we are seeking but his improvement'.[22] The writer denounces those who use 'things done under the law to defend riches by interpreting them simply and without mystical imagery', while at the same time 'they strive

[20] Countryman (1980). [21] Ibid., p. 89.
[22] *De Divitiis*, 10, 1, G. Caspari (ed.) in *PL, Supplementum* 1 (Paris, 1958), cols. 1380–1418, 'Cesset nunc falsa allegoria, ubi ueritatis adstruitur, et ubi lectoris non fauor quaeritur, sed profectus.'

to conceal the precepts of the Gospel under a cloak of allegorical obfuscation with no regard for the simple, literal truth'.[23] The documents of suppressed heresies are rarely preserved. This tract, therefore, offers an invaluable and rare glimpse of the opinions of those who felt that the Orthodox position was a betrayal of Christ's Word, and that an institution which preached against worldly splendour should not be similarly ostentatious itself through dependence on the charity of rulers and aristocrats.

A parallel to the adoption by the Church of the propagandistic methods of the 'treasure society' may be drawn with the acceptance (or otherwise) of icons and Christian images in general. In that example, 'defence lagged behind attack, as attack had lagged behind practice'.[24] The difference between the two instances is that if icons were implicitly accepted and then questioned, treasure decoration would not come under serious popular attack until the very end of the Middle Ages. This is not to say that there was uniformity of opinion. I have already mentioned Jerome's misgivings about church art. He condemned painters, sculptors, stone-masons and other 'minions of dissoluteness',[25] and commented on Jesus' words, 'consider the lilies of the field, how they grow; they toil not, neither do they spin: yet I say to you that even Solomon in all his glory was not arrayed like one of these',[26] by asking, 'what silk, what royal purple, what weaving patterns can be compared with flowers? . . . The eyes even more than words, pronounce that no other purple matches the purple of the violet.'[27] Many build churches these days, Jerome tells us, that shine with marbles and glitter with gold, their altars studded with gems, while little attention is paid to the choice of Christ's ministers. It is of no concern that the Temple in Judea was bright with gold, for that was when priests offered up victims and 'the blood of sheep was the redemption of sins'.[28]

Conversely, many others, such as the poet Prudentius, clearly loved the sparkle and the glitter, yet the moral teachings of Jesus on wealth meant that they had to carefully deny the physical prominence of treasure in a way that was not commonly seen as hypocrisy until the very end of the Middle Ages. So, in Prudentius' set of poems, *Crowns of Martyrdom (Peristaphanon)*, when a *procurator* arrived to confiscate church riches, St Lawrence displayed to him women consecrated to Christ after the

[23] Ibid., 18, 11, 'quae in lege sunt gesta, ad defensionem diuitum simpliciter et absque imaginariae interpretationis mysterio subutantur, euangelica uero praecepta, omni historiae simplicitate et ueritate submota, allegorica nitantur obumbratione uelare'.
[24] Kitzinger (1954a), p. 87. [25] Jerome, *Ep.*, 88, 18, 'luxuriae ministros'.
[26] Matthew 6: 28–9, 'Considerate lilia agri quomodo crescunt: non laborant neque nent. Dico autem vobis quoniam nec Salomon in omni gloria sua coopertus est sicut unum ex istis.'
[27] Jerome, *Commentariorum in Evangelium Matthaei*, 1, 6; PL 26, c. 47, 'Quod sericum, quae regum purpura, quae pictura textricum potest floribus comparari? . . . Violae vero purpuram nullo superari murice, oculorum magis quam sermonis iudicium est.'
[28] Jerome, *Ep.*, 52, 2, 'sanguis pecudum erat redemptio peccatorum'.

loss of their first husband. They, he asserted, were the 'jewels of flashing light with which this temple is adorned',[29] they were 'the church's necklace, the jewels with which she decks herself, thus dowered she is pleasing to Christ'.[30] But it is through such rhetoric that the very treasure aesthetic that we have seen condemned by Jerome can be found beautifully expressed all through Prudentius' work.[31] So, of two soldiers who refused to serve the pagan Empire and so suffered martyrdom, Emetrius and Chelidonius, Prudentius wrote that: 'written in heaven (*in caelo*) are the names of the two martyrs. Christ has entered them in letters of gold, while on earth he recorded them in characters of blood.'[32] In just this fashion, the insignia of saints appeared on the ceiling (*caelum*) of the great churches.

Neither in mosaic nor in poetic description of heaven was the martyr shown in physical ruin, an aesthetic based on the denial that 'the death of the Very Special Dead had anything to do with the observed effects of the death of the average Christian'.[33] The saint is imagined as dressed in the otherworld like the powerful on earth: 'I think I see the hero flashing with brilliant gems, whom the heavenly Rome has chosen to be her perpetual consul', wrote Prudentius.[34] The same vision of serenity, the same sense of decorum, can be seen in Constantinian and Theodosian statuary. The emperors were vindicated by victories. Triumph in alliance with God was omnipresent and eternal; 'the victory was general and non-specific, and the serenity of the composition not disturbed by anything so crude' as blood and gore.[35] As we have seen, both imperial and Christian artistic iconography spoke this symbolic language. Degradation was erased. Christ's crown of thorns became of oak leaves, and its acorns become jewels.[36] Exceptions are few. Crucifixion scenes were notably rare, being represented primarily from the Holy Land, such as the miniature in the sixth-century Syrian Rabula Gospels[37] and on a number of ampullae produced there as relics.[38] But even on the latter there was a notable attempt to dodge the issue. Unlike his two companions, Christ was often not shown realistically, but was replaced by a nimbate head over a cross-shape.

[29] Prudentius, *Perist.*, 2, 299–300, 'gemmas corusci luminis, ornantur hoc templum quibus'.

[30] Ibid., 2, 305–7; pp. 126–7, 'hoc est monile ecclesiae, his illa gemmis comitur; dotata sic Christo placet'.

[31] Of which Palmer (1989) is a general study.

[32] Prudentius, *Perist.*, 1, 1–2, *Caelum* was used to mean 'heaven' and 'ceiling'.

[33] P. R. L. Brown (1977), relics, p. 227.

[34] Prudentius, *Perist.*, 2, 556–60, 'Videor videre inlustribus gemmis coruscantem virum, quem Roma caelestis sibi legit perennem consulem.'

[35] MacCormack (1981), p. 205. Although, fascinatingly, the rules of literary decorum did permit the most lurid examples of torture and execution of the saints to be described, as throughout the stories in Prudentius, *Perist.*

[36] Brandon (1975), p. 164, 'early Christians visualised Christ in a form that had no apparent relation to the conceptions implied or promoted in the New Testament'.

[37] Beckwith (1970), pl. 45, Gospels now in the Bibliotheca Laurentiana, Florence.

[38] For example, Kühnel (1987), pl. 19, Dumbarton Oaks Collection, Washington, D.C., *ampulla* 48, 18.

Ambiguities in the rhetorics of text and image appear strikingly in the context of clothing. The State was marked by strong distinctions in dress type relating to the construction of a 'sacred' hierarchy. The Republican equivalent was the pyramid of the *ordines*. The Apostles, of course, would originally have preached in whatever dress was theirs. The poverty of many of the earliest Christians, above all of Christ himself, led to the idolization of the shabby, as opposed to the brilliant, in clothing, so as to demonstrate a sharp lifestyle-contrast with the gaudy oligarchies of the east, or with their counterparts at Rome who traditionally guarded their dress prerogatives such as the width of their purple *clavi*. Holy men provided in dress, as in their other habits of life, an antithesis that the emperors of late Rome could not ignore. In the face of the wisdom of the desert, the government flattered the holy ones.

Potentially, the world-denying ethos would appear to have been strikingly subversive. The incident in which Martin of Tours cut his cloak in two and gave half to a beggar is an example of enormous symbolic daring. Martin was a soldier, and his cloak was the chlamys, the 'sacred' symbol of military rank and allegiance to the Empire.[39] Similarly, the ex-soldier Germanus of Auxerre used his military cloak (*sagulum*, a variety of chlamys) with sacking as sheets on a bed made of compacted ashes.[40] Such acts were far more subversive than renunciation of private elite symbols. Yet the two systems coexisted. Renunciation would have lost its social power if everyone had been doing it. A glimpse of the symbolic power-play of dress in late Antiquity can be seen in the life of Melania the Younger. She went to the baths as a child, not because she wanted to go, but so as to obey her parents. She soon began to wear 'under her silken clothing, a coarse woollen garment',[41] and was chastised by her aunt who noticed this. Forced into marriage, she and her husband were together of the highest order of wealth and possessed estates scattered across the Empire. Fleeing the Goths, they journeyed to the Holy Land after Melania had persuaded her husband to embrace the ascetic life.[42] Having invited the holy lady to the imperial palace, the empress was 'greatly moved when she saw the blessed woman in her humble garment, and having welcomed her, the empress had Melania sit on the golden royal throne'.[43]

The presence of antithesis was *not* generally read as a call to universal renunciation, because the calling of perfection was understood to be available to very few. Moreover, the idea of hierarchy was not challenged. Holy men were subjects of the

[39] Sulpicius Severus, *Vita Sancti Martini*, 3, 2, J. Fontaine (ed. and trans.) *Sulpice Sévère: 'Vie de Saint Martin'*, 3 vols, SC 133–5 (Paris, 1967–9).

[40] Constantius, *Vita Germani*, 1, 4, R. Borius (ed. and trans.) *Constance de Lyon, Vie de Saint Germain d'Auxerre*, SC 112 (Paris, 1965). On Germanus' civilian career, see Gaudemet (1950).

[41] *Vita Melaniae*, 4, D. Gorce (ed. and trans.) *Vie de saint Mélanie*, SC 90 (1962).

[42] Clark (1986b), pp. 61ff. [43] *Vita Melaniae*, 12.

divine ruler. Christ, according to the Apocalypse, would come as 'the King of Kings'. There is a story in the life of Martin in which the devil appears dressed as an emperor, 'enveloped in a purple light, thinking to deceive more easily if he shone with borrowed splendour. He wore, too, a royal robe and was crowned with a diadem of gems and gold, and gold gleamed on his shoes.' But the holy man recognized him, ' "the Lord Jesus", said he, "did not say he would come in a purple robe and glittering diadem. I will only believe in a Christ who comes in the garments and the lineaments of the Passion, who comes bearing on him the wounds of the cross".'[44] Such rhetoric illustrates the constant tension between the desire for visual honour and the abhorrence of inappropriate display that coexisted in that age.

Holy men were understood as those with treasured souls. And the more they had dressed shabbily in life the more they were imagined as clad in the pomp of the otherworld, hence the events which saw the wretched cadaver of Cuthbert (who appears to have starved himself to death) robed in the greatest splendour that could be managed by the monks of Lindisfarne.[45] If the holy were expected to be indifferent to their mode of dress, worshippers were expected to be highly attentive to such matters. To do otherwise would imply a lack of respect. Although Christ is usually dressed in non-imperial attire in mosaic depictions, his clothing is often purple, so distinguishing him from lesser figures. The early-sixth-century bishop, Severus of Antioch, 'often attempted to persuade the multitude in the very church of the most holy Michael that white vestments and not purple ones were appropriate to angels'.[46] Yet, in Sant'Apollinare Nuovo, the archangels Michael and Gabriel are shown on each side of the altar in full imperial-purple dress (figure 8, p. 120).[47] If a bishop was an aristocrat he often clearly felt quite comfortable wearing the dress of his rank. Thus, the early fifth-century mosaic of Sant'Ambrogio at San Vittore shows Ambrose in aristocratic dress.[48] Expensive liturgical vestments were soon developed, primarily the chasuble dyed with high grade *blatta* purple.[49] The role of

[44] Sulpicius Severus, *Vita Martini*, 24, 4, 'circumiectus ipse luce purpura, quo facilius claritate adsumpti fulgoris inluderet. Veste etiam regia indutus, diademate ex gemmis auroque redimittus, calceis auro inlitis ... "non se", inquit, "Iesus Dominus purpuratum nec diademate renidentem venturum esse praedixit. Ego, Christum, nisi in eo habitu formaque qua passus est, nisi crucis stigmata praeferentem venisse non credam".' The Devil was frequently seen as a trickster in late Antiquity, Amat (1985), pp. 333–5 and Straw (1988), pp. 50 and 64.
[45] See the articles in Battiscombe (1956), with a summary in Webster & Backhouse (1992), pp. 132–4.
[46] John of Gabala, fragment from *A Life of Severus*, quoted from C. Mango (1986), p. 44.
[47] Von Simson (1987), pl. 21. [48] Shepherd (1967), p. 62.
[49] Steigerwald (1990), p. 239, 'für den höchsten kirchlichen Würdenträger, die Patriarcher und die Bischöfe, ist ein blattapurpurne Amtskostüm bezeugt: die Casula/Planeta'. The *Apostolic Constitutions* (c. 380) refer to a 'splendid vestment', habitually worn for the sacred liturgy, see *Apostolic Constitutions*, 8, 12, discussed with references in Shepherd (1967), p. 63.

Constantine in engendering vastly enhanced splendour in the church context even extended to the question of garments. He apparently sent a gold-threaded robe to bishop Macarius of Jerusalem. We known this because Acacius of Caesarea disparaged Cyril's sale of it, together with other items, although it was done to relieve a famine.[50]

Biblical legitimization, such as the tradition of linking heaven and jewels, allowed the use of 'accessible precedents in imperial iconography... [which] gave the image-makers the means of representing symbolically the power of God'.[51] Christ had triumphed, and thus triumphal ornaments, such as jewelled crowns and thrones, were more than simply appropriate for him; they would be necessary out of simple respect, let alone in the context of worship.[52] This vision of holy rule likewise received legitimization in the context of the Christian emperors in so far as King Solomon appears nothing if not surrounded by the brilliance of gold.[53] Cyril Mango has written that, 'in speaking of Early Byzantine or Early Christian art (which comes to almost the same thing) we must remember that we mean the art of the Later Roman Empire adapted to the needs of the Church'.[54] It is my argument that such modes of depiction emphasize the interdependence of the Church and the State in the deployment of exalted imagery. The cult of pagan images preceded that of icons[55] and the aim of Roman imperial portraits rapidly evolved in sacred context to be that of the portrayal of the heroic, of the superhuman.[56] In a similar fashion, the Christian mosaics 'show a divinity unfathomable, majestic and infinitely distant'.[57] Other aspects of Christian art were distinctly dissimilar from that of the State. Any 'copying' was not necessarily, if at all, sycophantic in nature and nor was it a straightforward matter of the adoption of themes by one institution from another.

The Empire did not triumph over the Church, nor vice versa. The two co-existed, sometimes helping one another, sometimes at odds. They used related symbolic vocabularies for different ends. They both struggled for a prominent display of excellence that could not be condemned as luxury. This complex game of display on the one hand and denial of luxury on the other was also being played by many prominent pagans. It should be recalled that it was Julian's flamboyant austerity that contrasted with the style of the Antiochene Christians. In the pagan emperor's view, Constantine had been a profligate. The worship of the true Gods had been driven out by impure and vulgar luxury.[58] Similarly, the anonymous tract

[50] Discussed by Shepherd (1967), p. 63. [51] Grabar (1968a), p. 45. [52] Brandon (1975).
[53] Averincev (1979), p. 61. [54] C. Mango (1980), p. 258. [55] Kitzinger (1954a), p. 91.
[56] Van Der Meer (1967), p. 26. [57] Volbach (c. 1943), p. 5.
[58] A jolly account of Julian at Antioch in given by Gibbon (1910), II, pp. 409–12, from chapter 24. Lieu (1989) is a modern introduction to the sources including Julian himself. See also Nicholson (1994).

De Rebus Bellicis, dated to *c.* 370,[59] described the age of prodigality and luxury as having dated from the time of Constantine, 'when the gold and silver and the enormous quantity of precious stones which had been hoarded up in the temples many years ago, reached the public'.[60]

Ascetic paganism appears to have campaigned on a rather similar agenda to ascetic Christianity, just as another manifestation of pagan fervour was expressed through grand buildings and display. Philosophical systems provided an intellectual superstructure for both religions. Both offered access, via priests, for the people to divinity. That divinity could offer help in the here and now. Christianity, however, had the special 'selling point' of a precise afterlife, something that was emphasized in its verbal and visual propaganda. Persecution, sparked by refusal to sacrifice to the emperor, did temporarily curtail the growth of Christianity. Nevertheless, the ensuing deaths provided Christianity with a race of heroes to rival those of the pagans. Those martyrs were celebrated with all the resources with which the Church already gave praise to God. Such celebration, it was claimed, was not luxury since it was done for the honour of God and the saints. Constantine gave Christians huge new opportunities for display, whilst allegedly stripping these from the pagans.[61] The exclusive nature of Christian worship acted to trap people once they had converted and so the backdrop was set for the dramatic growth of what was now the State-cult.[62] Furthermore, Jesus was both man and God. He was shown walking in ordinary scenes, as well as in grandeur in heaven. Churches therefore had an extra element of accessibility to go with their splendour. Worship was carried out in public halls (the basilicas), rather than in secret in temples, whilst the ancient pagan festivals were Christianized with the development of urban, stational liturgy.[63] Although theological debate took place at a high level, it was not self-consciously exclusive as was the case with much philosophy. Universal salvation was at the core of Christian practice. Christianity must needs have addressed the whole world, and not merely that portion of mankind with which it found communication most easy. Treasures communicated to the mass of society and symbolic understanding provided the tool to enable treasure metaphor to be identified with Christian salvation.

By the early Middle Ages, carefully organized monasteries and other religious

[59] Alan Cameron (1979).
[60] *De Rebus Bellicis,* 2, 'cum enim antiquitus aurum argentumque et lapidem pretiosorum magna uis in templis reposita ad publicam peruenisset'.
[61] Discussed by A. Alföldi (1969), pp. 97 and 108.
[62] Temples were only converted to churches in any numbers from the fifth century, Hanson (1978).
[63] Scranton (1946) argues that interiors of temples, hung with lamps, were not in fact the intensely dark places which they have sometimes been supposed to have been. Visitors such as Pausanias were able to make detailed examinations of cult statues. The stress in Christian descriptions of churches on general brilliance may reflect the greater prominence of abstraction in late antique art-historical appreciation, Onians (1980). On urban liturgy, Limberis (1994) and Baldovin (1987), esp. pp. 253–68.

institutions offered the chance to combine the advantages of a community with the personal perfection of ascetic life. Robert Markus has written of the 'blurring of frontiers' between the 'desert' and the 'city', as 'ascetic' lifestyles became increasingly important for bishops.[64] Such personal behaviour acted to legitimate the splendour of the institutions over which these people presided. The case of Paulinus of Nola provides a fascinating example of such a situation. Paulinus was a wealthy and important figure in the late fourth century, who crowned his public career with a suffect consulship and the governorship of Campania.[65] It was an inexplicable mystery to his sometime tutor, Ausonius, when Paulinus embraced an ascetic lifestyle and gave away much of his family property.[66] Jerome wrote to congratulate him and, of course, to admonish and advise. 'The true temple of Christ is the believer's soul', he wrote, 'adorn this, clothe it, offer gifts to it, welcome Christ in it. What use are walls blazing with jewels when Christ in his poor is in danger of perishing from hunger?'[67]

Retreating to Cimitale, near Nola, Paulinus devoted himself to the cult of the local saint, Felix. He was elected bishop of the town around the year 409. As we know from the evidence of his writings, and despite the words of Jerome, he spent much of his remaining money and energy on the churches at Nola and Fundi.[68] His poem on the construction of a baptistery (*Carmen* 28) describes his pleasure at having renewed the decoration of the old part of the church complex there. Now, he wrote, 'the black ugliness is hidden and painting has restored youthful brilliance to the old architecture by pouring over it the splendour of varied colours'.[69] He then inserted a polemic on the need for personal denial of things of this world and continued, 'if God's lessons from the light of the Word do not open up understanding, let us then at any rate obtain examples from the buildings themselves and let stone and wood be teachers to us dullards, so that we may achieve such a work in faith as we have accomplished by our handicraft'.[70] He declared that 'idle wealth, impure love, soiled passion, are the rubble of the soul',[71] and as the physical rubble

[64] Markus (1990), chapters 12 and 13, pp. 181–211.
[65] On Paulinus see the entry by S. Constanza in Di Berardino (1992), II, pp. 660–1, Lienhard (1977) and on his churches, Goldschmidt (1940), which includes a discussion of poem 28.
[66] Markus (1990), pp. 36–8.
[67] Jerome, *Ep.*, 58, 7, 'Uerum Christi templum anima credentis est: illam exorna, illam uesti, illi offer donaria, in illa Christum suscipe. Quae utilitas parietes fulgere gemmis et Christum in paupere fame mori?' This letter dates from *c.* 394–6.
[68] Reconstructions of the apses are given in Ihm (1960).
[69] Paulinus, *Carmina*, 28, 212–14, 'niger abducitur horror, et sensibus tectis iuvenem pictura nitorem reddidit infuso variorum flore colorum'.
[70] Ibid., 28, 258–62, 'Si nobis doctrina Dei de lumine verbi non aperit sensum, saltem capiamus ab ipsis aedibus exempla, et lapides ac ligna magistri sint stolidis, ut quale manu confecimus istic tale fide faciamus opus.' Compare Jerome, *Ep.*, 52, on the interpretation of the riches of Solomon's Temple.
[71] Paulinus, *Carmina*, 28, 285–6, 'luxus iners, inpurus amor, maculosa libido rudera sunt animae'.

had given way to marble and mosaic, so 'let the earthly image die and the heavenly come'.[72] This was the man who had written to Jovinian that we must resist the 'outward loveliness of temporal things'![73] The material and the spiritual were combined in late Antiquity, just as they had been mingled in the person of Christ.

Gregory the Great mentioned a vision beheld by a soldier when grievously smitten by the plague which was then ravaging Italy. The man saw a bridge of the dead spanning a black smoking river, leading to palaces of gold amid green fields. Those who were good passed safely over, but sinners were plunged in the waters.[74] Churches were the main luxurious urban edifices to survive in much of the west. In those buildings there was piled up a fusion of urban and rural motifs, of splendour and of living nature in which, 'overhead the gleaming roof flashes light down from its gilded panels and shaped stones diversify the floor so that it seems like a rose-coloured meadow blushing with varied blooms'.[75] 'Flowers' and 'colours' and 'gems' were all words of praise that were applied both to mosaics and to texts. Interpretation and aesthetic pleasure cohered and reinforced one another.[76] Prudentius described the baptistery at Old St Peter's as though it were a shaded pool on a hillside surrounded with mosses,[77] and he wrote of the mosaics of the church of Paul in Rome, that Theodosius had 'covered the curves of the arches with splendid glass of different hues, like meadows that are bright with spring flowers'.[78] The artificiality of these very public and self-serving gifts was glossed over.[79] The peace of an ideal countryside was presented to the community of the faithful, the city was baptized and the rigours of the desert watered into a garden. Most believers, seeing such pure and yet seductive visions, would thank the Lord and ask no questions. After all, had not Jesus said, 'blessed are the *poor in spirit* for theirs is the kingdom of heaven?'[80]

[72] Ibid., 28, 322, 'terrena intereat, subeat caelestis imago'.

[73] Paulinus of Nola, *Epistulae*, 16, 7–8; G. De Hartel (ed.), *CSEL* 29 (1894), 'omnes rerum temporalium species'. It is ironic, considering the classical desire to be remembered by posterity, that although Ausonius believed that Paulinus was condemning himself to oblivion by giving away his family estates, the memory of holy Paulinus was alive and well in the following century, by which time Ausonius' family had either died out or had, at any rate, vanished from social notice, Van Dam (1985), ch. 14, pp. 303–11, 'The fates of Ausonius and Paulinus of Nola'.

[74] Gregory the Great, *Dialogus*, 4, 36; *PL* 77, cols. 144–430.

[75] Prudentius, *Perist.*, 3, 196–200, 'tecta corusca super rutiliant de lacqueribus aureolis saxaque caesa solum varrant, floribus ut rosulata putes prata rubescere multimodis'.

[76] M. Roberts (1989), p. 76. [77] Prudentius, *Perist.*, 12, 36ff.

[78] Ibid., 12, 52–4, 'Tum camiros hyalo insigni varie cucurrit arcus: sic prata vernis floribus renident.'

[79] Compare the ideas of 'necessary misrecognition' in ritual as explored in chapter 1, together with Bloch & Parry (1989), p. 25, 'morally equivocal money derived from short-term exchange cycles is transformed by a simple symbolic operation into a positively beneficial resource which sustains the ideal order of the unchanging community'. As C. Mango (1992), comments, what seems to us paradoxical appeared quite natural to people of that age. The material and the spiritual were generally understood to complement each other.

[80] Matthew 5: 2, from the Sermon on the Mount. Also quoted at the beginning of chapter 3 of this book.

Epilogue

I began my inquiry by asking a series of questions: to recap, why was the Christian God expressed symbolically by gold when that substance had traditionally been used to display the power of the secular nobility and pagan gods of Antiquity? Why did Christianity, with its scripturally enshrined mission to redistribute wealth, not only do so little to disturb ancient patterns of aristocratic symbolism, but even adopt them itself? Why should an apparently world-denying religion have employed such a considerable part of its resources in late Antiquity to the construction of worldly splendour? My answers have been reached through examination of the symbolic associations of gold and treasures. I have considered their primary value to be as markers of esteem. As such, they were only tainted with 'worldliness' or 'pagan associations' in so far as they were understood as being part of the non-Christian world. However, the extensive presence of treasures and treasure symbolism in Holy Scripture demonstrated that gold was associated with the worship of God in the divine plan. With the conversion of the emperors to Christianity, establishment magnificence was at the disposal of the Church. From the Christian point of view, the riches of nature came from God and the issue at stake was not so much their intrinsic evil, but the moral dilemma of their correct use. The mainstream attitude was to stress the desirability of employing extensive resources in the worship of the Lord and the presentation of the faith. To that end, the symbols of prestige were now re-deployed, as they would see it, correctly, in the endowment and decoration of churches. Symbolic interpretation combined with a Neo-Platonic belief in the viewing of matter as a first stage in the perception of divinity to encourage the perception of links between physical and spiritual riches.[1] This use of gold and treasures in the church context further allowed individuals to unburden themselves of wealth and so become spiritually rich, whilst rule and splendour were allotted to Christ the King. This was how the symbols of royalty and poverty, shown on opposite sides of a balance on a mosaic from

[1] Barasch (1992), p. 179, Pseudo-Dionysius saw the image as 'the starting point to heaven'.

Pompeii of the first century AD (mentioned on p. 45), were brought together in the golden propaganda of Christian victory.

This book has shown how the institution whose duty was the propagation of the values of Christ could not do other than interpret this mission in the light of contemporary cultural understandings. By his very exalted existence, Jesus, flanked by the Apostles, indicated the presence of a sacred hierarchy amongst people. The construction of the Christian Church was accompanied by a conception of a hierarchy of organizations. The Church saw itself as the premier institution in this world since it was the primary instrument of God's will. It wished to explain not only the excellence of God but also of itself. To that end, it was orthodox opinion that the Lord had set down in this world the tools for just such a presentation. We may understand the Church to have copied secular use of gold and treasure to show sublime status, but Christians of late Antiquity could say that these things were creations of God and should be turned to their proper purpose. *Literal* sanction for such practices was lacking in the Gospels and had to be sought in allegorical readings of the earlier Jewish tradition, yet for most people the *symbolic* literary and visual employment of splendour in propagating the Christian message was not simply acceptable but desirable and necessary.

The classical striving for fame, along with the ancient civic practice of donation of treasures and grand buildings with dedication inscriptions, appears directly replicated in the Christian context. We may be able to trace all manner of links with ancient pagan practice, but that was not at all how these matters were understood in late Antiquity. The churches were filled with treasure through Christian piety of a sort that possessed a very physical understanding of how to communicate with the divine. This establishment attitude was never entirely entrenched. Jesus' mission can be seen today as one of protest against the wealthy complacency of established Rabbinical Judaism. Those who, in the later Christian centuries, pointed to the literal meaning of the words of Jesus and who denied the significance of the grandeur of the Church and of its churches, either went out into the 'desert' to attempt to save their own souls, or voiced opposition, in which case they could be accused of heresy.[2] This is not to say that there was a complete absence of reservations on the part even of the great doctors of the Church. Augustine may have been wary of using gold imagery, Jerome may have wondered that so much money was being spent on decoration, but the previously mentioned example of Paulinus of Nola is telling: he saw himself as having devoted his later life, in an ascetic manner, to God.[3] An important element of this was the using up of much of

[2] The hard-line Protestant attitude that the Church from Constantine 'sold out' to worldly authority is well exemplified by Kee (1982).

[3] These views are discussed earlier in this chapter (pp. 163–4).

his money in the material construction and decoration of churches. In the late Roman world such an act of praise was very hard to deny.

Mainstream opinion built and preserved the many splendid monuments of the late Antique church that I have had the privilege to study. A taste for gilded splendour endures in many Catholic and Orthodox churches to the present day, which is not to say that modern attitudes are identical to those of many centuries ago.[4] Camille, contrasting images of gold coins placed as symbols of status in the margins of ninth-century gospel books and of cash shown as 'the shit of monkeys' in late medieval books of hours, has argued that the sacral signifying function of gold had begun to fade in the course of the later Middle Ages.[5] Gold mosaic was, of course, to have no place in the Protestant churches of early modern Europe, but it was also under attack in Renaissance Italy. Alberti commented disparagingly on those who make 'excessive' use of gold since they think it provides majesty. He roundly criticized the practice, since the reflective quality of gold got in the way of a naturalistic representation. Even if he were to paint Dido with golden hair, quiver, chariot and clasp, he would use yellow, to avoid this 'wealth of rays of gold that blinds the eyes of spectators from all angles'.[6] But that is precisely what the late Antique patron desired. Eusebius talked of the glory of the Lord appearing on the mount, 'when His face shone like the sun and His garments like light'.[7] Who, he asks, by means of 'dead colours' would be able to represent such majesty.[8] Such a supremely dazzling vision was impossible to reproduce, but people tried, and their best vehicles were the less 'dead', less matt, materials of glass and gold. In late Antiquity, a powerful impression was to be achieved not by lucid appreciation, but by an emotional response to the incomprehensible greatness of heaven as mysteriously conveyed by these metaphors.[9] Gombrich has spoken of that 'extreme position', in which the distinction between the symbol and that which it symbolizes is worn thin by hope.[10] Amongst the mysteries of the imagery and the dazzling gold of the walls, the late Roman faithful thirsted to find the help that they sought from on high.

During the all too brief time I was able to spend in Rome I think the church that impressed me most was the relatively small *martyrium* of Saint Agnes, which stands

[4] Other studies would have to be carried out to address this question! [5] Camille (1989), pp. 261–2.
[6] Alberti, *De Pictura*, C. Grayson (ed.) *On Painting and on Sculpture: The Latin Texts of 'De Pictura' and 'De Statuta'* (London, 1972), pp. 92–3, 'auroreum radiorum copiam, quae undique oculos visentium perstringat'.
[7] Matthew 17: 2. [8] Eusebius, *Letter to Constantia*, quoted in C. Mango (1986), p. 17.
[9] Alberti's scorn can be related to the reassertion of single-point perspective, and the dismissal of Photius' awed 'whirling', see C Mango (1958), p. 187.
[10] See Gombrich (1972), pp. 123–98. '*Icones symbolicae*: philosophies of symbolism and their bearing in art', quotation at p. 172.

outside the city walls by the side of the Via Nomentana. Agnes was reputedly killed under the persecution of Diocletian. The *Liber Pontificalis* tells us that Constantine, at the request of his daughter Constantina, built a church at the burial place of the saint. There he placed a gold paten, chalice and chandelier together with two silver patens, five silver chalices, thirty silver chandeliers, forty brass chandeliers and forty brass candlesticks, together with donations of land to provide future revenues.[11] Rebuilding was carried out by pope Symmachus (498–514)[12] and then by pope Honorius (625–638). His is the building we see today. The *Liber Pontificalis* tells us that Honorius 'decorated it to perfection all round, and put there many gifts. He decorated her tomb with silver weighing 252 lb., placed over it a gilt-bronze canopy of remarkable size and gave three gold bowls each weighing 2 lb. He also had made there a mosaic in the apse.'[13] The silver-work has not survived, although a dedication inscription describing the offering of such an item by Honorius has been recorded. But the apse mosaic, together with its dedication inscription, has been preserved *in situ* (figure 13, p. 169).[14]

Clarity of symbolism triumphed in this work.[15] Three figures stand isolated on a huge sheet of gold. The earth has been reduced to a narrow strip of green at their feet. Fruit and verdure survive as a thin decorative band emerging from vessels on each side of the vault and enclosed by the jewelled-band motif on each side. Similarly vestigial is a tiny zone of silver and gold stars against a background of blue, out of which God hands down a crown. At the centre stands Agnes herself, draped in gems. The imperative was that the saint should be brilliantly present, directly over her earthly remains, watching and listening.[16] The inscription describes the way in which the image shines out at the viewer in the streaming of light that drives away the darkness from around the martyr's tomb.[17] This depiction reflects her resurrected appearance, just as she was seen by her parents, eight days after her death, dressed in splendid garments.[18] Just twelve at the time, she was ready to be married to Christ. Prudentius tells us that, as her spirit rose into

[11] *Liber Pontificalis*, 34 (Silvester).

[12] Ibid., 53, 'Absidam beate Agnae, quae ruinam minabatur, et omnem basilicam renovavit.'

[13] Ibid., 72, 'quam undique ornavit et exquisivit, ubi et multa dona posuit. Ornavit et sepulchrum ejus ex argento pens libras CCLII. Posuit desuper ciborium aereum deauratum mirae magnitudinis. Fecit et gabatas aureas tres pensantes singulas libras II. Fecit autem et absidem ejusdem basilicae de musivo.'

[14] De Rossi (1899), is not paginated, so the references below apply to his section, 'Musaico dell'abside di S. Agnese Fuori le Mura', on the revetment, 'hoc opus argento construxit Honorius', on the apse, 'Praesul Honorius haec vota dicata dedit.'

[15] Bertelli (1989), colour pl. at pp. 88–9.

[16] Kitzinger (1980), p. 150. The same effect, one that was to be repeated again and again in later art, can be seen in the late-fifth-century mosaics of San Vittore in Cielo d'Oro, Milan. The martyr stares down from the dome's centre, alone in a sea of gold.

[17] De Rossi (1899). [18] Von Simson (1987), pp. 50 and 134 n. 52.

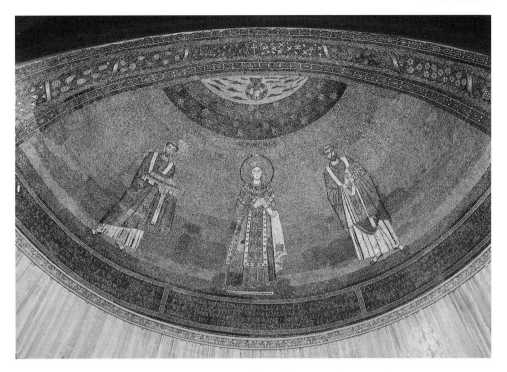

Figure 13. Apse Mosaic, Sant'Agnese, Rome (early-seventh-century), in which St Agnes, dressed like a Byzantine empress, stands against a brilliant sheet of gold.

heaven, she trampled pomp, gold, silver, garments, dwellings, anger, fear, paganism and all the other failings and vanities of the world.[19] Having taken those upward steps, she attained the splendour of heaven.

She is not shown on her own in the apse. She is flanked by two bishops, one of whom holds out an image of the church. The inscription which mentions Honorius' offering strongly suggests that the pope had placed himself next to Agnes in the vault, with perhaps Symmachus on the other side. Honorius, no doubt, regarded himself as the faithful servant of the saint who merely waited upon her. Agnes, after all, was placed in the position of honour. She looks straight out and seems attentively present for the viewer. But at the same time, shimmering in the golden ether, she appears like a vision of something infinitely far away.[20] This was the stuff of those dreams of late Antiquity that were shared by holy men and emperors alike and which were passed on to the Middle Ages.

[19] Prudentius, *Perist.*, 14, 100ff, with the comments of Palmer (1989), pp. 250–4.
[20] Admittedly a subjective comment, but one inspired by my own visit to the church.

Bibliography

It is the purpose of the bibliography to provide a reference to the written materials on which this study has been based, the majority of which appear in footnote citations. The principal aims of the referencing system are to provide full details in as compact a form as possible. In order to achieve this a large number of abbreviations (listed at the beginning of this work) have been employed. The results are a personal adaptation of conventions. Unfortunately, those very 'standard' conventions represent a spectrum of variants, to which I have thus added. A number of specific points should be made. References to page/column numbers of complete works are given in all bibliographic references except for some primary sources which occupy a predominant proportion of the volumes in which they appear. Works are cited under the name of the author at the time of publication, even if the name of that author subsequently changed. In the case of a book published simultaneously in two places, reference is given to whichever location was cited first in the original. Use has always been made, where possible, of works in the original language. However, note has also been made of useful translations of primary sources. Also, in the small number of cases in which I was not able to gain access to original editions of secondary works, I have cited the translation that I read. Furthermore, in the handful of instances in which a translated edition represents the most recently edited or revised version of a work, that has also been employed and cited. I have tried to make use of the most recent editions of texts, except in cases of simple reproduction or reissuing. Reprinted editions have been cited only when I have been unable to locate the original text. In general, I have struggled for consistency of practice, knowing I could not hope entirely to achieve it.

PRIMARY SOURCES

Alberti, L. B. *De Pictura*, C. Grayson (ed.) *On Painting and on Sculpture: The Latin Texts of 'De Pictura' and 'De Statuta'* (London, 1972).

Aldhelm. *Opera*, R. Ehwald (ed.), *MGH, AA* 15 (1919); M. Lapidge & M. Herrin (trans.) *The Prose Works* (Ipswich, 1979) and Lapidge & J. L. Rosier (trans.) *The Poetic Works* (Cambridge, 1985)

Agnellus. *Liber Pontificalis Ecclesiae Ravennatis*, O. Holder-Egger (ed.), MGH, *Rerum Langobardicarum et Italicarum Saec. VI–IX* (1878)

Ambrose. *Commentarius in Canticum Canticorum*, PL 15, cols. 1946–2060 (collected by William of St Thierry)

 Commentarius in Psalmo CXVIII, L. F. Pizzolato (ed. and trans.) *S. Ambrogio di Milano: Commento al Salmo CXVIII*, 2 vols., SAEMO 9 and 10 (1987)

 De Fide, O. Faller (ed. and trans.) *S. Ambrogio di Milano: La fede*, SAEMO 15 (1984).

 De Virginibus, E. Cazzaniga (ed.) and F. Gori (trans.) *S. Ambrogio di Milano: Verginate e vindovanza*, SAEMO 14i/i (1989), pp. 100–241

 Expositiones Evangeli Secundum Lucam, M. Adriaen & G. Coppa (eds.), G. Coppa (trans.) *S. Ambrogio: Esposizione del Vangelo secondo Luca*, 2 vols., SAEMO 11 and 12 (1978)

Ammianus Marcellinus. *Rerum Gestarum Libri*, J. C. Rolfe (ed. and trans.) 3 vols., rev. edn, LCL (1950–2)

Aponius. *In Cantica Canticorum Expositionem*, B. de Vregille & L. Neyrand (eds.) CCSL 19 (1986)

Apringius of Beja. *Tractatus in Apocalypsin*, P. A. C. Vega (ed.) (Madrid, 1941)

Augustine of Hippo. *Confessiones*, L. Verheijen (ed.) CCSL 27 (1983); S. R. Pine-Coffin (trans.) *Confessions* (Harmondsworth, 1961)

 De Civitate Dei, B. Dombart & A. Kalb (eds.) 2 vols., CCSL 47–8 (1955); D. B. Zema & G. C. Walsh (trans.), *The City of God*, 3 vols., FC 8, 14 and 24 (Washington, 1962–4)

 De Doctrina Christiana, J. Martin (ed.) CCSL 32 (1962); D. W. Robertson (trans.) *On Christian Doctrine* (Indianapolis, 1958)

 De Genesi ad Litteram, PL 34, cols. 245–485

 De Trinitate, W. J. Mountain (ed.) 2 vols., CCSL 50–50a (1968)

 Enarrationes in Psalmos, D. E. Dekkers & J. Fraipont (eds.) 3 vols., CCSL 38–40 (1956).

 Sermo [Mainz 54], F. Dolbeau (ed.) REA 37 (1991), pp. 261–306

Bede. *De Natura Rerum*, PL 90, cols. 187–273

 De Tabernaculo, D. Hurst (ed.), CCSL 119a, pp. 1–139; A. G. Holder (trans.) *On the Tabernacle*, TTH 18 (Liverpool, 1994)

 De Templo, D. Hurst (ed.) CCSL 119a, pp. 140–234

 Explanatio Apocalypsis, PL 93, cols. 129–206

 In Cantica Canticorum Allegorica Expositio, D. Hurst (ed.) CCSL 119b (1985), pp. 166–375

 Vita Sancti Cuthberti, B. Colgrave (ed. and trans.) *Two Lives of Saint Cuthbert* (Cambridge, 1946), pp. 142–307

Biblia Sacra Iuxta Vulgata Versionem, R. Weber (ed.), rev. 3rd edn (Stuttgart, 1983)

Caesarius of Arles. *Expositio in Apocalypsin*, PL 35, cols. 2417–2452

Canones Concilium Liberitanum, J. D. Mansi (ed.) *Sacrorum Concilium Nova et Amplissima Collectio* 2 (Florence, 1759), cols. 1–20

Cassian. *Conlationes*, E. Pichery (ed. and trans.) *Jean Cassien: Conférences*, SC 42 (1955)

Cassiodorus. *Complexiones in Epistolis Apostolorum et Actibus Apostolorum et Apocalypsi*, PL 70, cols. 1381–1418

Codex Iustinianus, in *Corpus Iuris Civilis* 2 (1954)

Codex Theodosianus, T. Mommsen & P. M. Meyer (eds.) 2 vols. (Berlin, 1905); C. Pharr (trans.) *The Theodosian Code and Novels and the Sirmondian Constitutions* (Princeton, 1952)

Constantius of Lyons. *Vita Germani*, R. Borius (ed. and trans.) *Constance de Lyon, Vie de Saint Germain d'Auxerre*, SC 112 (Paris, 1965)

BIBLIOGRAPHY

Corippus. *In Laudem Iustini Augusti Minoris*, Averil Cameron (ed. and trans.) (London, 1976)

Corpus Iuris Civilis, T. Mommsen & P. Krueger (eds.), 3 vols. (Dublin, 1954)

Damasus. *Epigrammata*, A. Ferrua (ed.) Sussidi allo studio delle antichità cristiane 2 (Rome, 1942)

De Divitiis, G. Caspari (ed.) in *PL, Supplementum* I (Paris, 1958), cols. 1380–1418: R. Rees (trans.) *The Letters of Pelagius and his Followers* (Woodbridge, 1991), pp. 171–211

De Rebus Bellicis, R. Ireland (ed. and trans.) *De Rebus Bellicis* II (of 2 vols.), *The Text*, BAR, IS 63ii (Oxford, 1979)

Digesta, in *Corpus Iuris Civilis* 1 (1954); C. H. Monro (trans.) *The Digest of Justinian*, 2 vols. (Cambridge, 1904–9)

Diplomata, Chartae, Epistolae, Leges aliaque Instrumenta ad Res Gallo-Francicas Spectantia nunc Nova Ratione Ordinata, J. M. Pardessus (ed.) 2 vols. (Paris, 1843–9)

Eddius Stephanus. *Vita Sancti Wilfridi*, B. Colgrave, (ed. and trans.) *The Life of Bishop Wilfrid* (Cambridge, 1927)

Epiphanius. *De Gemmis*, PG 43, cols. 321–66 (Latin version); R. P. Blake & H. de Vis (ed. and trans.) *'De Gemmis', the Old Georgian Version with the Armenian and Coptic-Sahidic fragments*, Studies and Documents 2 (London, 1934) (fragments of other versions)

Eusebius. *De Vita Constantini Imperatoris*, PG 20, cols. 909–1230 (Greek and Latin)
Oratio Constantini Imperatoris, PG 20, cols. 1233–1316 (Greek and Latin)
Oratio de Laudibus Constantini in eius Tricennalibus Habita, PG 20, cols. 1315–1440 (Greek and Latin)

Gellius. *Noctes Atticae*, J. C. Rolfe (ed. and trans.) *The Attic Nights of Aulus Gellius*, 3 vols., LCL (1946)

Gennadius. *De Scriptoribus Ecclesiasticis*, PL 58, cols. 1053–1120

Gesta apud Zenophilum, C. Ziwsa (ed.) *CSEL* 26, pp. 185–97

Gesta Pontificum Autissiodorensium, de Desiderio, in L. M. Duru (ed.) *Bibliothèque historique de l'Yonne* (Auxerre, 1850), pp. 332–40

Gregory of Elvira. *Tractatus de Epithalamio*, J. Fraipont (ed.) *CCSL* 69 (1967), pp. 167–210

Gregory the Great. *Dialogus*, PL 77, cols. 144–430; O. J. Zimmermann (trans.) *Dialogues*, FC 39 (New York, 1959)
Expositiones in Cantica Canticorum, P. Verbraken (ed.) *CCSL* 144 (1963), pp. 1–46; R. Bélanger (ed. and trans.) *Grégoire le Grand, Commentaire sur le Cantique des Cantiques*, SC 314 (1984)
Homilae in Hiezechihelem Prophetam, M. Adriaen (ed.) *CCSL* 142 (1971)
Moralia in Job, M. Adriaen (ed.) 3 vols., *CCSL* 143-a-b (1979–85)
Registrum Epistularum, D. Norberg (ed.) 2 vols., *CCSL* 140–140a (1982–3); J. Barmby (trans.) *Selected Epistles*, NPNF (2nd ser.) 13 (Oxford, 1898)
Regula Pastoralis, PL 77, cols. 13–128; H. Davis (trans.) *Pastoral Care*, ACW 11 (Westminster, Md., 1950)

Gregory of Tours. *Decem Libri Historiarum*, B. Krusch & W. Levison (eds.) *MGH, SRM* 1i (1951); L. Thorpe (trans.) *History of the Franks* (Harmondsworth, 1974)
Liber Vitae Patrum, W. Arndt & B. Krusch (eds.) *MGH, SRM* 1ii (1885), pp. 661–744; E. James (trans.) *Life of the Fathers*, 2nd edn, TTH 1 (Liverpool, 1991)

Hippolytus Romanus. *De Cantico*, G. Garitte (ed. and trans.) *Traites d'Hippolyte, version Georgienne*, Corpus Scriptorum Christianorum Orientalium 263–4, Scriptores Iberici 15–16 (Louvain, 1965)

Isidore of Seville. *De Natura Rerum*, PL 83, cols. 965–1018
Etymologiae, W. M. Lindsay (ed.) 2 vols. (Oxford, 1910)

Jerome. *Commentarius in Hiezechielem*, F. Glorie (ed.) *CCSL* 75 (1964)
 Epistulae, I. Hildberg (ed.) 3 vols., *CSEL* 54–6 (Berlin, 1910–19); W. H. Freemantle (trans.) *Letters and Select Works*, NPNF (2nd ser.) 6 (New York, 1893)
 Homilia de Nativitate Domini, D. Morin (ed.) *CCSL* 78 (1953), pp. 524–9
 Tractatus in Marci Evangelium, D. Morin (ed.) *CCSL* 78 (1953), pp. 451–500
 Tractatus sive Homilae in Psalmos, D. Morin (ed.) *CCSL* 78 (1953), pp. 1–447
Julian of Eclanum. *Commentarius in Cantica Canticorum*, L. de Coninck & M. J. d'Hont (eds.) *CCSL* 88 (1977), pp. 398–401
Justus of Urgel. *In Cantico Canticorum Salamonis Explicatio Mystica*, PL 67, cols. 961–94
Liber Pontificalis, Pars Prior, T. Mommsen (ed.) *MGH, Gestorum Pontificum Romanorum* 1 (Berlin, 1898); R. Davis (trans.) *The Book of Pontiffs (to A.D. 715)*, TTH 5 (Liverpool, 1989)
Libri Carolini, H. Bastgen (ed.), *MGH, Concilia* 2 (1924)
Liutprand of Cremona. *Antapodosis*, G. H. Peertz (ed.) *MGH, S* 3 (1839)
Livy. *Ab Urbe Condita*, B. O. Foster (ed. and trans.) *Works*, 14 vols., LCL (1924–60)
Origen. *Commentarium in Cantica Canticorum*, in W. A. Baehrens (ed.) *Origenes Werke* VIII, Die Griechischen Christlichen Schriftsteller der ersten drei Jahrhunderte 33 (Leipzig, 1923), pp. 61–198. R. P. Lawson (trans.) *Song of Songs: Commentary and Homilies* (London, 1957) (texts are Rufinus of Aquilea's Latin version, collated with the surviving Greek fragments)
Ovid. *Ars Amatoria*, in J. H. Mozley (ed. and trans.) *Works* II (of 6 vols.), LCL, 2nd edn (1979), pp. 11–175
[XII] Panegyrici Latini, R. A. B. Mynors (ed.) (Oxford, 1964)
Paterius. *De Expositione Veteris ac Novi Testamenti de Diversis Libris S. Gregorii Magni Concinnatus*, PL 79, cols. 903–16
Paulinus of Nola. *Carmina*, G. de Hartel (ed.) *CSEL* 30 (1894); P. G. Walsh (trans.) *Poems*, ACW 40 (New York, 1975)
 Epistulae, G. de Hartel (ed.), *CSEL* 29 (1894); P. G. Walsh (trans.) *Letters*, 2 vols., ACW 35–6 (Westminster, Md., 1967)
Perle, M. Andrew & R. Waldron (eds.), *The Poems of the Pearl Manuscript*, rev. edn (Exeter, 1987); C. Finch (trans.) *The Complete Works of the Pearl Poet* (Berkeley, 1983)
Pliny the Elder. *Historia Naturalis*, H. Rackham, W. H. S. Jones & D. E. Eichholz (eds. & trans.) *Natural History*, 10 vols., LCL (London, 1938–62)
Pliny the Younger. *Panegyricus*, B. Radice (ed. and trans.) *Letters and Panegyricus* II (of 2 vols.), LCL (1969), pp. 317–548
Primasius of Hadrumentum. *In Apocalypsin*, A. W. Adams (ed.) *CCSL* 92 (1985)
Prudentius. *Peristaphanon*, in H. J. Thomson (ed. and trans.) *Works* II (of 2 vols.), LCL (1949), pp. 98–345
 Psychomachia, in H. J. Thomson (ed. and trans.) *Works* I (of 2 vols.), LCL (1949), pp. 274–343
Pseudo-Isidore. *Commemoratorium in Apocalypsin*, K. Hartung (ed.) *Ein Traktat zur Apokalypse des Ap. Johannes in einer Pergamenthandschrift der K. Bibliothek in Bamberg* (Bamberg, 1904)
Remigius of Rheims. *Testamentum*, B. Krusch (ed.) *MGH, SRM* 3 (1896), pp. 336–41
Res Gestae Divi Augusti, P. A. Brunt & J. M. Moore (ed. and trans.) *The Achievements of the Divine Augustus* (London, 1967)
Scriptores Historiae Augustae, D. Magie (ed. and trans.), 3 vols., LCL (1921–32)
Seneca. *Ad Lucilium Epistulae Morales*, R. M. Gummere (ed. and trans.), 3 vols., LCL (1925)

Sidonius Apollinaris. *Epistolae et Carmina*, W. B. Anderson (ed. and trans.) *Poems and Letters*, 2 vols., LCL (1936 and 1963)

Suetonius. *De Vita Caesarum*, J. Rolfe (ed. and trans.) *Lives of the Caesars*, 2 vols., LCL (1951)

Suger of St Denis. *Liber de Rebus in Administratione sua Gestis*, in E. Panofsky (ed. and trans.) *Abbot Suger on the Abbey Church of St. Denis, and its Art Treasures* (Princeton, 1946), pp. 40–81

Sulpicius Severus. *Vita Sancti Martini*, J. Fontaine (ed. and trans.) *Sulpice Sévère: 'Vie de Saint Martin'*, 3 vols., SC 133–5 (1967–9)

Tacitus. *Germania*, M. Hutton (ed. and trans.), in *Dialogus: Agricola: Germania*, LCL, rev. edn. (1970)

Tertullian. *De Spectaculis*, in T. R. Glover (ed. and trans.) *Tertullian and Minucius Felix*, LCL (1931), pp. 230–301

Tyconius. *Commentarius in Apocalypsin*, F. Lo Bue (ed.) *The Turin Fragments of Tyconius' Commentary on Revelation* (Cambridge, 1963)

Venantius Fortunatus. *Opera Poetica*, F. Leo (ed.) MGH, AA 4 (1881); M. C. Nisard (trans.) *Venance Fortunate: Poésies mêlées* (Paris, 1887)

Vergil. *Aeneid*, in H. R. Fairclough (ed. and trans.), *Works*, 2 vols., LCL (1934)

Victorinus of Petau. *Commentarius in Apocalypsin*, J. Haussleiter (ed.) *Comentarius in Apocalypsin Editio Victorini et Recensio Hieronymi*, CSEL 49 (1916), pp. 10–154

Vita Desiderii, R. Poupardin (ed.) *La vie de Saint Didier, évêque de Cahors* (Paris, 1900)

Vita Eligii Episcopi Noviomagensis, B. Krusch (ed.) MGH, SRM 4 (1902), pp. 634–742

Vita Melaniae, D. Gorce (ed. and trans.) *Vie de saint Mélanie*, SC 90 (1962)

SECONDARY WORKS

Adhémar, J. 1934. 'Le trésor d'argenterie donné par Saint Didier aux églises d'Auxerre (VIIe siécle)', *Revue archéologique* (6th ser.) 4, pp. 44–54

Aitchison, L. 1960. *A History of Metals*, 2 vols. (London)

Alexander, J. J. G. 1975. 'Some aesthetic principles in the use of colour in Anglo-Saxon art', *ASE* 4, pp. 145–54

Alexander, P. J. 1952. 'Hypatius of Ephesus: a note on image worship in the sixth century', *Harvard Theological Review* 45, pp. 177–84

1962. 'The strength of empire and capital as seen through Byzantine eyes', *Speculum* 37, pp. 339–56

Alexander, S. S. 1971. 'Studies in Constantinian church architecture', *RAC* 47 (1971), pp. 281–330 and 49, pp. 33–44

1977. 'Heraclius, Byzantine imperial ideology and the David plates', *Speculum* 52, pp. 217–37

Alföldi, A. 1969. *The Conversion of Constantine and Pagan Rome*, H. Mattingley (trans.), new edn (Oxford)

1970a. 'Die Ausgestaltung des monarchischen Zeremoniells am römischen Kaiserhofe', in Alföldi (1970c), pp. 1–118 (reprinted from *MDAI, RA* 49 (1934))

1970b. 'Insignien und Tracht der römischen Kaiser', in Alföldi (1970c), pp. 119–276 (reprinted from *MDAI, RA* 50 (1935))

1970c. *Die monarchische Repräsentation in römischen Kaiserreiche* (Darmstadt)

Alföldi, M. R. 1963. *Die Constantinische Goldprägung* (Mainz)

Alföldi-Rosenbaum, E. 1970. 'External mosaic decoration on late Antique buildings', *Frühmittelalterliche Studien* 4, pp. 1–7

Alföldi-Rosenbaum, E. & Ward-Perkins, J. 1985. *Justinianic Mosiac Pavements in Cyrenaican Churches*, Monografie di archeologia Libica 14 (Rome)
Altet, X. B. I. 1978. *Les mosaïques romaines et médiévales de la 'regio laietana' (Barcelone et ses environs)* (Barcelona)
Amat, J. 1985. *'Songes et visiones': l'au-delà dans la littérature latine tardive* (Paris)
Amiet, P., Baratte, F., Noblecourt, C.D., Pasquier, A., et al. (eds.) 1994. *Forms and Styles: Antiquity* (Cologne)
Anamali, S. 1993. 'Oreficerie, gioielle bizantini in Albania: Komani', *CCARB* 40, pp. 435–46
André, J. 1949. *Etude sur les termes de couleur dans la langue Latine*, Etudes et commentaires 7 (Paris)
Armstrong, G. T. 1967. 'Constantine's churches', *Gesta* 6, pp. 1–9
Arnold, C. J. 1988. *An Archaeology of the Early Anglo-Saxon Kingdoms* (London)
Arrhenius, B. 1985. *Merovingian Garnet Jewellery* (Stockholm)
Asad, T. 1986. 'The concept of cultural translation in British social anthropology', in Clifford & Marcus (1986), pp. 141–64
Astell, A. W. 1990. *The Song of Songs in the Middle Ages* (Ithaca)
Aston, M. 1987. 'Gold and images', in Sheils & Wood (1987), pp. 189–207
Auerbach, E. 1943. *Mimesis: dargestellte Wirklichkeit in der abendländischen Literatur* (Berne)
Averincev, S. 1979. 'L'or dans le système des symboles de la culture protobyzantine', *Studi medievali* (3rd ser.) 20, pp. 47–67
Avi-Jonah, M. 1934. 'Mosaic pavements in Palestine', *Quarterly of the Department of Antiquities of Palestine* 3, pp. 26–73
Axboe, M. & Kromann, A. 1992. 'DN ODINN P F AUC? Germanic "imperial portraits" on Scandinavian gold bracteates', *Acta Hyperborea* 4, pp. 271–306
Bagatti, B. 1971. *The Church from the Gentiles in Palestine: History and Archaeology*, E. Hoade (trans.), SBF, smaller ser. 4 (Jerusalem)
Baldwin, B. 1982. 'Literature and society in the later Roman Empire', in Gold (1982), pp. 67–83
Baldwin, J. F. 1987. *The Urban Character of Christian Worship: The Origins, Development, and Meaning of Stational Liturgy*, Orientalia Cristiana Analecta 228 (Rome)
Balty, J. 1977. *Mosaïques antiques de Syrie* (Brussels)
Bannister, J. 1965. *An Introduction to English Silver* (London)
Barasch, M. 1992. *Icon: Studies in the History of an Idea* (New York)
Baratte, F. 1975. 'Les ateliers d'argenterie au bas-empire', *Journal des Savants*, pp. 193–212
 1978. *Mosaïques romaines et paléochrétiennes du Musée du Louvre* (Paris)
 (ed.) 1988. *Argenterie Romaine et Byzantine* (Paris)
 1992. 'Les trésors de temples dans le monde romain: une expression particulière de la piété', in Boyd & Mango (1992), pp. 111–21
Barber, C. 1990. 'The imperial panels at San Vitale: a reconsideration', *BMGS* 14, pp. 19–42
Barbet, A. 1985. *Le peinture murale romain: les styles decoratifs Pompéiens* (Paris)
Barker, D. 1993. 'Gold and the renascence of the Golden Race: a study of the relationship between gold and the "Golden Age" ideology of Augustan Rome', University of Cambridge, PhD dissertation
Barley, N. F. 1974a. 'Anthropological aspects of Anglo-Saxon symbolism', University of Oxford, DPhil dissertation
 1974b. 'Old English colour classification: where do matters stand?', *ASE* 3, pp. 15–28

Barnes, G. L. 1986. 'Jiehao, tonghao; peer relations in East Asia', in Renfrew & Cherry (1986), pp. 79–92

Barnes, T. D. 1981. *Constantine and Eusebius* (Cambridge, Mass.)

Barrett, C. 1990. 'The language of ecstasy and the ecstasy of language', in M. Warner (ed.) *The Bible as Rhetoric: Studies in Biblical Persuasion and Credibility* (London), pp. 205–21

Barry, I. 1988. 'Africa', in Mack (1988b), pp. 25–45

Bastiaensen, A. A. R. 1993. 'Prudentius in recent literary criticism', in J. den Boeft & A. Hilhorst (eds.) *Early Christian Poetry: A Selection of Essays*, VCS 22 (Leiden), pp. 101–34

Battiscombe, C. F. (ed.) 1956. *The Relics of Saint Cuthbert* (Oxford)

Bauckham, R. 1993. *The Theology of the Book of Revelation* (Cambridge)

Baur, P. V. C. 1934. 'The paintings of the Christian chapel', in M. I. Rostovtzeff (ed.) *The Excavations at Dura-Europos: Preliminary Report of the Fifth Season of Work* (New Haven)

Bauss, K. 1940. *Der Kranz in Antike und Christentum*, Theophaneia 2 (Bonn)

Baynes, N. H. 1972. *Constantine the Great and the Christian Church*, British Academy Raleigh Lecture on History, 1929, 2nd edn (London)

Beckwith, J. 1970. *Early Christian and Byzantine Art* (Harmondsworth)

Beierwaltes, W. 1986. 'The love of beauty and the love of God', in A. H. Armstrong (ed.) *Classical Mediterranean Spirituality: Egyptian, Greek, Roman* (London), pp. 293–313

Bélanger, R. 1986. 'Anthropologie et parole de dieu dans le commentaire de Grégoire le Grand sur le Cantique de Cantiques', in Fontaine, Gillet & Pellistrandi (1986), pp. 245–54

Belting, H. 1981. *Das Bild und sein Publikum im Mittelalter: Form und Funktion früher Bildtafeln der Passion* (Berlin)

Belting-Ihm, C. 'Theophanic images of divine majesty in early medieval Italian church decoration', in Tronzo (1989), pp. 43–59

Benz, E. 1972. 'Die Farbe in Erlebnisbereich der Christlichen Vision', *EY* 41, pp. 265–325

Berger, P. C. 1981. *The Insignia of the 'Notitia Dignitatum'* (New York)

Berlin, B. & Kay, P. 1969. *Basic Colour Terms: Their Universality and Evolution* (Berkeley)

Bertelli, C. (ed.) 1989. *The Art of Mosaic*, P. Foulkes & S. Harris (trans.) (London)

Berti, F. 1976. *Ravenna I*, Mosaici antichi in Italia, regione 8 (Rome)

Bestman, J. C., Bos, J. M. & Heidinga, H. A. (eds.) 1990. *Medieval Archaeology in the Netherlands* (Assen)

Bierkert, W. 1987. 'Offerings in perspective: surrender, destruction, exchange', in Linders & Nordquist (1987), pp. 43–50

Bietenhard, H. 1953. 'The millennial hope of the early church', *Scottish Journal of Theology* 6, pp. 12–30

Bishop, M. C. & Coulson, J. N. C. 1993. *Roman Military Equipment* (London)

Black, M. 1962. *Models and Metaphors: Studies in Language and Philosophy* (Ithaca)

Blanchard-Lemée, M. 1983. 'Nouvelles recherches sur les mosaïques de Djemila', in Campanati (1983), I, pp. 277–86

Bloch, Marc. 1933. 'Le problème de l'or au Moyen Age', *AHS* 5, pp. 1–34

Bloch, Maurice & Parry, J. 1989. 'Introduction: money and the morality of exchange', in Bloch & Parry (eds.) *Money and the Morality of Exchange* (Cambridge), pp. 1–32

Boardman, J., Griffin, J. & Murray, O. (eds.) 1986. *The Oxford History of the Classical World* (Oxford)

Boas, F. 1928. *Primitive Art* (Harvard)

Boatswain, T. 1988. 'Images of uncertainty: some thoughts on the meaning of form in the art of late Antiquity', *BMGS* 12, pp. 27–45
Boëthius, A. 1946. 'Nero's Golden House', *Eranos* 44, pp. 442–54
 1951. 'The reception halls of the Roman emperors', *Annual of the British School at Athens* 46, pp. 25–31
 1960. *The Golden House of Nero: Some Aspects of Roman Architecture* (Ann Arbor)
Bonner, G. 1966. *Saint Bede in the Tradition of Western Apocalypse Commentary*, Jarrow Lecture (Jarrow)
 1970. 'Augustine as biblical scholar', in P. R. Ackroyd & C. F. Evans (eds.) *From the Beginnings to St. Jerome*, The Cambridge History of the Bible 1 (Cambridge), pp. 541–62
Borsook, E. 1990. *Messages in Mosaic: The Royal Programmes of Norman Sicily (1130–1187)* (Oxford)
Bottini, G. C., Di Segni, L. & Alliata, E. (eds.) 1990. *Christian Archaeology in the Holy Land, New Discoveries: Essays in Honour of Virgilio C. Corbo*, SBF, Collectio Maior 36 (Jerusalem)
Bourdieu, P. 1977. *Outline of a Theory of Practice*, R. Nice (trans.), CSSA 16 (Cambridge)
 1984. *Distinction: A Social Critique of the Judgement of Taste*, R. Nice (trans.) (London)
 1991. *Language and Symbolic Power*, J. B. Thompson (ed.), G. Raymond & M. Adamson (trans.) (Cambridge)
Bousfield, J. 1979. 'The world seen as a colour chart', in Ellen & Reason (1979), pp. 195–220
Bovini, G. 1954. *Sarcofagi paleocristiani di Ravenna: tentativo di classificazione cronologica*, Collezione 'amici delle catacombe' 20 (Rome)
 1956. *Mosaici di Ravenna* (Milan)
 1968. *Saggio di bibliografia su Ravenna antica* (Bologna)
 1969b. 'I mosaici di S. Vittore "in ciel d'oro" di Milano', *CCARB* 16, pp. 71–80
 1969b. 'S. Michele in Alfrisco di Ravenna', *CCARB* 16, pp. 81–96
 1970. 'I mosaici del S. Aquilino di Milano', *CCARB* 17, pp. 61–82
Bowman, A. & Woolf, G. (eds.) 1994. *Literacy and Power in the Ancient World* (Cambridge)
Boyd, S. A. 1988. 'A bishop's gift: openwork lamps from the Sion treasure', in Baratte (1988), pp. 191–210
Boyd, S. A. & Mango, M. M. (eds.) 1992. *Ecclesiastical Silver Plate in Sixth-Century Byzantium* (Washington)
Boyle, R. 1972. *An Essay about the Origine and Virtues of Gems*, G. W. White (ed.), facsimile of 1672 edn (New York)
Bradley, R. 1993. *Altering the Earth: The Origins of Monuments in Britain and Continental Europe*, Society of Antiquaries of Scotland, Monograph Ser. 8 (Edinburgh)
Braithwaite, M. 1982. 'Decoration as ritual symbol: a theoretical proposal and an ethnographic study in southern Sudan', in Hodder (1982a), pp. 80–9
 1984. 'Ritual and prestige in the prehistory of Wessex, c. 2200–1400 BC: a new dimension to the archaeological evidence', in Miller & Tilley (1984), pp. 93–110
Brandon, S. G. F. 1975. 'Christ in verbal and depicted imagery: a problem of early Christian iconography', in Neusner (1975), II, pp. 164–72
Bray, W. 1978. *The Gold of Eldorado: Catalogue of an Exhibition Held at the Royal Academy of Arts* (London)
Bray, W. & Trump, D. (eds.) 1982. *The Penguin Dictionary of Archaeology*, 2nd edn (London)
Breckelmans, A. J. 1965. *Martyrerkranz: eine symbolgeschichtliche Untersuchung im frühchristlichen Schriftum*, Analecta Gregoriana 150 (Rome)

Breckenridge, J. D. 1974. 'Apocrypha of early Christian portraiture', *BMGS* 67, pp. 101–9
 1980–1. 'Christ on the lyre-backed throne', *DOP* 34–5, pp. 247–60
Bremmer, J. 1988. 'An imperial palace guard in heaven: the date of the Vision of Dorotheus', *Zeitschrift für Papyrologie und Epigraphik* 75, pp. 82–8
Brendel, O. 1944. 'Origin and meaning of the mandorla', *Gazette des beaux-artes* (6th ser.) 25, pp. 5–24
Brenk, B. 1972. 'Early gold mosaics in Christian art', *Palette* 38, pp. 16–25
 1987. '*Spolia* from Constantine to Charlemagne: aesthetics versus ideology', *DOP* 41, pp. 103–9
Bridgeman, J. 1987. 'Purple dye in Late Antiquity and Byzantium', in Spanier (1987), pp. 159–65
Brilliant, R. 1979. 'Scenic representations', in Weitzmann (1979a), pp. 61–5
 1984. *Visual Narratives: Storytelling in Etruscan and Roman Art* (Ithaca)
Brown, D. 1972. 'The brooches in the Pietroasa treasure', *Antiquity* 46, pp. 111–16
Brown, K. B. 1979. 'The mosaics of San Vitale: evidence for the attribution of some early Byzantine jewellery to court workshops', *Gesta* 18, pp. 57–62
 1981. *Guide to the Provincial Roman and Barbarian Metalwork and Jewelry in the Metropolitan Museum of Art* (New York)
Brown, P. R. L. 1967. *Augustine of Hippo: A Biography* (London)
 1969. 'The diffusion of Manichaeism in the Roman Empire', *JRS* 59, pp. 92–103
 1971. *The World of Late Antiquity: From Marcus Aurelius to Muhammad* (London)
 1977. *Relics and Social Status in the Age of Gregory of Tours* (Reading)
 1978. *The Making of Late Antiquity* (Cambridge, Mass.)
 1980. 'Art and society in Late Antiquity', in Weitzmann (1980), pp. 17–28
 1981. *The Cult of the Saints* (Chicago)
 1982. 'The view from the precipice', in P. R. L. Brown, *Society and the Holy in Late Antiquity* (London), pp. 196–206 (reprinted from *New York Review of Books* 21 (1974))
 1987. 'Late Antiquity', in P. Veyne (ed.) *A History of Private Life* (5 vols., P. Ariès & G. Duby (eds.)) 1, *From Pagan Rome to Byzantium* (Cambridge, Mass.), pp. 235–311
 1988. *The Body and Society: Men, Women and Sexual Renunciation in Early Christianity* (New York)
 1990. 'Bodies and minds: sexuality and renunciation in early Christianity', in D. M. Halperin, J. J. Winckler & F. I. Zeitlin (eds.) *Before Sexuality: The Construction of Erotic Experience in the Ancient Greek World* (Princeton), pp. 479–93
 1992. *Power and Persuasion in Late Antiquity: Towards a Christian Empire* (Madison)
Brown, S. 1992. 'Death as decoration: scenes from the arena on Roman domestic mosaics', in A. Richlin (ed.) *Pornography and Representation in Greece and Rome* (New York), pp. 180–221
Bruce-Mitford, R. 1975–83. *The Sutton Hoo Ship Burial*, 3 vols. (London)
Brumfiel, E. M. 1987. 'Elite and utilitarian crafts in the Aztec state', in Brumfiel & Earle (1987), pp. 102–18
Brumfiel, E. M. & Earle, T. K. (eds.) 1987. *Specialisation, Exchange and Complex Societies* (Cambridge)
Brush, K. A. 1993. 'Adorning the dead: the social significance of early Anglo-Saxon funerary dress in England (fifth to sixth centuries A.D.)', 2 vols.., University of Cambridge, PhD dissertation
Bruun, P. 1976. 'Notes on the transmission of imperial images in Late Antiquity', in *Studia Romana in Honorem Petri Krarup* (Odense), pp. 122–31
Buckton, D. (ed.) 1994. *Byzantium: Treasures of Byzantine Art and Culture from British Collections*

(London)

Budge, W. 1992. *Amulets and Talismans* [reprint of *Amulets and Superstitions*] (New York)

Bullough, D. 1983. 'Burial, community and belief in the early medieval west', in P. Wormald (ed.) *Ideal and Reality in Frankish and Anglo-Saxon Society* (Oxford), pp. 177–201

Burkert, W. 1987. 'Offerings in perspective: surrender, distribution, exchange', in Linders & Nordquist (1987), pp. 43–50

Burns, T. 1984. *A History of the Ostrogoths* (Bloomington and Indianapolis)

Burrow, J. W. 1985. *Gibbon* (Oxford)

Butler, A. S. & Morris, R. K. (eds.) 1986. *The Anglo-Saxon Church: Papers in Honour of Dr H. M. Taylor*, Council for British Archaeology, Research Reports 60 (London)

Butler, C. 1967. *Western Mysticism: The Teaching of Augustine, Gregory and Bernard on Contemplation and the Contemplative Life*, 3rd edn (London)

Cabrol, F. & Leclercq, H. (eds.) 1907–53. *Dictionnaire d'archéologie chrétienne et de liturgie*, 15 vols. (Paris)

Caillet, J.-P. 1993. *L'évergétisme monumental chrétien en Italie et à ses marges: d'après l'épigraphie des pavements de mosaïque (IVe–VIIe s.)*, CEFR 175 (Rome)

Caird, G. B. 1980. *The Language and Imagery of the Bible* (London)

Cameron, Alan. 1970. *Claudian: Poetry and Propaganda at the Court of Honorius* (Oxford)

 1979. 'The date of *De Rebus Bellicis*', in Hassall (1979), pp. 1–7

 1982. 'A note on ivory carving in fourth-century Constantinople', *American Journal of Archaeology* 86, pp. 126–9

 1985. *Literature and Society in the Early Byzantine World*, Variorum Reprints (London)

 1992. 'Observations on the distribution and ownership of late Roman silver plate', *JRS* 5, pp. 178–85

Cameron, Alan & Shauer, D. 1982. 'The last consul: Basilius and his diptych', *JRS* 72, pp. 126–45

Cameron, Averil. 1970. *Agathias* (Oxford)

 1975. 'Corippus' poem on Justin II: a terminus of antique art?', *Annali della Scuola Normale Superiore di Pisa* (3rd ser.) 5 (Pisa), pp. 129–5

 1979. 'Elites and icons in late sixth-century Byzantium', *PP* 84, pp. 3–35

 1981. *Continuity and Change in Sixth-Century Byzantium*, Variorum Reprints (London)

 1991. *Christianity and the Rhetoric of Empire: The Development of Christian Discourse*, Sather Classical Lectures 55 (Berkeley)

 1992. 'Byzantium and the past in the seventh century', in Fontaine & Hillgarth (1992), pp. 250–71

 1993a. *The Later Roman Empire, A.D. 284–430* (London)

 1993b. *The Mediterranean World in Late Antiquity, A.D. 395–600* (London)

 1994. 'Texts as weapons: polemic in the Byzantine dark ages', in Bowman & Woolf (1994), pp. 198–215

Camille, M. 1985. 'Seeing and reading: some visual implications of medieval literacy and illiteracy', *AH* 8, pp. 26–49

 1989. *The Gothic Idol: Ideology and Image-Making in Medieval Art* (Cambridge)

Campanati, R. F. (ed.) 1983. *III Colloquio Internazionale sul Mosaico Antico, Ravenna, 6–10 settembre, 1980*, 2 vols. (Ravenna)

Campbell, L. A. 1968. *Mithraic Iconography and Ideology*, EPROER 11 (Leiden)

Campbell, S. 1988. *The Mosaics of Antioch*, Pontifical Institute of Mediaeval Studies, *Subsidia Mediaevalia* 15 (Toronto)

Canivet, M-T. & Canivet, P. 1975. 'La mosaïque d'Adam dans l'église Syrienne de Mûarte (Ve. s.)', *CA, FAMA* 24, pp. 49–69

Cannadine, D. & Price, S. (eds.) 1987. *Rituals of Royalty: Power and Ceremony in Traditional Societies* (Cambridge)

Carpenter, D. 1987. 'Gold and silver', in Eliade et al. (1987), VI, pp. 67–9

Carr, G. L. 1984. *The Song of Solomon*, Tyndale Old Testament Comentaries (Leicester)

Carver, M. O. H. (ed.) 1992a. *The Age of Sutton Hoo: The Seventh Century in North-Western Europe* (Woodbridge)

 1992b. 'The Anglo-Saxon cemetery at Sutton Hoo: an interim report', in Carver (1992a), pp. 343–71

Cecchelli, C. 1922.'Origini del mosaico parietale cristiano', *Architettura e arti decorative* 2, pp. 3–21

 1956. *I mosaici della basilica di S. Maria Maggiore* (Turin)

Chadwick, H. 1964. 'Philo and the beginnings of Christian thought', in A. H. Armstrong (ed.) *The Cambridge History of Later Greek and Early Medieval Philosophy* (Cambridge, 1964), pp. 137–92

 1966. *Early Christian Thought and the Classical Tradition: Studies in Justin, Clement and Origen* (Oxford)

 1972. 'Preface to the second edition', in Baynes (1972), pp. iii–viii

Champion, S. 1985. 'Production and exchange in early Iron Age central Europe', in Champion & Megaw (1985), pp. 133–60

Champion, T. C. & Megaw, J. V. S. (eds.) 1985. *Settlement and Society: Aspects of West European Prehistory in the First Millennium B.C.* (Leicester)

Champlin, E. 1991. *Final Judgements: Duty and Emotion in Roman Wills, 200 B.C.–A.D. 250* (Berkeley)

Cheal, D. 1988. *The Gift Economy* (London)

Chiflet, J. 1655. *Anastasius Childerici I Francorum Regis* (Antwerp)

Chocheyras, J. 1988. 'Fin des terres et fin des temps d'Hésychius (Ve siècle) à Beatus (VIIIe siècle)', in Verbeke, Verhelst & Welkenhuysen (1988), pp. 72–81

Christie, Y. 1970. 'A propos du décor absidal de Saint Jean du Latran à Rome', *CA, FAMA* 20, pp. 197–206

 1974. '"Apocalypse" et interprétation iconographique: quelques remarques liminaires sur les images du Règne de Dieu et de l'Église à l'époque paléo-chrétienne', *BMGS* 67, pp. 92–100

Christie, Y., Velmans, T., Losowska, H. & Recht, R. (eds.) 1982. *La grammaire des formes et des styles: le monde chrétien* (Fribourg)

Chydenius, J. 1960. *The Theory of Medieval Symbolism*, SSF, CHL 27ii (Helsingfors)

 1965. *Medieval Institutions and the Old Testament*, SSF, CHL 37ii (Helsinki)

Clark, E. A. 1986a. *Ascetic Piety and Women's Faith: Essays on Late Ancient Christianity*, Studies in Women and Religion 20 (Lewiston)

 1986b. 'Piety, propaganda and politics in the life of Melania the Younger', in Clark (1986a), pp. 61–94 (reprinted from Livingstone (1989) II)

 1986c. 'The uses of the Song of Songs: Origen and the later Latin fathers', in Clark (1986a), pp. 386–427 (reprinted from *Society of Biblical Literature* (1981))

Clark, G. 1993. *Women in Late Antiquity: Pagan and Christian Lifestyles* (Oxford)

Clifford, J. 1986. 'Introduction: partial truths', in Clifford & Marcus (1986), pp. 1–26

Clifford, J. & Marcus, G. E. (eds.) 1986. *Writing Culture: The Poetics and Politics of Ethnography* (Berkeley)

Codex Purpureus Rossanensis. 1985–7. 2 vols.., *Codices Mirabiles* 1/*Codices Selecti Phototypice Impressi*

81 (Rome and Graz)
Cohen, A. 1974. *Two-Dimensional Man: An Essay on the Anthropology of Power and Symbolism in Complex Society* (London)
Collinet-Guérin, M. 1961. *Histoire du nimbe des origines aux temps modernes* (Paris)
Conant, K. J. 1956. 'The original buildings at the Holy Sepulchre in Jerusalem', *Speculum* 31, pp. 1–48
Conkey, M. & Hastorf, C. (eds.) 1990. *The Uses of Style in Archaeology* (Cambridge)
Conrad, G. W. & Demerast, A. A. 1984. *Religion and Empire: The Dynamics of Aztec and Inca Expansion* (Cambridge)
Cooke, R. G. & Bray, W. 1985. 'The goldwork of Panama: an iconographic and chronological perspective', in Julie Jones (1985), pp. 34–45
Cormack, R. 1969. 'The mosaic decoration of S. Demetrios, Thessaloniki: a re-examination in the light of the drawings of W. S. George', *Annual of the British School of Archaeology at Athens* 64, pp. 17–52
 1981. 'Interpreting the mosaics of S. Sophia at Istanbul', *AH* 4, pp. 131–49
 1985a. 'The church of Saint Demetrios: the watercolours and drawings of W. S. George', *Catalogue of an Exhibition Organised by the British Council* (Thessalonica), pp. 45–72
 1985b. *Writing in Gold: Byzantine Society and its Icons* (London)
 1992. 'But is it art?', in Shepard & Franklin (1992), pp. 219–36
Corzo, M. A. & Afshar, M. (eds.) 1993. *Art and Eternity: The Nefertari Wall-Paintings Conservation Project, 1986–1992* (Cairo)
Coulton, G. G. 1953. *Art at the Reformation* (Cambridge)
Countryman, L. W. 1980. *The Rich Christian in the Church of the Early Empire: Contradictions and Accommodations* (New York)
Cramp, R. 1986. 'The furnishing and sculptural decoration of Anglo-Saxon churches', in Butler & Morris (1986), pp. 101–4
Crema, L. 1959. *Architettura Romana*, Encyclopedia classica 3, 12, 1 (Turin)
Crone, P. 1989. *Pre-Industrial Societies* (Oxford)
Crowfoot, J. W. 1941. *Early Churches in Palestine* (London)
Cuscito, G. 1975. 'Riquadri musivi a destinazione liturgica nelle basiliche paleocristiana dell'alto Adriatico', in *Mosaici in Aquileia e nell'alto Adriatico*, Antichita Altoadriatiche 8 (Udine), pp. 177–216
Cutler, A. 1975. *Transfigurations: Studies in the Dynamics of Byzantine Iconography* (University Park)
Dagron, G. 1991. 'Holy images and likeness', *DOP* 45, pp. 23–33
Dahl, R. 1986. 'Power as the control of behaviour', in Lukes (1986b), pp. 37–58
Dalton, G. 1981. 'Anthropological models in archaeological perspective', in I. Hodder, G. Isaac & N. Hammond (eds.), *Pattern of the Past: Studies in Honour of David Clarke* (Cambridge), pp. 17–48
Daly, R. 1978. *God's Altar: The World and the Flesh in Puritan Poetry* (Berkeley)
Daniélou, J. 1953. 'Terre et paradis chez les Pères de l'Église', *EY* 22, pp. 433–72
 1964. *Primitive Christian Symbols*, D. Attwater (trans.) (London)
Davidson, J. 1994. Review, 'Stage emperor: *Reflections of Nero*, ed. J. Elsner & J. Masters', *London Review of Books*, 28 April, pp. 22–3
Davies, W. D. 1974. *The Gospel and the Land: Early Christianity and Jewish Territorial Doctrine* (Berkeley)

Davis, R. P. 1976. 'The value of the *Liber Pontificalis* as comparative evidence for territorial estates and church property from the fourth to the sixth century', University of Oxford, DPhil dissertation

Davis, W. 1990. 'Style and history in art history', in Conkey & Hastorf (1990), pp. 18–31

Davis-Weyer, C. 1986. *Early Medieval Art, 300–1150*, MAA, RT 17 (Toronto)
 1989. 'S. Stefano Rotundo in Rome and the Oratory of Theodore I', in Tronzo (1989), pp. 61–80

Dawson, D. 1992. *Allegorical Readers and Cultural Revision in Ancient Alexandria* (Berkeley)

Deckers, J. G. 1979. 'Die Wandmalerei im Kaiserkultraum von Luxor', *Jahrbuch des Deutschen Archäologischen Instituts* 94, pp. 600–52

De Hamel, C. *A History of Illuminated Manuscripts*, rev. edn (Oxford)

Deichmann, F. W. 1948. *Frühchristliche Kirchen in Rom* (Basle)
 1969–89. *Ravenna: Haupstadt des spätantiken Abendlandes*, 6 vols. (Wiesbaden)

Delbrueck, R. 1929. *Die Consulardiptychen und verwandte Denkmäler* (Berlin and Leipzig)
 1932a. *Antike Porphyrwerke* (Berlin)
 1932b. 'Der spätantike Kaiserornat', *Die Antike* 8, pp. 1–21
 1933. *Spätantike Kaiserporträts von Constantius Magnus bis zum Ende des Westreichs* (Berlin)

Delmaire, R. 1977. 'La caisse des largesses sacrées et l'armée au bas-empire', in *Armées et fiscalité dans le monde antique*, Colloques nationaux du Centre National de la Recherche Scientifique 936 (Paris), pp. 311–29
 1988. 'Les largesses impériales et l'émission d'argenterie du IVe au VIe siècle', in Baratte (1988), pp. 113–22
 1989a. 'Le déclin des largesses sacrées', in *Hommes et richesses dans l'Empire byzantin* 1 (of 2 vols.), IVe–VIIe siècle, Réalités byzantines 1 (Paris), pp. 265–77
 1989b. *Largesses sacrées et 'Res Privata': L'"Aerarium" impérial et son administration du IVe au VIe siècle*, CEFR 121 (Rome)

Delvoye, C. 1965. 'Les ateliers d'arts somptuaires à Constantinople', *CCARB* 12, pp. 171–210

Demus, O. 1949. *The Mosaics of Norman Sicily* (London)

De Nie, G. 1987. *Views from a Many-Windowed Tower: Studies of Imagination in the Works of Gregory of Tours*, Studies in Classical Antiquity 7 (Amsterdam)

De Rossi, G. B. 1899. *Musaici cristiani e saggi dei pavimenti delle chiese di Roma anteriori al secolo XV* (Rome)

Derrett, J. D. M. 1984. 'Whatever happened to the land flowing with milk and honey?', *VC* 38, pp. 178–84

De Ste Croix, G. E. M. 1975. 'Early Christian attitudes to property and slavery', in D. Baker (ed.) *Church, Society and Politics*, SCH 12 (Oxford), pp. 1–38

Di Azevedo, M. C. 1979. 'Il palazzo imperiale di Salonico', *FR* 117, pp. 7–28

Di Berardino, A. (ed.) 1992. *Encyclopedia of the Early Church*, A. Walford (trans.), W. H. C. Friend (rev.), 2 vols. (New York)

Dirimtekin, F. 1965. 'Les palaix imperieux byzantins', *CCARB* 12, pp. 225–45

Di Segni, L. 1990. 'Horvath Hesheq: the inscriptions', in Bottini, Di Segni & Alliata (1990), pp. 379–87

Dodd, E. C. 1973. *Byzantine Silver Treasures* (Berne)
 1987. 'Three early Byzantine silver crosses', in Tronzo & Lavin (1987), pp. 165–80

Dodwell, C. R. 1982. *Anglo-Saxon Art: A New Perspective*, Manchester Studies in the History of Art 3 (Manchester)

1993. *The Pictorial Arts of the West, 800–1200* (New Haven)
Donceel-Voûte, P. 1988. *Les pavements des églises byzantines de Syrie et du Liban: décor, archéologie et liturgie*, Publications d'histoire de l'art et d'archéologie de l'Université catholique de Louvain 69 (Louvain)
Dorigo, W. 1971. *Late Roman Painting: A Study of Pictorial Records, 30 B.C.–A.D. 500* (London)
Douglas, M. 1967. 'Primitive rationing', in R. Firth (ed.) *Themes in Economic Anthropology* (London), pp. 119–47
Douglas, M. & Isherwood, B. 1979. *The World of Goods: Toward an Anthropology of Consumption* (London)
Downey, G. 1962. 'Constantine's churches at Antioch, Tyre and Jerusalem', *Mélanges de l'Université Saint Joseph* 38, pp. 189–96
Drake, H. A. 1975. *In Praise of Constantine: A Historical Study and New Translation of Eusebius' 'Tricennial Orations'*, University of California, Classical Studies 15 (Berkeley)
Drinkwater, J. & Elton, H. (eds.) 1992. *Fifth-Century Gaul: A Crisis of Identity* (Cambridge)
Dronke, P. 1972. 'Tradition and innovation in medieval western colour imagery', *EY* 41, pp. 51–108
Duffy, E. 1992. *The Stripping of the Altars: Traditional Religion in England, c. 1400–c. 1580* (New Haven)
Dunbabin, K. M. D. 1978. *The Mosaics of Roman North Africa: Studies in Iconography and Patronage* (Oxford)
Dupont-Sommer, A. 1947. 'Une hymne Syriaque sur la cathédrale d'Edesse', *CA*, FAMA 2, pp. 29–39
Duval, N. 1977. *La mosaïque funéraire dans l'art paléochrétien* (Ravenna)
1978. 'Comment reconnaître un palais impérial ou royal? Ravenne et Piazza Armerina', *FR* 115, pp. 27–62
1979. 'Palais et cité dans la "Pars Orientis"', *CCARB* 26, pp. 41–51
Dynes, W. 1962. 'The first Christian palace-church type', *Marsyas* 11, pp. 1–9
Earle, T. K. 1987. 'Specialisation and the production of wealth: Hawaiian chiefdoms and the Inka empire', in Brumfiel & Earle (1987), pp. 64–75
Ebersolt, J. 1910. *Le Grand Palais de Constantinople et le 'Livre des cérémonies'*, Bibliothèque de la Fondation Thiers 21 (Paris)
Eco, U. 1986. *Art and Beauty in the Middle Ages*, H. Bredin (trans.) (New Haven)
Edwards, C. 1993. *The Politics of Immorality in Ancient Rome* (Cambridge)
Effenberger, A. & Severin, H.-G. 1992. *Das Museum für spätantike und Byzantinische Kunst, Berlin* (Mainz)
Egan, J. P. 1989. 'Towards a mysticism of light in Gregory Nazianzen's *Oration* 32: 15', in Livingstone (1989), III, pp. 473–482
Elbern, V. H. 1964. 'Zum Justinuskreuz im Schatz von Sankt Peter zu Rom', *Jahrbuch der Berliner Museen* 6, pp. 24–38
1979. 'Altar implements and liturgical objects', in Weitzmann (1979a), pp. 592–8
Eliade, M. 1976. *Myths, Rites and Symbols: A Mircea Eliade Reader*, 2 vols., W. C. Beane & W. G. Doty (eds.) (New York)
Eliade, M., Adams, C. J., Kitagawa, J. M., et al. (eds.) 1987. *The Encyclopedia of Religion*, 16 vols. (New York)
Ellen, R. F. & Reason, D. (eds.) 1979. *Classifications in their Social Context* (London)
Elliott, A. G. 1987. *Roads to Paradise: Reading the Lives of the Early Saints* (Hanover, New Engl.)
Ellis, S. P. 1988. 'The end of the Roman house', *American Journal of Archaeology* 92, pp. 565–76

Elm, S. 1994. 'Virgins of God': The Making of Asceticism in Late Antiquity (Oxford)
Elsner, J. 1991. Review, 'Eve Borsook: Messages in Mosaic', Burlington Magazine 133, pp. 198–9
 1994a. 'Constructing decadence: the representation of Nero as an imperial builder', in Elsner & Masters (1994), pp. 112–27.
 1994b. 'The viewer and the vision: the case of the Sinai apse', AH 17, pp. 81–102
 1995. Art and the Roman Viewer: The Transformation of Art from the Pagan World to Christianity (Cambridge)
Elsner, J. & Masters, J. (eds.) 1994. Reflections of Nero: Culture, History and Representation (London)
Emmerson, R. K. & McGinn, B. (eds.) 1992. The Apocalypse in the Middle Ages (Ithaca)
Englund, G. 1987. 'Gifts to the Gods – a necessity for the preservation of cosmos and life: theory and practice', in Linders & Nordquist (1987), pp. 57–66
Evans, G. R. 1984. The Language and Logic of the Bible: The Earlier Middle Ages (Cambridge)
 1985. The Language and Logic of the Bible: The Road to Reformation (Cambridge)
 1986. The Thought of Gregory the Great, Cambridge Studies in Medieval Life and Thought 2 (Cambridge)
Faris, J. C. 1983. 'From form to content in the structural study of aesthetic systems', in Washburn (1983a), pp. 90–112
Farrell, R. & De Vegvas, C. N. (eds.) 1992. Sutton Hoo: Fifty Years After, American Early Medieval Studies 2 (Ohio)
Fehring, G. P. 1991. The Archaeology of Medieval Germany: An Introduction, R. Samson (trans.) (London)
Fentress, J. & Wickham, C. 1992. Social Memory (Oxford)
Ferber, S. 1976. 'The Temple of Solomon in early Christian and Byzantine Art', in J. Gutmann (ed.) The Temple of Solomon: Archaeological Fact and Medieval Tradition in Christian, Islamic, and Jewish Art, Religion and the Arts 3 (Missoula), pp. 21–44
Finley, M. I. 1975a. The Ancient Economy, corrected edn (London)
 1975b. The Use and Abuse of History (London)
Finney, P. C. 1987. 'Images on finger rings and early Christian art', in Tronzo & Lavin (1987), pp. 181–6
 1994. The Invisible God: The Earliest Christians on Art (New York)
Fischer, J. L. 1971. 'Art styles as cultural cognitive maps', in Otten (1971), pp. 140–60
Fishbane, M. 1985. Biblical Interpretation in Ancient Israel (Oxford)
Foerster, G. 1990. 'Allegorical and symbolic motifs with Christian significance from mosiac pavements of sixth-century Palestinian synagogues', in Bottini, Di Segni & Alliata (1990), pp. 545–52
Fontaine, J., Gillet, R. & Pellistrandi, S. (eds.) 1986. Grégoire le Grand (Paris)
Fontaine, J. & Hillgarth, J. N. (eds.) 1992. The Seventh Century: Change and Continuity (London)
Fowler, B. H. 1989. The Hellenistic Aesthetic (Bristol)
Frazer, J. 1993. The Golden Bough: A Study in Magic and Religion, reprint of 1922 abridged edn (Ware)
Frazer, M. E. 1979a. 'Apse themes', in Weitzmann (1979a), pp. 556–7
 1979b. 'Iconic representations', in Weitzmann (1979a), pp. 513–7
 1992. 'Early Byzantine silver book covers', in Boyd & Mango (1992), pp. 71–6
Fredriksen, P. 1992. 'Tyconius and Augustine on the Apocalypse', in Emmerson & McGinn (1992), pp. 20–37

Frerichs, W. W. 1969. *Precious Stones as Biblical Symbols* (Basle)
Friedländer, L. 1964. *Darstellungen aus der Sittengeschichte Roms in der Zeit von Augustus bis zum Ausgang der Antonine*, 4 vols., 10th edn (Aalen)
Frugoni, C. 1991. *A Distant City: Images of Urban Experience in the Medieval World*, W. McCuig (trans.) (Princeton)
Fulford, M. G. 1985. 'Roman material in barbarian society, c. 200 B.C.–c. A.D. 400', in Champion & Megaw (1985), pp. 91–108
Gabrielli, G. M. 1960. 'I sarcofagi di tipo Ravennate nella Marche', *FR* 82, pp. 97–116
Gage, J. 1978. 'Colour in history: relative and absolute', *AH* 1, pp. 104–30
 1993. *Colour and Culture: Practice and Meaning from Antiquity to Abstraction* (London)
Gaimster, M. 1992. 'Scandinavian gold bracteates in Britain: money and media in the Dark Ages', *Medieval Archaeology* 36, pp. 1–28
Galavaris, G. P. 1958. 'The symbolism of the imperial costume as displayed on Byzantine coins', *American Numismatic Society, Museum Notes* 8, pp. 99–117
Ganz, D. 1987. 'Preconditions for Caroline miniscule', *Viator* 18, pp. 23–43
Gardiner, E. 1993. *Medieval Visions of Heaven and Hell: A Sourcebook*, Garland Reference Library of the Humanities 1256/Garland Medieval Bibliographies 11 (New York)
Garnsey, P. 1991. Review, 'The generosity of Veyne', *JRS* 81, pp. 164–8
Gaudemet, J. 1950. 'Le carrière civile de saint Germain', in Société des Sciences Historiques et Naturelles de L'Yonne, *Saint Germain d'Auxerre et son temps* (Auxerre), pp. 111–18
 1989. *L'église dans l'empire romain (IVe–Ve siècles)*, rev. edn (Paris)
Geake, H. 1992. 'Burial practice in seventh- and eighth-century England', in Carver (1992a), pp. 83–94
Geary, P. 1978. *'Furta Sacra': Thefts of Relics in the Central Middle Ages* (Princeton)
Gellner, E. 1988. *Plough, Sword and Book: The Structure of Human History* (London)
George, E. W. 1992. *Venantius Fortunatus: A Latin Poet in Merovingian Gaul* (Cambridge)
Gero, S. 1975. 'Hypatius of Ephesus and the cult of images', in Neusner (1975), I, pp. 208–16
Gerson, L. P. 1994. *Plotinus* (London)
Ghirshman, R. 1962. *Iran, Parthians and Sassanids*, S. Gilbert & J. Emmons (trans.) (London)
Gibbon, E. 1910. *The Decline and Fall of the Roman Empire*, Everyman Library, 6 vols. (London)
Gilbert-Rolfe, J. 1981. 'Color as metaphor', *Res* 2, pp. 104–6
Gipper, H. 1964. 'Purpur: weg und leistung eines umstritten Farbworts', *Glotta* 43, pp. 39–69
Girouard, M. 1980. *Life in the English Country House: A Social and Architectural History* (Harmondsworth)
Godman, P. 1987. *Poets and Emperors: Frankish Politics and Carolingian Poetry* (Oxford)
Gold, B. K. (ed.) 1982. *Literary and Artistic Patronage in Ancient Rome* (Austin)
Goldschmidt, R. F. 1940. *Paulinus' Churches at Nola: Texts, Translations and Commentary* (Amsterdam)
Golomstock, I. 1990. *Totalitarian Art in the Soviet Union, the Third Reich, Fascist Italy and the People's Republic of China*, R. Chaneller (trans.) (London)
Gombrich, E. H. 1972. *Symbolic Images: Studies in the Art of the Renaissance* (London)
 1984. *The Sense of Order: A Study in the Psychology of Decorative Art*, 2nd edn (London)
Gonda, J. 1991. *The Functions and Significance of Gold in the 'Veda'*, Orientalia Rheno-Traiectina 37 (Leiden)
Gonzalez, J. L. 1990. *Faith and Wealth: A History of Early Christian Ideas on the Origin, Significance*

and Use of Money (San Francisco)

Goodenough, E. R. 1953–68. *Jewish Symbols in the Graeco-Roman Period*, 13 vols., BS 37 (New York)

 1962. *An Introduction to Philo Judaeus*, 2nd edn (Oxford)

Goody, J. 1983. *The Development of the Family and Marriage in Europe* (Cambridge)

Gordon, R. L. 1980. 'Reality, evocation and boundary in the mysteries of Mithras', *Journal of Mithraic Studies* 3, pp. 19–99

 1990. 'Religion in the Roman Empire: the civic compromise and its limits', in M. Beard & J. North (eds.) *Pagan Priests: Religion and Power in the Ancient World* (London), pp. 233–55.

Gorman, F. H. 1990. *The Ideology of Ritual: Space, Time and Status in the Priestly Theology*, Journal for the Study of the Old Testament, Suppl. Ser. 91 (Sheffield)

Gould, G. 1987. 'Basil of Caesarea and the problem of the wealth of monasteries', in Sheils & Wood (1987), pp. 15–24

Goy, R. J. 1992. *The House of Gold: Building a Palace in Medieval Venice* (Cambridge)

Grabar, A. N. 1936. *L'empereur dans l'art Byzantin: recherches sur l'art officiel de l'empire d'orient*, Publications de la faculté des lettres de l'Université de Strasbourg 75 (Paris)

 1943–6. *'Martyrium': recherches sur le culte des reliques et l'art chrétien antique*, 2 vols. (Paris)

 1947. 'L'architecture et la symbolique de la cathédrale d'Édesse', *CA, FAMA* 2, pp. 41–67

 1948. *Les peintures de l'Evangilaire de Sinope* (Paris)

 1968a. *L'art de la fin de l'antiqité et du moyen age*, 3 vols. (Paris)

 1968b. *Christian Iconography: A Study of its Origins*, BS 35 / A. W. Mellon Lectures 10 (Princeton)

 1968c. 'La trône des martyrs', in Grabar (1968a), I, pp. 341–50 (reprinted from *CA, FAMA* 6 (1952))

 1968d. 'Quel est le sens de l'offrande de Justinien et de Théodora sur les mosaïques de Saint-Vital?', in Grabar (1968a), I, pp. 461–8 (reprinted from *FR* (1960))

 1975. *Les revêtements en or et en argent des icones byzantines du moyen âge*, Bibliothèque de l'Institut Hellénique d'Études Byzantines et Post-Byzantines de Venise 7 (Venice)

Grabar, A. N. & Nordenfalk, C. 1957. 'Mosaics and mural painting', in *Early Medieval Painting from the Fourth to the Eleventh Century*, S. Gilbert (trans.) (Lausanne), pp. 23–86

Granfield, P & Jungmann, J. A. (eds.) 1970. *Kyriakon: Festschrift Johannes Quasten*, 2 vols. (Münster)

Green, T. 1982. *The New World of Gold: The Inside Story of the Mines, the Markets, the Politics, the Investors* (London)

Greenhalgh, M. 1989. *The Survival of Roman Antiquities into the Middle Ages* (London)

Grégoire, H. 1939. 'La rotunde de S. Georges à Thessalonique est le Mausolée de Galère', *Byzantion* 14, pp. 323–4

Gregory, C. A. 1982. *Gifts and Commodities* (London)

Greifenhagen, A. 1974. *Schmuck der alten Welt* (Berlin)

Grierson, P. 1982. *Byzantine Coinage*, Dumbarton Oaks, Byzantine Collection, Publication 4 (Washington)

Grierson, P. & Blackburn, M. 1986. *Medieval European Coinage*, I (of 14 vols.), *The Early Middle Ages* (Cambridge)

Grigg, R. 1977. 'Constantine the Great and the Cult of Images', *Viator* 8, pp. 1–32

Gros, P. 1976. *'Aurea templa': recherches sur l'architecture religieuse de Rome à l'époque d'Auguste*, Bibliothèque des Écoles Françaises d'Athénes et de Rome 231 (Rome)

Gross, K. 1992. *The Dream of the Moving Statue* (Ithaca)

Hagberg, U. G. 1987. 'The Scandinavian votive deposits of weapons and jewellery in the Roman Iron Age and the Migration Period', in Linders & Nordquist (1987), pp. 77–81

Hall, J. 1979. *Dictionary of Subjects and Symbols in Art*, rev. edn (London)
Halsberghe, G. H. 1972. *The Cult of 'Sol Invictus'*, EPROER 23 (Leiden)
Halsall, G. 1992. 'The origins of the *Reihengräberzivilisation*: forty years on', in Drinkwater & Elton (1992), pp. 196–207
Hamilton, B. 1986. *Religion in the Medieval West* (London)
Hamilton, J. A. 1956. *Byzantine Architecture and Decoration*, 2nd edn (London)
Hanfmann, G. F. 1975. *From Croesus to Constantine: The Cities of Western Asia Minor and their Arts in Greek and Roman Times* (Ann Arbor)
Hanfmann, G. M. A. 1964. 'The sixth campaign at Sardis (1963)', *Bulletin of the American Schools of Oriental Research* 174, pp. 3–58
Hanson, R. P. C. 1978. 'The transformation of pagan temples into churches in the early Christian Centuries', *Journal of Semitic Studies* 23, pp. 257–67
Hardie, P. R. 1986. *Virgil's 'Aeneid': 'Cosmos' and 'Imperium'* (Oxford)
Harhoiu, R. 1977. *The Fifth-Century A.D. Treasure from Pietroasa, Romania, in the Light of Recent Research*, N. Hampartumian (trans.), BAR, SS 24 (Oxford)
Harries, J. 1984. '"Treasure in heaven": property and inheritance among senators of late Rome', in E. M. Craik (ed.) *Marriage and Property* (Aberdeen), pp. 54–70
Harrision, M. 1989. *A Temple for Byzantium: The Discovery and Excavation of the Anicia Juliana's Palace-Church in Istanbul* (London)
 1994. 'From Jerusalem and back again: the fate of the treasures of Solomon', in K. S. Painter (ed.) *Churches Built in Ancient Times*, Society of Antiquaries, Occasional Papers 16 (London), pp. 239–48
Harvey, W. & Harvey, J. H. 1937. 'Recent discoveries at the church of the Nativity, Bethlehem', *Archaeologia* 87, pp. 7–17
Hassall, M. W. C. (ed.) 1979. *De Rebus Bellicis* I (of 2 vols.), *Papers Presented to E. A. Thompson*, BAR, IS 63i (63i–ii) (Oxford)
Hauschild, T. & Schlunk, H. 1961. 'Vorbericht über die Untersuchungen in Centcelles', *Madrider Mitteilungen* 2, pp. 119–82
Hawkes, J. 1968. *Dawn of the Gods* (London)
Hedeager, L. 1978. 'A quantitative analysis of Roman imports in Europe north of the *limes* (A.D. 0–400) and the question of Romano-Germanic exchange', in K. Kristiansen & C. Paudan-Müller (eds.) *New Directions in Scandinavian Archaeology*, Studies in Scandinavian Prehistory and Early History 1 (Copenhagen), pp. 191–216
 1992. 'Kingdoms, ethnicity and material culture: Denmark in a European perspective', in Carver (1992a), pp. 279–300
Heidinga, H. A. 1990. 'From Krootwijk to Rhenen: in search of the elite in the Central Netherlands in the early Middle Ages', in Bestman, Bos & Heidinga (1990), pp. 9–40
Helms, M. W. 1981. 'Precious metals and politics: style and ideology in the Intermediate Area and Peru', *Journal of Latin American Lore* 7, pp. 215–37
Hen, Y. 1994. 'Popular culture in Merovingian Gaul, A.D. 481–751', University of Cambridge, PhD dissertation
Henderson, G. 1980. *Bede and the Visual Arts*, Jarrow Lecture (Jarrow)
 1987. *From Durrow to Kells: The Insular Gospel Books, 650–800* (London)
Henderson, P. 1989. 'The early Byzantine mosaic pavements of Palestine and their interpretation by the threefold method', in Livingstone (1989), v, pp. 37–43

Hendy, M. F. 1985. *Studies in the Byzantine Monetary Economy c. 300–1450* (Cambridge)
Hengel, M. 1973. *Eigentum und Reichtum in der frühen Kirche: Aspekte einer frühchristlichen Sozialgeschichte* (Stuttgart)
Henig, M. (ed.) 1983a. *A Handbook of Roman Art: A Survey of the Visual Arts of the Roman World* (London)
 1983b. 'The luxury arts: decorative metalwork, engraved gems and jewellery', in Henig (1983a), pp. 139–65
Herbert, E. W. 1984. *Red Gold of Africa: Copper in Pre-Colonial History and Culture* (Madison)
Herlihy, D. 1957–8. 'Treasure hoards in the Italian economy, 960–1139', *Economic History Review* (2nd ser.) 10, pp. 1–14
Hermann, A. & Di Azevedo, M. C. 1969. 'Farbe', in T. Klauser (ed.) *Reallexikon für Antike und Christentum 70* (Stuttgart), cols. 358–447
Herzfeld, E. 1920. 'Der Thron des Khosrô: quellenkritische und ikonographische Studien über Grenzgebiete der Kunstgeschichte des Morgen- und Abendslandes', *Jahrbuch der Preuszischen Kunstsammlungen* 41, pp. 1–24 and 103–47
Herzog, I. 1987. 'Hebrew porphyrology', M. Ron (ed.), in Spanier (1987), pp. 17–145
Heurgon, J. 1958. *Le trésor de Ténès* (Paris)
Hicks, C. 1986. 'The birds on the Sutton Hoo purse', *ASE* 15, pp. 153–66
Higgins, R. A. 1961. *Greek and Roman Jewellery* (London)
Hill, B. T. 1983. 'Constantinopolis', in R. Winkes & T. Hackens (eds.) *Gold Jewellery: Craft Style and Meaning from Mycenae to Constantinoplis*, Aurifex 5 (Louvain), pp. 141–60
Hillgarth, J. N. 1992. 'Eschatological and political concepts in the seventh century', in Fontaine & Hillgarth (1992), pp. 212–31
Hinks, R. P. 1933. *Catalogue of the Greek, Etruscan and Roman Paintings and Mosaics in the British Museum* (London)
Hitchcock, M. 1988. 'The Far East', in Mack (1988b), pp. 95–114
Hodder, I. (ed.) 1982a. *Symbolic and Structural Archaeology* (Cambridge)
 1982b. *Symbols in Action: Ethnoarchaeological Studies of Material Culture* (Cambridge)
 1987. (ed.) *Archaeology as Long-Term History* (Cambridge)
Hodges, R. 1986. 'Peer polity interaction in Anglo-Saxon England', in Renfrew & Cherry (1986), pp. 69–78
 1989. *The Anglo-Saxon Achievement: Archaeology and the Beginnings of English Society* (London)
Hoffman, R. & Honeck, R. P. (eds.) 1980. 'A peacock looks at its legs: cognitive science and figurative language', in Honeck & Hoffman (1980), pp. 3–24
Holbrook, C. A. 1984. *The Iconoclastic Deity: Biblical Images of God* (Lewisburg)
Holder, A. 1989. 'New treasures and old in Bede's *De Tabernaculo* and *De Templo*', *Revue Bénédictine* 99, pp. 237–249
Holmes, U. T. 1934. 'Medieval gem stones', *Speculum* 9, pp. 195–204
Honeck, R. P. & Hoffman, R. (eds.) 1980. *Cognition and Figurative Language* (Hillsdale)
Hopkins, K. 1978. *Conquerors and Slaves: Sociological Studies in Roman History 1* (Cambridge)
 1983. *Death and Renewal: Sociological Studies in Roman History 2* (Cambridge)
Hubert, H. & Mauss, M. 1964. *Sacrifice: Its Nature and Function*, W. D. Halls (trans.) (London)
Hubert, J., Porcher, J. & Volbach, W. P. 1967. *L'Europe des invasions*, L'univers des formes 12 (Paris)
Humphreys, S. C. & King, H. (eds.) 1981. *Mortality and Immortality: The Anthropology and*

Archaeology of Death (London)

Hunn, E. 1979. 'The abominations of Leviticus revisited: a commentary on anomaly in symbolic archaeology', in Ellen & Reason (1979), pp. 103–16

Hunt, E. D. 1982. *Holy Land Pilgrimage in the Later Roman Empire, A.D. 312–460* (Oxford).

Hunter, D. G. (ed.) 1989. *Preaching in the Patristic Ages: Studies in Honor of Walter J. Burghardt* (New York), pp. 36–52

Hutter, I. 1988. *Early Christian and Byzantine*, The Herbert History of Art and Architecture, A. Laing (trans.) (London)

Ihm, C. 1960. *Die Programme der Christlichen Apsismalerei vom vierten Jahrhundert bis zur Mitte das achten Jahrhunderts*, Forschungen zur Kunstgeschichte und christlichen Archäologie 4 (Wiesbaden)

Irwin, T. 1989. *Classical Thought*, A History of Western Philosophy 1 (Oxford)

Isager, J. 1991. *Pliny on Art and Society: The Elder Pliny's Chapters on the History of Art*, H. Rosenmeier (trans.) (London).

Iturgaiz, D. 1972. 'Luz y color en la arquitectura basilical paleocristiana', *Ciencia Tomista* 99, pp. 367–400

Ivanov, T. 1972. 'Représentations de Constantin Ier et de ses fils sur des fibules en forme de bulbe de Bulgarie', *Archeologija (Sofia)* 14, pp. 9–29

James, Edward. 1977. *The Merovingian Archaeology of South-West Gaul*, 2 vols.., BAR, SS 25i&ii (Oxford)

 1981. 'Archaeology and the Merovingian monastery', in H. B. Clarke & M. Brennan (eds.) *Columbanus and Merovingian Monasticism*, BAR, IS 113 (Oxford), pp. 33–58

 1988. *The Franks* (Oxford)

 1989. 'Burial and status in the early medieval west', *TRHS* (5th ser.) 39, pp. 23–40

 1992. 'Royal burials amongst the Franks', in Carver (1992a), pp. 243–54

James, Elizabeth. 1990. 'Colour perception in Byzantium', University of London, PhD dissertation

 1991. 'Colour and the Byzantine rainbow', *BMGS* 15, pp. 66–94

James, Elizabeth & Webb, R. 1991. 'To understand ultimate things and enter secret places', *AH* 14, pp. 1–17

Janes, D. T. S. 1996a. 'The Christian display of wealth in western Europe, A.D. 300–750', University of Cambridge, PhD dissertation

 1996b. 'The golden clasp of the late Roman state', *Early Medieval Europe* 5, pp. 127–53

 forthcoming. 'Treasure bequest: death and gift in the early Middle Ages', in J. Hill & M. Swan (eds.) *The Community, Family and the Saint: Patterns of Power in Early Medieval Europe*, Selected Proceedings Series, Leeds International Medieval Congress

Janson, T. 1979. 'Preface', in T. Janson (ed.) *A Concordance to the 'XII Panegyrici Latini' and to the Panegyrical Texts and Fragments of Ausonius, Merobaudes, Ennodius, Cassiodorus*, Alpha-Omega, A, Lexika, Indizes, Konkordanzen zur klassischen Philologie 37 (Hildesheim), pp. vii–x

Jart, U. 1970. 'The precious stones in the Revelation of St John XXI, 18–21', *Studia Theologica* 24, pp. 150–81

Jastrzebowska, E. 1975. 'Les origines de la scène du combat entre le coq et la tortue dans les mosaïques Chrétiennes d'Aquilie', in *Mosaici in Aquileia e nell'alto Adriatico*, Antichita Altoadriatiche 8 (Udine), pp. 93–107

Jay, P. 1985. *L'exégèse de Saint Jérôme d'après son 'Commentaire sur Isaïe'* (Paris)

Johns, C. 1990. 'Research on Roman silver plate', *JRA* 3, pp. 29–43

Johnson, M. J. 1988. 'Toward a history of Theodoric's building program', *DOP* 42, pp. 73–96

Johnston, D. 1985. 'Munificence and *municipia*: bequests to towns in classical Roman laws', *JRS* 75, pp. 105–25

Joly, D. 1962. 'La mosaïque pariétale au 1er siècle de notre ère', *MAH, EFR* 74, pp. 123–69

Jones, A. H. M. 1986. *The Later Roman Empire 284–602: A Social, Economic and Administrative Survey*, 2 vols. (Oxford)

Jones, A. H. M., Grierson, P. & Crook, J. A. 1957. 'The authenticity of the *Testamentum S. Remigii*', *Revue Belge de philologie et d'histoire* 35, pp. 356–373

Jones, John. 1930. *The History and Object of Jewellery*, 2nd edn (Edinburgh)

Jones, Julie (ed.) 1985. *The Art of Pre-Columbian Gold: The Jan Mitchell Collection* (New York)
 1988. 'Precolumbian America', in Mack (1988b), pp. 135–48

Jones, Julie & King, H. 'The catalogue', in Julie Jones (1985), pp. 85–242

Joyce, H. 1981. *The Decoration of Walls, Ceilings and Floors in Italy in the 2nd and 3rd Centuries A.D.* (Rome)

Känzl, E. 1988. 'Zwei silberne Tetrarchenporträtes im Römisch-Germanischen Zentralmuseum Mainz', in Baratte (1988), pp. 187–90

Kaske, R. E., Groos, A. & Twomey, M. W. 1988. *Medieval Christian Literary Imagery: A Guide to Interpretation*, Toronto Medieval Bibliographies 11 (Toronto)

Kaster, R. A. 1988. *Guardians of Language: The Grammarian and Society in Late Antiquity* (Berkeley)

Kautsky, J. H. 1982. *The Politics of Aristocratic Empires* (Chapel Hill)

Kazhdan, A. P., Talbot, A.-M., Cutler, A. et al. 1991. *Oxford Dictionary of Byzantium*, 3 vols. (Oxford)

Kee, A. 1982. *Constantine versus Christ: The Triumph of Ideology* (London)

Kehrer, H. 1908. *Die heiligen drei Könige in Literatur und Kunst*, 2 vols. (Leipzig)

Kelly, F. 1988. *A Guide to Early Irish Law*, Dublin Institute for Advanced Studies, Early Irish Law Ser. 3 (Dublin)

Kelly, J. N. D. 1975. *Jerome: His Life, Writings and Controversies* (London)

Kent, J. P. C. & Painter, K. S. 1977. *Wealth of the Roman World, A.D. 300–700* (London)

Kessler, H. L. 1985. 'Pictorial narrative and church mission in sixth-century Gaul', in Kessler & M. S. Simpson (eds.) *Pictorial Narratives in Antiquity and the Middle Ages*, National Gallery of Art, Washington, Studies in the History of Art 16 (Washington), pp. 75–91

Kilerich, B. 1991. 'A different interpretation of the Nicomachorum-Symmachorum diptych', *JAC* 34, pp. 115–28

King, C. E. 1980. 'The *sacra largitiones*, revenues, expenditure and the production of coin', in C. E. King (ed.) *Imperial Revenue, Expenditure and Monetary Policy in the Fourth Century A.D.*, BAR, IS 76 (Oxford)

King, V. T. 1988. 'Maloh, Malay and Chinese: silversmithing and cultural exchange in Borneo and elsewhere', in J. W. Christie & V. T. King (eds.) *Metal Working in Borneo: Essays on Iron and Silver-Working in Sarawak* (Hull), pp. 29–56

Kinney, D. 1970–1. '*Capella reginae*: S. Aquilino in Milan', *Marsayas* 15, pp. 13–35
 1992. 'The Apocalypse in Early Christian monumental decoration', in Emmerson & McGinn (1992), pp. 200–16

Kirschbaum, E. 1968–76. 'Farbensymbolik', in E. Kirschbaum (ed.) *Lexikon der christliche Ikonographie*, II (of 8 vols.) (Freiburg), pp. 7–14

Kitson, P. 1978. 'Lapidary traditions in Anglo-Saxon England: part I, the background: the Old

English lapidary', *ASE* 7, pp. 9–60

1983. 'Lapidary traditions in Anglo-Saxon England: part II, Bede's *Explanatio Apocalypsis* and related works', *ASE* 12, pp. 73–124

Kitzinger, E. 1951. 'Studies on late Antique and early Byzantine floor mosaics I, mosaics of Nikopolis', *DOP* 6, pp. 83–122

1954a. 'The cult of images in the age before iconoclasm', *DOP* 8, pp. 83–150

1954b. 'Observations on the Milan Iliad', *Nederlands kunsthistorisch Jaarbaek* 5, pp. 241–64

1970. 'The threshold of the holy shrine: observations on the floor mosaics at Antioch and Bethlehem', in Granfield & Jungmann (1970), II, pp. 639–47

1977. *Byzantine Art in the Making* (London)

1980. 'Christian imagery: growth and impact', in Weitzmann (1980), pp. 141–64

Klauser, T. 1944. '*Aurum coronarium*', *MDAI, RA* 59, pp. 129–53

Kleiner, D. 1992. *Roman Sculpture* (New Haven)

Koester, C. R. 1989. *The Dwelling of God: The Tabernacle in the Old Testament, Intertestamental Jewish Literature and the New Testament*, The Catholic Biblical Quarterly Monograph Ser. 22 (Washington)

Krautheimer, R. 1965. *Early Christian and Byzantine Architecture* (Harmondsworth)

1967. 'The Constantinian basilica', *DOP* 21 (1967), pp. 115–40

1983. *Three Christian Capitals: Topography and Politics* (Berkeley)

Kubler, G. 1971. 'On the colonial extinction of the motifs of Pre-Columbian art', in Otten (1971), pp. 212–26

Kühnel, B. 1987. *From the Earthly to the Heavenly Jerusalem: Representations of the Holy City in Christian Art of the First Millenium*, RQCAK, Suppl. 42 (Rome)

La Bonnardière, A. M. 1955. 'Le "Cantique de Cantiques" dans l'oeuvre de Ste. Augustin', *REA* 1, pp. 225–37

Lacombrade, C. 1951a. *Synésios de Cyrène: Hellène et Chrétien* (Paris)

1951b. *Le discours sur la royauté de Synésios de Cyrène à l'empereur Arcadios* (Paris)

Ladner, G. B. 1979. 'Medieval and modern understanding of symbolism', *Speculum* 54, pp. 223–56

1992. *Handbuch der frühchristlichen Symbolik: Gott, Kosmos, Mensch* (Stuttgart)

Lafontaine-Dosogne, J. 1987. 'Pour une problématique de la peinture de l'église Byzantin à l'époque iconclaste', in Tronzo & Lavin (1987), pp. 321–37

Lafourie, J. 1977. 'Eligius Monetarius', *Revue numismatique* (6th ser.) 19, pp. 111–51

Lahusen, G. 1978. 'Goldene und vergoldete römische Ehrenstatuten und Bildnisse', *MDAI, RA* 85, pp. 385–95

Laird, A. 1993. 'Sounding out ecphrasis: art and text in Catullus 64', *JRS* 133, pp. 18–30

Laistner, M. L. W. 1947. 'Antiochene exegesis in Western Europe during the Middle Ages', *Harvard Theological Review* 40, pp. 19–31

Lamberton, R. 1986. *Homer the Theologian: Neoplatonist Allegorical Reading and the Growth of the Epic Tradition* (Berkeley)

Lampe, G. W. H. 1969. 'To Gregory the Great', in Lampe (ed.) *The West from the Fathers to the Reformation*, The Cambridge History of the Bible 2 (Cambridge), pp. 158–83

Lanciani, R. 1891. 'Insigne Larario del Vico Patrizio', *Bullettino della Commissione Archeologica Comunale di Roma* 19, pp. 305–11

Landes, P. F. 1982. 'Tyconius and the end of the world', *REA* 28, pp. 59–75

Landes, R. 1988. 'Lest the Millennium be fulfilled: apocalyptic expectations and the pattern of Western chronography, 100–800 C.E.', in Verbeke, Verhelst & Welkenhuysen (1988), pp.

137–211

Lane Fox, R. 1986. *Pagans and Christians* (London)

Larocca, E. 1986. 'Il lusso come espressione di potere', in *Le tranquille dimore degli dei: la residenza imperiale degli horti Lamiani* (Rome), pp. 3–35

Lavin, I. 1962. 'The house of the Lord: aspects of the role of palace *triclinia* in the architecture of late Antiquity and the Middle Ages', *Art Bulletin* 44, pp. 1–27

1967. 'The ceiling frescos in Trier and illusionism in Constantinian painting', *DOP* 21, pp. 97–113

Layton, R. 1991. *The Anthropology of Art*, 2nd edn (Cambridge)

Leach, E. 1976. *Culture and Communication: The Logic by which Symbols are Connected: An Introduction to the Use of Structuralist Analysis in Social Anthropology* (Cambridge)

Lehmann, K. 1945. 'The dome of heaven', *Art Bulletin* 27, pp. 1–27

Lévi-Strauss, C. 1949. *Les structures élémentaires de la parenté* (Paris)

Lewis, G. 1980. *The Day of Shining Red: An Essay on Understanding Ritual*, CSSA 27 (Cambridge)

Lewis, I. M. 1985. *Social Anthropology in Perspective: The Relevance of Social Anthropology*, 2nd edn (Cambridge)

Lewis, T. & Short, C. 1879. *A Latin Dictionary* (Oxford)

L'Huillier, M.-C. 1992. *L'empire des mots: orateurs gaulois et orateurs romaines 3e et 4e siècles*, Annales littéraires de l'Université de Besançon 464/Centre de Recherches d'Histoire Ancienne 114 (Paris)

Liebeschuetz, J. H. W. G. 1972. *Antioch: City and Imperial Administration in the Later Roman Empire* (Oxford)

Lienhard, J. T. 1977. *Paulinus of Nola and Early Western Monasticism*, Theophaneia 28 (Cologne)

Lieu, S. N. C. (ed.) 1989. *The Emperor Julian: Panegyric and Polemic*, 2nd edn, TTH 2 (Liverpool)

Limberis, V. 1994. *Divine Heiress: The Virgin Mary and the Creation of Christian Constantinople* (London)

Linders, T. 1987. 'Gods, gifts, society', in Linders & Nordquist (1987), pp. 115–22

Linders, T. & Nordquist, G. (eds.) 1987. *Gifts to the Gods: Proceedings of the Uppsala Symposium, 1985*, Acta Universitatis Upsaliensis: Boreas: Uppsala Studies in Ancient Mediterranean and Near Eastern Civilisations 15 (Uppsala)

Ling, R. 1991. *Roman Painting* (Cambridge)

Lipinsky, A. 1962. 'Oreficerie e gioielli nei mosaici ravennati e romani', *CCARB* 9, pp. 367–403

Liversidge, J. 1983. 'Wall painting and stucco', in Henig (1983a), pp. 97–115

Livingstone, E. A. (ed.) 1985–90. *'Studia Patristica': Papers of the Ninth International Conference on Patristic Studies, Oxford, 1983*, 4 vols., SP 18i–iv (Kalamazoo)

(ed.) 1989. *'Studia Patristica': Papers Presented to the Tenth International Conference on Patristic Studies, Held in Oxford, 1987*, 5 vols., SP 19–23 (Leuven)

Llewellyn, P. A. B. 1974. 'The Roman Church in the seventh century', *Journal of Ecclesiastical History* 25, pp. 363–80

Lloyd, G. E. R. 1990. *Demystifying Mentalities* (Cambridge)

Lloyd, J. E. B. 1990. 'Das goldene Gewand der Muttergottes in der Bildersprache mittelalterliche und frühchristlicher Mosaiken in Rom', *RQCAK* 85, pp. 66–85.

Loerke, W. C. 1985–7. 'The Rossano Gospels: the miniatures', in *Codex Purpureus Rossanensis* II, pp. 109–67

Long, A. A. 1985. 'Post-Aristotelian philosophy'', in P. E. Easterling & B. H. W. Knox (eds.) *Cambridge History of Classical Literature* I, *Greek Literature* (Cambridge)

L'Orange, H. P. 1947. *Apotheosis in Ancient Portraiture*, ISK, ser. b: Skrifter 44 (Oslo)

 1952. 'É un palazzo di Massimiano Erculeo che gli scavi di Piazza Armerina portano alla luce?', *SO* 29, pp. 114–28

 1953. *Studies in the Iconography of Cosmic Kingship in the Ancient World*, ISK, ser. a: Forelesninger 23 (Oslo)

 1956. 'Il Palazzo di Massimiano Erculeo di Piazza Armerina', in *Studi in onore di Aristide Calderini e Roberto Paribeni* III (of 3 vols.) (Milan), pp. 593–600

 1965a. *Art Forms and Civic Life in the Later Roman Empire* (Princeton)

 1965b. 'Nuovo contributo allo studio del Palazzo Erculio di Piazza Armerina', *AAAHP* 2, pp. 65–104

 1966. 'The history of mosaics', in L'Orange & Nordhagen (1966), pp. 3–30

L'Orange, H. P. & Kähler, H. 1969. 'La villa di Massenzio a Piazza Armerina', *AAAHP* 4, pp. 41–50

L'Orange, H. P. & Nordhagen, P. J. 1966. *Mosaics*, A. E. Keep (trans.) (London)

Lorimer, H. L. 1936. 'Gold and silver in Greek Mythology', in C. Bailey, C. M. Bowra, E. A. Barber et al. (eds.) *Greek Poetry and Life: Essays Presented to Gilbert Murray on his Seventieth Birthday, Jan. 2nd, 1936* (Oxford), pp. 14–33

Lowden, J. 1992. 'The luxury book as diplomatic gift', in Shepard & Franklin (1992), pp. 249–60

Lowenthal, D. 1985. *The Past is a Foreign Country* (Cambridge)

Lubac, H. de. 1959. *Exégèse médiévale: les quatre sens de l'écriture, première partie*, 2 vols. (Paris)

Lukes, S. 1979. *Power: A Radical View* (Basingstoke)

 1986a. 'Introduction', in Lukes (1986b), pp. 1–18

 (ed.) 1986b. *Power* (Oxford)

Maas, M. 1992. 'Ethnicity, orthodoxy and community in Salvian of Marseille', in Drinkwater & Elton (1992), pp. 275–84

McClain, J. P. 1956. *The Doctrine of Heaven in the Writings of Saint Gregory the Great*, The Catholic University of America, Studies in Sacred Theology, 2nd ser. 95 (Washington)

McClinton, K. M. 1962. *Christian Church Art Through the Ages* (New York)

McClure, J. 1978. 'Gregory the Great: exegesis and audience', University of Oxford, DPhil dissertation

MacCormack, S. G. 1972. 'Change and continuity in late Antiquity: the ceremony of *adventus*', *Historia* 21, pp. 721–52

 1981. *Art and Ceremony in Late Antiquity*, TCH 1 (Berkeley)

McCormick, M. 1986. *Eternal Victory: Triumphal Rulership in Late Antiquity, Byzantium, and the Early Medieval West* (Cambridge)

McDannell, C. & Lang, B. 1988. *Heaven: A History* (New Haven)

McGinn, B. 1979. *Visions of the End: Apocalyptic Traditions in the Middle Ages* (New York)

 1988. 'Portraying Antichrist in the Middle Ages', in Verbeke, Verhelst & Welkenhuysen (1988), pp. 1–48

 1992. 'Introduction: John's Apocalypse and the Apocalypse Mentality', in Emmerson & McGinn (1992), pp. 3–19

McGuckin, J. A. 1987. 'The vine and the elm tree: patristic interpretation of Jesus' teachings on wealth', in Sheils & Wood (1987), pp. 1–14

McGurk, P. 1994. 'The oldest manuscripts of the Latin Bible', in R. Gameson (ed.) *The Early Medieval Bible: Its Production, Decoration and Use* (Cambridge), pp. 1–23

Mack, J. 1988a. 'Adorning the body, expressing the person', in Mack (1988b), pp. 9–23

(ed.) 1988b. *Ethnic Jewellery* (London)

McKendrick, S. 1994. '*Codex Purpureus Petropolitanus*', in Buckton (1994), pp. 78–9

McKinnon, J. 1990. 'Christian Antiquity', in J. McKinnon (ed.) *Antiquity and the Middle Ages from Ancient Greece to the Fifteenth Century*, Man and Music 1 (Basingstoke), pp. 68–87

McKitterick, R. 1983. *The Frankish Kingdoms under the Carolingians 751–987* (London)

1989. *The Carolingians and the Written Word* (Cambridge)

Macky, P. W. 1990. *The Centrality of Metaphors to Biblical Thought: A Method of Interpreting the Bible* (Lewiston)

Maciver, R. M. 1947. *The Web of Government* (New York)

Macmullen, R. 1962. 'The emperor's largesses', *Latomus* 21, pp. 159–66

1963. *Soldier and Civilian in the Later Roman Empire* (Harvard), appendix, 'Rank designated by uniform', pp. 179–80

1981. *Paganism in the Roman Empire* (New Haven)

1984. *Christianising the Roman Empire (A.D. 100–400)* (New Haven)

1987. *Constantine*, reprint edn (London)

1990. 'Some pictures in Ammianus Marcellinus', in *Changes in the Roman Empire: Essays in the Ordinary* (Princeton), pp. 78–106 (reprinted from *Art Bulletin* 66 (1964))

McNally, S. 1994. 'Some American-Croatian excavations in Split (1965–1974)', *Antiquité tardive* 2, pp. 107–21

1996. *The Architectural Ornament of Diocletian's Palace, Split*, BAR, IS 639 (Oxford)

MacQueen, D. J. 1972. 'Saint Augustine's concept of property ownership', *Recherches augustiniennes* 8, pp. 187–229

MacRides, R. & Magdalino, P. 1988. 'The architecture of *ekphrasis*: construction and context in Paul the Silentiary's poem on Hagia Sophia', *BMGS* 12, pp. 47–82

Maguire, E. D., Maguire, H. P. & Duncan-Flowers, M. J. 1989. *Art and Holy Powers in the Early Christian House*, Illinois Byzantine Studies 2 (Urbana)

Maguire, H. P. 1981. *Art and Eloquence in Byzantium* (Princeton)

1987a. 'Adam and the animals: allegory and the literal sense in early Christian art', in Tronzo & Lavin (1987), pp. 363–73

1987b. *Earth and Ocean: The Terrestrial World in Early Byzantine Art* (University Park)

1990. 'Garments pleasing to God: the significance of domestic textile designs in the early Byzantine period', *DOP* 44, pp. 215–24

Mamboury, E. & Wiegand, T. 1934. *Die Kaiserpaläste von Konstantinopel zwischen Hippodrom und Marmara-Meer* (Berlin)

Mango, C. 1958. *The Homilies of Photius*, DOS 3 (Washington)

1959. *The Brazen House: A Study of the Vestibule of the Imperial Palace at Constantinople*, Arkaeologisk-Kunsthistorike Meddelelser udgivet af det Kongelige Danske Videnskabernes Selskab 4.4 (Copenhagen)

1962. *Materials for the Study of the Mosaics of St. Sophia at Istanbul*, DOS 8 (Washington)

1963. 'Antique statuary and the Byzantine beholder', *DOP* 17, pp. 55–75

1980. *Byzantium: The Empire of New Rome* (London)

1981. 'Discontinuity with the classical past in Byzantium', in Birmingham University, Centre for Byzantine Studies, *Byzantium and the Classical Tradition* (Birmingham), pp. 48–57

1986. *The Art of the Byzantine Empire, 312–1453*, MAA, RT 16 (Toronto)

1992. 'Aspects of Syrian piety', in Boyd & Mango (1992), pp. 99–105

Mango, M. M. 1986. *Silver from Early Byzantium: The Kaper Koraon and Related Treasures* (Baltimore)
 1988. 'The origins of the Syrian ecclesiastical silver treasures of the sixth–seventh centuries', in Baratte (1988), pp. 163–84
 1992. 'The monetary value of silver revetments and objects belonging to churches, A.D. 300–700', in Boyd and Mango (1992), pp. 123–36
Mansfield, J. 1988. 'Philosophy in the service of scripture: Philo's exegetical strategies', in J. M. Dillon & A. A. Ling (eds.) *The Question of 'Eclecticism': Studies in Later Greek Philosophy*, Hellenistic Culture and Society 3 (Berkeley), pp. 70–102
Marasovic, J. & Marasovic, T. 1994. 'Le ricerche nel Palazzo di Diocleziano a Split negli ultimi 30 anni (1964–94)', *Antiquité tardive* 2, pp. 89–106.
Marasovic, J., McNally, S. & Wilkes, J. *Diocletian's Palace: Report on Joint Excavations in South-East Quarter*, 2 vols. (Split)
Markus, R. A. 1978. 'The cult of icons in sixth-century Gaul', *Journal of Theological Studies* (new ser.) 29, pp. 151–7
 1990. *The End of Ancient Christianity* (Cambridge)
Marrou, H.-I. 1958. *Saint Augustin et la fin de la culture antique*, 4th edn (Paris)
 1963. 'Synesius of Cyrene and Alexandrian Neoplatonism', in A. Momigliano (ed.) *The Conflict Between Paganism and Christianity in the Fourth Century* (Oxford, 1963), pp. 126–50
Marshall, F. H. 1911. *Catalogue of the Jewellery, Greek, Etruscan and Roman in the Departments of Antiquities, British Museum* (London)
Mason, J. A. 1968. *The Ancient Civilisations of Peru*, rev. edn (London)
Mathews, T. F. 1971. *The Early Churches in Constantinople: Architecture and Liturgy* (University Park)
 1993. *The Clash of Gods: A Reinterpretation of Early Christian Art* (Princeton)
Matter, E. A. 1990. *The Song of Songs in Western Medieval Christianity* (Philadelphia)
 1992. 'The Apocalypse in early medieval exegesis', in Emmerson & McGinn (1992), pp. 38–50
Matthiae, G. 1962. *Le chiese di Roma del IV al X secolo*, Roma cristiana 3 (Bologna)
Matthews, J. 1975. *Western Aristocracies and Imperial Court, A.D. 364–425* (Oxford)
Mauss, M. 1990. *The Gift: The Form and Reason for Exchange in Archaic Societies*, W. D. Halls (trans.) (London)
Maxfield, V. A. 1981. *The Military Decorations of the Roman Army* (London)
Mazzotti, M. 1960. 'La croce argentea del vescovo Agnello del Museo Arcivescovile di Ravenna', *CCARB* 2, pp. 261–70
Megaw, R. & Megaw, V. 1994. 'Through a window on the European Iron Age darkly: fifty years of reading early Celtic art', *World Archaeology* 25, pp. 287–303
Meier, C. 1977. *'Gemma spiritalis': Methode und Gebrauch der Edelstein-Allegorese vom frühen Christentum bis ins 18. Jahrhundert*, Münstersche Mittelalter-Schriften 34i (Munich)
Menis, G. C. (ed.) 1990. *I Longobardi* (Milan)
Meslin, M. 1972. 'Vases sacrés et boissons d'éternité dans les visions des martyrs africains', in J. Fontaine & C. Kannengiesser (eds.) *'Epektasis': mélanges patristiques offerts au Cardinal Jean Daniélou* (Paris), pp. 139–53
Metcalf, P. 1981. 'Meaning and materialism: the ritual economy of death', *Man* (new ser.) 16, pp. 563–78
Meyvaert, P. 1964. *Bede and Gregory the Great*, Jarrow Lecture (Jarrow)
Michaelides, D. 1988. 'Mosaic pavements of early Christian cult buildings in Cyprus', in

R. F. Campaneti (ed.) *Mosaic Floors in Cyprus*, Bibliotheca di Felix Ravenna 3 (Ravenna), pp. 79–153

Miles, M. M. 1985. *Image as Insight: Visual Understanding in Western Christianity and Secular Culture* (Boston)

Millar, F. 1977. *The Emperor in the Roman World, 31 B.C.–A.D. 337* (London)

Millard, R. 1992. 'Offices with a powerful appeal', *The Times*, 28 October, p. 15

Miller, D. 1982. 'Artefacts as the products of human categorisation processes', in Hodder (1982a), pp. 17–25

Miller, D. & Tilley, C. (eds.) 1984. *Ideology, Power and Prehistory* (Cambridge)

Miller, P. C. 1994. *Dreams in Late Antiquity: Studies in the Interpretation of a Culture* (Princeton)

Mohrmann, C. 1958–65a. *Études sur le latin des chrétiens*, 3 vols., Storia e letteratura 65, 87 & 103 (Rome)

 1958–65b. 'Linguistic problems in the early Christian church', in Mohrmann (1958–65a), III, pp. 171–96 (reprinted from *VC* 11 (1957))

 1958–65c. 'Saint Augustine and the "*eloquentia*"', in Morhmann (1958–65a), I, pp. 351–70 (reprinted from *Christendom en Oudheid* (Eindhoven, 1947))

Momigliano, A. 1980. 'After Gibbon's *Decline and Fall*', in Weitzmann (1980), pp. 7–16

Morphy, B. 1989. 'On representing ancestral beings', in B. Morphy (ed.) *Animals into Art*, One World Archaeology 7 (London), pp. 144–59

Morris, B. 1979. 'Symbolism as ideology: thoughts around Navaho taxonomy and symbolism', in Ellen & Reason (1979), pp. 117–38

 1987. *Anthropological Studies of Religion: An Introductory Text* (Cambridge)

Morris, I. 1986. 'Gift and commodity in archaic Greece', *Man* 21, pp. 1–17

 1989. 'Circulation, deposition and the formation of the Greek Iron Age', *Man* 24, pp. 502–19

 1992. *Death-Ritual and Social Structure in Classical Antiquity* (Cambridge)

Morris, L. 1987. *Revelation*, Tyndale New Testament Commentaries, 2nd edn (Leicester)

Moss, A. 1993. 'Commonplace-rhetoric and thought-patterns in early modern culture', in R. H. Roberts & J. M. M. Good (eds.) *The Recovery of Rhetoric: Persuasive Discourse and Disciplinarity in the Human Sciences* (Charlottesville), pp. 49–60

Mukherjee, M. 1978. *Metalcraftsmen of India* (Calcutta)

Munn, N. D. 1973. 'Symbolism in ritual context: aspects of symbolic action', in J. Honigman (ed.) *Handbook of Social and Cultural Anthropology* (Chapel Hill), pp. 613–35

Munro, J. H. 1983. 'The medieval scarlet and the economics of sartorial splendour', in H. B. Harte & K. Ponting (eds.) *Cloth and Clothing in Medieval Europe: Essays in Memory of Prof. E. Carus Wilson*, Pasoald Studies in Textile History 2 (London), pp. 13–70

Muro, P. C. & Shimada, I. 1985. 'Behind the golden mask: the Sicán gold artifacts from Batán Grande, Peru', in Julie Jones (1985), pp. 60–75

Murray, C. 1977. 'Art and the early Church', *Journal of Theological Studies* 28, pp. 303–45

 1981. *Rebirth and Afterlife: A Study of the Transmutation of some Pagan Imagery in Early Christian Funerary Art*, BAR, IS 100 (Oxford)

Murray, O. 1986. 'Life and society in Classical Greece', in Boardman, Griffin & Murray (1986), pp. 204–33

Murray, R. 1975. *Symbols of Church and Kingdom: A Study in Early Syriac Tradition* (Cambridge)

Muthesius, A. 1991. 'Crossing traditional boundaries: grub to glamour in Byzantine silk weaving', *BMGS* 15, pp. 326–65

1992. 'Silken diplomacy', in Shepard & Franklin (1992), pp. 237–48
Nelson, J. L. 1977. 'Inauguration rituals', in P. H. Sawyer & I. N. Wood (eds.) *Early Medieval Kingship* (Leeds), pp. 50–71
1987. 'Making ends meet: wealth and poverty in the Carolingian Church', in Sheils & Wood (1987), pp. 25–35
Neusner, J. (ed.) 1975. *Christianity, Judaism and other Graeco-Roman Cults: Studies for Morton Smith at Sixty*, 4 vols., Judaism in Late Antiquity 12i–iv (London)
1991. *Symbol and Theology in Early Judaism* (Minneapolis)
Nichols, A. 1980. *The Art of God Incarnate: Theology and Image in the Christian Tradition* (London)
Nichols, S. G. 1992. 'Prophetic discourse: Saint Augustine to Christina de Pizan', in B. S. Levy (ed.) *The Bible in the Middle Ages: Its Influence on Literature and Art*, Medieval and Renaissance Texts and Studies 89 (New York), pp. 51–76
Nicholson, O. 1994. 'The "pagan churches" of Maximinus Daia and Julian the Apostate', *Journal of Ecclesiastical History* 45, pp. 1–10
Nordhagen, P. J. 1963. 'The mosaics of the great palace of the Byzantine emperors', *BZ* 56, pp. 53–68
1966. 'The development of mosaic technique', in L'Orange & Nordhagen (1966), pp. 31–68
1983. 'The penetration of Byzantine mosaic technique into Italy in the 6th century A.D.', in Campanati (1983), I, pp. 73–84
1987. 'Icons designed for the display of sumptuous votive gifts', in Tronzo & Lavin (1987), pp. 453–60
Nordström, C. O. 1953. *Ravennastudien*, Figura 4 (Uppsala)
Oakeshott, W. 1959. *Classical Inspiration in Medieval Art* (London)
1967. *The Mosaics of Rome from the 3rd to the 14th Centuries* (London)
Oberhelman, S. M. 1991. *Rhetoric and Homiletics in Fourth-Century Christian Literature: Prose Rhythm, Oratorical Style and Preaching in the Works of Ambrose, Jerome and Augustine*, American Philological Association, American Classical Ser. 26 (Atlanta)
Ohly, F. 1958. *Hohelied-Studien: Grundzuge einer Geschichte der Hoheliedauslegung des Abendlandes bis um 1200* (Wiesbaden)
Omont, H. 1929. *Miniatures de plus anciens manuscrits Grecs de la Bibliothèque Nationale du VIe au XIVe siècle* (Paris)
Onians, J. 1979. *Art and Thought in the Hellenistic Age: The Greek World View, 350–50 B.C.* (London)
1980. 'Abstraction and imagination in late Antiquity', *AH* 3, pp. 1–24
Onions, R. B. 1954. *The Origins of European Thought: About the Body, the Mind, the Soul, Time and Fate: New Interpretations of Greek, Roman and Kindred Evidence, also of some Jewish and Christian Beliefs*, 2nd edn (Cambridge)
Oppenheimer, A. L. 1949. 'The golden vestments of the gods', *Journal of Near-Eastern Studies* 8, pp. 172–93
Orchard, A. 1994. *The Poetic Art of Aldhelm*, Cambridge Studies in Anglo-Saxon England 8 (Cambridge)
Ostrogorsky, G. 1968. *History of the Byzantine State*, J. Hussey (trans.), 2nd edn (Oxford)
Otten, C. M. 1971. *Anthropology and Art: Readings in Cross-Cultural Aesthetics* (New York)
Pader, E.-J. 1982. *Symbolism, Social Relations and the Interpretation of Funerary Remains*, BAR, IS 130 (Oxford)
Page, R. I. 1970. *Life in Anglo-Saxon England* (London)

Painter, K. S. 1988. 'Roman silver hoardes: ownership and status', in Baratte (1988), pp. 97–112
Palmer, A.-M. 1989. *Prudentius on the Martyrs* (Oxford)
Paredi, A. 1960. *S. Ambrogio e la sua età*, 2nd edn (Milan)
Pariset, P. 1970. 'I mosaici del battistero di S. Giovanni in Fonte nello sviluppo della pittura paleocristiana a Napoli', *CA, FAMA* 20, pp. 1–13
Parlasca, K. 1959. *Die römischen Mosaiken in Deutschland* (Berlin)
　1977. *Ritratti di mummie*, Repertorio d'arte dell'egitto Greco-Romano, ser. B, 2 (Rome)
Parry, D. W., Ricks, S. D. & Welch, J. W. 1991. *A Bibliography on Temples of the Ancient Near East and Mediterranean World Arranged by Subject and by Author* (Lewiston)
Parry, J. 1986. ' "The Gift", the Indian gift and the "Indian gift" ', *Man* 21, pp. 453–73
Parshall, L. B. & Parshall, P.-W. 1986. *Art at the Reformation: An Annotated Bibliography* (Boston)
Pasi, S. 1989. 'L'iconografie regale in età teodoriciana', *CCARB* 36, pp. 253–68
Pater, W. 1986. *The Renaissance: Studies in Art and Poetry*, A. Philips (ed.) (Oxford)
Patterson, J. R. 1992. 'The city of Rome: from Republic to Empire', *JRS* 82, pp. 186–215
Percival, J. 1976. *The Roman Villa: An Historical Introduction* (London)
　1992. 'The fifth-century villa: new life or death postponed?', in Drinkwater & Elton (1992), pp. 156–64
Périn, P. 1992. 'The undiscovered grave of King Clovis', in Carver (1992a), pp. 255–64
Perrin, N. 1976. *Jesus and the Language of the Kingdom: Symbol and Metaphor in New Testament Interpretation* (Philadelphia)
Peterson, J. M. 1985–90. 'The influence of Origen upon Gregory the Great's exegesis of the Song of Songs', in Livingstone (1985–90), 1, pp. 343–7
Pietri, C. 1978. 'Evergetisme et richesses ecclésiastiques dans l'Italie du IVe à la fin du Ve s.: l'exemple romain', *Ktema* 3 (1978), pp. 317–37
　1981. 'Donations et pieux établissements d'après le légendier romain (Ve–VIIe s.)', in *Hagiographie, cultures et sociétés, IVe–XIIe siècles: actes du colloque organisé à Nanterre et à Paris (2–5 Mai 1979)* (Paris)
Piganiol, A. 1945. 'Le problème de l'or au IVe siècle', *AHS* 7, pp. 47–53
Pinasa, D. 1992. *Costumes: modes et manières d'être* (Paris)
Pole, L. M. 1988. 'The Pacific', in Mack (1988b), pp. 115–34
Pollitt, J. J. 1983. *The Art of Rome, c. 753 B.C.–A.D. 337: Sources and Documents*, reissued edn (Cambridge)
　1986. *Art in the Hellenistic Age* (Cambridge)
Poque, S. 1984. *Le langue symbolique dans le prédication d'Augustin d'Hippone: images héroïques*, 2 vols. (Paris)
Pöschl, V. 1964. *Bibliographie zur antiken Bildersprache*, Heidelberger Akademie der Wissenschaften, Bibliothek der klassischen Altertumswissenschaften, neue Folge 1 (Heidelberg)
Powis, J. 1984. *Aristocracy* (Oxford)
Price, S. R. F. 1984. *Rituals and Power: The Roman Imperial Cult in Asia Minor* (Cambridge)
　1987. 'From noble funerals to divine cult: the consecration of Roman Emperors', in Cannadine & Price (1987), pp. 56–105
Radice, R. & Runia, D. T. 1988. *Philo of Alexandria: An Annotated Bibliography*, VCS 8 (Leiden)
Rahner, H. 1963. *Greek Myths and Christian Mystery* (London)
Rahtz, P. & Watts, L. 1986. 'The archaeologist on the road to Lourdes and Santiago de Compostela', in Butler & Morris (1986), pp. 51–73

Randsborg, K. (ed.) 1989. *The Birth of Europe: Archaeology and Social Development in the First Millennium A.D.*, Analecta Romana Instituti Danici, Suppl. 16 (Rome)
 1991. *The First Millennium A.D. in Europe and the Mediterranean: An Archaeological Essay* (Cambridge)
Raw, B. 1992. 'Royal power and royal symbols in Beowulf', in Carver (1992a), pp. 167–74
Reece, R. 1983. 'Late Antiquity', in Henig (1983a), pp. 234–48.
Reekmans, L. 1989. 'L'implantation monumentale chrétienne dans le paysage urbain de Rome de 300 à 850', in *Actes du XIe congrès international d'archéologie chrétienne* II (of 3 vols.), CEFR 123 (Rome), pp. 861–915
Reichmann, P. F. & Coste, E. L. 1980. 'Mental imagery and the comprehension of figurative language: is there a relationship?', in Honeck & Hoffman (1980), pp. 183–200
Reidlinger, H. 1958. *Die Makellosigkeit der Kirche in den Lateinischen Hoheliedkommentaren des Mittelalters*, Beitrage zur Geschichte der Philosophie und Theologie des Mittelalters 38iii (Munster)
Reinhold, M. 1970. *History of Purple as a Status Symbol in Antiquity*, Collection Latomus 116 (Brussels)
Renaud, R. 1993. 'Des oiseux dans les architectures', in E. M. Moorman (ed.) *Functional and Spatial Analysis of Wall Painting: Proceedings of the 5th International Congress on Ancient Wall Painting, Amsterdam 1992*, Bulletin Antieke Beschaving, Annual Papers on Classical Archaeology, Suppl. 3 (Leiden), pp. 168–73
Renfrew, C. 1994. 'The archaeology of religion', in Renfrew & Zubrow (1994), pp. 47–54
Renfrew, C. & Bahn, P. 1991. *Archaeology: Theories, Methods and Perspectives* (London)
Renfrew, C. & Cherry, J. F. (eds.) 1986. *Peer Polity Interaction* (Cambridge)
Renfrew, C. & Zubrow, E. B. W. (eds.) 1994. *The Ancient Mind: Elements of Cognitive Archaeology* (Cambridge)
Reuter, T. 1985. 'Plunder and tribute in the Carolingian Empire', *TRHS* (5th ser.) 35, pp. 75–94
Reutersward, P. 1960. *Studien zur Polychromie der Plastik Griechenland und Rome: Untersuchungen über die Farbwirkung der Marmor- und Bronzeskulpturen* (Stockholm)
Rheinisches Landesmuseum, Trier. 1984. *Trier: Kaiserresidenz und Bischofssitz: die Stadt in spätantike und frühchristliche Zeit* (Mainz)
Rice, D. T. 1972. *The Appreciation of Byzantine Art*, The Appreciation of the Arts 7 (London)
Richards, J. 1980. *Consul of God: The Life and Times of Gregory the Great* (London)
Richards, J. D. 1992. 'Anglo-Saxon symbolism', in Carver (1992a), pp. 131–48
Richards, J. F. 1983. 'Introduction', in Richards (ed.) *Precious Metals in the Later Medieval and Early Modern Worlds* (Durham, N.C.), pp. 3–26
Richter, M. 1979. '*Latina lingua – sacra seu vulgaris?*', in W. Lourdaux & D. Verhelst (eds.) *The Bible and Medieval Culture*, ML, Ser. I, Studia 7 (Leuven), pp. 16–34
Rizzardi, C. 1993. 'Mosaici parietali esistenti e scomparsi di età Placidiana a Ravenna: iconografie imperiali e apocalittiche', *CCARB* 40, pp. 385–408
Robert, A. 1945. 'La description de l'Épouse et l'épouse dans *Cant.* V, 1–5 et VII, 2–6', in *Mélanges E. Podechard: études de sciences religieuses offertes pour son éméritat au doyen honoraire de la faculté de théologie de Lyon* (Lyon), pp. 211–23
Roberts, J. 1992. 'Anglo-Saxon vocabulary as a reflection of material culture', in Carver (1992a), pp. 185–204
Roberts, M. 1985. *Biblical Epic and Rhetorical Paraphrase in Late Antiquity*, Arca: Classical and

Medieval Texts, Papers and Monographs 16 (Liverpool)
 1989. *The Jewelled Style: Poetry and Poetics in Late Antiquity* (Ithaca)
Robertson, A. S. 1962–82. *Roman Imperial Coins in the Hunter Coin Cabinet*, 5 vols. (London)
Rodley, L. 1994. *Byzantine Art and Architecture: An Introduction* (Cambridge)
Rogers, G. 1991. *The Sacred Identity of Ephesos: Foundation Myths of a Roman City* (London)
Rollinson, P. 1981. *Classical Theories of Allegory and Christian Culture*, Duquesne Studies, Language and Literature Ser. 3 (Pittsburgh, 1981)
Römisch-Germanische Museum, Köln. 1993. *Goldschmuck der römischen Frau: eine Ausstellung vom 16. Juni – 3. Oktober 1993* (Cologne)
Roncuzzi, I. F. 1993. 'L'effeto oro sulle parieti musive', *CCARB* 40, pp. 125–31
Rorem, P. 1984. *Biblical and Liturgical Symbols within the Pseudo-Dionysian Synthesis*, Institute of Pontifical Studies, Studies and Texts 71 (Toronto)
 1993. *Pseudo-Dionysius: A Commentary on the Texts and an Introduction to their Influence* (New York)
Ross, M. C. 1979. 'Objects from daily life', in Weitzmann (1979a), pp. 297–301
Rouche, M. 1979. *L'Aquitaine des Wisigoths aux Arabes 418–781: naissance d'une région* (Paris)
Rowe, C. 1972. 'Conceptions of colour and colour symbolism in the Ancient World', *EY* 41, pp. 327–64
Rowland, C. 1982. *The Open Heaven: A Study of Apocalyptic in Judaism and Early Christianity* (London)
Rowlands, M. J. 1972. 'The archaeological interpretation of prehistoric metalworking', *World Archaeology* 5, pp. 210–23
Runciman, S. 1980. 'The country and suburban palaces of the Byzantine emperors', in A. E. Laiou-Thomadakis (ed.) *Charanis Studies: Essays in Honour of Peter Charanis* (New Brunswick), pp. 219–28
Runia, D. T. 1987. 'Further observations of the structure of Philo's allegorical treatises', *VC* 41, pp. 105–38
Rush, A. C. 1970. 'The colours of red and black in the liturgy of the dead', in Granfield & Jungmann (1970), II, pp. 698–708
Sackett, J. R. 1990. 'Style and ethnicity in archaeology: the case for isochretism', in Conkey & Hastorf (1990), pp. 32–43
Sahlins, M. 1974. *Stone Age Economics* (London)
 1976. 'Colors and cultures', *Semiotica* 16, pp. 1–21
Samson, R. 1991. 'Economic anthropology and Vikings', in Samson (ed.), *Social Approaches to Viking Studies* (Glasgow), pp. 87–96
Sapir, J. D. 1977. 'The anatomy of metaphor', in J. D. Sapir & J. C. Crocker (eds.) *The Social Use of Metaphor: Essays in the Anthropology of Rhetoric* (Philadelphia), pp. 3–32
Saradi-Mendelorovici, H. 1990. 'Christian attitudes toward pagan monuments in late Antiquity and their legacy in the later Byzantine centuries', *DOP* 44, pp. 47–61
Savon, H. 1977. *Saint Ambroise devant l'exégèse de Philon le Juif*, 2 vols. (Paris)
 1986. 'L'antéchrist dans l'oeuvre de Grégoire le Grand', in Fontaine, Gillet & Pellistrandi (1986), pp. 389–400
Scarce, J. 1988. 'The Middle East', in Mack (1988b), pp. 47–64
Schlunk, H. 1959. *Untersuchungen im frühchristlichen Mausoleum von Centcelles* (Berlin)
Schlunk, H. & Hauschild, T. 1978. *'Hispania Antiqua': die Denkmäler der frühchristlichen und*

westgotischen Zeit (Mainz)

Schnapp, A. 1994. 'Are images animated: the psychology of statues in Ancient Greece', in Renfrew & Zubrow (1994), pp. 40–44

Scranton, R. L. 1946. 'Interior design of Greek temples', *American Journal of Archaeology* 50, pp. 39–51

Scully, V. 1979. *The Earth, the Temple and the Gods: Greek Sacred Architecture*, rev. edn (New Haven)

Seaford, R. 1978. *Pompeii* (London)

Sear, F. B. 1977. *Roman Wall and Vault Mosaics* (Heidelberg)

Seiber, J. 1974. 'The urban saint in early Byzantine social history', University of Oxford, BLitt dissertation

Seymour-Smith, C. 1986. *Macmillan Dictionary of Anthropology* (London)

Shanks, M. & Tilley, C. 1982. 'Ideology, symbolic power and ritual communication: a reinterpretation of Neolithic mortuary practices', in Hodder (1982a), pp. 129–54

Sheils, W. J. & Wood, D. (eds.) 1987. *The Church and Wealth*, SCH 24 (Oxford), pp. 15–24

Shelton, A. 1988. 'Latin-American Indian jewellery', in Mack (1988b), pp. 149–53

Shelton, K. J. 1981. *The Esquiline Treasure* (London)

Shennan, S. 1982. 'Ideology, change and the European early Bronze Age', in Hodder (1982a), pp. 155–61

Shepard, J. & Franklin, 1992. S. *Byzantine Diplomacy: Papers from the 24th Spring Symposium of Byzantine Studies, Cambridge, March 1990* (Aldershot)

Shephard, J. 1979. 'The social identity of the individual in isolated barrows and barrow cemeteries in Anglo-Saxon England', in B. C. Burnham & J. Kingsbury (eds.) *Space, Hierarchy and Society: Interdisciplinary Studies in Social Area Analysis*, BAR IS 59 (Oxford), pp. 47–79.

Shepherd, M. H. 1967. 'Liturgical expressions of Constantinian triumph', *DOP* 21, pp. 59–78

Shimada, I. & Griffin, J. A. 1994. 'Precious metal objects of the Middle Sicán', *Scientific American* 270, pp. 60–7

Shimada, I. & Merkel, J. 1993. 'A Sicán tomb in Peru', *Minerva* 4, pp. 18–25

Sieben, H. J. 1983. *'Exegesis Patrum': saggio bibliografico sull'esegesi biblica dei Padri della Chiesa*, IPA, SP 2 (Rome)

Simonetti, M. 1980. *Profilo storico dell'esegesi patristica*, IPA, SP 1 (Rome)

Simpson, J. A. & Weiner, E. S. C. (eds.) 1989. *The Oxford English Dictionary*, 20 vols., 2nd edn (Oxford)

Sinding-Larsen, S. 1984. *Iconography and Ritual: A Study of Analytical Perspectives* (Oslo)

Small, A. (ed.) 1996. *Subject and Ruler: the Cult of the Ruling Power in Classical Antiquity*, Journal of Roman Archaeology, Supplementary Series 17 (Ann Arbor)

Smalley, B. 1983. *The Study of the Bible in the Middle Ages*, 3rd edn (Oxford)

Smith, D. J. 1983. 'Mosaics', in Henig (1983), pp. 116–38

Smith, J. 1975. 'The garments that honour the cross in "The Dream of the Rood"', *ASE* 4, pp. 29–35

Smith, J. Z. 1987. 'Golden age', in Eliade et al. (1987), VI, pp. 69–73

Smith, M. T. 1970. 'The Lateran *fastigium*: a gift of Constantine the Great', *RAC* 46, pp. 149–75

Smith, R. R. R. 1988. *Hellenistic Ruler Portraits* (Oxford)

Soskice, J. M. 1985. *Metaphor and Religious Language* (Oxford)

Southern, R. W. 1985. 'Beryl Smalley and the place of the Bible in medieval studies, 1927–84', in K. Walsh & D. Wood (eds.) *The Bible and the Medieval World: Essays in Honour of Beryl Smalley*,

SCH, *subsidia* 4 (Oxford)
Spanier, E. (ed.) 1987. *The Royal Purple and the Biblical Blue: 'Argamen' and 'Tekhelet'* (Jerusalem)
Speake, G. 1980. *Anglo-Saxon Animal Art and its Germanic Background* (Oxford)
Sperber, D. 1978. *Le symbolisme en général* (Paris)
Spiro, M. 1978. *Critical Corpus of the Mosaic Pavements on the Greek Mainland, 4th to 6th centuries – with architectural surveys*, 2 vols. (New York)
Spufford, P. 1988. *Money and its Use in Medieval Europe* (Cambridge)
Stache, U. J. 1976. *Flavius Cresconius Corippus, 'In laudem Iustini minoris': ein Kommentar* (Berlin)
Stähl, H.-P. 1988. *Antike Synagogenkunst* (Stuttgart)
Stancliffe, C. 1982. 'Red, white and blue martyrdom', in D. Whitelock, R. D. McKitterick & D. Dumville (eds.) *Ireland in Early Medieval Europe* (Cambridge), pp. 21–46
Stapleford, R. 1978. 'Constantinian politics and the atrium church', in H. A. Millon & L. Nochlin (eds.) *Art and Architecture in the Service of Politics* (Cambridge, Mass.)
Steigerwald, G. 1990. 'Das kaiserliche Purpurprivileg in spätrömischer und frühbyzantinischer Zeit', *JAC* 33, pp. 209–39
Steiner, P. 1906. 'Die dona militaria', *Bonner Jahrbücher* 114–15, pp. 1–98
Steinhauser, K. B. 1987. *The Apocalypse Commentary of Tyconius: A History of its Reception and Influence* (Frankfurt)
Stern, H. 1978a. 'Remarques sur les sujets figurés des mosaïques du palais dit Théodoric à Ravenne', *FR* 116, pp. 45–55
 1978b. 'Sur un motif ornemental des mosaïques du palais dit Théodoric à Ravenne', *FR* 116, pp. 57–85
Steuer, H. 1989. 'Archaeology and history: proposals on the structure of the Merovingian kingdom', in Randsborg (1989), pp. 106–22
Stewart, A. 1993. *Faces of Power: Alexander's Image and Hellenistic Politics*, Hellenistic Culture and Society 11 (Berkeley)
Straub, J. A. 1967. 'Constantine as *Koinoe Epiekopoe*: tradition and innovation in the representation of the first Christian Emperor's majesty', *DOP* 21, pp. 37–55
Straw, C. 1988. *Gregory the Great: Perfection in Imperfection*, TCH 14 (Berkeley)
Stricevic, G. 1962. 'Sur le problème de l'iconographie des mosaïques de Saint-Vital', *FR* 85, pp. 80–100
Strong, D. E. 1966. *Greek and Roman Silver Plate* (London)
Strzygowski, J. 1930. *Asiens bildende Kunst: in Stichproben ihr Wesen und ihre Entwicklung* (Augsburg)
Swift, E. H. 1934. 'Byzantine gold mosaic', *American Journal of Archaeology* 38, pp. 81–2
 1951. *Roman Sources of Christian Art* (New York)
Swoboda, K. M. 1969. *Römische und romanische Paläste: eine architekturgeschichtliche Untersuchung*, reprint edn (Vienna)
Tainter, J. 1988. *The Collapse of Complex Societies* (Cambridge)
Tait, H. (ed.) 1976. *Jewellery Through 7000 Years* (London)
Tatarkiewicz, W. 1970. *History of Aesthetics* II (of 3 vols.), *Medieval Aesthetics*, J. Harrell & C. Barrett (eds.), A. Czerniawski (trans.) (The Hague)
Tavano, S. 1975. 'Mosaici parietali in Istria', in Centro di Antichità Altoadriatiche, *Mosaici in Aquileia e nell'alto Adriatico*, Antichita Altoadriatiche 8 (Udine), pp. 245–73
Terry, A. 1986. 'The *opus sectile* in the Eufrasius Cathedral at Poreč', *DOP* 40, pp. 147–64
Thébert, Y. 1985. 'Vie privée et architecture domestique en Afrique romaine' in P. Veyne (ed.)

Histoire de la vie privée [5 vols., P. Ariés & G. Duby (eds.)] 1, *De l'Empire romain à l'an mil* (Paris), pp. 301–97

Thielman, F. S. 1987. 'Another look at the eschatology of Eusebius of Caesarea', *VC* 41, pp. 226–37

Thomas, E. 1934. 'Guilds and craftsmen and small traders in the ancient world (exclusive of Egypt) from the earliest Greek times to the end of the fifth century A.D.', University of Oxford, BLitt dissertation

Thompson, L. L. 1990. *The Book of Revelation: Apocalypse and Empire* (New York)

Tilley, C. 1984. 'Ideology and power in the middle Neolithic of southern Sudan', in Miller & Tilley (1984), pp. 111–46

1991. *Material Culture and Text: The Art of Ambiguity* (London)

Todd, M. 1992. *The Early Germans* (Oxford)

Tomlinson, R. 1992. *From Mycenae to Constantinople: The Evolution of an Ancient City* (London)

Toynbee, A. 1973. *Constantine Porphyrogenitus and his World* (London)

Toynbee, J. M. C. & Painter, K. S. 1986. 'Silver plates of late antiquity: A.D. 300 to 700', *Archaeologia* 108, pp. 15–65

Toynbee, J. M. C. & Ward-Perkins, J. B. 1956. *The Shrine of St. Peter and the Vatican Excavations* (London)

Trigg, J. W. 1985. *Origen: The Bible and Philosophy in the Third-Century Church* (London)

Trilling, J. 1989. 'The soul of the empire: style and meaning in the mosaic pavement of the Byzantine imperial palace in Constantinople', *DOP* 43, pp. 27–72

Trombley, F. R. 1993. *Hellenistic Religion and Christianisation, c. 370–529*, 2 vols., Religions in the Graeco-Roman World 115 i & ii (Leiden)

Tronzo, W. (ed.) 1989. *Italian Church Decoration of the Middle Ages and Early Renaissance: Functions, Forms and Regional Traditions*, Villa Spelman Colloquia 1 (Bologna)

Tronzo, W. & Lavin, I. (eds.) 1987. *Studies on Art and Archaeology in Honor of Ernst Kitzinger on his 75th Birthday*, *DOP* 41

Tsuji, S. 1970. 'Nouvelles observations sur les miniatures fragmentaires de la Genèse de Cotton: cycles de Lot, d'Abraham et de Jacob', *CA, FAMA* 20, pp. 29–46

Underwood, P. A. 1960. 'Notes on the work of the Byzantine Institute in Istanbul: 1957–1959', *DOP* 14, pp. 205–22

Untracht, O. 1988a. 'India', in Mack (1988b), pp. 65–94

1988b. 'Materials and techniques', in Mack (1988b), pp. 173–99

Van Dam, R. 1985. *Leadership and Community in Late Antique Gaul*, TCH 8 (Berkeley)

Van Den Broek, R. 1972. *The Myth of the Phoenix According to Classical and Early Christian Traditions*, EPROER 24 (Leiden)

Van Der Meer, F. 1967. *Early Christian Art*, P. & F. Brown (trans.) (London)

1978. *Apocalypse: Visions from the Book of Revelation in Western Art* (London)

Van Oort, J. 1991. *Jerusalem and Babylon: A Study in Augustine's 'City of God' and the Sources of his Doctrine of the Two Cities*, VCS 14 (Leiden)

Van Sickle, C. E. 1954. 'The *salarium* of Claudius Gothicus (*Claudius* XIV, 2–15) viewed as a historical document', *L'antiquité classique* 23, pp. 47–62

Veblen, T. 1899. *Theory of the Leisure Class: An Economic Study in the Evolution of Institutions* (New York)

Verbeke, W., Verhelst, D. & Welkenhuysen, A. (eds.) 1988. *The Use and Abuse of Eschatology in the Middle Ages*, ML, Ser. 1, *Studia* 15 (Leuven)

Vermaseren, M. J. 1963. *Mithras: The Secret God*, T. & M. Megaw (trans.) (London)
 1971. *Mithraica 1, the Mithraeum at S. Maria Capua Vetere*, EPROER 16 (Leiden)
Vermaseren, M. J. & Van Essen, C. C. 1965. *The Excavations in the Mithraeum of the Church of Santa Prisca in Rome* (Leiden)
Vermeule, E. 1979. *Aspects of Death in Early Greek Art and Poetry*, Sather Classical Lectures 46 (Berkeley)
Vestergaard, E. 1987. 'The perpetual reconstruction of the past', in Hodder (1987), pp. 63–7
Veyne, P. 1976. *Le pain et le cirque* (Paris)
Vickers, M. 1973. 'Observations on the Octagon at Thessaloniki', *JRS* 63, pp. 111–20
 1985. 'Artful crafts: the influence of metalwork on Athenian painted pottery', *Journal of Hellenic Studies* 105, pp. 108–28
Vidler, A. 1992. *The Architectural Uncanny: Essays in the Modern Unhomely* (Cambridge, Mass.)
Vierk, H. E. F. 1974. 'Werke des Eligius', in *Studien zur vor- und frühgeschichtlichen Archäologie: Festschrift für J. Werner zum 65. Geburtstag* II (of 2 vols.), Münchener Beitrager zur Vor- und Frühgeschichte, Ergänzungsband 1 (Munich), pp. 309–80
 1978. 'La "chemise de Sainte-Bathilde" a Chelles et l'influence Byzantine sur l'art de cour Mérovingien au VIIe siècle', in *Centenaire de l'Abbé Cochet: actes du Colloque internationale d'archéologie* (Rouen), pp. 521–70
 1981. '*Imitatio imperii* und *interpretatio Germanica* vor der Wikingerzeit', R. Zeitler (ed.) *Les pays du nord et Byzance* (Uppsala)
Vilar, P. 1976. *A History of Gold and Money, 1450–1920*, J. White (trans.) (London)
Volbach, W. F. c. 1943. *Early Christian Mosaics from the Fourth to the Seventh Centuries: Rome, Naples, Milan, Ravenna* (London)
 1961. *Early Christian Art* (London)
Von Simson, O. G. 1987. *Sacred Fortress: Byzantine Art and Statecraft in Ravenna*, rev. edn (Princeton)
Wailes, S. L. 1987. *Medieval Allegories of Jesus' Parables*, Publications of the UCLA Centre for Medieval and Renaissance Studies 23 (Berkeley)
Wallace-Hadrill, A. 1982. 'The Golden Age and sin in Augustan ideology', *PP* 95, pp. 19–36
 1994. *Houses and Society in Pompeii and Herculaneum* (Princeton)
Walter, C. 1982. *Art and Ritual in the Byzantine Church*, Birmingham Byzantine Ser. 1 (London)
Ward-Perkins, B. 1984. *From Classical Antiquity to the Middle Ages: Urban Public Building in Northern and Central Italy, A.D. 300–850* (Oxford)
Ward-Perkins, J. B. 1954. 'Constantine and the origins of the Christian basilica', *Papers of the British School at Rome* 22, pp. 69–90
 1981. *Roman Imperial Architecture*, 2nd edn (Harmondsworth)
Washburn, D. (ed.) 1983a. *Structure and Cognition in Art* (Cambridge)
 1983b. 'Toward a theory of structural style in art', in Washburn (1983a), pp. 1–7
Webster, L. 1992. 'Death's diplomacy: Sutton Hoo in the light of other male princely burials', in Farrell & De Vegvas (1992), pp. 75–81
Webster, L. & Backhouse, J. (eds.) 1991. *The Making of England: Anglo-Saxon Art and Culture A.D. 600–900* (London)
Weidemann, M. 1982. *Kulturgeschichte der Merowingerzeit nach den Werken Gregor von Tours*, 2 vols. (Mainz)
Weitzmann, K. 1977. *Late Antique and Early Christian Book Illumination* (New York)

(ed.) 1979a. *Age of Spirituality: Late Antique and Early Christian Art, Third to Seventh Century* (New York)

1979b. 'Representations of daily life', in Weitzmann (1979a), pp. 270–2

(ed.) 1980. *Age of Spirituality: A Symposium* (New York)

Weitzmann, K. & Kessler, H. L. 1990. *The Frescoes of the Dura Synagogue and Christian Art*, DOS 28 (Washington)

Welbourn, S. 1985. 'Production and exchange in early Iron Age central Europe', in Champion & Megaw (1985), pp. 133–60

Werner, J. 1961. 'Fernhandel und Naturalwirtschaft im östlichen Merowingerreich nach archäologischen und numismatischen Zeugnissen', *Bericht der Römisch-Germanisch Kommission* 42, pp. 307–46

1964. 'Frankish royal tombs in the Cathedrals of Cologne and Saint-Denis', *Antiquity* 38, pp. 210–16

Wes, M. A. 1992. 'Crisis and conversion in fifth-century Gaul: aristocrats and ascetics between "horizontality" and "verticality"', in Drinkwater & Elton (1992), pp. 252–63

Wessel, K. 1971. *Reallexikon zur Byzantinischen Kunst* 2 [ser. in progress] (Stuttgart)

Wharton, A. J. 1992. 'The Baptistery of the Holy Sepulchre in Jerusalem and the politics of sacred landscape', *DOP* 46, pp. 313–25

1995. *Refiguring the Post-Classical City: Dura Europos, Jerash, Jerusalem and Ravenna* (Cambridge)

White, L. M. 1990. *Building God's Home in the Roman World: Architectural Adaptation among Pagans, Jews and Christians* (Baltimore)

Whittaker, C. R. 1994. *Frontiers of the Roman Empire: A Social and Economic Study* (Baltimore)

Wickham, C. 1989. 'Italy and the early middle ages', in Randsborg (1989), pp. 140–51

Wiessner, P. 1990. 'Is there a unity to style?', in Conkey & Hastorf (1990), pp. 105–12

Wightman, E. M. 1970. *Roman Trier and the Treveri* (London)

Wilder, A. N. 1964. *Early Christian Rhetoric: The Language of the Gospel* (London)

Wilks, M. 1987. 'Thesaurus ecclesiae', in Sheils & Wood (1987), pp. xv–xlv

Willmes, A. 1962. 'Bedas Bibelauslegung', *Archiv für Kulturgeschichte* 44, pp. 281–314

Wilpert, J. 1976. *Die römischen Mosaiken der kirklichen Bauten vom IV–XIII Jahrhundert*, W. N. Schumacher (ed.) (Freiburg)

Wilson, D. 1981. *The Anglo-Saxons*, 3rd edn (London)

Wilson, R. J. A. 1983. *Piazza Armerina* (Austin)

Wilson-Kastner, P. 1989. *Imagery for Preaching* (Minneapolis)

Winfield, J. & Winfield, D. 1982. *Proportion and Structure of the Human Figure in Byzantine Wall-Painting and Mosaic*, BAR, IS 154 (Oxford)

Winslow, D. F. 1989. 'Poverty and riches: an embarrassment for the early church', in Livingstone (1989), II, pp. 317–27

Wisskirchen, R. 1991. 'Leo III und die Mosaikprogramme von S. Apollinare in Classe und SS. Nereo ed Achilleo in Rom', *JAC* 34, pp. 139–51

Wistrand, E. 1952. *Konstantins Kirche am heiligen Grab in Jerusalem nach den ältesten literarischen Zeugnissen*, Acta Universitatis Gotoburgensis, Göteborgs Högskolas Årsskrift 58 (1952)

Wood, I. N. 1986. 'The audience of architecture in post-Roman Gaul', in Butler & Morris (1986), pp. 74–9

1994. *The Merovingian Kingdoms, 450–751* (London)

Wood, M. 1988. 'North-American Indian jewellery', in Mack (1988b), pp. 155–72

Woolfskeel, C. W. 1976. 'Some remarks with regard to Augustine's conception of man as the image of God', *VC* 30, pp. 63–71

Wright, D. H. 1986. 'Constantius, Constantine and the mint of Trier', in Bryn Mawr College, *Abstracts of Papers, Twelfth Annual Byzantine Studies Conference* (Bryn Mawr), pp. 8–9

Zahan, D. 1972. 'White, red and black: colour symbolism in Black Africa', *EY* 41, pp. 365–96

Zanker, P. 1987. *Augustus und die Macht der Bilder* (Munich)

Zimdars-Swartz, S. 1986. 'A confluence of imagery: exegesis and Christology according to Gregory the Great', in Fontaine, Gillet & Pellistrandi (1986), pp. 327–35

Index

This index lists the main occurrences of names, places and concepts. It is not intended to list primary-source citations. Buildings are given under their location. Entries on such widely covered topics as gold and wealth only indicate selected passages.

Aachen, palace of Charlemagne, 52
Abraham, 155
Agnellus of Ravenna, 103, 132
 cross of, 125–6, 125
Agnes, St, 168–9
Alexander the Great, 26–7
Ambrose of Milan, St, 59, 69, 70, 86, 160
Antioch, Golden Octagon, 56
Antiochus, 60
Apocalypse, see Revelation of John
Aponius, 69
Apringius of Beja, 69
Ark of the Covenant, 85
Artemis, 44
Asclepius, 45
Augustine of Hippo, St, 10, 70, 89, 145, 155
Augustus, emperor, 21, 24, 25, 41
aurichalcum, 76
Auxerre, 135

baptism, 41 n. 164
Bede, 69, 71, 82–3
Bethlehem, 128
 Church of the Nativity, 55–6
Bible, 64–5
Billfrith, 126
birds, as symbols, 99, 101, 103
bodies, and status, 34
Book of Kells, 126
books, covers of, 126
bracteates, 40
bronze, 18
brooches, see fibulae

Caesarius of Arles, 69
Caligula, emperor, 22, 25, 31, 32
Capernaum, synagogue, 101
Capua
 mithraeum under Santa Maria, 47
 San Prisco, 128, 129
Casaranello, basilica, 123, 128
Cassiodorus, 69
Centcelles, cupola, 58–9, 111
chlamys, 27, 114, 118, 159
Chosro II, emperor of Persia, 25 n. 44
Christ, see Jesus Christ
Cimitale, 163
Cirta, 54
cities, symbolism of, 128–9
Claudius Gothicus, emperor, 26
Clement of Alexandria, 103, 154
Codex Purbureus Rossanensis, see Rossano Gospels
coinage, Roman, 38
colour, perception of, 149–50
Comites Sacrorum Largitionem, 36, 38
Constans, emperor, 59
Constantine the Great, emperor, 27, 41, 48–51, 49, 52–4, 132, 147, 152, 161–2, 168
Constantine Porphyrogenitus, emperor, 31, 32
Constantinople, 48
 Church of Holy Apostles, 48 n. 205
 Church of the Saviour, 56 n. 262
 Great Palace, 32, 35, 51, 60, 100. n. 37, 108
 Hagia Eirene, 56 n. 262
 Hagia Euphemia, 60
 Hagia Sophia, 56 n. 262, 123, 124, 126
 Palace of Hormisdas, 60

207

Constantinople (cont.)
 SS. Sergius and Bacchus, 60
copper, 18
council of Nicaea, 50
craftsmen, 36
 see also metalworkers
cross, as a symbol, 123–5
 see also crux gemmata
crowns, as symbols, 126–8
crux gemmata, 53, 56, 123
crystal, 73
Cuthbert, St, 160

David, king of Israel, 119
decorum, 11, 16, 22, 104, 139
Demetrius, St, 113, 116, 118
desert, 156, 163–4
Desiderius of Auxerre, 135
diadem, 27–8, 48, 110, 114
Diocletian, emperor, 26, 34
domes, 56
Dominus Julius, mosaic of, 35
Domitian, emperor, 22
Dura Europos
 house church, 54
 synagogue, 44, 101

ekphrasis, 141–2
Electrum, 77
Elegabulus, emperor, 48
Eligius, St, 36 n. 119, 89
Ephesus, 44
Epiphanius of Salamis, 81–2
Etruscans, 20
euergetism, 44, 54
Eusebius, 50, 54
Eusthasians, 154
Eve, 77
exegesis, 63–84

fibulae
 cross-bow, 28–30, 118–19
 imperial, 28–9, 48–9
Fundi, 129

Galerius, emperor, 26, 59
Gallienus, emperor, 143
Gaza, St Sergius, 103
Gellius, 19
gifts, 11, 14, 136

gods, pagan, attributes of, 19
gold
 Golden Age, 96
 and pagan gods, 19
 supplies, 41
 symbolism of, 74–9
 value and attributes, 18, 24, 91
grave goods, 39
Gregory of Elvira, 69
Gregory the Great, St, pope, 66, 69, 70–1, 87–8, 142, 163
Gregory Nazianzen, 104
Gregory of Tours, 141

heaven, 94–5, 96, 105
Heraclius, emperor, 25 n. 44
Herculaneum, 43
Hercules, 34, 48
Hesiod, 66
Hippolytus of Rome, 69
Homer, 66
Honorius, pope, 168–9
Horti Lamiani, 31
Hypatius of Ephesus, 142

iconoclasm, 46
imperial cult, 24–5, 26, 47–8
iron, 18

Jerome, 3, 69, 70, 86, 155, 157
Jerusalem, 128, 147
 Church of the Holy Sepulchre, 50
 Golgotha, 56–7, 123
Jesus Christ,
 imagery of, 91, 111–12, 119, *121*, 127, 130–1, *131*, 162, 166,
 passion of (Crucifixion), 93, 100, 118, 158
 teachings of, 61, 93, 94, 153
jewelled band, motif, 128–9
jewelled style, 92
jewellery, 6
 imperial, 28–30
jewels, symbolism of, 80–3
Jewish symbolism, 101
Job, 87–8
John VII, pope, 113
John of Atramytium, 142
Judas, 153
Julius Caesar, 22, 25, 41, 130
Jupiter, 20 n. 17, 34, 48, 51, 103, 127

INDEX

Justin II, emperor, 28
Justinian, emperor, 29–31, *30*, 110, 114
Justus of Urgel, 69

Kaper Karaon, treasure of, 136
Konz, villa at, 35

labarum, 53, 123
lapidaries, 80
Lausus, 60
law
 Irish, 36 n. 119
 Roman, 39
Leo, emperor, 110
Liber Pontificalis, 54, 57
Licinius, emperor, 49
light, symbolism of, 74, 101, 143–6
Lindisfarne, 126, 160
liturgy, 95
Luxor, temple at, 48, 109
luxury, 14, 21

Magi, 54, 61
mandorla, 144
Manichaeism, 145
Marculus, 97
Marianus, 97
Martin of Tours, St, 160
martyrs, 95, 97
Mary, the Virgin, imagery of, 113, 119
Maximian, emperor, 26, 34
Melania, St, 57, 137, 155, 159
metalworkers, 36 nn. 118 and 119
metaphor, 16, 90 n. 202
Michael, archangel, *120*
Milan
 San Ambrogio, Chapel of San Vittore, 127, 160
 Sant'Aquilino, 59, 111, 112, 147
 San Lorenzo, 59
Mildenhall, treasure of, 135
missorium of Theodosius, 28–9, *29*
Mithraism, 46–7
mosaics, 105–39
murex-dye, *see* purple

Naples, Baptistery of San Giovanni, 129, 147
Neo-Platonism, 45–6, 145–6, 165
Nero, emperor, 21–2, 24, 32
nimbus, 143–5
Notitia Dignitatum, 51

Onesipheros, St, 118
opus sectile, 34, 108, 124
Origen, 66, 69
Ostia, mithraeum, 47, 108–9

paintings, 43
palaces, 31–3, 51–2 (for individual palaces see under their location)
panegyric, Roman, 23, 26 n. 50
Paul, St, 94
Paul of Samosata, 130
Paulinus of Nola, 163–4, 166
pearls, 19
Pelagianism, 156
Pergamum, 98
Persian, material culture, 37
persecutions, 53, 54, 162
Pesaro, SS. Decenzio e Germano, 124
Phidias, 98
Philo of Alexandria, 66
Piazza Armerina, villa, 34
pillars, jewelled, 114
Pliny the Elder, 22, 81
plunder, 39
Pompeii, 42–3, 45, *107*, 165–6
Poreč, Basilica Euphrasiana, 126, 132, 144–5
power, 11, 26
preaching, 90
Prudentius, 157–8
Pseudo-Dionysius, 145
Pseudo-Isidore, 69
purple, from murex-dye, 21, 37, 129, 151, 160
Primasius of Hadrumentum, 69

Qasr-el-Lebia, 124

Rabula Gospels, 158
Rabulla of Edessa, 60
Ravenna
 Archiepiscopal Chapel, 119, *131*, 144
 Archiepiscopal Museum, 99, *102*
 Baptistery of the Arians, *frontispiece*, 109, 128, 129
 Baptistery of the Orthodox, 109, 123, 129
 Mausoleum of Galla Placidia, 117, 123, 147
 Palace of Theodoric, 34, 52
 Sant'Apollinare in Classe, 112, 119, *120*, 122, 123, 126
 Sant'Apollinare Nuovo, 60, 109, 112, *121*, 126–8, 132, 144, 160

INDEX

Ravenna (*cont.*)
 San Michele, 123, 129, 132
 San Vitale, 30, 60, 110, 114, 115, 124, 126–7, 129, 132, 147
Republic, Roman, 20
Revelation of John, Latin exegetes of, 69–70
ritual, 11–13, 36, 37
Rome
 basilica of Junius Bassus, 35
 Domus Aurea, 25, 32
 Lupercal Chapel, 44, 109
 mausoleum of the Julii, 111
 mithraeum under Santa Prisca, 47 n. 197
 Old St Peters, 55, 128, 144, 164
 Palatine hill, 31
 Sant'Agnese, 112, 117, 126, 127, 128, 129, 168–9, 169
 Santa Constanza, 58, 98, 99, 109, 129
 SS. Cosma e Damiano, 112, 127, 129, 146
 San Giovanni in Laterano, 35, 55, 134–5, apse, 58 n. 271
 Baptistery, 124
 Chapel of San Venanzio, 118, 126, 128, 129
 fastigium, 57, 130
 Palace, 52
 San Lorenzo, 123, 127, 128, 129, 144
 Santa Maria Antiqua, 113
 Santa Maria Maggiore, 111, 112, 117, 119, 128, 129
 San Pietro in Vincoli, 127
 Santa Pudenziana, 112, 116, 123, 130, 132, 147
 Santa Sabina, 128
 San Stefano Rotundo, 123, 129
 Temple of Apollo, 44
 Temple of Pietas, 44
Rossano Gospels, 119
Rufinus of Aquileia, 69

Sadducees, 95 n. 1
Salutaris, C. Vibius, 44
sarcophagi, 99, 102
Sardis, synagogue, 100 n. 35, 101
scarlet, from *coccum* dye, 37
Scaurus, 32
senators, 24
Serdica, 59
Serenus of Marseille, 142
sermons, 16
shields, decoration of, 42 n. 169
silk, 20, 37, 151

silver, tableware, 39
sin, 21 n. 19
Sinai, Monastery of St Catherine, 112 n. 101, 144
Sinope Gospels, 119
Sixtus III, pope, 124
Sol Invictus, 50, 51
solidi, 57
 see also coinage, Roman
Solomon, king of Israel, 67, 95, 161
 Temple of, 15 n. 66, 61, 95
Solomone, 113
Song of Songs, Latin exegetes of, 69–70
Split, Palace of Diocletian, 32–3
style, 8–9
Suetonius, 22
Suger of St Denis, 89
symbolism, theory of, 6, 7–8, 9, 11, 16 n. 75
Symmachus, pope, 168–9
Synod of Gangra, 154
Synod of Frankfurt, 142

Tabernacle, 61, 95
tetrarchy, 26, 48
Thagaste, 137
Theodora, empress, 114, 119
Theodore of Sykeon, 18 n. 5
Theodoric, king of the Ostrogoths, 60, 132
Theodosius I, emperor, 104
Theodosius II, emperor, 60
Thessalonica, 98
 St Demetrius, 116, 118
 St George, 59, 118, 144
thrones, symbolism of, 129–30
toga, 20, 27
Toulouse, Golden Church, 59, 113
trabea, 27
transparency, symbolism of, 73
Treasure
 defined, 6
 in society, 38, 41
Trier, imperial palace, 33
True Cross, relic of, 48 n. 206
Tusculum, Villa of the Caecilii, 43
Tyconius, 69, 71
tyranny, 21

Umn-er-Rus, 124

Valerian, emperor, 26
Venice, San Marco, 104

Victorinus of Petau, 69, 70
Visigoths, 39, 59
votive offerings, 14 n. 63

wealth, 21, 153–7

white, symbolism of, 72
Whore of Babylon, 64, 76–7
wills, 39

Zoe, empress, 126